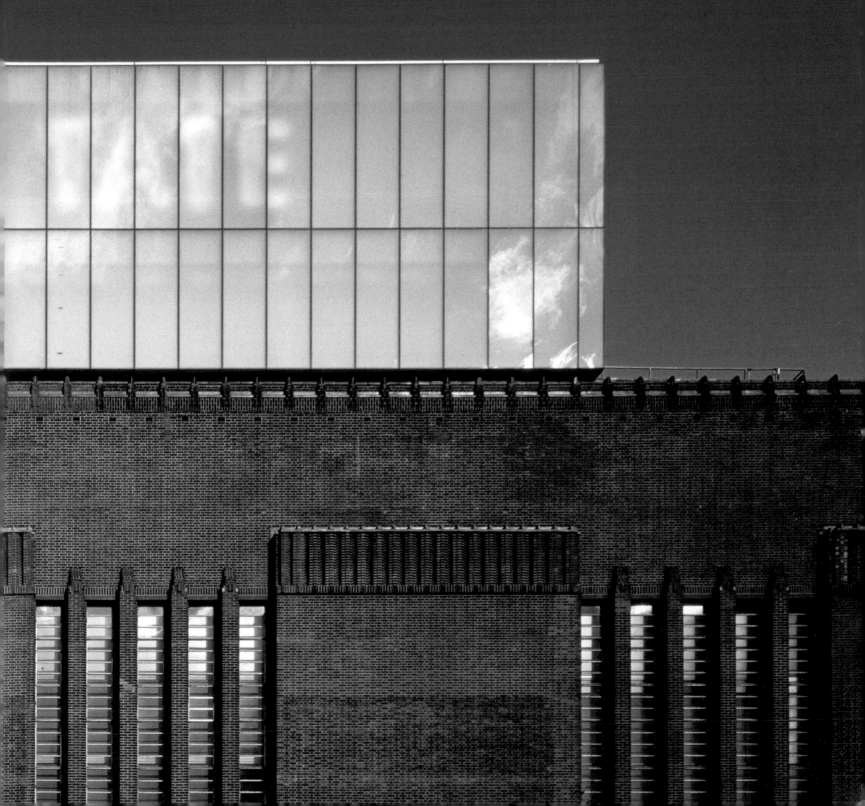

First published 2000 by order of the Tate Trustees
by Tate Publishing, a division of Tate Enterprises Ltd,
Millbank, London SW1P 4RG
www.tate.org.uk/publishing

First revised edition published 2006
Second revised edition published 2010
Reprinted with amendments 2011 (twice)
Third revised edition published 2012

A catalogue record for this book is available
from the British Library

ISBN: 978 1 84976 039 3

Distributed in the United States and Canada by
ABRAMS, New York

Library of Congress Control Number applied for

Designed by Rose
Printed by Grafos, Barcelona

Mixed Sources
Product group from well-managed
forests and other controlled sources
www.fsc.org Cert no. SGS-COC-005160
© 1996 Forest Stewardship Council
FSC

Front cover and page 9:
Tate Photography/Andrew Dunkley/Marcus Leith
Frontispiece: Shigeo Anzai

Contents

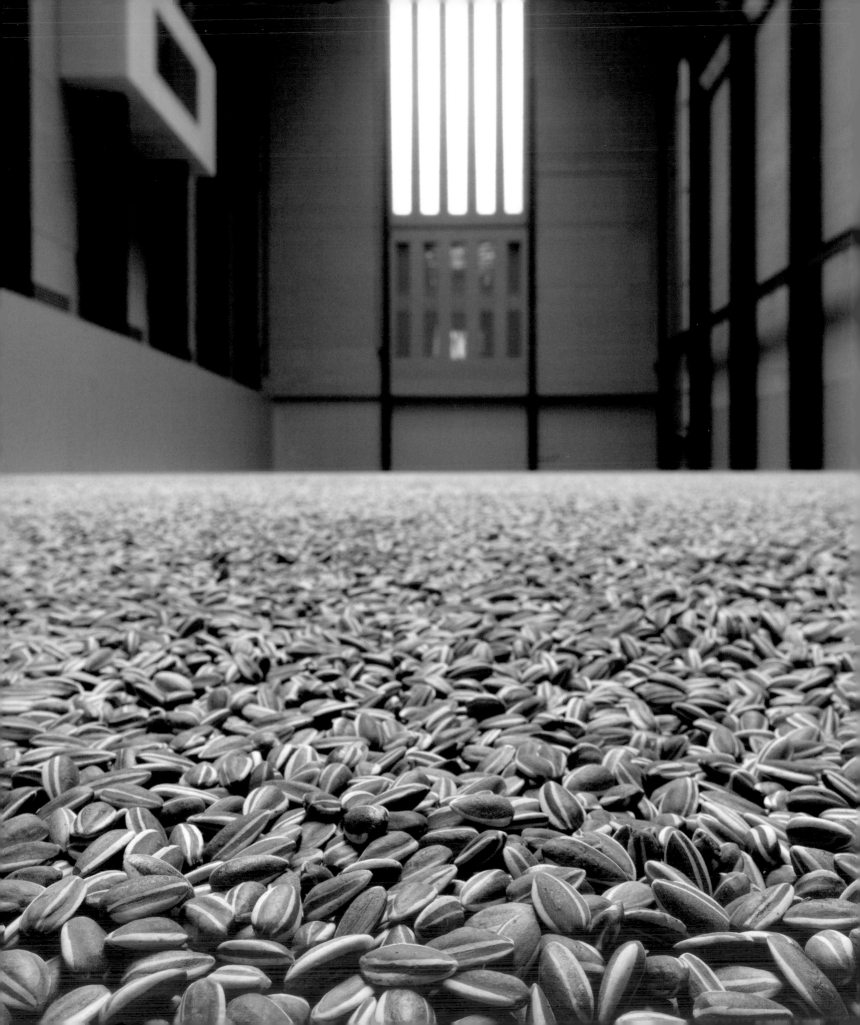

Director's Foreword

Tate Modern is a site of interchange, a contemporary equivalent to the *agora* of ancient Greece that was the marketplace for all manner of goods as well as a place for the exchange of ideas. In the twenty-first century the museum increasingly serves a comparable role as an intellectual, cultural and social site and, since it opened in 2000, Tate Modern has been a key site for this transformation. In this short lifetime, more than four and a half million visitors have been welcomed each year. We come here for many different reasons – too many to grasp – but among them are the desires to appreciate and to question, to explore, to learn, to be inspired and to create, to engage and interact. In some senses the museum is a clear reflection of this huge variety. A century ago the futurist F.T. Marinetti attacked the 'promiscuity' of the museum's combination of artworks from different eras and places. Now we embrace this multiplicity and appreciate how enriching are the juxtapositions, the flowing-together, of many different streams of cultures beyond those simply of Europe and North America. Just as our view of the world can no longer be monolithic, so London – among the most culturally diverse cities on the planet – demands places that reflect this continual enrichment but also allows for this state to be questioned and explored.

Since it opened over a decade ago, Tate Modern has helped to transform the way that we think about and experience museums. How to balance the presentation of works of art – some in need of contemplation, some demanding performance – has been one of the challenges as the role of culture evolves in a rapidly changing and increasingly complex world. Tate Modern has shown that the museum in the contemporary world is no longer a fixed entity with an established circuit of acknowledged masterpieces. It is a place where the audience and the collection are both in a process of transformation, coming together to make culture. Works that hold a certain meaning in one moment, for particular viewers, take on different nuances in new contexts. Like the proverbial stone dropped into a pond, the way in which we display the Tate Collection today sends ripples through our history as an institution. Necessarily it sets up new ways of looking back at the past, but it also ruffles the surface for the future.

In this way, each reconfiguration of the Tate Collection shown at Tate Modern – as well as the spectrum of exhibitions, installations, performances, screenings, conferences and other activities – provides an adjustment to the balance of the whole. The museum is, in essence, a giant composition at any one moment, constantly shifting and responding to developments, to research, to new acquisitions, to audiences, to you. There will always be enthusiasts for certain forms of art – whether the iconic, the arcane or the newest (not necessarily the same thing) – as well as those who cannot share that enthusiasm: as John Cage said many years ago, 'sometimes it works, sometimes it doesn't.' One of our challenges is to give people the space to enjoy the work they love and, perhaps, to be open to the unexpected.

In 2000 the scope of Tate Modern's ambition was matched by restructuring the curatorial vision. The new building, developed by Herzog & de Meuron within the skin of Giles Gilbert Scott's Bankside power station, was a stage for an audacious rethinking of the way in which to address the collection and bring it to our audiences. The original thematic display of the collection caused excitement as well as some dismay among those expecting chronology. It is the excitement that has been sustained. When the further reconfiguration was unveiled in 2006 it demonstrated, above all, how rich great art can be. This arrangement of the collection continues to revolve around spaces devoted to pivotal moments of the art of the last hundred years and more. These are associated with abstraction, with surrealism, with art informel and with arte povera, but in each case a broadly inclusive approach to the age of modernity is explored through divergent responses. As our understanding of these moments is conditioned by our view from the present, so the surrounding galleries explore precedents, contemporaneous or subsequent developments. The proposition in placing them alongside each other is that their common ground enriches our understanding and sheer pleasure on encountering these works.

Tate Modern displays increasingly highlight works that are new to the collection. We are extremely grateful to the artists, whose judgements and commitment are invaluable. We are also indebted to the generosity of collectors who lend key works through which the displays are amplified. Among those with whom we have worked closely over the years are David King, the Joan Mitchell Foundation, the Wilson Centre for Photography, the National Gallery and the Victoria and Albert Museum. As is now well known at Tate Modern and across the country, the ARTIST

ROOMS collection continues the transformative impact that it has had since being acquired jointly in 2008 with the National Galleries of Scotland through The d'Offay Donation with the assistance of the National Heritage Memorial Fund, the Art Fund and the Scottish and British Governments.

Our endeavours at Tate Modern would not be possible without the help of our supporters at all levels, from each individual who becomes a Tate Member or a Patron, to the Acquisition Committees, through whose advocacy the collection is growing more diverse and international. We are grateful for the ongoing support of Bloomberg that has enabled us to invest in innovative new technologies like the Multimedia Guide to enhance audience interaction with the collection. We are also grateful to Unilever for its support of The Unilever Series, as with its support we have been able to present a decade of memorable responses to the iconic Turbine Hall. We would also like to thank HM Government for providing Government Indemnity for works on loan, and the Department for Culture, Media and Sport and the Arts Council for arranging this indemnity.

Tate Modern: The Handbook is designed to extend your interaction with the Tate Collection as disposed across the building. Prefaced by Nicholas Serota's celebration of the first decade, it includes Andrew Marr's essay on Tate Modern's impact as well as Michael Craig-Martin's account of the generative process behind the original project. Texts by our colleagues Frances Morris (Head of the International Collection), Matthew Gale (Head of Displays) and Sheena Wagstaff (Chief Curator 2001–12) provide overviews of the collection, displays and exhibitions respectively. To work in and for a great organisation is to work collaboratively and the multiple voices of the A–Z section provide an indication of this wider endeavour. Many of the individuals who have contributed these texts are past or present members of the Tate Modern Displays group and we would particularly like to thank those who make up the current team: Simon Baker, Tanya Barson, Simon Bolitho, Stuart Comer, Ann Coxon, Marko Daniel, Flavia Frigeri, Mark Godfrey, Kyla McDonald, Shoair Mavlian, Jessica Morgan, Valentina Ravaglia, Helen Sainsbury, Rachel Taylor and Catherine Wood, together with Phil Monk for the technical planning. We would also like to acknowledge the dedication of colleagues, too numerous to mention, across the organisation including those in the Archive and Library, Art Handling, Communications, Conservation, Curatorial, Development, Front of House, Learning, Legal, Media, Press, Special Events and Registrars. We should also like to thank Emily Breakell, Simon Elliott and Terry Stephens for the design of *The Handbook*, and Deborah Metherell who has overseen the current publication at Tate Publishing.

It is a pleasure to work with such creative colleagues on a daily basis as we seek ways in which the art in our care can enlighten, enrich and excite. Just as it is in the encounter with the art in the Tate Collection that a communal culture is created, at Tate Modern we want to enable the visitor to give meaning to art objects, to explore and conceive new and hitherto unimagined meanings. While we adapt to the endless potential of the newest means of communication and the revolution of social media, our memory or (to use an almost perfect word in this context) our *recollection* of the past – even the most recent past – seems to be fading away. The museum is one of the few remaining sites where we can still learn to construct and to trust memory. Unlike other visual production, visual art delivers immense sets of subjectivities that provoke us to thought, contemplation and exchange even as they resist measure or control.

Chris Dercon
Director, Tate Modern

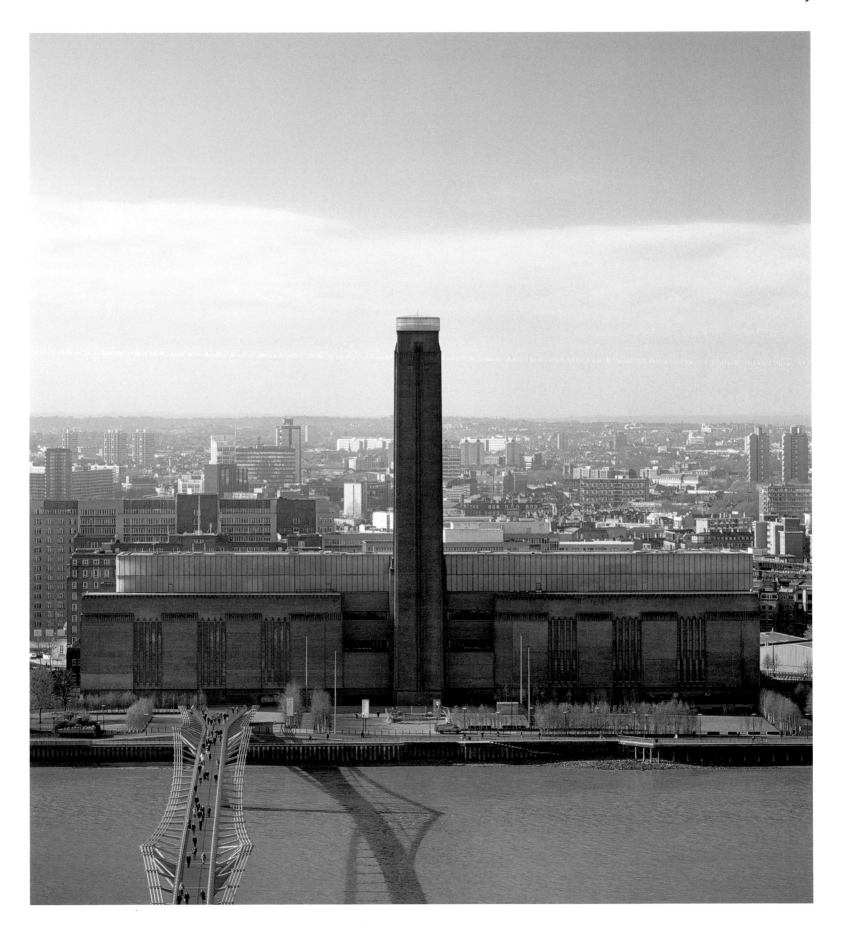

TATE
MODERN

Authors
Nicholas Serota
Andrew Marr
Frances Morris
Matthew Gale
Sheena Wagstaff
Michael Craig-Martin

In the decade since it opened, Tate Modern has been visited by over forty-five million people and has become an established part of the experience of London. It is now difficult to remember the city and its culture without Herzog & de Meuron's powerhouse for art and Norman Foster's elegant Millennium Bridge. However, in the wake of this success it is also easy to overlook the fact that Tate Modern is only half built and that further benefits to the city and its culture will flow from the completion of the phase of work that began in the summer of 2010.

Any city is an economic, social and physical organism that is in a constant state of flux. For decades Bankside lay dormant. Sir Christopher Wren's house, occupied by the architect while he was designing St Paul's, sits as a reminder that this area was once at the centre of the city and surrounded by the bustle of the theatre district with The Globe and Rose nearby. In the nineteenth century the needs of the metropolis for heat and light brought coal and then oil-fired installations for the generation of power. Giles Gilbert Scott's magnificent postwar building was completed in the 1960s, only to be made redundant by the early 1980s. It had become a dark, brooding presence as it slowly decayed over the following fifteen years; notwithstanding its central location in the city, life was passing Bankside by.

However, an urban fabric needs constant new investment and the decision to redeploy the power station as a museum of modern art and to create a new footbridge across the Thames acted like pebbles thrown into a stagnant pond. Slowly, transformation has gathered pace with office and residential developments stimulating improvements to the public realm. The structure of Bankside nevertheless remains tight and small in scale, with the exception of Southwark Street, driven through the area in the late nineteenth century. The most promising development in the wake of Tate Modern has therefore been the initiative to create a new character for the public realm, the Bankside Urban Forest, led by a group of local companies and a team of architects, Witherford Watson Mann. Their proposal is designed to green and humanise the city through planting and change the balance between vehicles and pedestrians in favour of people in order to bring scale and humanity to a somewhat harsh, utilitarian realm dominated by the railway viaducts, through traffic and small-scale industrial activities that service the more prosperous parts of the city. Over the next decade the steady implementation of the Bankside Urban Forest will transform our experience of this triangle of London running south from the river between Blackfriars Road and Borough High Street, culminating at Elephant and Castle, the gateway to London from the South.

Tate Modern's success as a museum has grown from a powerful combination of the building, the collection and the imagination of its curators. It was the brilliance of Herzog & de Meuron to see the potential of the redundant Turbine Hall, transforming it into a covered street, almost a city square, within the museum. It is a space that changes its character according to the time of day, the quality of light and the number of visitors, but it is always welcoming and offers the community a place for congregation. The architects also created a series of rooms for learning and social engagement as well as galleries that can rival those in any of the new museums across the world. Yes, we all complain that the galleries are too full on a weekend afternoon, but at other times the side light from the Thames or from above, through the clerestory lights of Level 4, encourages a moving and often surprisingly intimate encounter with art.

The collection itself has grown dramatically in the past ten years. The relative neglect of the visual arts in Britain in the twentieth century means that the collection has far fewer recognised masterpieces than the museums in Paris or New York, but Tate Modern has created new favourites such as Rebecca Horn's *Concert for Anarchy* 1990 and the group of Anselm Kiefers (p.151) that were among many works displayed as a result of Anthony d'Offay's extraordinary gesture in giving his collection to the nation in the form of the ARTIST ROOMS. Above all, it is the imagination of the team of Tate Modern curators that has defined the originality of the institution, showing collections in new configurations that have been adopted by others across Europe and North America. In working with artists in the Turbine Hall, or in devising the innovative displays of the collection, in one structure from 2000–6 and, since then, under a different frame, the curators have set out to make vivid the ideas, achievements and connections between different generations of artists. Contemporary art lies at the heart of the debate about ideas and values, not, as often elsewhere, relegated to the end of a long historical line where it suffers in comparison with the now-established masters of the early twentieth century: Picasso, Matisse, Mondrian, Beckmann and Duchamp. These initiatives are described in detail later in this volume, but they have established Tate Modern as an institution that serves its audience by suggesting new ways of seeing.

Tate Modern: the First Decade
Nicholas Serota

Left:
Interior view of the former eastern oil tank under renovation at Tate Modern, November 2011

Right:
Architectural visualisation of the view from the south of the new development of Tate Modern, 2011
© Hayes Davidson and Herzog & de Meuron

The very success of Tate Modern in opening up our experience of contemporary and modern art and in changing our relation to the city compels us to seek ways of realising the further potential of the site and of the building itself. Herzog & de Meuron's new plans for Tate Modern will be realised over the next few years. Work has begun and will create new gallery and social spaces to relieve the overcrowded rooms in the present building and respond to the changing nature of art, with facilities for new media and spaces to reflect Tate's new commitment to photography and art from across the world, not just from north-west Europe and North America. There will be enhanced spaces for learning, with access to studios, seminar and study rooms that will be places for dialogue and exchange not simply instruction. Beneath these exciting new facilities lie the former oil tanks from the power station: rough, raw spaces where we shall present (beginning in the summer of 2012) special installations by artists, and performance in the realm of dance, music, the spoken word and film. Now in its second decade, Tate Modern is continuing to explore new ways to interpret the art that we already know and to present emerging trends. Artists oblige us to look again and to think again. Tate Modern gives us the opportunity to join them in that search.

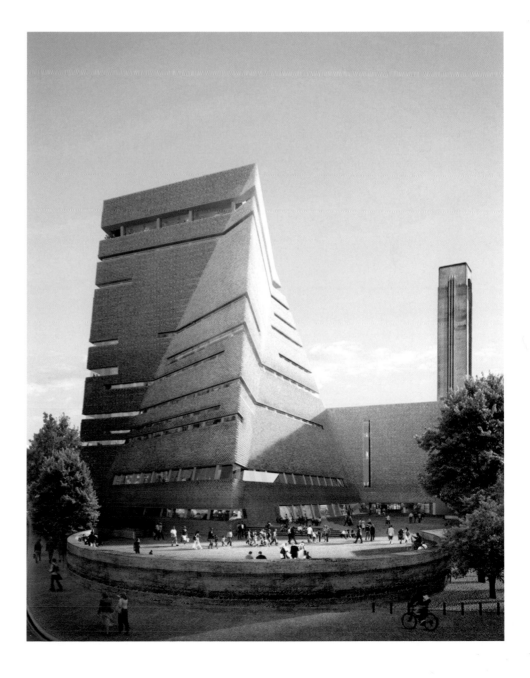

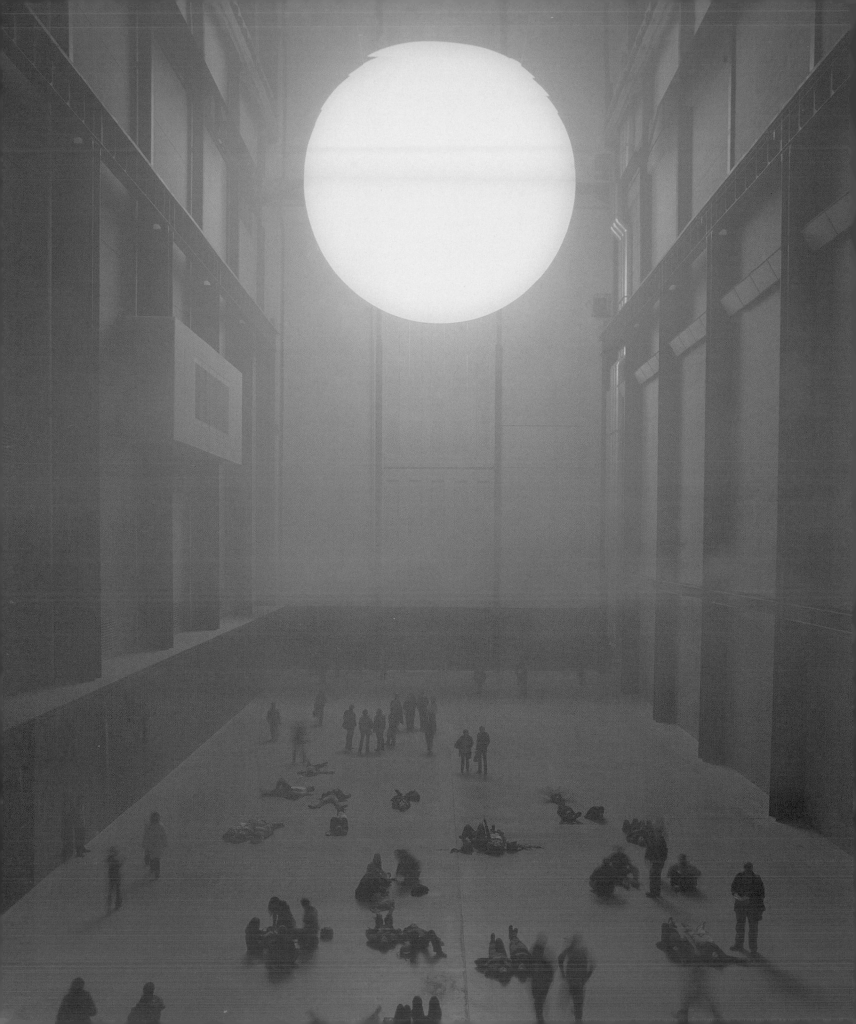

The story of Tate Modern is a new story. It is a tale on a big scale, about huge risks, a river of millions of visitors alongside London's river; it's a story brimming with symbols, above all the obvious one of an old industrial power station scooped out and remade as a cultural powerhouse. And what of those of us passing time here – perhaps squatting down to stare at a completely unfamiliar sculpture, or standing and gawping upwards in the awesome Turbine Hall, or browsing through the shop, acutely aware of sore soles, watching other watchers, daydreaming? In a busy, grindingly urban world, we learn to value our time. What do we hope to get by spending it here: little spasms of pleasure, a slightly grander sense of ourselves, a time of contemplation, freed from the usual demands of earning, shopping and moving?

Church or holiday?

The contemporary art museum is often compared to a secular cathedral, where agnostics come to engage in a pale mimicry of worship. The artist Jake Chapman, a ferocious critic of Tate Modern, expressed the complaint that its architecture is 'concussive': 'You feel very small in the face of the magnitude of this cathedral. It sends messages for miles: this is important, this is a sacred place, everything here is sacred. Things that are sacred aren't questioned, and that's the problem.' Every honest visitor to a contemporary gallery knows what he means. You just have to look at the false-pious expressions, the dazed reverence, on some faces; or hear the hushed murmuring; or attempt to read some of the hectoring prose written about modern art. Yes, there is an attempt by some people, some of the time, to mimic religion and browbeat visitors. Whether it is fair to judge Tate Modern in that way is another question. Is there laughter here? Is there 'art impiety'? Are there arguments going on around the building? Do people gasp with actual pleasure or are they really solemn and intimidated? This is a difficult thing to analyse. My impression as a regular visitor is that the Tate is not concussive, despite its almost ludicrous size, and is rather a welcoming place. But yours may be different.

In other words, Tate Modern does not feel like a cathedral. For one thing, to make an obvious and mildly barbarian point, it is a great deal more popular than most cathedrals. It draws in around four million visitors a year, more than double the number originally planned for, and apparently holding steady. In raw pulling power, that makes it the most successful modern art gallery in the world, easily outstripping New York's Museum of Modern Art. It is the third most popular free attraction in London, this constantly distracting, 'watch me', 'do this' mayhem of an international city. Its audience is relatively young. Cathedrals, perhaps sadly, tend to attract older congregations, but six out of ten visitors to this place are under thirty-five. Walk around and you will find all ages, colours and styles of ambulant human. Tate Modern works hard to attract children, in groups and individually, and there are plenty of them, particularly on week days. All of which is not bad, you may think, for a building full of allegedly difficult art.

The days are long gone when we were taught a story of one genius or group of them following and eclipsing previous schools, so that a line of advance is discovered, and art moves ahead, as if artists were explorers or experimental scientists. A major contemporary gallery, like this one, exists to teach and to expose us to new art and new experience. That involves history, including the history of ideas. But modern art, with its complex, writhing pattern of movements, its glittering dead ends and its surprising passages, has become hard to categorise into hierarchies of good and bad. We lack the words. If you are dealing with oil paint on a flat surface, or an etching, then comparison between two works is relatively easy. Comparing a huge colour field painting by an American abstract painter with a Fragonard may be hard, but it is not impossible. How, though, do you compare an arrangement of Brillo boxes by Andy Warhol, a Sam Taylor-Wood DVD of fruit rotting, Joseph Beuys's basalt columns and a Dan Flavin light sculpture? We are lacking in a common language for this. Calling one of these works more or less successful than another pushes us back into our own individual responses, which are in turn shaped by the chances of our lives and personal experience. In earlier eras, people could fall back on using technical ability as their criterion, highlighting the work's craft and artifice. We have been taught that there is something barbarian about this, but for centuries it gave people a jumping-off point. But craft is almost irrelevant to an age when artists employ others to do the actual making, subcontracting the welding, assembling and occasionally even the painting or mark-making.

Art has also consciously disconnected itself from external systems of values. There are overtly political works in Tate Modern, reflecting our unease about the environment and global warming. There is Tony Cragg's sideways map of Britain made out of junk, and an Irish dirty protest, an electric chair, as well as Germanic anti-heroes, throwing out thoughts on the darkest time of the twentieth century. But when we ask what contemporary art says about the world around it, the words continue to scrabble and slide. A medieval Londoner could read the

The Magic Box
Andrew Marr

symbolic iconography of saints, a lexicon of images that was instantly accessible, summoning stories heard orally and their moral conclusions. An art lover in Georgian times understood the classical fables, reading off the fauns and Dianas like notes on a score, and could bask in the memory of sunlit afternoons among Roman ruins. A mid Victorian gallery goer had a whole internal dictionary of romantic responses to waterfalls, Shakespearean scenes and the like. As with the concept of skilfulness, this gave them ways into the art. They could come away feeling the truth of a Bible story more strongly, or preening themselves on appreciating subtle jokes about Bacchus, and thus on being part of the educated elite, or feeling soulful, and liking themselves the better for it. But a lot of what is in Tate Modern repels 'reading' in that way; the shiny metal, abstract canvas or curved wood has cut itself adrift from anything verbal. That makes things hard. It can mean our responses are more intensely personal; but it can also stop us describing, or discussing those responses with one another in anything other than the blandest way, in terms of how it makes us feel. Perhaps we suspect there are secret societies of adepts who know more but, if so, they speak to us rarely.

As compared to the agreed stories and hierarchies of Christianity or Islam, Tate Modern offers puzzles, questions and dilemmas. One critic, John Carey, argues that this demonstrates conclusively that such art is inferior to literature, which contains the eloquence to criticise itself. I would say, rather, that all our moving around rooms, the time we spend in front of artworks, and how they hold up in the memory once we depart, adds up to a kind of perpetual market of emotion and imagination. Works fail if they cannot attract an audience, a glow of enthusiasm. They succeed, or survive, if enough people enjoy them enough … which, after all, is much the same with books. Tate Modern is an ordered, or at least curated, quasi-chaos of creative and mental activity. The curators are provoking us, challenging us to decide what moves us. Some work survives; other work fails. And, as we know, one era's failures may be regarded, in time, as successes. Almost certainly, in the galleries you may have visited, there are examples of art that will in the future be seen as ultimately unsuccessful. Through the obscure working of art fashion, paintings and sculptures currently standing proudly in the light-washed, thronged rooms, will one day be packed away into Tate storage, to sit in silence and dark, relegated and forgotten. Then, perhaps, a few decades later they will be rediscovered. (Wouldn't it be wonderful if all the seen-too-often Monets and Bacons, for instance, could be hidden away for a generation and revealed in their radical glory to fresh eyes? Ha! Surprise!)

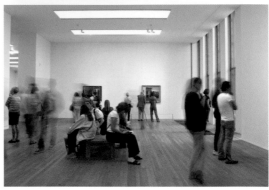

So this is a bogus cathedral whose worshippers disagree about basic tenets of the faith. It does contain common stories, from the tale, or fable, of Joseph Beuys's near-death wartime experience, to Richard Long's discovery of the walk as art. Stand behind other people, room by room, listen to them talking and you will hear the parables of contemporary art being retold again and again. Yet for most people, the experience of the work will be full-on, of the moment and unclouded by even these stories. This is not necessarily a good thing. It can make the work seem dull, off-putting or incomprehensible: as with other art forms, the audience has to work a bit, too. There is a sentimental assumption, sometimes, that you can put anyone in front of a work of art and they will respond to it – that this is the ultimate democratic experience. It is a nice thought, but untrue. Put a twelve-year-old in front of a Donald Judd and what happens? First, the talking has to start, the gabble of explanation.

But if the galleries can be thought of as side-chapels to the cathedral, each with a different clutch of images and questions, then the Turbine Hall is where the communal acts take place. With the help of generous sponsors and an awesome space, a string of artists have produced public art on a blow-your-mind scale. Louise Bourgeois's disconcerting huge spider and Olafur Eliasson's *Weather Project*, with its great, hazy, apricot sun disc, were among the works – or events – that were surrounded by crowds of awed observers hour after hour. We have had moments at Tate Modern when contemporary art folded into mass experience, if not an act of collective worship then perhaps a silent, optical rave.

In the end, though, we should be nervous of the simile between art and religion. Religion is supposed to give people answers to questions about life and death, fundamental meanings and a code by which to live. Art may 'ask questions', console and delight, but it rarely presumes to offer new ways to live. Tate Modern contains some works of obvious profundity, which have the power to shake and provoke serious reflection – I am thinking in particular of the extraordinary Rothko room, which is for me among the most sobering places on the planet. Other works instantly delight and somehow reassure – think of Matisse's *Snail*, or the work of Anish Kapoor. Others genuinely provoke questioning. But the heterodox, jumbled, multiform nature of contemporary art, ranging from satire to

Previous page:
Olafur Eliasson (born 1967)
The Weather Project
16 October 2003 – 21 March 2004

Above:
Visitors to Tate Modern during
the Edward Hopper exhibition
27 May – 5 September 2004

Right:
Aerial view of the partially built
Bankside Power Station, 1951

solemnity, wax and hair to oil paint and DVD, pop to abstract cerebration, beauty to extreme ugliness, means that to talk of any single typical or ideal experience in a building such as Tate Modern, is hooey – marsh-gas and night-soil, as denizens of London's South Bank might have put it centuries ago.

Dirt and money

The place matters too. London is moving home again – back east, where the original city hugged the slimy riverbank, after the best part of three centuries of spreading west. The area around Tate Modern was originally a zone of pleasure and luxury, then squalor and wildness. Southwark was outside the limit of the city, which was on the northern bank of the Thames. From the southern entrance to London Bridge, the laws and enforcement of London's civic rulers lapsed. Rich merchants' houses, squatting across the road south, gave way over time to bear-baiting and cock-fighting, prostitution, crime of all kinds, and eventually, famously, to the great theatres of Elizabethan times. In the rebuilt Globe, crouching beside Tate Modern, there is a modern remembering of that. But Tate Modern's building, the old power station, recalls the later fate of Southwark as a grimy industrial area. London was once a manufacturing city, a centre of the industrial revolution, and nowhere was as ruthlessly disfigured by factories and crammed slum housing as Southwark. It must have stank with the smells of iron-making and brewing, distilling and glass-making. Along the river, where you can now saunter so easily, there were crammed wharves, jostling masts and barges, the constant clamour and shriek of dockers, cranes, cables and steam engines. The air was thick with smoke and the streets slimy with filth. Just across the sewer-like river were the finer buildings and opulent offices of the City, already a world hub of banking. Its wealthy citizens looked and lived to the West, where parks and terraces, new villages and crescents, were springing up. But back in Southwark there was danger and discomfort. No-one would have dreamed of building something as necessary as a power station on the other bank.

By the time the great British architect Giles Gilbert Scott was asked to design Bankside power station, Southwark was already in steep decline, well on the way to the neglected and decaying era it is now beginning to escape. Scott, who had in fact designed a cathedral too, in Liverpool, produced a massive and instant landmark, almost as dramatic as his other London power station, Battersea, further along the river. The thick, blunt chimney at its centre, somewhere between a cubist Doric column and a proletarian spire, rises from what is essentially a big brick shed, interestingly detailed but simple in form. Readers intrigued by the story of how this industrial-era building became Tate Modern are directed to Michael Craig-Martin's gripping essay later in this handbook.

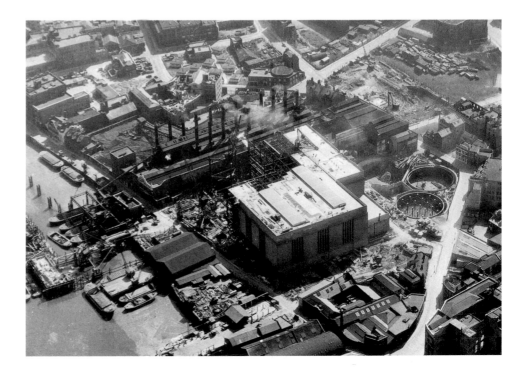

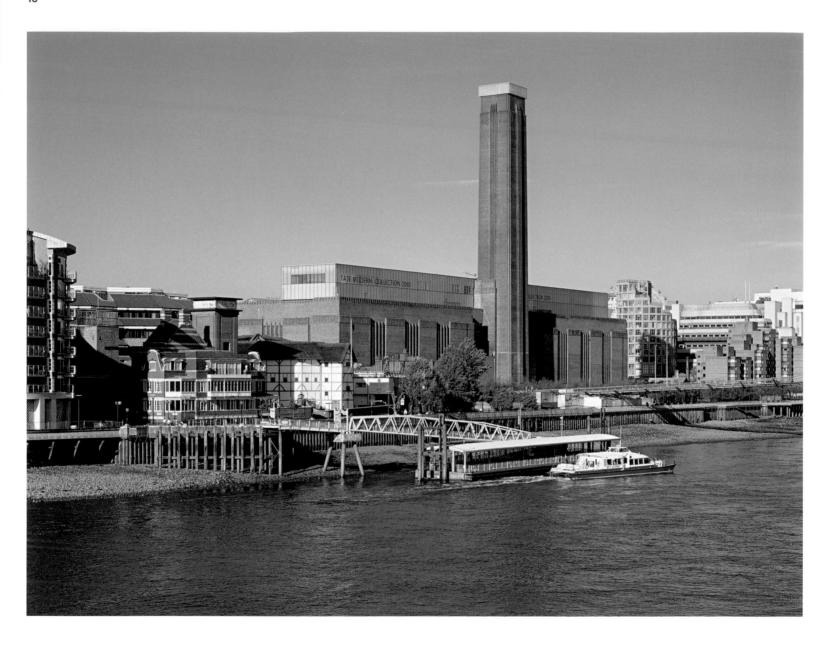

Left:
Bankside during the construction
of the Millenium footbridge, 2001

Below:
View of St Paul's Cathedral from
Tate Modern, 2003

In modern times, the area around Bankside had become a classic example of what happens to post-industrial land without enough money and imagination. Large, gloomy blocks of social housing, bomb-sites, railways – some still operating – and spectacularly ugly office blocks hemmed it in to the south. Schools, scraps of green urban park and fairly dismal shopping struggled to compete with choked, busy roads. It was a place people moved out of when they could. The good life was elsewhere. It was in the London villages, Blackheath, Highgate, Chiswick, even Clapham; or in the more spacious suburbs, or in the wealthier housing of Westminster, Chelsea and beyond. The working-class population remaining after deindustrialisation was, here, mostly white. But across East London, the ethnic mix was changing fast. Poorer immigrants moved in. The old white working classes began to move out, to Essex and Kent. More recently still, the story began to change again. Somehow, after nearly three centuries when London was moving west, and the centre of gravity swinging away from the old city, that mysterious pendulum is swinging back. London is coming east. London is coming home. Whether it is the migration of artists and restaurants to Hoxton, or the somewhat crass commercial development of the old docklands, or the revival of the Thames riverside, there is a return migration of money and energy. It has certainly affected the area around Tate Modern, though when the decision to create the gallery was taken, there were few signs of what was about to happen.

One of the best food markets in London now operates nearby, filled at the weekend with delicious smells, exotic and homely supplies from across England, and visitors cramming bags and mouths with all manner of good things. Specialist shops, restaurants and cafés have opened all over the area. Warehouses have been converted into expensive riverfront lofts; the Thames has been straddled by the Millennium Footbridge – which infamously, but rather enjoyably, wobbled as you crossed it, until it was de-wobbled at some expense. On the other side, Tate Modern has encouraged the development of pedestrian space, sunnier and more open lines of sight and regeneration at street level. Some of the duller old buildings have been pulled down. Students have colonised other areas.

I don't want to overplay the changes, because this part of London is still home to some of the ugliest buildings in the Western world, notably on the Thames's north bank. But there is an air of hope, a genial buzz, at Bankside these days. It has become part of a linear sweep, a riverbank boulevard, which connects it to the concrete galleries, theatres and concert halls of the South Bank, home of the postwar Festival of Britain, and ultimately to Westminster. There has been dramatic change too: the former Greater London Council buildings became empty after Margaret Thatcher's Conservative government abolished the leftist GLC and now house, among other things, a hotel and an aquarium. The pleasant walk under trees extends east from the huge O of the London Eye, past Tate Modern and the rebuilt Globe theatre. It is briefly obliterated by buildings, and then picks up again towards Tower Bridge, a berthed Second World War cruiser and the new London Assembly building, variously compared to a fencer's mask and a testicle. In its childlike geometric variety – circle, block, stick, globe, bobble – this is the frontage of contemporary London. Tate Modern has its place firmly in the middle of a new family photo.

Who comes, and why?

So what are we looking for, when we stop here and come inside? Is Tate Modern simply a convenient, decorated space to amble through, a destination in itself, the ultimate excuse for slowing down? Among its many functions, it is a refuge. We need refuges. We are carried through our lives in a constant gurgle of activity and anxiety, defined by what we are doing – as workers, consumers, travellers, followers, leaders. Every few hundred metres of the modern city calls on us to buy, to change our lifestyle, to do better, earn more, look smarter. We live in a cacophony; not only the obvious one of electronic bleeps, traffic and plane noise, half-conversations through mobiles, recorded voice messages and sirens, but also in a visual cacophony of image and colour designed to make us buy. If we travel between cities, on business or holiday, we touch down and re-enter the cacophony. We have become urban creatures and we rarely escape it. Behind this noise are the deeper pressures we live with – to survive an illness or thrive in a place of work; to pass exams; to retain contact with friends, children, parents; to mourn; to achieve a difficult change of life. Then, like a distant grinding, are the wider anxieties, the worries about global warming, pollution, poverty and ultimate meanings.

In many ways we may have been living through a golden age in the West, a time of cheap travel and huge material affluence. The warning rumbles about rising sea-levels or mass migrations are just that, not imminent. Most of us are not oppressed in any direct way. We do not fear the state, as so many millions feared it during the middle of the last century. There are no near-at-hand tyrannies. Ugly prejudice, aimed at skin colour, sexuality or religion, is

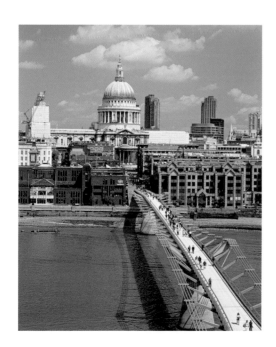

comparatively rarely expressed, particularly given the mixed societies of most large European cities. Yet we are harried people too. We are busier than ever, living faster than ever, surrounded by buzz, questioning and the jabbing finger of choice. In such a life, there are surprisingly few places that let you alone, that stand back and do not demand that you buy, or state your business, or explain yourself. The modern public gallery is one such place. It is constantly available to be probed and thought about, but it doesn't press itself on you. It waits. It lets you be yourself, at your own pace, following your own track and thinking your own thoughts. Drenched in light, surrounded by the work of tense, alert minds, you can feel yourself washed and strengthened before the cacophony begins again.

Or so it is for me. I revel in being able to enter a free gallery for half an hour and spend it with one or two works, as I could not do in a paid-for exhibition. Around me will be knowledgeable students, unknown artists, academics, excitable tourists, local idlers, all with their own agendas. Tate Modern wasn't here a few years ago. It is only here because of the high-rolling gamble taken by some administrators and politicians, and then frantically hard work by the teams who redesigned, converted and opened this extraordinary place. Yet already, a few years on, it feels as much a part of this city as Tower Bridge or St James's Park. Its beautiful wooden floors are changing colour. Its gallery spaces are being reorganised and will soon expand to the south. The flow of people never stops, but there is a rhythm to the arrivals and departures, as the sun moves round the windows, a tide of walking and talking. It belongs to the world of contemporary art but it belongs to London too, a place we are already proud of. It shows that among the botched public works, overruns and administrative failures, things can be made on time, to cost, and can be popular without being crass. It knits an older English aesthetic with the neat decorations and burned-biscuit bricks of Gilbert Scott's power station, and the newer, cooler aesthetic of Herzog & de Meuron, and makes that pairing feel natural. It has brought jobs, helped revive local businesses, and will do more in the years to come. It has excited hundreds of thousands of people with its paying shows, from *Matisse Picasso* to *Frida Kahlo*, and has educated even more through clear labelling, talks, public education programmes, computer links and film.

It was a power station and is, of course, a powerhouse, pumping out energy of a different kind. It is not a cathedral or the site of a new mock religion. But it is both a refuge and a box of magic tricks. In the end, perhaps the simplest description is the best. Tate Modern is the most interesting box on these old and busy islands.

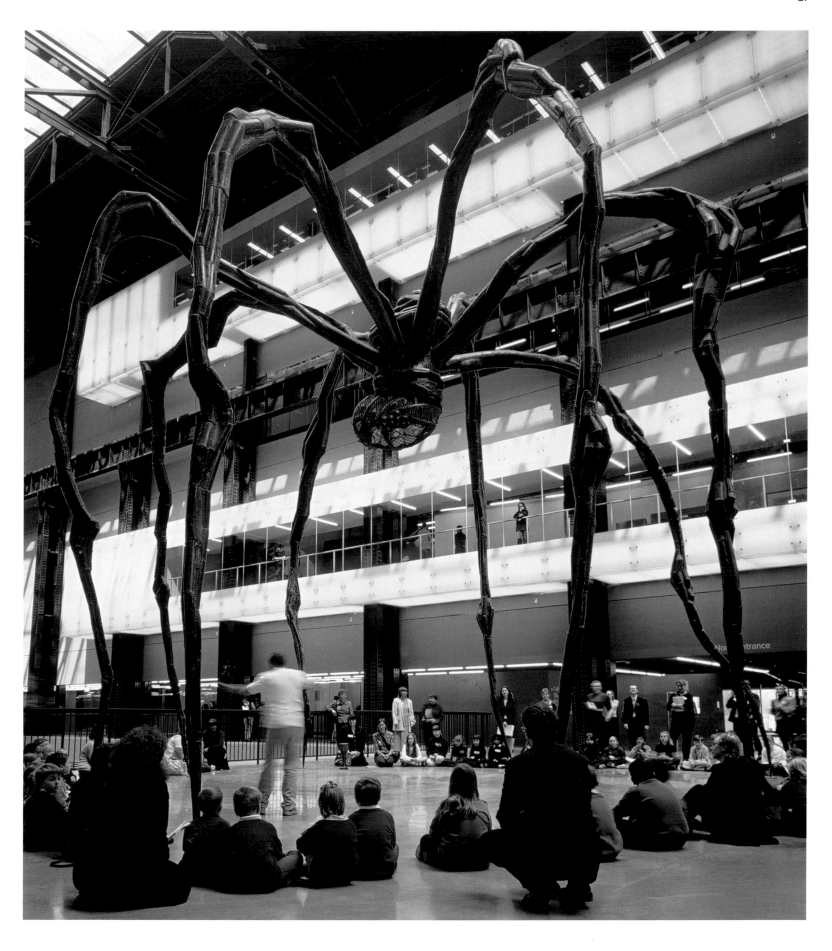

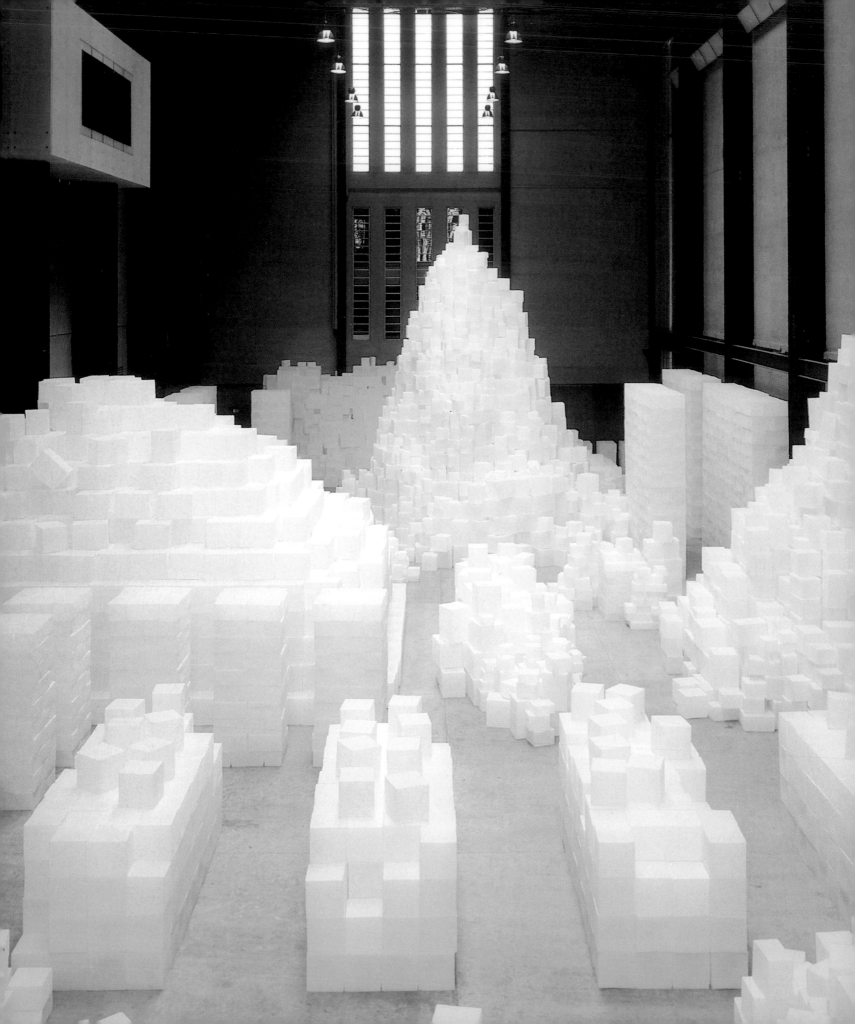

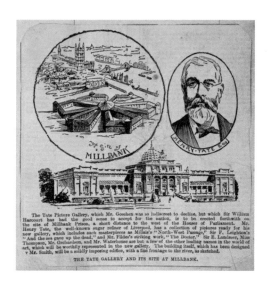

To enter the exhilarating space of the Turbine Hall is to escape, momentarily, from the onslaught of everyday life and work. Throughout its varied spaces, Tate Modern has found opportunities to inspire and support myriad new artistic initiatives, from interventions and live events to smaller-scale projects and commissions for its restaurant, members' room and outside landscape. The development, within the compass of just over a century, from the founding ambition of the sugar magnate and philanthropist Henry Tate – to celebrate and encourage national art – to the extraordinary institutional engagement with the production and display of contemporary art constitutes an enormous leap.

The first Tate Gallery was built in 1897 at Millbank, on the north side of the Thames, upstream from Westminster, on the sprawling, waterlogged site of the old Millbank penitentiary, once Europe's largest prison. As institutions, prisons and museums have a surprising amount in common. Within them, both inmates and works of art, removed from their private spheres, are gathered together, regulated and controlled. Once inside, they rub along with new companions from different backgrounds; changing governors choose the company they keep, determine their status, distribute privileges and control public access.

Not surprisingly, artists have always resisted such terms of confinement. To the painter Maurice Denis, writing in 1907, museums were 'cemeteries abandoned to decay, where the silence and the musty smell denote the lapse of time'. Two years later, F.T. Marinetti, poet and spokesman for the futurist movement, dismissed them as 'musty graveyards' dedicated to the 'futile worship of the past'. More recent artists, such as Marcel Broodthaers and Susan Hiller, have made the museum itself a subject for their critical gaze, laying bare in their work the conventions and values that underpin its practices. Others, like Hans Haacke, have exposed the ideological frameworks that lie behind the museum, or, like Mark Dion, have excavated rich seams of poetry latent within museum systems of classification and display. Battered but unbowed, art museums – Tate among them – have shown themselves to be both resilient and responsive, riding the storm waves but also responding to the ebb and flow of the tide.

Since it first opened in May 2000, Tate Modern has been inundated with visitors, young and old, from near and far. It has become a people's palace, a national treasure, cresting the wave of cultural effervescence as well as spurring the economic regeneration of its neighbourhood. It is a phenomenal visitor attraction – its bars, restaurants and bookshops packed, its public spaces animated with late-night entertainments, its galleries heaving with human traffic, embedded in the chaos and momentum of contemporary life. Like art galleries and museums everywhere, Tate Modern is intent on encouraging and promoting new artistic initiatives, on participating in debate, on responding to and promoting emerging art.

If Tate's emphasis on the contemporary increasingly occupies centre-stage, what has become of its original aim, and its task of defining and safeguarding heritage? What should museums such as Tate Modern do with their permanent collections? And how should they balance the needs and priorities of the contemporary and the modern, the temporary and the permanent? Curators nowadays are faced with a dual challenge: to engage in and make sense of new art and to re-present the old; to approach and communicate history, and display works of art in such a way that meaning can be communicated and experience can be felt by audiences of every kind.

The expectation that permanent-collection displays must somehow address both the history of the works they contain and the wider history from which those works are born is a forceful legacy of the first generation of nineteenth-century art museums, rooted as they were in Enlightenment thinking. Of course, museums have always had to grapple with the restrictions imposed on their historical narratives by the partial nature of their holdings: the 'history' that any collection can address is guided by its particular strengths and weaknesses. Nineteenth-century curators displayed plaster casts of originals to stand in for the 'missing links', while today, the need to 'fill gaps' often drives a museum's acquisitions policy. Until the advent of photography, students of art history seeking to view art were necessarily confined to those museums they could conveniently visit and to what they could see there. Photography, as André Malraux's famous *Imaginary Museum* of 1947 demonstrated, opened up limitless possibilities for the historian: any work from any era could be reproduced in combination with any other, on the printed page. Far from denuding museums of their function, however, this in fact prompted a reassessment of their role. It was Walter Benjamin, exploring the impact of photographic reproduction on the work of art a decade earlier, in 1936, who had identified the notion of 'aura' as the unique power of the work of art, which can only be appreciated in the presence of the original and is lost in the business of reproduction. Museums, rather than art books, are where you can see the real thing, engage with the original work of art and its 'aura'. That is why people visit and revisit museums, why they care, sometimes passionately, about curator's choices, and

Above:
'The Tate Gallery and its Site at Millbank', press cutting from *The Times*, 1892
Tate Archive

Left:
Rachel Whiteread (born 1963)
EMBANKMENT
11 October 2005 – 1 May 2006

From Then to Now and Back Again:
the Tate Collection at Tate Modern
Frances Morris

why they love or loathe interpretative texts, or other means by which the museum might mediate their experience of the work of art.

Tate has developed two complementary collections: one following the history of British art – the purpose for which it was originally founded – and, since 1917, one of modern international art. The collections have their own characters: the British collection is more broadly based and the international more selective and idiosyncratic. Tate's collection reflects both the visions of different directors and curators and the realities of taste, economics and opportunity. Until recent years, its geographical focus was principally on Europe and North America, and its strengths and weaknesses were easily categorised according to recognisable historical/stylistic focal points. Surrealism, abstract expressionism and pop art were well represented; dada, interwar realism and expressionism were notably lacking. Highlights include celebrated individual works – Auguste Rodin's *The Kiss* 1901–4 (p.220), Edgar Degas's *Little Dancer Aged Fourteen* 1880–1 (p.101), Henri Matisse's *The Snail* 1953 (p.174) – as well as significant groups of works by key artists including Pierre Bonnard, Mark Rothko, Alberto Giacometti, Germaine Richier, Donald Judd and Joseph Beuys.

Beyond these triumphs of acquisition, Tate's history is punctuated by moments when it failed, or passed up the opportunity, to secure important and now highly regarded masterpieces. Other areas of omission emerge over time. As women or black and ethnic-minority artists play an increasing role in shaping the field of contemporary art, it has become apparent that these constituencies are largely absent from the earlier part of the modern collection. For many years, Tate focused its collecting exclusively on painting, sculpture and works on paper. The amazing vitality of new art in video, film and photography, which Tate has actively pursued since, highlights the absence of these media from its holdings of earlier contemporary art. Changing role models and shifting agendas as well as the impact of new research in art history cause a continuous rethinking of collecting priorities.

Tate's collection, rich in texture and depth, and yet uneven, is available to us in its entirety only as a virtual experience on its website, through a database that allows users to access artists by name, date, medium and other categories. The collection is physically spread over multiple sites – at Tate Britain on Millbank, Tate St Ives in Cornwall, Tate Liverpool as well at Tate Modern on Bankside. A fifth site, a warehouse in Southwark, houses works currently not on view and manages the daily transaction of objects as they are shifted between Tate sites as well as travelling as loans to temporary exhibitions in the UK and abroad. Each of the four gallery sites calls for a different means of organisation for its permanent collection displays, reflecting its principal focus and inflected by the different physical qualities of its spaces.

Tate Modern is in effect a new building, created within the imposing brick skin of an older one. Bankside power station was designed by Giles Gilbert Scott during the middle years of the twentieth century, and is an emphatic design statement of its own era. It was transformed at the end of the century by the Swiss architectural team of Herzog & de Meuron into an equally powerful statement of contemporary cultural life. Echoes of the past abound. Some, such as the gantry crane in the Turbine Hall or the vertiginous windows, are original. Others, like the compact metal floor grilles or the untreated oak floors, are new but represent a conscious response on the part of the architects to the character of the original building. Galleries for the permanent collection were provided within the seven-storey refurbishment of the building's river-facing side. Instead of a series of uniform spaces, the architects designed a range of different rooms – some exhilarating expanses lit from high clerestories, others smaller and more domestic in scale – to provide for the display of huge contemporary works as well as for more intimately scaled paintings and photographs. Views onto St Paul's Cathedral interrupt the walls on the (north) river facade, while high balconies project into the Turbine Hall on the galleries' south side, generating a continuous interplay between outside and in, city and museum, life and art. The architectural solution answers both the ambitions of the 'white cube' as an isolated, neutral space, and the tradition of the 'enfilade', of galleries unfolding in sequence.

Alongside the constraints and opportunities afforded by its collections and buildings, every museum display is also guided by a set of assumptions determining the layout of works of art. Until recently, most collections of modern and contemporary art have tended to follow a structure of display originated by the famous founding director of the Museum of Modern Art in New York, Alfred Barr. His brilliant and influential flow chart of artists and movements, compiled in 1936, reflected and reinforced a particular and subsequently widely shared view of modern art's lineage and development. Centring on Europe and North America, it traced a succession of moments of innovation, 'isms', all leading towards pure abstraction. Barr's

Above:
Press cuttings from the launch
of Tate Modern, May 2000

Right:
André Malraux's
Imaginary Museum, 1947

model not only informed the way in which he displayed his museum's collection; it also guided the growth of the collection itself, and its acquisitions policy and priorities, especially during the period of his own tenure as director. His template suited the classic decades of twentieth-century avant-garde movements but it has proved less adequate as a means to interpret more recent international developments in art.

The manner in which to narrate the history of modern art has been under question since the 1960s, as artists have sought new alliances with mass culture and innovative technologies, and reflected on their own practice and its history in fresh and revealing ways. As many younger artists are unwilling to accept modernism as the defining force in their cultural heritage, old hierarchies of art, gender and geography are constantly assailed and dismantled. Art history, developing within a wider theoretical context informed by semiology, Marxism, feminism, psychoanalysis, analytical philosophy and the politics of identity, has explored the powerful yet complex impulses of politics, society and geography on art. It no longer seems possible to account for the diversity and dexterity of artistic innovation through a single, all-embracing historical narrative, nor to see art as a continual and inexorable progression, of reaction and innovation, towards a commonly agreed end. This open and fluid situation was what the new Tate Modern, inaugurated in 2000, felt called upon to confront and address.

Tate Modern's first five-year display, challenged the idea of a synthetic overview of history by adopting four broad themes – Landscape, Still Life, The Nude and History – through which it explored connections between artists and works of art over the whole field of twentieth-century art. A mix of single artists, small groupings and more complex thematic displays across the century, often juxtaposing works and artists of different periods, allowed for a continuously shifting viewpoint, in which famous works could be seen in new contexts, and new works could be brought into play with more familiar ones. It deliberately avoided a general chronological disposition of displays, proposing alternative ways of looking at the history of art.

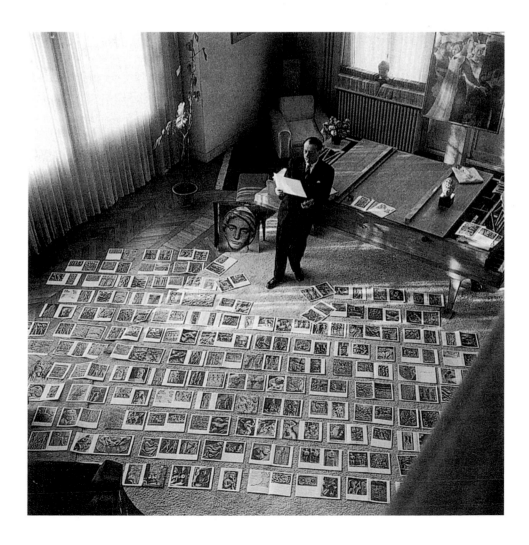

Below and right:
'Head to Head'
Display at Tate Modern,
30 May – 30 August 2004

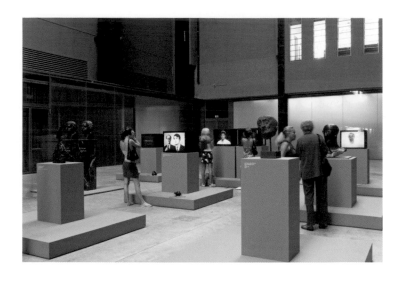

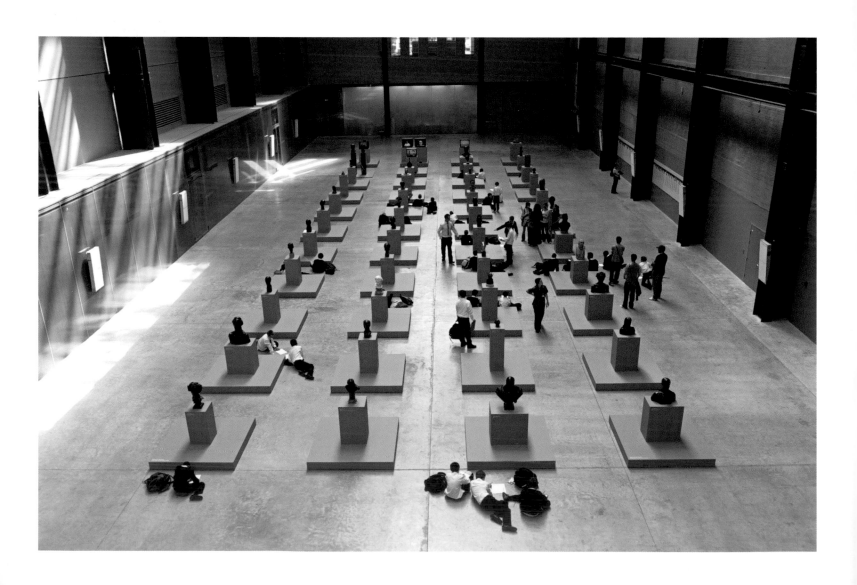

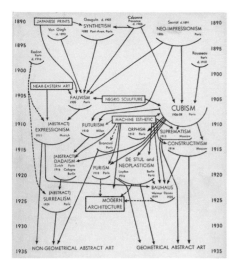

These displays, met variously with delight or derision, hinted at unexpectedly poetic as well as engaging and provocative ways by which the art museum can animate relationships over time.

Building on what was learnt over the opening five years, an entirely new scheme for display, launched in 2006, restates Tate Modern's ambition to pursue a discussion of art and its meanings; not to replace orthodox art history with an alternative narrative, but to suggest the possibility of multiple readings, conflicting stories and different agendas. In place of the single, institutionally authored history, the current display embraces different viewpoints and different framing devices, both in the works and in their disposition and presentation; it aims, crucially, at fresh reflection on history from the perspective of the present day.

The Tate Collection is increasingly inflected by contemporary and emerging works of art drawn from across the world. At the same time, current perspectives open up significant new narratives of modernism and extend the international understanding of twentieth-century production. The collection and, as a consequence, Tate displays and exhibitions can make connections between artists working in centres as far-flung as Beijing, Buenos Aires and Turin. Tate Modern's displays seek to accommodate the ever-evolving international collection, and to review and respond to new thinking about the nature of history and aesthetic experience. This open-minded commitment to speculation, experimentation and change is crucial. No single museum collection or gallery display can begin to enunciate all the multiple histories alive within a work of art, or the full range of connections between artists in and beyond their time. But art museums can reclaim and reanimate history for a contemporary audience, as well as providing a sense of context for the apprehension of contemporary work. Just as the search for antecedents and historical roots guides our understanding of the present, so contemporary practice opens up unforeseen perspectives on history. Artists go backwards to go forwards. The past only exists for us in the present. To suggest a fixed and permanent disposition would be to dare to impose a gagging order on a wonderfully rich and open-ended narrative that will continue to be contested for as long as artists make art, galleries are built to house collections, and audiences visit them.

Above:
Diagram of artistic
movements devised by Alfred
H. Barr, from the cover of
Cubism and Abstract Art,
The Museum of Modern Art,
New York 1936

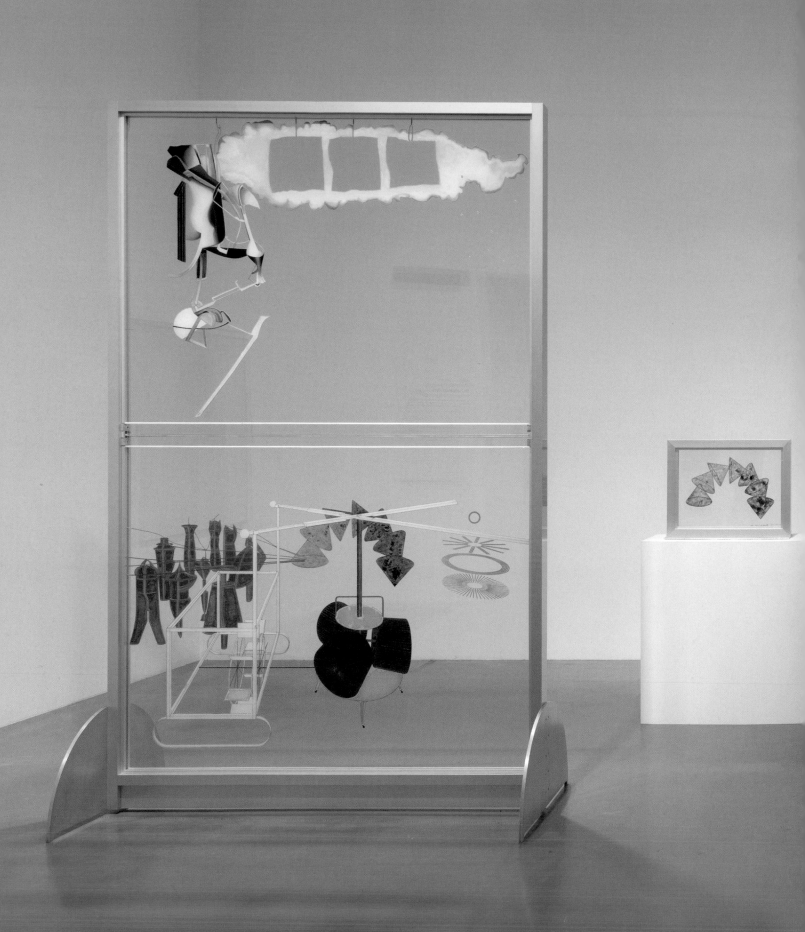

Above:
Joan Miró (1893–1983)
Message from a Friend
1964
Oil on canvas
262 x 275.5 cm
Purchased with assistance from
funds bequeathed by Miss H.M.
Arbuthnot through the Friends
of the Tate Gallery 1983

Left:
Installation view of Marcel
Duchamp's *The Bride Stripped
Bare by her Bachelors, Even
(The Large Glass)* 1915–23,
reconstruction by Richard
Hamilton 1965–6, lower panel
remade 1985, as installed in the
States of Flux wing, 2011

Works of art often have layers of meaning that change in relation to one another and as their context alters. In discussing his 1964 painting *Message from a Friend* Joan Miró remarked that some had seen its central shape as a cloud and others as a whale, though he conceded that it could also be interpreted as a bird or a strange form of future humanity. Miró's open speculation about his own work curiously recalls the famous passage by Shakespeare in which Hamlet identifies the form of a cloud as an equally plausible camel, weasel or whale. Hamlet shows the world as unpredictably changeable and Miró seems to have captured a similar mutability in paint. If artists see their works in particular ways, their audience may be influenced by equally subjective circumstances of encounter but also by the setting in which that engagement takes place. Just as Marcel Duchamp fundamentally asserted the choice of the artist by exhibiting a urinal as *Fountain* (p.105) at the *Independents* exhibition in New York in 1917 so, over the intervening century, we have become used to the expectations raised by the setting of the art gallery and how this has permeated a world view.

In acknowledging the diverse experiences of, and approaches to, works of art, one determinant in presenting Tate's collection at Tate Modern is to change displays so as to make works and their potential meanings available. It is the responsibility of the curator to facilitate this mediation, and to offer the circumstances in which an encounter can take place between the work and other works, and between art and receptive individuals. Through such regular adjustments, more possibilities emerge and, over the course of time, the works may encourage radically different connections. It has been one of the great strengths of Tate's changing displays that a work can move from one context to gain something further when seen in a new configuration. While providing different 'ways in' for those who look for such support we are alive to the power of the art to speak for itself to those open and equipped to engage with it.

The ways in which Tate's collection is shown respond to changes in art practice as well as public taste and acquisition strategies as they have developed over time. There are great strengths and inevitable limitations. A totally fixed display, such as emerged in the encyclopaedic museums two hundred years ago, implied a fixed view of culture, disguising circumstances and tastes as universally accepted truths. This is not a position that museums of contemporary art can countenance, because voices and other practices have been repressed in the process. It is widely recognised that such certainties have long been questioned by a global culture. Displays at Tate Modern change, therefore, in order to enrich the ways in which familiar works are seen and to bring the new or less familiar to light.

As is now well known, Tate Modern's opening displays dispensed with the long-expected chronological 'progression'. Instead, the structure of the spaces encouraged the view that four complex stories tracing the traditional genres of art should be told, each across half of a floor (an area comparable to that of a major exhibition). While this approach has matured in response to the needs of artworks and audiences alike, this physical division continues to allow the flexibility to encompass a variety of viewpoints. It has been reinforced by a mixture of display typologies – ranging from solo rooms or pairings to broader subjects addressed by a range of artists – that serve to vary the relationship between galleries encountered in sequence. The visitor experiences the displays individually, here and now. As the transformative injection of the ARTIST ROOMS (donated to Tate and the National Galleries of Scotland by Anthony d'Offay in 2008) shows, the exploration of an artist's work in depth remains crucial. However, as with any developing narrative, it is also important to anticipate the cumulative effect of connections, disruptions or continuities and how new components influence them.

Among the many realisations that emerged at Tate Modern was the thinking that one orthodoxy should not be replaced by another. Since the outset, the plan has been that the displays would be rethought periodically in their entirety. With the major overhaul in 2006, ideas of continuity were replaced with moments of rupture. In place of tracing the legacy of classical genres into the present, with which the opening Tate Modern displays were concerned, there is a focus on paradigm shifts in artistic practice over the last hundred years or so. These are the points around which broad themes are developed. The displays look back from now so that the significance of a particular epoch is necessarily seen through a present-day lens. The architectural structure of the building continues to define a four-part approach. The introductory rooms, so important as means of orientation, present a pairing of single artworks that give a sense of the issues that will arise as the visitor passes through the galleries. They are from different moments and lead onto the concentration found in the central gallery where the watershed is explored. Around this, other displays rotate or even subvert the key concerns. This has afforded a heightened awareness of history and time while avoiding an imposed, monolithic, linear narrative.

The richness of this scheme has allowed it to be fixed and changing. The first four

Fixed and Changing:
New Displays at
Tate Modern
Matthew Gale

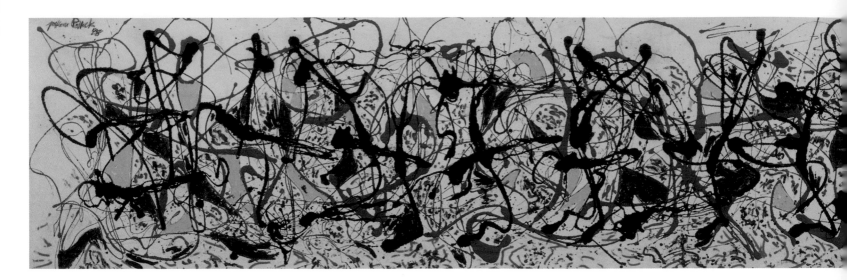

Jackson Pollock (1912–1956)
Summertime: Number 9A
1948
Oil, enamel and house paint
on canvas
84.8 x 555 cm
Purchased 1988

paradigmatic moments selected were around cubism/futurism/vorticism, surrealism, art informel/abstract expressionism, and minimalism. Each wing was titled more allusively in order to reach towards related practices rather than to imply a limitation to categories or 'isms'. In this way the journey through States of Flux, which encompassed the cubist moment at its heart, could lead to contrasting ways in which the experience of the everyday (seen in the café table of Georges Braque's still lifes, for instance) found its way into subsequent practice, through collage, through photography, through certain aspects of the engagement of pop art with mass media. The liberating impact of the unconscious, which was a central tenet of surrealism has, in Poetry and Dream, drawn together a wide variety of works concerned with accumulation and obsession but also, in a different register, with political radicalism. As well as being the home for Tate's world-renowned group of Mark Rothko's *Seagram Murals*, the Material Gestures wing opened up the possibility of encountering the gestural and sublime art of the 1940s both through abstract expressionism in the USA and art informel in Europe. The persistence of painting as an energising practice continued to feature in the work of Cy Twombly and Gerhard Richter, for instance. Idea and Object, the wing located around 1970s minimalism engendered considerable echoes in contemporary art, where the post-minimal and conceptual works are rich and challenging.

Of these four wings, the focus on surrealism continues to be sustained. Poetry and Dream opens with Giorgio de Chirico's *The Uncertainty of the Poet* of 1913 and Jannis Kounellis's 1979 wall drawing of an emptied urban scene with two pierced birds (p.155). This dialogue acknowledges the surrealists' debt to de Chirico, whom they saw as a precursor, but also the wider pervasiveness of what Sigmund Freud had termed the 'uncanny' that surfaces in Kounellis's work. In concentrating around surrealism, one of the great strengths of the Tate Collection, there were multiple ambitions. There was an opportunity to emulate the example of the *International Surrealist Exhibition* of 1936 held in London which Roland Penrose and E.L.T. Mesens installed in an extraordinary way by dispersing each artist's works and contrasting large and small, illusionistic and abstract, painting and sculpture. Our display (which is often subject to change) is a free interpretation of that method with a shared aspiration of immersion in the atmosphere of the surreal (see pp.48–9). Another ambition was to place film at the centre. Tate Modern had always set out to include moving image works (slides, videos, films) within the sequence of galleries. Here, adjacent to the paintings of Joan Miró, René Magritte, Dorothea Tanning and others, is a central space showing such classic films as Luis Buñuel and Salvador Dalí's *Un Chien andalou* (1929) or Maya Deren's *Meshes of the Afternoon* (1943).

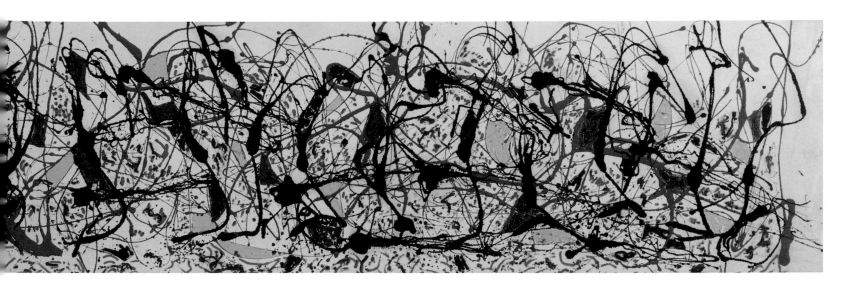

It should be clear that galleries that unfold in sequence around Poetry and Dream are not confined to surrealist practices and ideas but may be linked to – or cut against – aspects of their revolutionary propositions. Joseph Beuys's *Lightning with Stag in its Glare* has been a fixture since the building opened and the context of surrealism has afforded an emphasis upon his concerns with material qualities as well as the overlap of his social and shamanistic actions. At various times, the work of Ai Weiwei, Francis Bacon, Miroslaw Balka, Louise Bourgeois, Mona Hatoum, Susan Hiller, Lamia Joreige, Pablo Picasso and many others has been seen in solo rooms or in pairings in this broad context. They have drawn out explicit or more covert concerns with eroticism, repression and anxiety. There have also been group displays encompassing humour, chance and the microscopic, as well as a long-standing room of realist works made concurrently at the highpoint of surrealism and running against it as well as absorbing some of its lessons.

Beginning in 2009, three new wings have been introduced to focus on different paradigmatic moments. Energy and Process has brought together arte povera and anti-form art of the 1970s, in which conceptual thinking saw the adoption of materials and processes unusual to art production until that period. Such 'poor' materials, which included sacking, coffee beans, ducting, felt, rags or lead, were submitted to physical processes and natural forces such as magnetism, torsion, pouring, stretching, pilling and balancing. Among many things they serve as a trace of the encounter between the artist and the world. Giuseppe Penone's *Tree of 12 Metres* 1980–2 (p.66) is both an extraordinary act of imagination and action, as the natural structure of growth is revealed as embedded within the functional form of the timber. This and other actions witness a political engagement between the artists and their times (especially the revolutionary impetus of the late 1960s) and address the relation of culture to nature.

This liberation of practice has its antecedents in the most radical explorations of assemblage and other experiments with cutting, burning and puncturing tested out by artists of the 1950s and 1960s such as Lucio Fontana and Niki de Saint Phalle. The exchange across time is introduced by the pairing of Kasimir Malevich's *Dynamic Suprematism* 1915 or 1916 (p.169) and one of Richard Serra's free-balanced steel sculptures, *Trip Hammer* 1988. Malevich's paintings had come to be a marker for a rethinking of the possibilities of art after the exuberance of gestural abstraction. For a generation open to exploring new means of art production he represented a restructuring of art from first principals. As well as being a

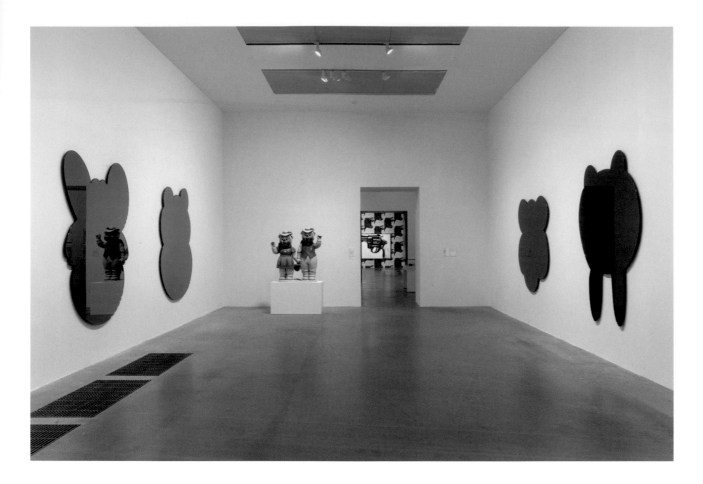

showcase for some remarkable works from the original arte povera artists – including Giovanni Anselmo, Luciano Fabro, Michelangelo Pistoletto, Gilberto Zorio and others – the practice of a wider generation is seen here, with works at various times by Lynda Benglis, Eva Hesse, Susumu Koshimizu, Robert Morris and Kishio Suga included. Around this centre, rooms devoted to Magdalena Abakanowicz, Vito Acconci, Jannis Kounellis, Ana Mendieta, Marisa Merz, among others, have resonated with the hub gallery, as has the work of younger artists such as Fischli & Weiss, and Abraham Cruzvillegas.

Structure and Clarity, installed in 2012, takes its cue from the utopian abstraction of the 1920s and 1930s. For some in this period the new language of geometrical abstract art appeared to lay out the possibility of social change and political betterment. The range of this experience, as well as its visual precision and exuberance, is introduced by the juxtaposition of Henri Matisse's *Snail* 1953 with one of Bridget Riley's great canvases.

The optimism of the interwar years was seen in the painting and sculpture of artists like Piet Mondrian, Naum Gabo and Barbara Hepworth, but also in the architecture and design of their contemporaries. Though often having profound theoretical differences, the belief in the power of a new art distinct from nature – whether termed abstract, concrete, non-objective, constructive – fashioned a utopian attitude that withstood the shadow of world wars and dictatorships to provide an example for later practice. The first abstract films and abstract photographs were made at this time, and a broader approach to a global constructivism took root. Here related displays look backwards and forwards in time. A room devoted to cubism sets out one range of markers for abstraction, while the complex and personal responses of artists working from the 1950s onwards – including, for instance, Saloua Raouda Choucair (p.89) – are found elsewhere. In other respects the stricter minimalist aesthetic in America and Europe in the 1970s took soundings from those earlier moments of 'high modernism' and remains hugely influential today.

A new reflection on the art of the 1940s and 1950s is found in Transformed Visions. This relocates some works from Material Gestures but also offers an alternative emphasis on the persistence of the figurative *within* that moment of liberating abstraction. The necessity of the

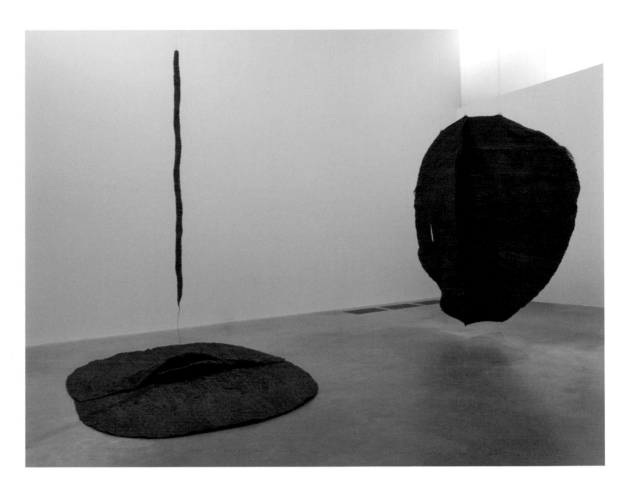

figure was evident in the output of such diverse artists as Francis Bacon, Jean Dubuffet, Alberto Giacometti and Willem De Kooning. For some this raised existential concerns with the isolation of the individual and the challenge of meaningful communication.

The wing opens with the juxtaposition of the postwar blasted sculptures by Germaine Richier and a recent work by Thomas Hirschhorn bearing only residual traces of humanity. One of the key points of contention in the middle of the twentieth century was how to continue to make art after the disaster of the Second World War and the Holocaust. For some a spiritual response proved possible and the work of Mark Rothko remains a touchstone in this respect. Comparable challenges mark a broad range of more recent and contemporary work, encompassing such diverse practices as those of Leon Golub, Alfredo Jaar and Kara Walker, among many others.

It is in the nature of changing displays that not all of those works mentioned above – together with many others that have had to be passed over here – have been or are on display at the same time. Many are fragile in unexpected ways: sculptures can be marked indelibly by the lightest caress (however tempting that may be); works on paper are sensitive to light, as are those made from a variety of fabrics. Rotating displays, therefore, includes the responsibility of stewardship in protecting the works for posterity as well as providing an opportunity to bring new works to public attention. Many of the new pieces will become the favourites of tomorrow, extending our shared visual vocabulary and expectations.

Change is structured into Tate. Though predating Tate Modern, this attitude of fertile regeneration achieved acceleration and focus with the rethinking of display possibilities for the collection. In doing so, of course, we set a challenge to ourselves (and to others). We aim to revitalise ways of seeing, looking at, and experiencing the art in the collection and its relations with its wider contexts, in conception, history and legacy. In instituting more changes, Tate gives new texture and new inflections to the received interpretations of familiar works as well as providing a platform for new practices that are continually drawn into the collection. The result is fixed and constantly changing.

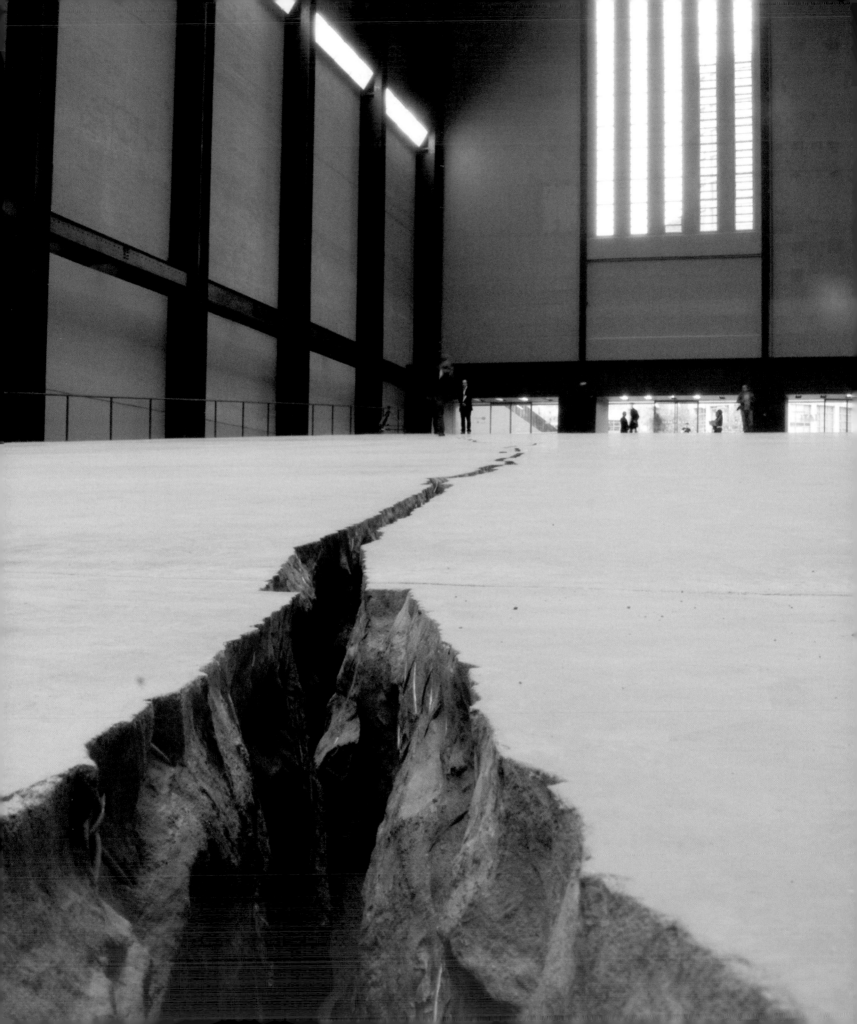

Raw Materials, created by Bruce Nauman in 2004, filled Tate Modern's Turbine Hall not with conventional sculptural forms but with intangible acoustic material. Moving from one sound zone to the next, visitors became aware that the effect of the repetition of words or phrases made what they were hearing hover at the edge of unknowingness. 'Language is a very powerful tool', Nauman has said. 'I think the point where language starts to break down as a useful tool for communication is the same edge where poetry or art occurs.'

It is this tension in art – a dynamic oscillation between what we see, what we think we know, and the revelation that there are other ways of responding to and thinking about our world – that Tate Modern's programme of exhibitions, commissions and events is devised to reflect. Each of these projects is debated and often disputed by the curators and directors, who are ever-conscious of the responsibility of making decisions about what is shown to audiences. This process challenges the curators' choices and the viability of their concepts, tests how artistic ideas can be unfolded in the museum's spaces, debates the placing and timing of the show within the overall programme, and struggles with how the art can be presented so that the diversity of its possible meanings comes across to a large and varied audience, which can then make up its own mind about what it sees.

To take on the challenge of making a new work within the Turbine Hall is a courageous and risky task. It is so enormous that it is officially designated as 'a covered street'. Standing at the heart of Tate Modern each commission for this space resonates beyond the significance of the work itself. The first Unilever Series installation for the Turbine Hall was by Louise Bourgeois (2000). Her idea was to create a sculptural theatre for the masses, tempered by the opportunity for intimate human encounters within that spectacle. Five years later, Anish Kapoor opted to create *Marsyas* (2005), a form whose massive volume prevented a complete view. To address his initial misgiving of an unwanted theatricality, Kapoor's solution was to ensure that in his collaboration with the engineer Cecil Balmond, the materials and engineering techniques were as much a part of the content as the form itself.

Known for creating works informed by her political sensibility, Doris Salcedo's complex response to the Turbine Hall in 2007 referred to the legacy of violence by drilling open a long multi-branched crack that extended the length of the hall. Unique in the strength of its confrontation with and physical breaking of the building, *Shibboleth* permanently marked Tate Modern. In 2001, when he was developing his commission for the Unilever series, *Double Bind*, the sculptor Juan Muñoz said he came 'to look at the Turbine Hall as part of a city rather than part of a museum. It's a fragment of the urban experience … It is a space of our time'.

Tate Modern has come to epitomise that urban sensation. Standing by the edge of the Thames, linked to the civic and economic centre of the city by the Millennium Footbridge, the museum offers startlingly different views north and south. At the interstice of this complex, chaotic and exhilarating social space, Tate Modern sits in a position to blend the energy and history of the surrounding city with the social function of the museum, via the stimulus of its programme of exhibitions and interventions.

One of the first exhibitions, *Century City: Art and Culture in the Modern Metropolis* (2001), addressed this condition. It presented, through diverse curatorial points of view, ten cities at significant periods of their cultural flourishing in the twentieth century and the ways in which the visual arts have addressed the vigour of the metropolis. The ambition of this project set the tone for the subsequent programme, prefiguring the increasing international reach of the artists it presents. It also heralded Tate Modern's recognition as a museum that has shifted the public attitude to modern and contemporary art within both the city and the nation as a whole, with an impact unrivalled by any other international museum.

Tate Modern exhibitions seek to challenge orthodox historical wisdom about past cultural periods by posing questions informed by the perspective of the present. An important strand is devoted to re-examining movements, or periods, in which artists have dealt with similar issues or have formal or stylistic affinities. *Surrealism: Desire Unbound* (2001) focussed on desire as the 'authentic voice of the inner self', and provided a distinct perspective on one of the most important artistic and intellectual movements of the twentieth century. *Zero to Infinity: Arte Povera 1962–1972* (2001) was the first comprehensive examination in the UK to explore the loosely affiliated group of artists who emerged in Italy during the 1960s and how they understood 'poor' materials to convey a vital energy and bodily experience through painting, sculpture, installation and performance. In response to a different aspect of that moment *Pop Life: Art in a Material World* (2009) traced various ways that artists since the 1980s have infiltrated the world of commerce and cultivated celebrity personas. Both these exhibitions, as well as *Open Systems: Rethinking Art c. 1970* (2005), were barometers of an historic moment and provided timely opportunities to rethink or define a theme or shared artistic sensibilities.

Raw Materials:
Tate Modern's Programme
Sheena Wagstaff

36

Another way in which exhibitions present the sheer diversity of artistic innovation is to chart artistic friendships. *Matisse Picasso* (2002) revealed how the twin giants of modern art inspired – and provoked – one another to create a fascinating and complex artistic narrative. Through an exploration of striking affinities *Duchamp, Man Ray, Picabia* (2008) demonstrated that the personal interaction between three friends amplified the resonance of each other's works. In the same vein, the creative dialogues explored in *Albers and Moholy-Nagy: From the Bauhaus to the New World* (2006), *Rodchenko & Popova: Defining Constructivism* (2009) and in *Van Doesburg & the International Avant-Garde* (2010) all testified in distinct ways to the conviction among pioneering twentieth-century artists of the potential of art to transform society at large.

While exhibitions, such as *Edward Hopper* (2004), *Gauguin: Maker of Myth* (2010) and *Joan Miró: The Ladder of Escape* (2011), have proved extraordinarily popular, Tate Modern does not undertake them simply because they attract a broader public, privileging mass appeal over educational value. Rather, the decision to include them is taken because the subject deserves re-examination, or because a new angle on old work suggests itself. Comparably popular was the first solo exhibition at Tate Modern dedicated to a Latin American artist, *Frida Kahlo* (2005), and the concentration on the less-explored late series, in the *Rothko* exhibition (2008). All were devised to retrieve the creative expressions of these artists from the symbolic ciphers and carriers of other mythologies they had come to assume.

Retrospectives of some of the most influential international sculptors of the postwar period have included *Eva Hesse* (2003) and *Donald Judd* (2004). Hesse's exhibition focused on her work as a synthesis of contemporaneous European and American artistic sensibilities, where the febrile and visceral tactility of her work is held in balance by an internal rhythm or formal seriality. The exhibition *Joseph Beuys: Actions, Vitrines, Environments* (2005) included the eccentric objects that Beuys deployed in his installation works, which were imbued by his unique fusion of political activism and utopian vision. By contrast, *Hélio Oiticica: The Body of Colour* (2007) took as its starting point his assertion that 'Colour is the first revelation of the world' and that art was an anarchic form of revolt against all forms of oppression.

To create exhibitions of artists whose work and life were as inextricably linked as that of Beuys or Oiticica, Alighiero e Boetti (2012) or Martin Kippenberger (2005) – and who are no longer alive to invigorate that union – presents a significant challenge. The crucial issue here is how empathetically close the curator can come to the vision of an artist in order to represent the work with the utmost integrity. When working with living artists who have achieved substantial bodies of work such as Francis Alÿs (2010), John Baldessari (2009), Peter Fischli & David Weiss (2006), Robert Frank (2004), Roni Horn (2009), Pierre Huyghe (2006), Per Kirkeby (2009), Cildo Meireles (2009), Gabriel Orozco (2011), Gerhard Richter (2011) and Jeff Wall (2005), the curatorial role is necessarily different and varies considerably from one project to another. A hallmark of success is the degree of receptivity that the curator has for an artist's ideas, engendering the close working relationship necessary to fulfil the artist's ambitions whilst also providing the optimal viewing conditions, both environmental and informational, for visitors. The most effective artist-and-curator teams are conscious that every aspect of developing a show is a form of interpretation, which therefore presents the work to the public from a particular viewpoint.

Another strand of the programme 'takes the temperature' of the current social, political, economic and environmental climate across our many continents, capturing in large group shows the momentum of a new artistic idea among mostly younger artists. Ideas about the possibility of the unexpected occurring as a result of audience interaction with the work characterise the approach of the artists included in the exhibition *Common Wealth* (2003). Acknowledging the rich historical relationship between visual art and theatre, *The World as a Stage* (2007) challenged the often negative connotation of 'the spectacle' within the gallery space. The idea of theatre was treated by artists as a fertile terrain to be experimented with or plundered.

It is impossible to understand the forces behind today's visual production without representing other fields of visual culture through the museum's programme. To be able to achieve this, creative partnerships with organisations such as Dance Umbrella, the Live Art Development Agency or Sadler's Wells, are vital for sharing different areas of expertise, for introducing fresh ideas into artistic and curatorial practice, and for generating new audiences. Over the past ten years, Tate Modern has pioneered a programme of live performance, to create a different context through which to explore an increasingly interdisciplinary and ever-

Previous page:
Doris Salcedo (born 1958)
Shibboleth
9 October 2007 – 6 April 2008

Below:
Gabriel Orozco (born 1962)
La DS 1993
Installation view,
Gabriel Orozco
19 January – 25 April 2011

Right:
Installation view of *Rotating Labyrinth* 2007 by Jeppe Hein (born 1974) with work in the background by Rita McBride (born 1960) in *The World as a Stage*, 24 October 2007 – 1 January 2008

expanding international arena of contemporary art. Amongst presentations by over 200 artists, seminal historical works staged in collaboration with Dance Umbrella include: Merce Cunningham's 50th 'golden' anniversary performance (2003), staged under the glow of Olafur Eliasson's commission in the Turbine Hall; a restaging of Joan Jonas's *Lines in the Sand: Helen in Egypt* (2004); Trisha Brown's *Man Walking Down the Side of a Building* (2006); Robert Morris's *Bodyspacemotionthings* (2009), a reconstruction of his 1971 Tate exhibition, the museum's first participatory show; and the Michael Clark Company's unique summer residencies (2010–11). The Live programme also proffers cutting-edge work by both emerging and established artists, amongst whom are Ulla von Brandenburg, Pablo Bronstein, Tania Bruguera, Tony Conrad, Keren Cytter, Cyprien Gaillard, Matt Mullican and Sturtevant. As is often the case, many performances are multidisciplinary, involving aspects of theatre, music and film.

Launched in 2006 as an annual arts festival for the late May Bank Holiday, The Long Weekend provided the opportunity to present a series of dramatic live events and music, often in thematic connection with Tate Modern's collection displays. In 2008 Fluxus artist Larry Miller programmed a number of events that resuscitated the idea of a Flux-Olympiad, conceived by founding Fluxus artist George Maciunas but never realised. The evening was distinguished by Nan Goldin's seminal slide shows *The Ballad of Sexual Dependency* and *The Other Side*, with new soundtracks performed live by musicians Patrick Wolf and John Kelly. Afrobeat DJ Rita Ray set the scene for African filmmaker Djibril Diop Manbety's powerful, rarely seen films, and a screening of early experiments in computer animation featured among others Ed Emshwiller, Pierre Hebert, Malcolm Le Grice, Lillian Schwartz and Stan VanDerBeek.

Since 2003, Tate Modern has developed Tate's first dedicated film and video screening programme, now considered London's premiere platform and forum for artists working with the moving image. An acclaimed series devoted to international histories of experimental film and video has included extensive programmes devoted to work from Brazil, Eastern Europe, France, Germany, India, the Middle East and USA. Moving image works by hundreds of influential artists have been screened at Tate Modern, often for the first time in London. Highlights have included

surveys of films and videos by artists ranging from Bas Jan Ader, Pedro Costa, Harun Farocki, Robert Frank and Barbara Hammer, to David Lamelas, Daria Martin, Marie Menken, Deimantas Narkevicius, Ulrike Ottinger, Trinh T. Minh-ha, Margaret Tait, Lawrence Weiner and Akram Zaatari among many others. Ambitious film performances and installations by Steve Farrer, Luke Fowler, Tamara Krikorian, Malcolm Le Grice, Anthony McCall, Rabih Mroué and Lis Rhodes also have been presented in spaces ranging from the Starr Auditorium to the Turbine Hall and the Level 2 Gallery. Several major conferences and screening programmes have investigated related subjects such as animation, archival and found footage filmmaking, the relationship between still and moving images, and the Expanded Cinema movement.

The propensity of some of the artists to make art with political intent without considering themselves 'political artists' is shared by a number of the international panoply of artists, usually at the first stage of their vocation, represented in the Level 2 Series, launched in 2004. This has included individual projects by Mohamed Camara, Cui Xiuwen, Jan de Cock, Latifa Echakhch, Elmgreen & Dragset, Meshac Gaba, Simryn Gill, Nicholas Hlobo, Brian Jungen, Julia Loktev, Jill Magid, Roman Ondak, Damian Ortega, Michael Rakowitz, Julika Rudelius, Simparch, and Catherine Sullivan. Interspersed with a series of exhibitions of artists grouped by shared concerns identified by the younger curators at Tate Modern, this strand responds to and, crucially, promulgates the ongoing exchange of ideas on the international artistic network. These projects have increasingly addressed art histories in more distant, but nevertheless easily connected, cultural centres across the world as various as Beirut, Cairo, Kabul, Lagos, Mexico City, Moscow, Mumbai, São Paulo, Tokyo and Warsaw. This has helped to trace how historic networks of ideas and the mobility of artists has transcended national borders, prefiguring today's global communications networks.

While most artists embrace the opportunity for a one-person show or project to present and reflect on their artistic endeavour to date, some are nevertheless ambivalent about the ideological basis on which large institutions like Tate Modern operate. When Olafur Eliasson made *The Weather Project* for the Turbine Hall in 2003 (p.14), he wanted to create an installation that would 'hold up a mirror to the institution', reflecting upon the ways in which it influences or 'mediates' the experience of art for its audience; at the same time he was aware that simply by undertaking the commission, he was already complicit with the museum's public agenda. Using three simple elements – a huge half-sun made of low-sodium yellow bulbs, vaporised water and a mirrored ceiling – he created an installation whose visual impact and perceived sublimity had an immediate and unprecedented popular effect that has since become an iconic image, inextricably enmeshed in the public memory with the experience of Tate Modern's building.

Artists are indeed agents of transformation. They change the way we think and how we look at our world, its past and its present. They are also crucial in defining the identity of the museum and conveying the spirit of the place. Those who have made work in the Turbine Hall over the past ten years have demonstrated that it is not only an awe-inspiring architectural space and the pulsating public heart of Tate Modern, but that it also functions as an imaginative, intellectual and ethical framework for both the programme and the museum itself.

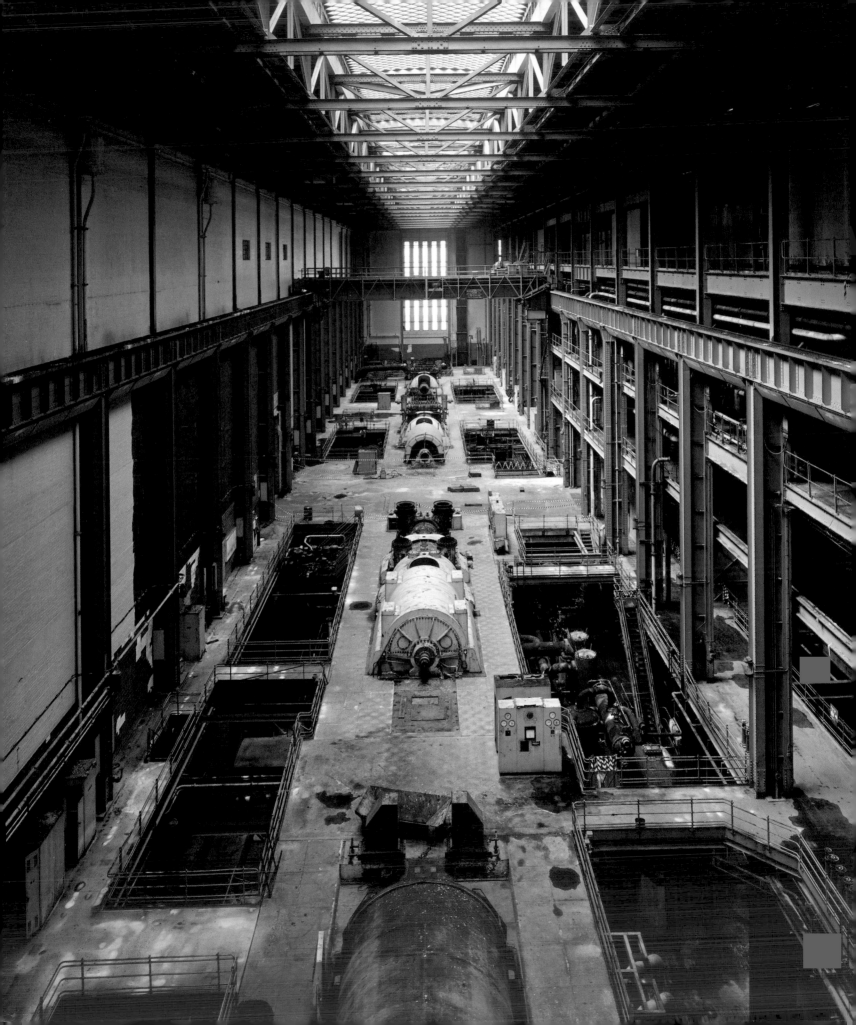

I had the good fortune to be appointed as an Artist Trustee of the Tate Gallery in 1989. The ten-year period of my Trusteeship proved to be one of the most proactive and expansive in Tate history. As a Trustee I had the opportunity to participate in the sequence of discussions and decisions that led to the creation of Tate Modern at Bankside.

Soon after his appointment as Director in 1988, Nicholas Serota initiated a number of key changes. He decided to restore the original architectural integrity of the Millbank building by the removal of all the temporary walls and false ceilings that had been constructed over the years. Most significantly, he decided to entirely reorganise the display of the collection. These changes brought into sharp focus the limited and inadequate exhibition space, and the urgent need for new buildings.

In the early 1980s an architectural master plan for the Millbank site had been created by James Stirling, shortly after his design of the Clore Gallery in 1981. On reconsideration of this plan, the Trustees decided that it did not provide for sufficient new exhibition space for the present and anticipated needs of the gallery. Although significant development possibilities at Millbank were identified, it was clear that these alone would not be adequate for the Tate properly to fulfil its responsibilities while maintaining and enhancing its international status.

The Trustees concluded that a second site in London would have to be found. This decision raised the critical curatorial and administrative problem of determining the basis on which work would be shown at each site. Should the collection be divided, and if so along what lines? Extensive discussions were held with a wide range of participants from both inside and outside the institution.

The Trustees decided to maintain and continue to develop the collection as a single holding, but to divide what might be shown at each London site on the basis of its two principal areas of responsibility: British art at Millbank, international modern art at Bankside. This would mean, in effect, that Bankside would become the extension of the National Gallery, showing work from 1900 onwards. It would also mean the work of any modern British artist held in the collection could be shown at Bankside as well as Millbank.

A search was begun to locate a new site. The basic requirements were not extensive and more or less obvious, but had the effect of severely limiting the options: a large-scale central location, ready accessibility by public transport (particularly the tube), within reasonably easy reach of Millbank, and available for development in the near future.

A number of sites were considered, but most fell through or were rejected as inadequate: the car park area on the river between Hungerford Bridge and Jubilee Gardens (very limited for building because of height restrictions); at the centre of a new park to be created as part of a proposed redevelopment of the wasteland area behind King's Cross (project eventually shelved); a docklands site east of Canary Wharf (too isolated and inaccessible).

Francis Carnwath, Deputy Director at the time, came across the decommissioned Bankside Power Station in Southwark and recommended that Nicholas Serota and the Trustees consider it. Despite its immense size and its key location on the south side of the river opposite St Paul's Cathedral, this building, more or less inaccessible from the riverwalk and hidden by seedy office buildings on the south side, was largely unknown. Abandoned as a power station for more than ten years but still housing an electricity switch station, the building had become a brooding presence and a blight on the redevelopment of the surrounding area.

Bankside Power Station was designed and built after the Second World War by the distinguished British architect Giles Gilbert Scott, to provide electricity for the City. Scott is best known as the designer of London's other great power station at Battersea, now sadly derelict, and Liverpool Anglican Cathedral, as well as the once ubiquitous red telephone box.

The Bankside building was notable for its plain red brick exterior and the powerful symmetry of its horizontal mass, bisected at the centre by a single tall, square chimney. The building was articulated on three sides by a series of immense, well-detailed windows. The only decoration came from the brickwork crenellation along the building's edging, cleverly mitigating its great bulk.

Inside, the building proved to be just as striking and unusual. Built to house the immense turbines, boilers and ancillary equipment of a power station, the building itself was architecturally simply a shell, a box. Its vast interior was divided along its entire length by a series of great steel columns, creating two interlocking spaces, the boiler house and the turbine hall. There were no normal floors, no staircases, no interior walls: everything inside had been built as part of the machinery, not part of the building. Removing the machinery would mean revealing a vast empty space within which virtually any construction might be possible.

The power station was far larger than anything we as Trustees had imagined building from scratch. From the beginning of the project, it had always been our assumption that we would

Towards
Tate Modern
Michael
Craig-Martin

be commissioning an entirely new building. The discovery of Bankside dramatically altered our perception of the possible appearance, scale and function of the new gallery.

The Trustees decided to acquire Bankside and develop it as the site for the new gallery of modern art. The site answered all the criteria governing the search: an unparalleled large-scale central London location, excellent transport facilities (including the new tube station at Southwark), the possibility of a riverboat connection with the gallery at Millbank, and immediate availability for development. The local council, Southwark, recognising the potential impact of the Tate project on development and employment in this largely run-down area, enthusiastically supported it from the start.

The vast size of the building meant that the Tate would be able to more than double its capacity for showing its collection as well as housing major large-scale temporary exhibitions. Bankside also provided a remarkable bonus for an institution with the remit to increase its holdings constantly: even after realising our most ambitious development plans, more than a third of the space in the existing building (the present switch station on the south side and the cavernous underground area below) would remain untouched, waiting for development in due course.

Anyone who has had experience of working on a major architectural project will tell you that for it to be truly successful there has to be a single-minded project leader, someone who has a clear idea of what is needed and a vision of what the best might be, who oversees the project from conception to completion. In this case such leadership was provided by the Director, Nicholas Serota. Early in the planning stages of the project, he asked the sculptor Bill Woodrow and myself to tour a number of recently built museums of modern and contemporary art on the Continent, to consider them critically from our point of view as artists, and report to the Trustees. We went to a variety of institutions including those at Bonn, Frankfurt, Münchengladbach and Maastricht, and came to several conclusions. In general these modern museums seemed to serve the interests of architecture and architects more clearly than those of art and artists. Many architects clearly considered designing a museum to be a prime opportunity for high-profile signature work. On the other hand few architects seemed truly to understand or be interested in the needs of art.

In comparison with the entrance halls, staircases, restaurants and other facilities, the galleries for showing art were often, in our view, the least successful spaces in the building. Few architects appeared to have established properly considered criteria for the design of good modern galleries. They tended either to create sequences of more or less identical and characterless neutral spaces or to make self-consciously over-designed spaces where art was barely necessary.

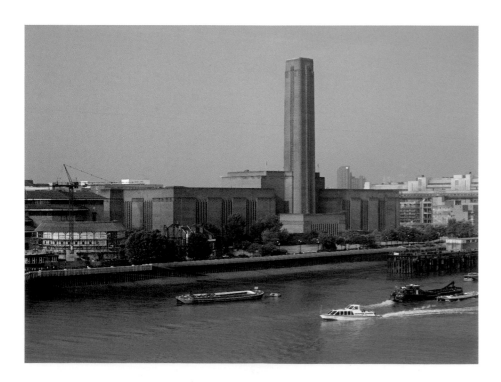

By contrast we found that the most sympathetic and stimulating places in which to see modern and contemporary art were in older buildings converted from an earlier industrial or other purpose, such as the private Dupont Foundation in Tilburg (similar in character to the Saatchi Gallery in London) and the Hallen für Neue Kunst at Schaffhausen near Zurich. None of the purpose-built museums could match the stimulating quality and variety of these exhibition spaces, nor the opportunity for interaction between the art and the space.

We reported these views to the Director and to the other Trustees, and they were later confirmed by the majority of artists responding to a questionnaire on the subject initiated by the Tate. As a consequence, a decision was taken that *the* central concern of the design of the new building would be to address the needs of art through the quality of the galleries and the range of opportunities, both sympathetic and challenging, for showing art. While seeking the best possible architectural solution, we determined that the project would be art led not architecture led.

Many architects were bitterly disappointed by the Trustees' decision to make use of the existing Bankside building rather than to create something entirely new. Some, seeing this as the betrayal of a unique architectural opportunity for London, interpreted it as the result of a loss of institutional nerve. I believe that the Tate showed exceptional courage and ambition in its decision to go to Bankside, which in turn demanded a radical architectural solution.

Under the guidance of Richard Burdett, Director of the Architecture Foundation, an open international architectural competition was initiated with the stated aim of finding the right architect for the Tate to work with, rather than a highly resolved design proposal. A jury of ten members was appointed, with Janet de Botton and myself representing the Trustees. The jury sought to consider the proposal of each architect in the light of three principal questions: their approach to the architectural problem, particularly how to deal with the existing building and its position in the urban context, their ideas for the display and presentation of modern and contemporary art, and their interest in and understanding of art itself.

Nearly 150 architects entered the competition, including many of the world's most distinguished, but it was clear from the start that few were comfortable with the problem of working with the shell of the Giles Gilbert Scott building. Some essentially ignored the structure and designed within it the building they would have made had it not existed, while others attempted to neutralise it by completely altering or removing significant parts. Some sought to dramatise the architectural confrontation of old and new by having parts of their proposed new internal museum structure pierce through the older power station shell.

The six finalists in the competition could be seen to represent two generations of architects: the established masters Tadao Ando, Raphael Moneo and Renzo Piano, and the rising generation of David Chipperfield, Jacques Herzog and Pierre de Meuron, and Rem Koolhaas. It would be difficult to exaggerate how stimulating and challenging it was to be part of a jury charged with interviewing architects of this calibre and evaluating their proposals, and how daunting was the sense of responsibility in making a final selection for a building of such lasting national importance. In the end the jury came to a unanimous decision to recommend to the Trustees that they appoint the Swiss architects Herzog & de Meuron.

Why did Herzog & de Meuron win against such formidable competition? There are of course many reasons, but one seems to me to be absolutely central. All the other proposals treated the existing building as a shell within which their new structure would stand. Herzog & de Meuron's was the only proposal that completely accepted the existing building – its form, its materials and its industrial characteristics – and saw the solution to be the transformation of the building itself into an art gallery. They proposed a true union of their design with that of Giles Gilbert Scott, turning the box into a new building. Open, flexible and pragmatic, Herzog & de Meuron's approach to the project was concept rather than design based, reflecting the similarity of their practice with that of many contemporary artists.

Their proposals acknowledged the symmetry of the exterior by creating within the boiler house a new five-storey structure, with three floors given entirely to six suites of galleries, two to a floor, built around a central service core containing the main staircase, escalators, lifts and toilets. The intention was to divide the displays into manageable units for visitors and create a building in which, despite its great size, one would always have a sense of where one was. The galleries would all have high ceilings and whenever possible be lit by the large existing windows.

The most dramatic alteration to the appearance of the existing building would be a new two-storey-high frosted-glass beam running its whole length, acting architecturally as a translucent horizontal counterfoil to the dark vertical mass of the chimney. This light beam would clearly signal the change of function of the building from power station to art gallery, its welcoming beacon a striking addition to the London skyline. The beam would, of course,

Left:
Bankside Power Station
in 1994

Above:
Working on a double
height gallery

This page:
Transforming the Turbine Hall
and restoring the brickwork

Opposite:
Views of Tate Modern's light
beam from the roof

provide exceptionally beautiful skylighting for the top floor galleries, but also house all the building's service equipment and make possible a restaurant with views across the river to St Paul's. At ground level the architects proposed removing most of the building's smaller wings and outcrops to create a simpler perimeter. The building would rise dramatically from the newly created open piazza stretching to the river.

During the intensive design period following their appointment, the architects, led on site by Harry Gugger, proposed that the existing turbine hall should retain its character more or less unaltered and function as the entrance to the new gallery as well as providing a vast new exhibition space. However, instead of the ground floor being at ground level, they decided it should be established at basement level, opening up the existing space even more. This interior ground floor would be reached by the public from outside down a long concrete ramp the width of the turbine hall. The new building in the boiler house would thus effectively gain a complete floor in height rather than a windowless basement. The turbine hall would become even higher and be crossed at actual ground level by a wide bridge.

Regular and intensive discussions took place between the design team, led by the architects Jacques Herzog and Harry Gugger, with the engineers Ove Arup & Partners and quantity surveyors Davies Langdon & Everest, and representatives of the Tate, both Trustees and staff (notably Peter Wilson who led the Tate team). The final character of the building and especially that of the gallery spaces, emerged from those meetings. It is important to remember that despite constructing the new gallery within an old building, this is not, in a conventional sense, a conversion: everything one sees is new, except the windows – and even these have new internal fittings. It was decided, however, that the basic aesthetic of the old building, its strong simple industrial character, should be continued into the new.

The exhibition galleries were designed to have the feel of real rooms, with substantial walls, plain ceilings, and oak doors, rather than the temporary quality of partitioned spaces. The overhead light fittings are hidden in deep boxes and show only as translucent glass rectangles flush with the ceiling. To emulate the quality of natural light on every floor, they offer a wide and flexible range of light from warm to cool. Though fitted with tracks for supplementary spotlighting where necessary, they have eliminated the need for the banks of light fittings that clutter the ceilings of most galleries. The floors are either rough-cut unpolished oak, which will develop a natural patina over time from the footsteps of millions of visitors, or polished concrete. Set into these floors are the forthright cast iron grids of the air vents.

There is a great variety of gallery spaces, rooms large and small of true individual character. The pride of the new gallery are the grandest of these rooms, the double height gallery on the second floor, with its full-size window, and the four central galleries on the fourth floor. These beautifully proportioned galleries do not have the usual ceiling skylights but receive natural light through massive clear-storey bands of frosted glass above and flush with their side walls. In my view they are the most beautiful exhibition spaces to be found in any modern museum of art in the world.

I have had the pleasure of watching this project grow from dreams and ideas through drawings and more drawings, from models and mock-ups through raw construction to finished rooms. I believe that Herzog & de Meuron have given the Tate precisely what it sought from the beginning: a great building where concern for the needs of art are given the highest priority.

Above:
Detail of the Turbine Hall
and the concourse, Level 4

Right:
View from the
Turbine Hall bridge

Overleaf:
Poetry and Dream wing,
installed in 2006

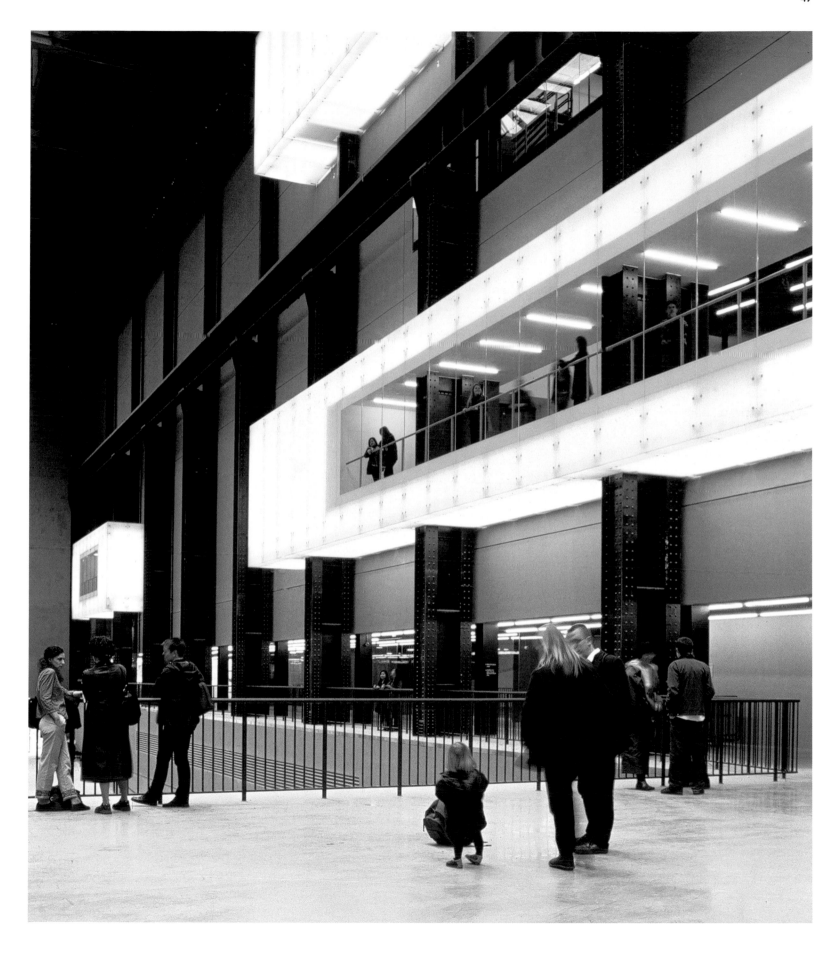

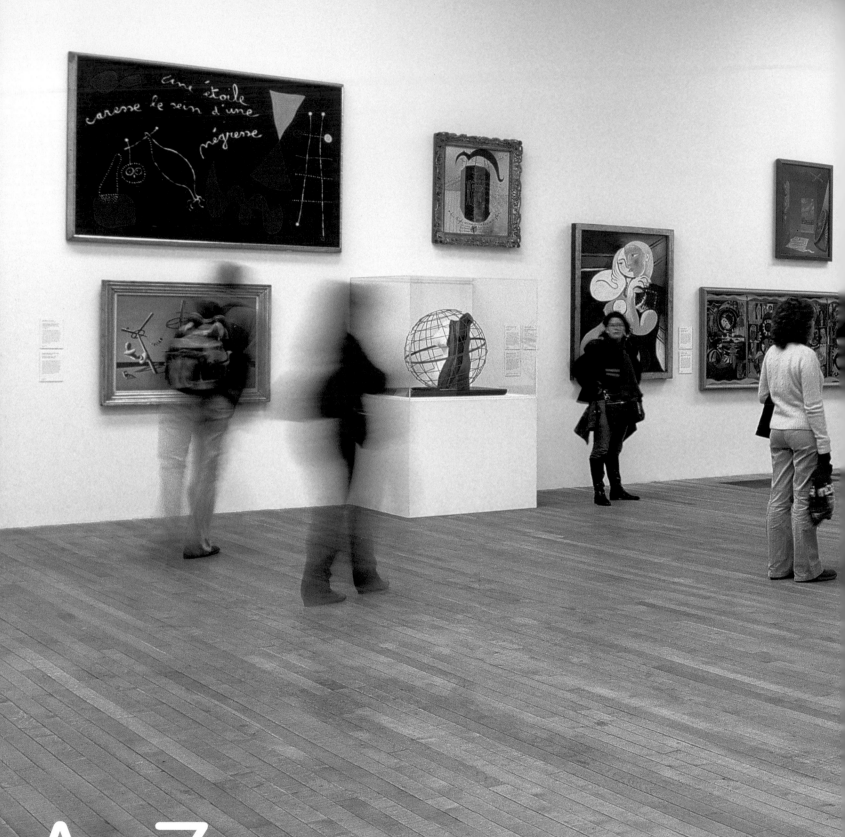

A–Z

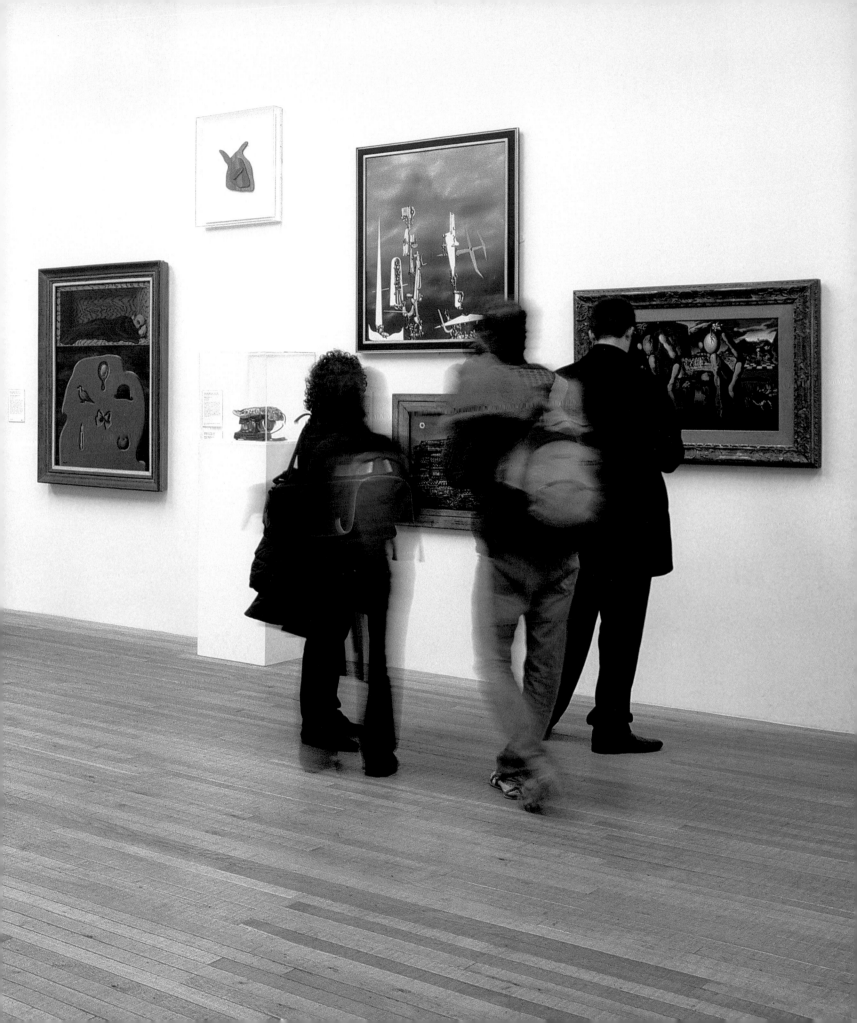

Introducing the A–Z

A selection of artists and works from Tate's collection with additional entries on key themes, movements and concepts in modern and contemporary art.

Measurements of artworks are given in centimetres, height before width.

Authorship of entries is indicated with initials beside each text.

Authors

LA	Lucy Askew
SB	Simon Baker
EB	Evi Baniotopoulou
TB	Tanya Barson
DB	David Batchelor
MB	Maria Bilske
JB	Juliet Bingham
SBo	Simon Bolitho
ABH	Achim Borchardt-Hume
BB	Ben Borthwick
CB	Craig Burnett
SC	Stuart Comer
AC	Ann Coxon
MD	Marko Daniel
ED	Emma Dexter
CF	Carl Freedman
FF	Flavia Frigeri
MG	Matthew Gale
AG	Adrian Glew
MGo	Mark Godfrey
KG	Kerryn Greenberg
SH	Sophie Howarth
RL	Rebecca Lancaster
KM	Kyla McDonald
EM	Elizabeth Manchester
SM	Shoair Mavlian
CM	Charlotte Merrett
JM	Jessica Morgan
FM	Frances Morris
AM	Anna Moszynska
MP	Maeve Polkinhorn
SR	Sean Rainbird
HS	Helen Sainsbury
CS	Chris Stephens
RT	Rachel Taylor
SW	Simon Wilson
CW	Catherine Wood

In *Abakan Red* 1969, Magdalena Abakanowicz conceived a huge sweep of coloured material in a form made almost amphibious by its free suspension in space. It is constructed, like its companion *Abakan Orange* 1971, from sisal that the artist culled from discarded ropes. Strong and harsh, but also pliable and amenable to weaving, sisal allowed the artist to develop dialogues in her work between hard and soft, the monumental and the found, that were outside the orthodoxies of existing sculptural practice.

Abakanowicz shared these interests with Polish compatriots, including the artist and theatre director Tadeusz Kantor, and they fed more broadly into a fundamental shift in artistic practice in the late 1960s. There are evident connections with the works of contemporaries such as Eva Hesse, Robert Morris and Pino Pascali in which the potential of formlessness emerged from the pliability of the original material. However, working in Poland under the fragile cultural conditions of the Eastern Bloc made Abakanowicz's position more precarious politically and materially: an advantage of sisal was that these works could be stored under the bed in her one-room apartment. Unfolded, the *Abakans* resume their large-scale potential to envelop their environment in a way that is both organic and suggestively bodily.

These themes are taken up in Abakanowicz's later works. A truncated anthropomorphism is evident in the *Backs* that, when gathered in groups, evoke rituals of prayer and mourning associated with the troubled history of Europe. More dramatic and viscerally disturbing are the accumulations of soft, stuffed forms in her *Embryology* installation of 1978–80. **MG**

Abakan Red
1969
Sisal and metal
300 x 300 x 350 cm
Presented anonymously 2009

Magdalena Abakanowicz
born 1930

Meir Eshel, who was known as Absalon, created all-white architectural constuctions which are a hybrid of model-making and minimalist sculpture. Fabricated out of polystyrene and cardboard, *Cell No. 1* 1992 is one of a series of six similar structures based on the concept of a single occupancy, self-contained home. Measured to fit Absalon's specific body dimensions, *Cell No. 1* has everything a home could want: a door, a window, a table, chair, bed, book-shelf and kitchen area.

Geometrically pure, ice-cool and silent, *Cell No. 1* is a futuristic dream house, perhaps a solitary astronaut's module, or a cell for a space age monk. Yet the restricted scale and claustrophobic design suggests the work is as much about existential isolation and imprisonment as about creating an ideal home.

Absalon's other sculptural work is similarly concerned with the relationship between architecture and design and the way they affect and control our lives. The titles of these works – *Arrangement, Order, Compartments, Departments* and *Proposals for Everyday Objects* – indicate formal, bureaucratic procedures, while their use of flimsy materials and prototype status give them an unsettled, fragile quality.

This sense of uneasiness is more forcibly present in Absalon's video work. In the videos he interacts with his cells and sculptural installations, leaning on them, moulding and bending his body to fit them, nervously pacing to and fro around them. In a video made in 1993, the year of his premature death aged twenty-nine, Absalon forgoes all restraint, letting out a primal scream with his head stuck in a large hole he has dug in the ground. **CF**

Cell No.1
1992
Wood, cardboard, fabric and neon lights
245 x 420 x 220 cm
Presented by the Patrons of New Art through the Tate Gallery Foundation 1997

Absalon
1964–1993

Abstract Expressionism

Abstract expressionism developed as a movement in America during the later 1940s and throughout the 1950s. The artists associated with it, including Jackson Pollock, Mark Rothko, Clyfford Still, Franz Kline, Lee Krasner, Willem De Kooning, Robert Motherwell and Barnett Newman, were mostly based in New York City, and are sometimes known as the 'New York School'. They are linked not so much by a similar style as by a common aim to make new forms of abstract art that would be expressive or emotional in their effect.

Several of the abstract expressionists, including Arshile Gorky and Adolph Gottlieb, had been inspired by the surrealists' belief that art should come from the unconscious mind. As a result they strove to work as intuitively as possible. They generally rejected the external world as a source of subject matter, and instead explored how material gestures could be used to express internal states of consciousness. Several of the artists were interested in religion and myth, and drew inspiration from sources as diverse as the writings of the Swiss psychologist Carl Gustav Jung, the Jewish Kabbalah, and the Christian Stations of the Cross.

Two broadly distinct approaches emerged among the group. The so-called 'action painters', led by Pollock and De Kooning, emphasised energetic physical acts of painting: Pollock famously placed his canvas on the ground and danced around it, pouring paint direct from the can or trailing it from the brush or a stick. The 'colour field' painters, including Rothko, Newman and Still, created simple compositions with large areas of a single colour intended to produce a contemplative or meditative response in the viewer. Both the action and the colour field painters shared common practices, ideals and an overall philosophy. The works are almost always made on large canvases, and brushstrokes and colour are applied across the whole space with equal importance.

With its emphasis on improvisation and the importance of process, abstract expressionism transformed the fundamentals of painting and sculpture in ways that were widely influential. It became the first American art movement to attain truly international status, putting New York City at the centre of the art world for the first time. Many factors contributed to the extent of this influence, including the championing of the movement by the influential American art critics Harold Rosenberg and Clement Greenberg, and its promotion as a symbol of American free thinking by the CIA during the Cold War.

The influence of the movement was strongly felt in Britain, where artists had the opportunity to see work by many of its key proponents in important exhibitions at the Tate Gallery in 1956 and 1959. **SH**

Opposite:
Arshile Gorky (c. 1904–1948)
Waterfall 1943
Oil on canvas
153.7 x 113 cm
Purchased with assistance from the
Friends of the Tate Gallery 1971

Left:
Willem De Kooning (1904–1997)
The Visit
1966–7
Oil on canvas
152.4 x 121.9 cm
Purchased 1969

Above:
Clyfford Still (1904–1980)
1953
1953
Oil on canvas
235.9 x 174 cm
Purchased 1971

56

Angel of Anarchy
1936–40
Textiles over plaster
and mixed media
52 x 31.7 x 33.6 cm
Presented by the Friends
of the Tate Gallery 1983

Eileen Agar's imaginative imagery combined elements of humour and the uncanny with her fascination for the geometry of the natural world. Having studied at the Slade School of Art in London, a stay in Paris in the late 1920s brought her into contact with some of the most influential avant-garde art of the day. She drew on abstraction and cubism, combining geometric forms with strange and quirky subjects through a range of techniques. As well

as painting, she used found objects to create collages and assemblages. These highly innovative works brought her to the attention of surrealist artists and her work was included in the *International Surrealist Exhibition* held in London in 1936, where she was the only professional British female artist whose work was shown.

Surrealism offered Agar an abundance of new possibilities in her quest to take art beyond the everyday. Turning to photography, she took shots of natural rock formations in a way that suggested new and extraordinary images. In the late 1930s she produced a number of plaster-cast heads, from which she created two versions of *Angel of Anarchy* 1936–40, Tate's being the second; the first was lost and is now only known through photographs. Tate's version is at once colourful and playful, bizarre and macabre. Covered in exotic feathers and fabrics, the angel is blinded, suggesting a certain malign energy. The integration of African beads and bark cloth recall the important influence of non-European objects to artists working in the early part of the twentieth century. **LA**

Eileen Agar
1899–1991

One of China's leading conceptual artists, Ai Weiwei is known internationally for his social and performance-based activities that include photography and film, sculpture, installation, as well as curating, architecture, publishing and activism. Citing Marcel Duchamp, he refers to himself as a 'readymade', merging his life and art in order to advocate both the freedoms and responsibilities of individuals. 'Your own acts and behaviour tell the world who you are and at the same time what kind of society you think it should be', he has said. As material for his art, he draws upon the society and politics of contemporary China, as well as ancient and traditional cultural artefacts, whose function and perceived value he challenges. This critical line of enquiry runs through his 1994 performative intervention *Dropping a Han Dynasty Urn* 1995,

and his eulogy to the thousands of children who perished in the Sichuan earthquake disaster, *Remembering* 2009.

Sunflower Seeds 2010 is the latest of a number of works that Ai has made using porcelain. Each seed was individually hand-sculpted and hand-painted by specialists working in small-scale workshops in the city of Jingdezhen, famed for its production of Imperial porcelain. This combination of mass production and traditional craftsmanship invites us to look more closely at the 'Made in China' phenomenon and the geopolitics of cultural and economic exchange. *Sunflower Seeds* references his 2010 Unilever Series commission in which he covered the east end of the Turbine Hall in a landscape of 100 million sunflower seeds. For Ai, sunflower seeds are associated with the Cultural Revolution (1966–76), when propaganda images depicted the people as sunflowers turning towards Chairman Mao Zedong, the sun. Yet Ai also remembers the sharing of this common street snack as a gesture of human compassion and friendship during a time of extreme poverty and repression. **JB**

Sunflower Seeds
2010
Porcelain
Overall display dimensions variable
Purchased with assistance from Tate International Council, the Art Fund, and Stephen and Yana Peel 2012

Ai Weiwei
born 1957

Homage to the Square:
Study for Nocturne
1951
Oil on wood
53.4 x 53.2 cm
Presented by The Josef and
Anni Albers Foundation 2006

When Josef Albers arrived at the newly founded Black Mountain College, North Carolina, in autumn 1933, he described his educational mission as 'To open eyes'. He had arrived fresh from the Bauhaus in Berlin, which only months before had closed due to pressures by the Nazis. Having enrolled as a student in 1920 and risen through the ranks to the position of Assistant Director, his affiliation with the famous art and design school was longer than that of any other artist.

While at the Bauhaus he had made a series of highly innovative abstract glass pieces which combined the semi-industrial technique of sandblasting sheets of coloured glass with the traditional format of easel painting. At Black Mountain, and later at Yale University, Albers continued the tradition of Bauhaus teaching, with its focus on liberating the creative potential he believed was universal to all mankind. Counting among his students the likes of Robert Rauschenberg and Eva Hesse, he became a critical link for the migration of modernist ideas from 1930s Europe to postwar America.

However, it was not until the age of sixty-two that he embarked on what would become his signature body of work, the *Homage to the Square*, a series of more than 1,000 variations on a formula of three or four different-coloured squares set inside each other and gravitating towards the bottom edge. Made by applying oil paint straight from the tube with a palette knife, the *Homages* subverted the then dominant notion of painting as a form of self-expression. Instead, their primary concern was with the psychology of visual perception and the *Interaction of Color*, the title of Albers's seminal book of 1963. **ABH**

Josef Albers
1888–1976

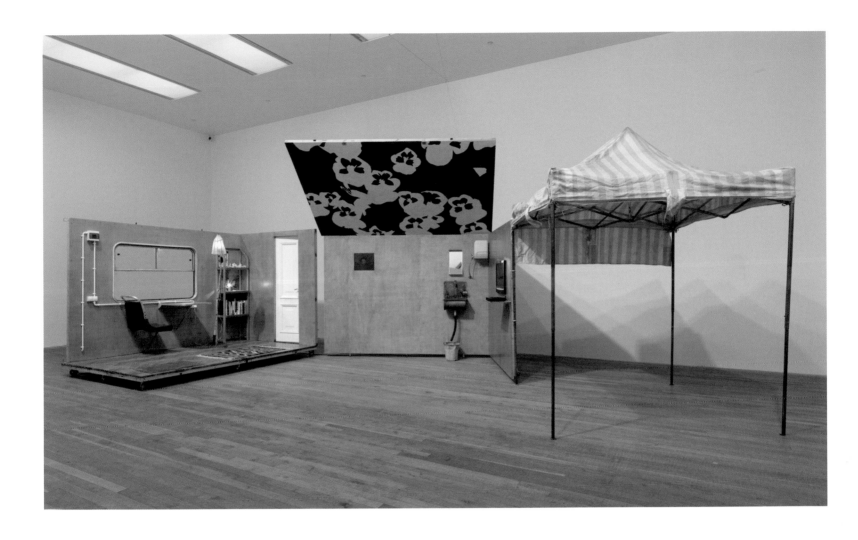

Pawel Althamer is one of the most significant Polish artists of his generation. His work is wide-ranging, encompassing sculpture, performance and installation, and often addresses questions of identity and the position of the individual within contemporary society. He began his career making visceral figurative sculptures using natural materials. *Monika and Paweł* 2002 depicts the artist and his first wife. The standing nude figures are made from straw over metal armatures, sewn to give the appearance of muscular anatomies and using animal intestines to give the effect of life-like skin.

Self-Portrait as a Businessman 2002 (with 2004 additions) is the trace of one of Althamer's performances: it consists of a pile of personal effects left behind after he undressed in a busy Berlin square. Another thirty-minute performance, *Film* 2000, re-enacts half an hour of ordinary life, played out by actors at least one of whom is a celebrity.

Foksal Gallery Foundation 2004 and *FGF, Warsaw* 2007 are representations of Althamer's Warsaw gallery, the Foksal Gallery Foundation, and refer to its history at the forefront of Polish avant-garde culture since the 1960s. *Foksal Gallery Foundation* is a handmade 1:5 scale model of the gallery positioned on a mobile table similar to the stalls used by street sales people in the early days of the post-communist economy in Poland. *FGF, Warsaw* is a large installation that takes the form of a structure with four walls and a ceiling that can be fitted together to create a transit crate. It incorporates works by other contemporary Foksal artists Wilhelm Sasnal, Monika Sosnowska, Jakub Julian Ziolkowski and Artur Żmijewski. Theoretically both works can be transported, enabling the Foundation to travel beyond the boundaries of its original home. **RT**

FGF, Warsaw
2007
Mixed media
856 x 428 x 309 cm
Purchased using funds provided by the 2007 Outset/Frieze Art Fair Fund to benefit the Tate Collection 2009

Paweł Althamer
born 1967

The Last Clown
1995–2000
Mixed media
Purchased with funds
provided by the American Fund
for the Tate Gallery 2002

Inspired by his experience of living and working in Mexico City, Belgian-born artist Francis Alÿs presents a decidedly urban view of everyday encounters, using a wide range of media including video, performance, drawing and painting. Alÿs is perhaps best known for his city walks, in which he uses props or enacts rituals in order to disrupt the everyday situations that he meets along the way. In one walk, he wore magnetic shoes, which gradually accumulated debris from the street as he proceeded. In another he sought out 'doppelgängers' – passers-by who resembled him – and walked alongside them until his footsteps fell into line with theirs. In all his walks, he relies on chance encounters in order to 'complete' the work.

Another theme explored by Alÿs is the role of the artist in contemporary society. The artist is seemingly expected to be a performer or entertainer but in doing so risks exposure to criticism and ridicule. The installation *The Last Clown* 1995–2000 may allude to this role by documenting a man who walks through the park and is tripped up by a passing dog. A painterly animation of the incident is repeated on a continuous loop and the installation is amplified by a series of paintings and drawings of the event. A soundtrack of circus music and canned laughter further emphasises the comedic quality and absurdity of the slapstick episode. **HS**

Francis Alÿs
born 1959

Carl Andre is a seminal figure of American minimalism. Since the 1960s he has made work that emphasises the inherent qualities of his materials. After a period carving wooden sculptures he began working with everyday industrial materials, arranging them in simple geometric shapes. These aestheticise the arrangements of industrial objects on the factory floor or in the forge. Andre has described his method of working as scavenging for 'physical realities' and he often seeks inspiration in the city streets.

In their elegant simplicity Andre's objects highlight the unique physical and sensual qualities of their materials. *Venus Forge* 1980 (p.180) is composed of steel and copper plates placed directly on the floor. The audience is invited to walk on the surface of the metal, experiencing the differences in density between the sculpture and the floor. The warmth and shine of the copper contrast with the dark, coarser surface of the steel. By placing his work directly on the floor rather than on the wall or plinth, Andre encourages the audience to interact with the objects in a much less hierarchical way.

Equivalent VIII 1966, otherwise known as the 'Tate bricks', is one of a series of eight works, each of which consists of 120 fire bricks in a different geometric configuration. When the *Equivalents* were first shown, the juxtaposition of the sculptures highlighted their similar volume and weight and the different configuration of their constituent parts. The artist intends the experience of walking around the two-brick height of *Equivalent VIII* to feel to the audience like wading through a shallow body of water. **RT**

Equivalent VIII
1966
Firebricks
12.7 x 68.6 x 229.2 cm
Purchased 1972

Carl Andre
born 1935

Zero to Infinity
1968–2007
Wood and paint
Component parts,
each 50 x 50 x 50 cm
Purchased 2009

Rasheed Araeen has long played a polemical part in the production and criticism of art in Britain. Through his own work, his writing (especially as founder and editor of the journal *Third Text* in 1987) and his exhibition organising, he has worked tirelessly to remind the establishment of the creativity of those habitually excluded from the Western canon by both deliberate and unconscious racism.

Initially trained as a civil engineer in Pakistan, Araeen began to paint in Karachi before moving to London in 1964. He responded to the painted steel sculpture of Anthony Caro by developing serial structures. His breakthrough works were composed of cubes with lattice cross-struts that can be associated with the functionalist modernism of constructivists like Naum Gabo and Vladimir Tatlin. Araeen was also interested in the viewer's interaction with his works, inviting friends, for instance, to reconfigure the multiple parts of *Zero to Infinity* 1968–2007. His concern with 'the relation between equal elements/objects' established a distinct lineage for the unitary production of minimalism. Even though the work bears comparison to the contemporary practices of American artists such as Donald Judd and Sol LeWitt, these were virtually unknown in Europe at that time and Araeen's points of reference were Islamic culture and modern engineering.

Activated by radical politics and the immigrant experiences of the 1960s and 1970s, a pivotal moment in Araeen's cultural polemic came with *The Other Story*, the exhibition he curated at the Hayward Gallery in London in 1989 of the work of (primarily) postwar artists of Black, Caribbean and Asian ancestry. Araeen's own subsequent works expose the political values underlying culture and, while post-colonialism and globalisation open new cultural networks, he remains sceptical of the dominance of the West and the narratives that its position sustains. **MG**

Rasheed Araeen
born 1935

Constellation According to the Laws of Chance
c. 1930
Painted wood
54.9 x 69.8 cm
Bequeathed by E.C. Gregory 1959

Chance

For the surrealists, chance was a vital concept; accidental encounters, 'found' objects and automatic processes of drawing or writing were all valued as means to free the mind from the restrictions of logic and take it into the realm of the unconscious. Being open to chance, through play, creativity or other spontaneous actions was a quality celebrated by the surrealists as the essence of radical or revolutionary living and the antithesis of rationalist, materialist norms.

Arp first introduced chance into his artistic practice in the dada years, when he made collages of torn paper, which were arranged by dropping the pieces randomly onto a surface. In the 1930s he discovered that some of his earlier works had deteriorated whilst in storage. He chose to incorporate the wrinkled or cracked surfaces of these pieces into new works, tearing up the originals and pasting the pieces together in new configurations. These serendipitous abstract compositions can be seen as precursors to the works of a number of artists who came to prominence in the mid twentieth century, such as Jackson Pollock. **AC**

Jean (Hans) Arp
1886–1966

Jean (Hans) Arp was one of the leading figures of the dada and surrealist movements, and is perhaps best known for his distinctive sculptural reliefs and collages.

Born in Strasbourg in 1886, Arp made his first abstract works in the early 1910s. In 1912 he met Wassily Kandinsky in Munich and took part in an exhibition of the Blaue Reiter (Blue Rider) group. However, it was not until 1916 that he came to prominence, as co-founder of dada, a radical, international art movement that sprung from a Zurich night-club, the Cabaret Voltaire. Based in neutral Switzerland during the First World War, the artists aimed to question and even destroy traditional values in life and in art. As Arp himself stated, 'Revolted by the butchery of the 1914 World War we in Zurich devoted ourselves to the arts. While the guns rumbled in the distance, we sang, painted, made collages and wrote poems with all our might.'

Arp started to develop his personal style during the dada period, when he made a number of wooden reliefs. Flat pieces of wood were cut into irregular, rounded shapes by a carpenter according to his instructions. They were then assembled and sometimes painted by the artist himself. These early reliefs expressed a number of themes that were continued in the free-standing sculptures he made from the mid 1920s until his later years. In particular, Arp was interested in the forms and processes of nature. In the mid 1930s he began to view his sculptures as a kind of 'concrete' art, their forms relating to those of the natural world, yet without deliberate imitation. **AC**

Art Informel

During the years immediately after the Second World War, a number of artists were searching for a style of art that could convey their sense of irrationality and fear. To many, realist practices seemed to have been tainted by political use in propaganda, and geometrical abstraction seemed too cold and measured for the heated emotional climate. The broad constituency of artists whose work was dubbed *informel* (literally 'without form') forged an impassioned form of abstraction characterised by a peculiarly physical handling of artistic materials. They included Karel Appel, Alberto Burri, Jean Dubuffet, Hans Hartung, Jean Fautrier, Georges Matthieu, Henri Michaux, Pierre Soulages, Antoni Tàpies and Wols. Many showed in the exhibition *Un Art Autre* (Art of Another Kind) organised in 1952 by the French writer and sculptor Michel Tapié, who saw the artists as trying to make a radical break with traditional notions of order and composition. In spite of this, their work can be seen as having pre-war roots in surrealism and expressionism, as well as the paintings of Wassily Kandinsky and Paul Klee.

Art informel is characterised by highly improvisatory styles of painting that emphasise spontaneity and gesture. Like the abstract expressionists in America, to which the movement is sometimes considered a European counterpart, many of the artists were influenced by the surrealist idea of automatism, and often executed their works at speed, aiming for a direct expression of the subconscious. 'Speed, intuition, excitement – that's my method of creation', Matthieu explained. Hartung was typical of the movement in believing that painting should record and evoke his immediate inner experiences, tensions and energies. He rejected observation and memory as starting points and relied instead on spontaneous feeling and direct physical action. His painting *T1963-R6* 1963, with its repetitive calligraphic marks scratched into the top layer of a vinyl coating, is characteristic. Tàpies's *Grey and Green Painting* 1957 also shows a concern with texture: incised and scribbled lines, various lacerations and graffiti-like marks overlay a thick, highly textured base in which clay and marble dust have been mixed with the paint. Tàpies later wrote: 'My pictures became the truly experimental fields of battle.'

In the early 1960s, the introspection and bleakness of much of art informel was challenged by movements such as nouveau réalisme (new realism) and pop art, which sought a more direct engagement with everyday life and rejected the idea of art as the subjective expression of personality. However, the continued desire to express deep-seated creative impulses through gestural mark-making can be seen in the work of Lucio Fontana or Cy Twombly as well as younger painters including Fiona Rae and Luc Tuymans. **SH**

Above:
Cover of *Un Art Autre*
by Michel Tapié, 1952

Left:
Antoni Tàpies (born 1923)
Grey and Green Painting
1957
Oil, epoxy resin and
marble dust on canvas
114 x 161.3 cm
Presented by the Friends
of the Tate Gallery 1962

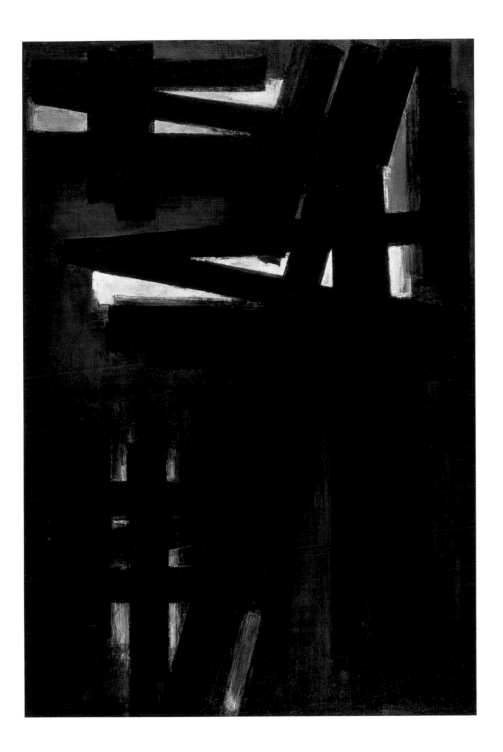

Left:
Pierre Soulages (born 1919)
Painting, 23 May 1953
1953
194.9 x 130.2 cm
Purchased 1953

Below:
Jean Dubuffet (1901–1985)
*Monsieur Plume with
Creases in his Trousers
(Portrait of Henri Michaux)*
1947
Oil and grit on canvas
130.2 x 96.5 cm
Purchased 1980

Arte Povera

The term arte povera (literally, 'poor art') was used for a loose and short-lived association of artists who first exhibited together in Italy in 1967. At a time of social and political unrest (which would climax in the student protests of the following year), this generation dismantled the role and function of art. In 'Arte Povera: Notes for a Guerrilla War' (published in November 1967) the critic Germano Celant described what he identified as an 'outlook' rather than a style. He wrote that it was concerned with 'contingency, events, ahistoricism, the present … and anthropological outlook, "real" man (Marx), and the hope (now a certainty) of discarding all visually univocal and coherent discourse'. As the subtitle of his essay indicates, Celant saw his friends as outside established practices, and characterised their interventions, installations and performances (using such diverse materials as earth, neon, water, plastic and trees) as assembling elements of reality rather than seeking to add gratuitously to the material world.

For this new phenomenological spirit Celant borrowed the term arte povera from the 'poor theatre' of the Polish director Jerzy Gorotowsky. Several of the artists, including Michelangelo Pistoletto, Luciano Fabro and Jannis Kounellis, were already established and responding to the conceptual and material experiments of the previous generation of Alberto Burri, Lucio Fontana and Piero Manzoni. The specifically Italian cultural context is evident in the maintenance of craft skills (despite the rejection of artistic traditions), and in the sophisticated relationship between past and present, history and the contemporary. That arte povera quickly became a national and international phenomenon was a testament to its timeliness. It had parallels with the growth in conceptual, 'anti-form' and land art of Joseph Beuys, Robert Morris and others, which was memorably dubbed the 'dematerialisation of the art object' by the American critic Lucy Lippard.

The first exhibitions in 1967 (in Genoa and Turin) included Giovanni Anselmo, Fabro, Kounellis, Giovanni Paolini, Pistoletto, Mario Merz, Marisa Merz and Gilberto Zorio, among others, building to a core group of around fourteen artists over the next few years. Many – especially those based in Turin – were bound together through collaboration. This fluidity was typified by the artworks (including Merz's wicker *Cone* c.1967), performances and interventions made for *Arte povera + azioni povere* at Amalfi in 1968. Much of their work centred on an investigation of the relationship between nature and culture. The artist's position within nature is explicit in Giuseppe Penone's interventions in the landscape, while Mario Merz's exploration of the Fibonacci series (a mathematical formula describing incremental growth) identified a unifying structure to the world. At the same time, the phenomenological actuality of 'being in the world' underpinned works by Fabro and Pistoletto, who each used reflective surfaces to confront the viewer. Pistoletto also explored the legacy of classical culture through confrontation with contemporary reality, notably in the earliest versions of his iconic *Venus of the Rags* 1967 (p.205).

A sequence of group exhibitions, such as *Live in Your Head: When Attitudes Become Form* held in Bern in 1969, confirmed arte povera's prominence and international connections. However, by 1971, Celant and many of the artists sought to abandon the term. They went on to extend their work in quite distinct ways, forming multiple legacies from arte povera's innovations. **MG**

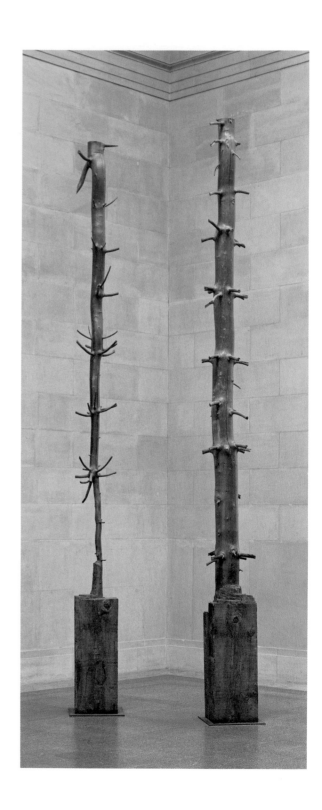

Giuseppe Penone (born 1947)
Tree of 12 Metres
1980–2
Wood (American larch)
Each 600 x 50 x 50 cm
Purchased 1989

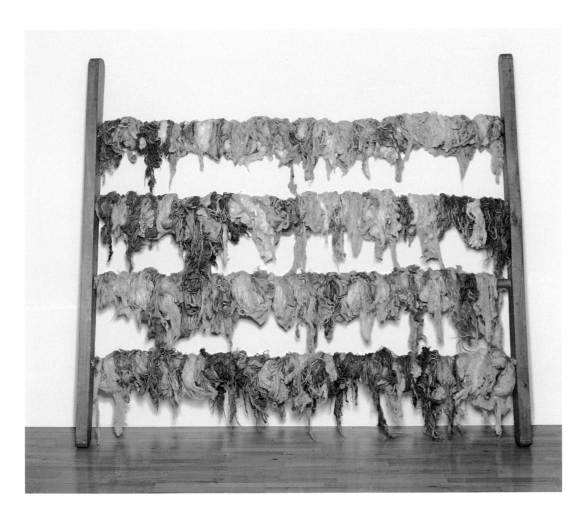

Above:
Jannis Kounellis (born 1936)
Untitled
1968
Wood and wool
250 x 281 x 45 cm
Purchased 1996

Right:
Mario Merz (1925–2003)
Cone
c. 1967
Wood (willow)
221 x 129.5 x 129.5 cm
Purchased 1983

As a second-generation immigrant to France, where he was born to Algerian parents, Kader Attia's own history and identity play a crucial part in his artworks. His work is preoccupied with colonial and post-colonial theory, combined with questions of modernity and post-modernity. He has explored many of these themes in a range of media including video, sculpture, installation and photography and often through an examination of the social impact of architecture. *Untitled (Ghardaïa)* 2009 is a scale model of the ancient city in the work's title, situated in the M'zab Valley in Algeria, and the work is made, significantly, out of the North African delicacy couscous. Taking the 1932 visit of the renowned architect Le Corbusier to the city as a starting point, the work brings to light a moment in the architectural exchange between Algeria and France. By using the specific history of Le Corbusier's adoption of principles learned at Ghardaïa, Attia is able to examine a wider concern with cultural appropriation – a factor underlined by the inclusion of photographs of Le Corbusier and of Fernand Pouillon (the architect of some of France's first social housing projects). The couscous is freshly made for each installation of the work and inevitably decays over time, literally demonstrating the themes of architectural degradation and the failings of modernity that are integral to the work's meaning.

Attia addresses similar concerns with architecture in other works. *Untitled (Concrete Blocks)* 2008, for example, plays on the notion of social housing being constructed from and likened to concrete blocks. As they list at forty-five to sixty degree angles to the floor, they act as a metaphor for the social collapse that such idealistic architecture aspired to rectify. **KM**

Untitled (Ghardaïa)
2009
Cooked couscous and photographs
Display dimensions variable
Purchased using funds provided by the Middle East North Africa Acquisitions Committee 2010

Kader Attia
born 1970

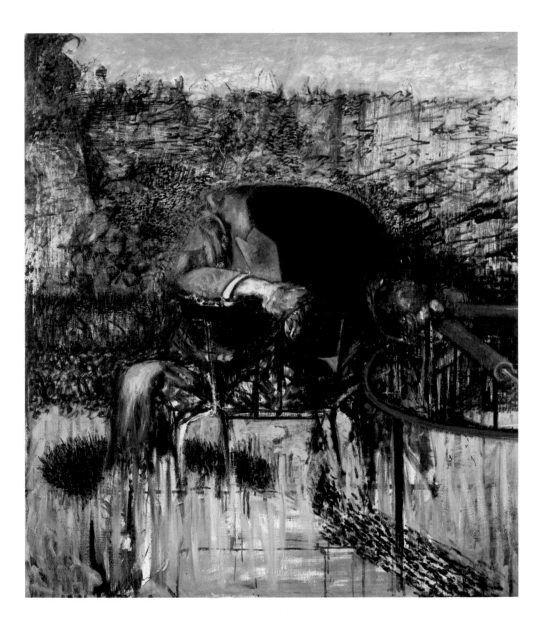

Figure in a Landscape
1945
Oil on canvas
144.8 x 128.3 cm
Purchased 1950

Though he had already been working as an artist for some years, Bacon became established in 1945 when he exhibited *Figure in a Landscape* 1945 alongside *Three Studies for Figures at the Base of a Crucifixion* c.1944. The coincidence of their display in London with the liberation of the concentration camps in Europe helped to secure his reputation as a painter of the violence and horrors of modern times. Throughout the 1950s his work was seen in relation to Existentialist philosophy as the representation of humankind's inherent bestiality and inevitable isolation in a godless world. As such, though he has frequently been seen as a solitary figure in the history of art, his paintings perhaps relate to postwar European art more than to British work.

Bacon can also be positioned within a modernist tradition of appropriating photographs as sources for art that runs from Degas to the present. Even in these early pieces he drew upon photographs for their imagery. *Figure in a Landscape* 1945, for instance, was based on a snapshot of Bacon's lover sitting on a chair in a park. Bacon particularly explored the ambiguity of images and what they represent, an aspect that became especially marked in his use of Eadweard Muybridge's nineteenth-century photographs of the human body and animals in motion. Frequently, as here, Bacon's figures can appear both threatening and threatened, victims perhaps of their own inherent violence. The primary focus of his art was on such paradoxes, as well as the visual similarities between, for example, humans and animals, sex and violence, threat and vulnerability. **CS**

Francis Bacon
1909–1992

70

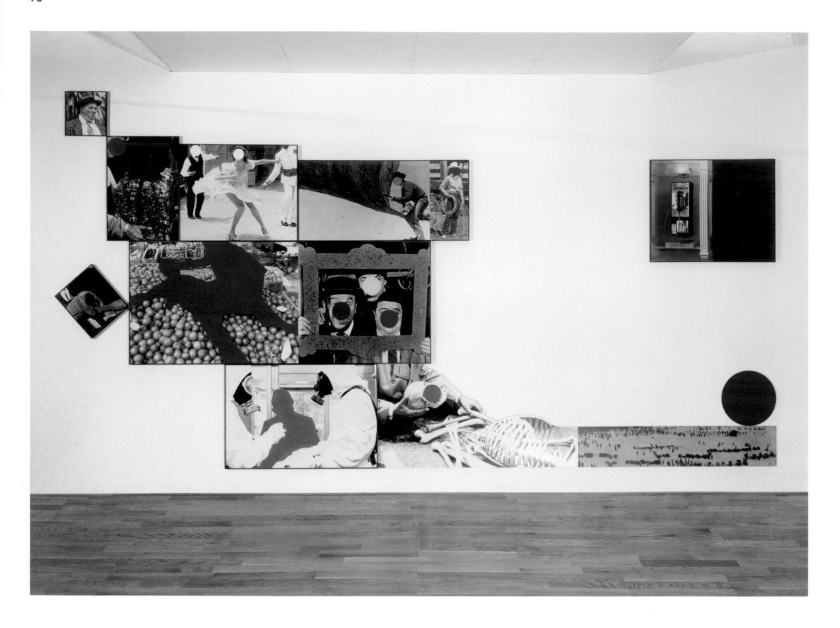

Whether he is depicting the banality of everyday life or appropriating film stills from Hollywood B-movies, the imagery of Southern California has always been central to John Baldessari's work. In the late-1960s, he was part of the group of West Coast Conceptual artists, including Ed Ruscha, whose work was characterised by deadpan wit in distinction to the analytical rigour of conceptual artists based in New York.

Baldessari has consistently explored the tension between photography and painting. Early works deployed photo-emulsion paint to develop photographs of mundane urban scenes on canvas, accompanied by large captions. These make obvious or arbitrary statements about the images that foreclose the narrative possibilities usually associated with photographs in newspapers and magazines. Subsequently, his work has been strongly associated with cinema, due to his use of film stills as well as his application of Sergei Eisenstein's theory of montage, in which meaning is generated by the collision of two contrasting images. In a work like *Hope (Blue) Supported by a Bed of Oranges (Life): Amid a Context of Allusions* 1991, meaning is displaced across a rhythmic chain of thirteen collaged elements. The focal points of the images, such as faces or silhouettes, have been cut out and the resulting holes are filled in with different coloured paints. Consequently, the face ceases to be the starting point from which a narrative emanates, instead becoming an abstract painted form that sucks the rest of the picture into its vacuum. The constellation of elements echoes the shape of the figure that has fallen on the oranges, framed by and cut out against a blank wall that adopts the shape and scale of a cinema screen. **BB**

Hope (Blue) Supported by a Bed of Oranges (Life): Amid a Context of Allusions
1991
Photograph on paper, oil tint, vinyl and acrylic on board
381 x 701.4 cm
Purchased with assistance from the American Fund for the Tate Gallery and Tate Members 2004

John Baldessari
born 1931

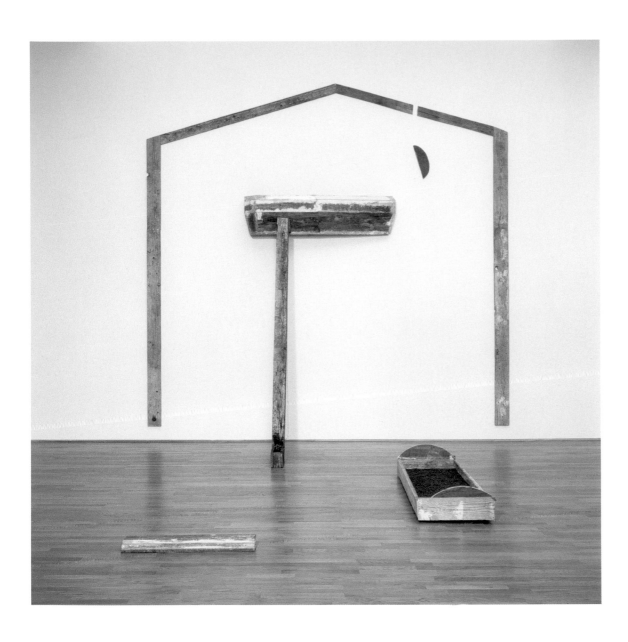

Polish sculptor Miroslaw Balka came to prominence during the mid 1980s with a series of deeply autobiographical figurative sculptures and performances, which reflected his memories of a Catholic childhood in Poland under Martial Law. Towards the end of the 1980s he began to move away from complex narrative pieces. *Oasis (C.D.F.)* 1989 dates from this period. Despite the simple and austere appearance of

the work, allusions to personal history continue to be strongly expressed. While the physical parameters refer to his own bodily dimensions, the formal components allude to the language of the home: the gable of a house, a drain pipe and door sill. In addition, Balka suggests the body through objects, such as the shallow bed, which evoke a human presence. He constructed the work from discarded domestic and industrial materials, some of them recycled from a previous work. Some parts, such as the weathered wooden planks, came from the family home in Otwock, near Warsaw. Balka has explained that such materials 'carry a history which I connect with when I touch them. It is like kissing the hand of history'. In combining these elements he makes connections between personal experience and the wider histories of family, community and country.

Since the 1980s Balka has continued to refine his sculptural language, but his materials, such as ash, soap and salt, as well as the forms and scales he employs, ensure that his works remain powerfully charged with a symbolism associated with life and death. **FM**

Oasis (C.D.F.)
1989
Mixed media
373 x 376.3 x 451 cm
Purchased 1999

Miroslaw Balka
born 1958

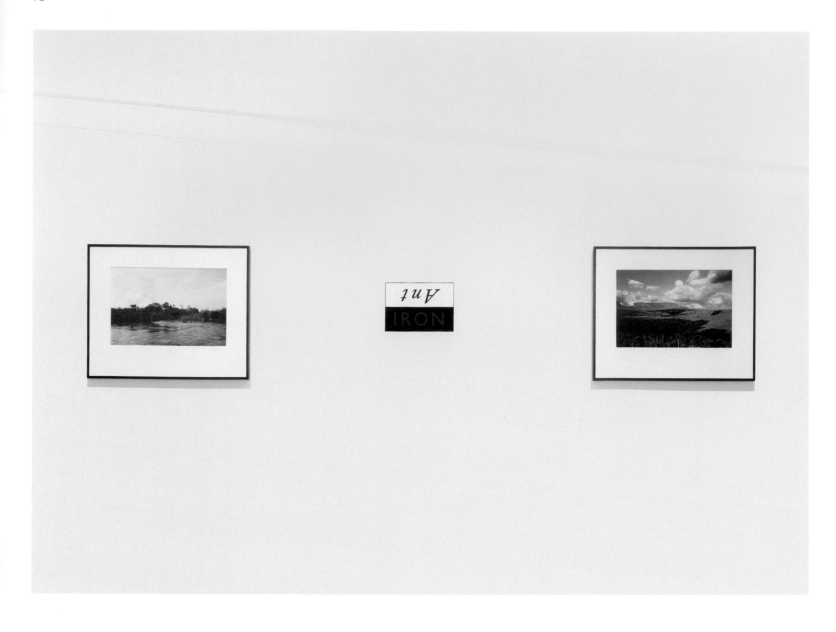

As a child, Lothar Baumgarten was taught by his anthropologist father an attentive way of looking at things in the world, profoundly influencing his later practice as an artist. Inspired by the accounts of the English explorer Sir Walter Raleigh and the writings of diverse ethnographers and anthropologists, he made imaginary maps of the New World (South America) many years before he visited it. Some of his earliest work was created in the swampy industrial wasteland on the banks of the Rhine, between Düsseldorf and Cologne, where he photographed incidental details of marshy vegetation, amphibious life and human rubbish. Between 1977 and 1983 he visited the Yanomámi people in the Orinoco basin in Venezuela, living with them for several months at a time. The installation *El Dorado – Gran Sabana* 1977–85 stems from this experience. It comprises a series of photographs taken by the artist in 1977 of the 'Gran Sabana' – the site of the legendary El Dorado sought by generations of European adventurers, an area spanning Venezuela, Brazil and Columbia. Between the photographs, paired words are painted on the wall, naming one of the heavy metals or minerals being mined in the region and an animal exterminated in the process. The creatures' names are upside down to signify death and mourning as well as the mining process of turning over the earth.

The plight of the indigenous people of this region became the subject of much of Baumgarten's work in the 1980s. Naming, as a means by which a culture may appropriate and inscribe itself on a landscape, is a central concept, used to draw attention to the erasure of one culture by another. **EM**

El Dorado – Gran Sabana
1977–85
Photographs and paint
195.5 x 1989 cm
Purchased with assistance from the American Fund for the Tate Gallery, courtesy Edwin C. Cohen and Echoing Green 1990

Lothar Baumgarten
born 1944

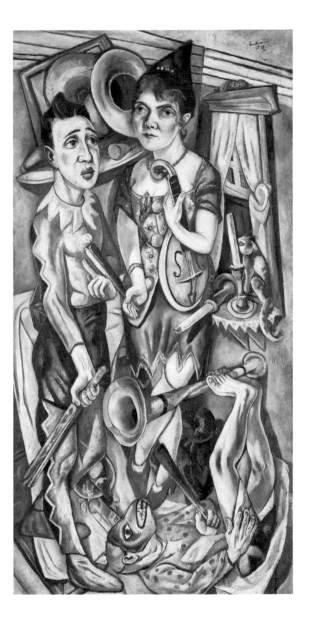

Carnival
1920
Oil on canvas
186.4 x 91.8 cm
Purchased with assistance
from the Art Fund and
Friends of the Tate Gallery
and Mercedes-Benz (UK) Ltd
1981

Max Beckmann was the most important German painter of the early twentieth century. In debates around contemporary art at the beginning of the century his early paintings, portraits, landscapes, mythological scenes and history paintings about modern catastrophes, aligned him with a more conservative trend. This viewed art as renewal and extension of a continuous tradition, while vanguard artists who seceded from established artists' societies to form their own groupings believed that modern art represented a break with the past.

However, Beckmann's experiences as a medical orderly in the First World War significantly changed his outlook and his art. Combining the legacies of gothic art and, more recently, cubism, he evolved densely packed compositions in shallow, stage-like spaces in his paintings of the early 1920s. Images of people he knew, sometimes in the guise of characters from the circus, cabaret or *commedia dell'arte*, as in *Carnival* 1920, displayed a sense of melancholy or world-weariness about the condition of humanity. Beckmann's mature style and increasing commercial success in the late 1920s can be traced through his lifelong sequence of self-portraits, the most important of which, *Self Portrait in a Tuxedo* 1927, depicts a confident, elegantly clad Beckmann confronting the viewer face on. Under the National Socialists his art was criticised then banned, and he went into exile in Holland, where he lived between 1937 and 1947. During this period he painted many of the complex allegorical triptychs upon which his reputation rests. He spent his final years in the United States and died days after completing his final triptych, *The Argonauts* 1950. **SR**

Max Beckmann
1884–1950

Quartered Meteor
1969, cast 1975
Lead and steel on steel base
150 × 168 × 158 cm
Presented by the American Fund
for the Tate Gallery, partial
purchase and partial gift of John
Cheim and Howard Read 2010

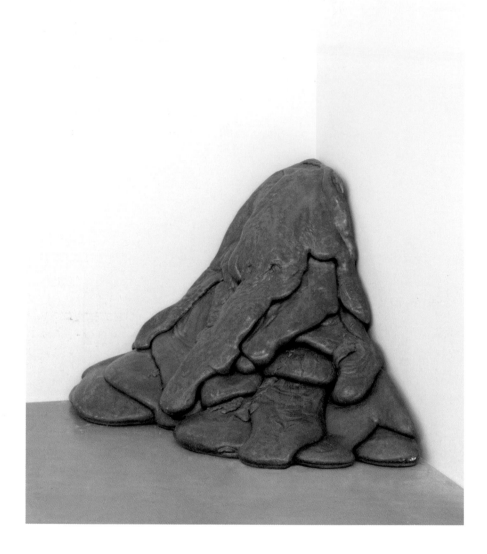

Lynda Benglis is one of the key figures of American post-minimal art of the 1960s and 1970s. Like many other artists of her generation, Benglis often worked from the principle that form should be derived from the inherent qualities of her chosen materials. She is arguably best known for brightly coloured poured latex works that move painting from the canvas onto the horizontal plane of the floor. Her metal sculptures, of which *Quartered Meteor* 1969 is a seminal example, also represent an important part of her early practice.

A lead sculpture to be displayed in the corner of a gallery space, *Quartered Meteor* is a cast of a form originally made from piled layers of polyurethane foam. Benglis first made foam sculptures as works in themselves; these were, by necessity, temporary and ephemeral. Casting them in metal not only ensured their longevity as artworks but it was also a deliberate attempt to subvert and make uncanny the material presence of the objects. Transformed from soft globs into solid masses of metal, these works signal the artist's complex but also humorous understanding of the differing nature of materials. In this case the static, heavy nature of the lead is at odds with the foam's amorphous shape, recalling the appearance of cooled lava. Benglis's interest in transforming a soft material into something hard may be related to her interest in the effects of nature (that can freeze, melt and congeal) as well as being a feminist critique of the phallocentric, vertical sculpture. **JM**

Lynda Benglis
born 1941

Materials

In the late 1960s, artists developed many new ways of working beyond the traditional media of painting and sculpture. Process art, arte povera, installation and site-specific art all expressed new attitudes towards the creation of art, often placing greater emphasis on the ideas behind or process of creating an artwork rather than the finished object. Artists such as Joseph Beuys, Robert Morris, Bruce Nauman, Jannis Kounellis or Barry Flanagan adopted a wide variety of materials with which to experiment. Although they were not part of a coherent movement, their works were brought together in several important exhibitions such as *When Attitudes Become Form* at the Kunsthalle, Bern, in 1969. Beuys's contribution to this exhibition included the smearing of fat along the bottom of a wall, and a bed of felt placed in a nearby room. Both of these materials held particular significance for Beuys and became part of his personal symbolism through their repeated use and surrounding mythology. **AC**

Joseph Beuys was one of the most influential German artists of the twentieth century. Following his wartime service as a radio operator in the Luftwaffe, he decided to become an artist rather than a natural scientist, another area of great interest to him. He evolved his ideas in the late 1940s to early 1960s, principally in the form of small sculptures and hundreds of drawings. In the 1960s, by now appointed professor at the Düsseldorf Art Academy, he became associated with the Fluxus movement. The nature of Fluxus, which collapsed boundaries between different disciplines, was markedly democratic and collaborative in character. This mirrored and influenced Beuys's own artistic approach. During the 1960s he came to international attention through his actions, which usually took place in galleries and extended over hours, and sometimes days. In the early 1970s he became increasingly active in the political spheres of educational reform and grass-roots democracy. His actions evolved to include public discussions and lectures, some of which were preserved in the form of blackboard drawings made while he talked.

Language was always vital to Beuys as an instrument for the formation and articulation of thoughts, and analogous to the manipulation of physical materials to make sculpture. As his fame, and sometimes notoriety, spread, he received invitations to make ever-more ambitious projects. Some of them, notably *7000 Oaks* 1982–7, for which he planted 7,000 oak trees in the city of Kassel, were only realisable outside the boundaries of museums and institutions. In parallel, he produced large numbers of editioned works, which took many forms, from sculptural objects to printed postcards. Through the production of multiples Beuys attempted to disseminate his ideas widely and make art objects that were widely available at affordable prices. **SR**

Four Blackboards
1972
Chalk on blackboard
121.6 × 91.4 × 1.8 cm
Transferred from the Archive 1983

Joseph Beuys
1921–1986

Insicuro Noncurante
1975
Print on paper,
collage and pencil
81 parts, each 55 x 44.7 cm
Presented by Tate Members 2010

Alighiero e Boetti was born in Turin, moved to Rome in the early 1970s and spent important periods of his working life in Afghanistan and travelling to other places. He was briefly associated with the arte povera group from 1966 to 1968 before moving towards a more idiosyncratic practice. His work includes constructions made with building materials, vast biro drawings, a light which illuminates for eleven seconds a year, a hotel that he set up in Kabul, a book classifying the 1000 longest rivers in the world, a vast series of embroidered maps, woven Kilims with patterns based on numeric systems, and a bronze self-portrait fountain sculpture. Boetti was particularly interested in ways of making art without inventing anything – bringing into his work materials and images that existed already. He was also fascinated with the passage of time, preferring extreme speed or slowness to the regulated time of industrial society.

In 1975 Boetti published an 81-part print portfolio in an edition of 44, titled *Insicuro Noncurante*. Most of the sheets were printed but some have hand-drawn additions. In every portfolio one is named 'originale' and has a unique motif that does not recur in the other editions. A few sheets look back to Boetti's arte povera constructions. Others include new versions of his 1968 doubled self-portraits such as *Gemelli*, a photomontage in which he appears hand-in-hand with his twin image. Several sheets are works based on his encounters in Kabul, and many look forward to the works he would make in the later 1970s, such as his watercolour drawings of aeroplanes. Boetti had always been fascinated by Marcel Duchamp and he saw *Insicuro Noncurante* as a portable museum of his own ideas comparable to the latter's *Boîte-en-valise* 1935–41. **MGo**

Alighiero e Boetti
1940–1994

Coffee
1915
Oil on canvas
73 x 106.4 cm
Presented by Sir Michael Sadler
through the Art Fund 1941

Pierre Bonnard is best known for his paintings of domestic scenes rendered in luminous colours whose treatment is derived from late impressionism. At the beginning of his career, around 1890, he became associated with the Nabis, a group of painters inspired by Paul Gauguin's use of flat areas of pure colour. The decorative aesthetic of Japanese prints, of which Bonnard made a study at this time, would prove to be another important influence. The 1890s saw Bonnard paired with another of the Nabis, Eduoard Vuillard, under the banner of intimisme, a term used to describe their small, decoratively designed and delicately coloured depictions of domestic settings.

His mature works, such as *Coffee* 1915, retain this interest in intimate household scenes but are infused with bold, complex, glowing colours that draw on impressionist Claude Monet's later paintings. *Coffee*, with its idiosyncratic composition in which the objects of pictorial interest are arranged around the edges of the picture, continues to show the influence of Japanese prints. *The Bowl of Milk* c.1919, used similar means to create a quality that transcends decoration. The painting shows a girl bringing a cat a bowl of milk in the environs of a comfortably furnished apartment. Through dramatic lighting, a darker palette and an austere design dominated by verticals, Bonnard's trademark evocation of sensuous domesticity becomes psychologically charged. While the figure in *The Bowl of Milk* was probably based on an ancient Greek statue, Bonnard's favourite model was his wife, Berthe. She appears sipping from a cup in *Coffee*, her pet dog beside her, and she is thought to appear again in *The Table* 1925, apparently preparing a meal for the dog waiting by her side. **MB**

Pierre Bonnard
1867–1947

Trauma
Trauma derives from the ancient Greek word for 'wound'). In non-medical terms it is defined as emotional shock, often leading to neurosis, or an event that causes great distress or disruption. Typical causes for trauma are abuse or violence, especially during childhood, natural events, such as earthquakes, or man-made events such as war.

Expressions of trauma frequently feature in modern and contemporary art. Many artists have responded to collective or personal trauma through their art, either instinctively or deliberately, and in more or less explicit ways. Trauma has been the subject of numerous psychoanalytic and philosophical theories. These in turn have been critiqued or expanded by art theorists. Hal Foster's take on Jacques Lacan's theory of trauma is one such case. He states: 'Lacan defines the traumatic as a missed encounter with the real. As missed, the real cannot be represented; it can only be repeated … Repetition serves to *screen* the real understood as traumatic. But this very need also points to the *real*, and at this point the real *ruptures* the screen of repetition.'

The various facets of trauma are central to many artists' work, such as Louise Bourgeois, Cindy Sherman, Yayoi Kusama, Eva Hesse and Tracey Emin. **EB**

Highly individual, Louise Bourgeois's work spans the best part of the twentieth century, and has touched on many movements, from surrealism to abstract expressionism, minimalism and feminism. Her themes sprang from personal trauma and experience, exploring human relationships and psychological states. A constantly renewed interest in isolated human body parts and their symbolic potential dates back to the early 1960s, when she started making biomorphic sculptures using materials such as bronze, plaster, resin and latex.

Amoeba 1963–5 is seemingly an inchoate mass with a bulging surface and single opening. It suggests the evolution of a living organism, but also alludes to neonatal forms and pregnancy. *Avenza* 1968–9, named after a town in Italy where Bourgeois worked, is made of latex; clusters of phallic bulges allude to both sexual and landscape themes. Bourgeois often focused on relationships between men and women, most significantly those of lovers and that of daughter and father. Thirty years on from *Avenza* a frieze-like panel of pink breasts titled *Mamelles* (breasts) 1991, showed her continuing interest in exploring gender roles and psycho-sexual meaning through body parts.

Bourgeois was the first artist to exhibit in Tate Modern's Turbine Hall, with her installation *I Do, I Undo, I Redo* 2000 and one of her signature spider sculptures, *Maman* 2000 (p.21). **EB**

Mamelles
1991, cast 2001
Rubber, fibreglass and wood
48.2 x 340.8 x 48.2 cm
Presented by the artist
(Building the Tate Collection) 2005

Louise Bourgeois
1911–2010

Fish
1926
Bronze, metal and wood
93.4 x 50.2 x 50.2 cm
Accepted by HM Government
in lieu of tax and allocated to
the Tate Gallery 1996

Developing forms of great purity on the verge of abstraction, the Romanian artist Constantin Brancusi epitomised what it meant to be a modernist sculptor in the first half of the twentieth century. He honed his extraordinary skills first in his native Romania, before moving to Paris in 1904. However, in 1907–9, he rejected modelling, as practised by Auguste Rodin, and turned instead to carving. He chose rough indigenous stones and responded to 'primitive' examples outside the classical tradition, blending African sources with Romanian wood-carving. Superfluous form was radically reduced. His contemplative, gradual approach led him to generate extended series from essential forms. The *Fish* series (1922–30), avoids zoological accuracy in order to capture the idea of streamlined motion. This is also evident in *Maiastra* 1911, an early sculpture in the series of *Birds* that Brancusi made in marble and bronze over a thirty-year period. The title refers to a Romanian folk-tale whose earthiness resonates in the roughly carved base, while the form of the uprising, crowing, bird is almost ballistic in its simplicity.

It was this reduction and refinement that resulted in the famous New York trial associated with Brancusi's *Bird* in 1927–8. Customs officials deemed it eligible for tax, like any machine-made object, since they did not recognise it as an artwork. The debate hinged around the legitimacy of abstraction and the verdict in Brancusi's favour became a milestone in the expanding definition of art. **MG**

Constantin Brancusi
1876–1957

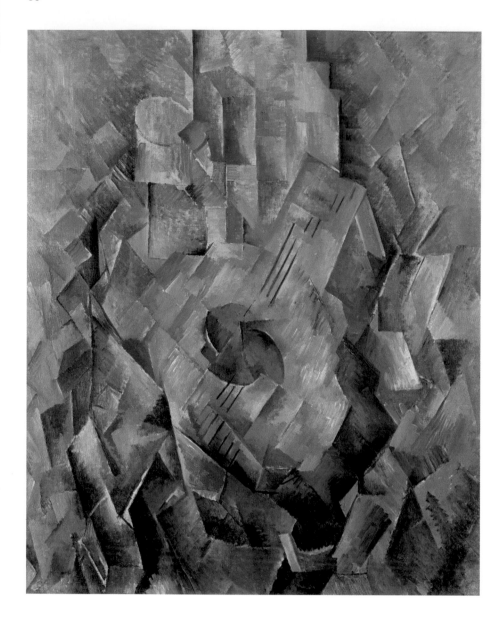

Georges Braque's early training as an artisan decorator instilled in him a sense of craftsmanship that he retained throughout his career as an artist. His skill with and concern for paint made him a master of the medium. Rarely executing preparatory studies, he preferred to explore his subjects spontaneously on the canvas.

Braque's early artistic career was dominated by his crucial involvement in the development of cubism. *Mandora* 1909–10 shows him at the height of his explorations with Pablo Picasso in expressing volumes in space. Braque frequently integrated images of musical instruments into his cubist still lifes, later commenting that 'a musical instrument as an object had the peculiarity that one could animate it by touching it'. The numerous fragmented planes seem to shift and shimmer across the canvas, suggesting the vibration of the strings of the lute-like mandora.

Even after cubism had dissolved as a movement, Braque continued to distort conventional ways of representing objects on a two-dimensional surface, focusing on interiors and still lifes. *The Billiard Table* 1945 is from one of his most important and monumental late series. Devoid of any sense of traditional perspective, the composition is dominated by the strangely angled billiard table, which forms a barrier across the canvas and prevents an easy reading of the interior. The space is further flattened by an arrangement of horizontal and vertical lines that seem to imitate the frame of the painting. This visual rhyme, coupled with the theme of the billiard table, may be a playful reference to painting as a 'game'. **LA**

Mandora
1909–10
Oil on canvas
71.1 x 55.9 cm
Purchased 1966

Georges Braque
1882–1963

Belgian artist Marcel Broodthaers began his creative life as a poet, a photographer and occasional avant-garde filmmaker. Around 1945 he met the surrealist artist René Magritte, who gave him a poem by Stéphane Mallarmé (1842–1898). This inspired a lifelong fascination with the French symbolist poet and his brand of abstraction, in which condensed imagery and cryptic allusions are intended to allow space for the viewer's imaginative interpretation. The art that Broodthaers created during his short twelve-year artistic career (1964–76) emulates Mallarmé's enigmatic style. Using a wide range of media, Broodthaers imitated and subverted the artistic movements of his time – nouveau réalisme, pop art, minimalism and conceptualism – while remaining rooted in traditional culture. He famously saw art as a way to create saleable commodities, which his poetry did not; his first artwork comprises volumes of his self-published poems embedded in plaster.

A central concern, inherited from Magritte, is the relationship between representation and reality. For Broodthaers this was expressed in the interplay between word and image or object. In 1973, the year he moved to London, Broodthaers created *Paintings*, one of a series of nine-canvas works comprising printed text. The words appear in varying configurations on the canvases, repeated at intervals in changing relationships to one another, forcing viewers to interpret meanings for themselves. Sixteen different words in red, yellow, blue and black refer to such elements of traditional painting as 'composition', 'perspective' and 'colour'. The elegant, old-fashioned cursive script evokes the high tradition of art, while the use of text and the spare, repetitive structure epitomise contemporary conceptual and minimal styles. **EM**

Paintings
1973
Oil on canvas
Each 80 x 100 cm
Purchased 1983

Marcel Broodthaers
1924–1976

Tania Bruguera lives and works between Chicago and Havana, and runs the first performance studies programme in Latin America themed around her notion of 'arte de conducta' (behaviour art).

Bruguera's work pivots around issues of power and control as she tests the claims of 'political art' against everyday reality. *Tatlin's Whisper #5* 2008 (Tate version) is one of a series tackling these themes. It involves two mounted policemen controlling the movement of the crowd within the space of the museum. Like much of Bruguera's work, this piece operates at the boundary between invention and reality, and she considers it important that the viewer does not necessarily know that the encounter is 'art' until they are already involved in the piece.

At the Centre Pompidou in Paris in 2009, Bruguera made *IP Detournement* ('IP' for Intellectual Property) in which she challenged ideas about copyright by selling dvd copies of all the film and video works in the museum's collection (with the agreement of the original artists) for one euro each. In the same year, a performance in Havana caused controversy when Bruguera invited people to say whatever they wanted into a microphone for one minute. After various attendees use the opportunity to appeal for freedom and democracy, the Cuban government denounced the project.

In 2011, under the auspices of a Creative Time commission, Bruguera set up a political party for immigrants in New York. As with all her projects, the involving nature of the work tests the limits of the role, ethics and efficacy of the artist in bringing about social as well as perceptual change. **CW**

Tatlin's Whisper #5
2008
Performance
Purchased with funds provided by Alin Ryan von Buch 2009

Tania Bruguera
born 1968

Alberto Burri was one of the pioneers of a new sensibility after the Second World War. Around 1948, while working in Rome, his highly wrought surfaces transformed the means and the impact of abstract art. He used discarded sacking and wood in place of canvas, mixing pumice, tar and other materials into his paint to lend it weight and texture. The sacks had been used for essential foods (floor, rice, sugar) imported under the US Marshall Plan aid scheme for European recovery and Burri often retained their stencilled lettering as part of his compositions. In this he anticipated the use of commercial signs found in the work of Robert Rauschenberg and others. During the mid 1950s, Burri also turned to destruction itself. Using a blowtorch, he licked the surface of wooden reliefs with fire, managing to contain the action of destruction with great immediacy. He took this further with the burning of plastic works in the early 1960s.

Burri's ruptured surfaces were readily understood as comments on the violence and isolation of the nuclear era. Early commentators drew attention to his wartime experience as a doctor serving with the Italian army. The association with the wounded body was powerful, and added to the controversy that surrounded his work. Exhibiting and working as much in America as in Europe, Burri was a dominant figure from the 1960s. There was no let-up in his activity, since his concern with materiality initiated a number of series with subtly pitted and cratered surfaces as well as monumental steel sculptures. Many of these explorations anticipated and inspired the arte povera generation. **MG**

Sacking and Red
1954
Acrylic and hessian
collage on canvas
86.4 x 100.3 cm
Purchased 1965

Alberto Burri
1915–1995

Cao Fei is one of the key figures in a vibrant generation of Chinese artists to have gained prominence in the early years of the twenty-first century. She has developed an extensive practice featuring photography, film, performance and digital and interactive media-based work.

She is arguably best known for *RMB City*, an ongoing project on Second Life, the three-dimensional virtual world on the internet where, in the guise of her alter ego, China Tracy, she has developed an interactive online art community.

Whose Utopia 2006 was filmed between October 2005 and April 2006 in the Osram lighting factory in Fosham near the artist's home in southern China. The video documents workers in the factory engaged in their everyday activities. The documentary sections are contrasted with dream-like episodes in which the workers act out what they would prefer to be doing: for example, ballet dancing, playing guitar or practising tai chi. The work is one of the first to document the new working conditions faced by the majority of the Chinese population. It provides a tender and poetic portrayal of individuality in the midst of a highly mechanised world. This can be considered to have particular resonance in the context of China where, traditionally, individual subjectivity has been subordinate to an identity defined by external socio-political forces. **RT**

Whose Utopia
2006
Video, colour, and audio track,
19 min 58 sec
Purchased with funds provided
by the Asia Pacific Acquisitions
Committee 2008

Cao Fei
born 1978

Janet Cardiff is best known for a number of works in which visitors are given headphones and a Walkman and invited to follow her directions on tours through the city, walking in time with her footsteps. Perceptions of experience and memory are questioned by the coincidences and discontinuities between the world described on the headphones and the reality of walking through the space.

40 Part Motet 2001 is a sound installation based on *Spem in Alium* by Thomas Tallis (c.1505–1585), a plain-song composition for a choir of forty voices. Unlike a conventional recording, which fuses the separate elements into a unified whole, the individual voice of each member of the choir is played back through a separate speaker. A significant section of the piece records the mundane chatter of the choir before the recital begins, and moving from speaker to speaker is like being in the stalls with the choir, eavesdropping on banal conversations that blend with the ambient sounds of visitors in the gallery. The presentation is minimal, simply a circle of forty speakers on stands. Even though this sparseness resists any visual interpretation, it still has a strong resonance with the codes of cinema. Each speaker functions like a close-up through which we discover the role played by individual members of the choir, revealing the alternating circuit of song and silence through which the full composition gains its texture. But when standing in the middle of the room, the voices blend and the recital functions like a panning shot, where viewers are given an immersive overview of the overall harmonies and composition. **BB**

40 Part Motet
2001
Mixed media
Lent by Pamela and Richard Kramlich and the American Fund for the Tate Gallery, fractional and promised gift 2003

Janet Cardiff
born 1957

Meticulously rendered images of the desert, lunar surfaces, water and the star-filled night sky recur in the work of the Latvian-born American artist Vija Celmins. The dedication to both her subject matter and the artistic techniques she employs is demonstrated by her consistent practice. Since the 1960s she has been creating black and white paintings, prints and drawings that painstakingly depict these close-up details of the natural environment. Her knowledge and use of traditional etching and woodcut techniques has secured for her a reputation as one of the best printmakers of her generation.

Celmins usually takes a photographic image as her starting point from which she isolates and reproduces a detail so that the work's subject matter becomes fragmented and abstracted. This approach can be seen in *Ocean Surface Woodcut 1992* 1992 where an image of the ocean's surface is intricately depicted. Every detail of movement, light and shadow on the water's surface is carefully recorded. Like many of her drawings and prints, *Ocean Surface Woodcut 1992* is positioned within a large expanse of white paper, which acts as a framing device, but also further separates the detail from its origin. This displacement allows Celmins to evoke a sense of invented space, a place of infinite possibility, but also of concentration. Each work by the artist is carefully planned and considered and the small details nearly always suggest a larger whole, albeit one that she never quite allows the viewer to see. Using the same subject matter Celmins continues to explore the endless possibilities in the ever-changing landscapes, constellations and the movement of light found in nature. **KM**

Ocean Surface Woodcut 1992
1992
Woodcut on paper
22.4 x 30.4 cm
ARTIST ROOMS Acquired jointly with the National Galleries of Scotland through The d'Offay Donation with assistance from the National Heritage Memorial Fund and the Art Fund 2008

Vija Celmins
born 1938

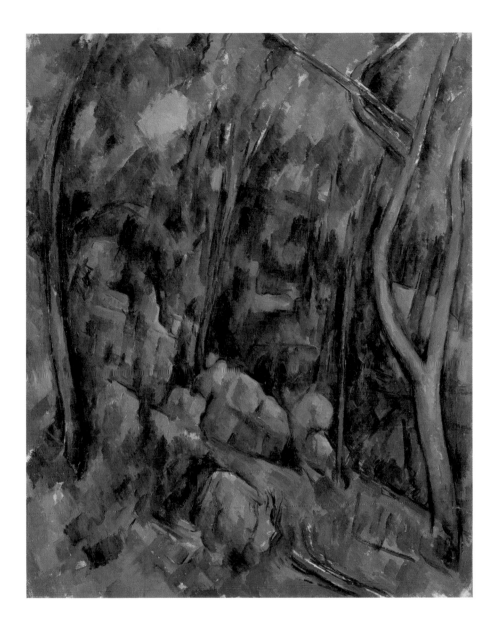

The Grounds of the Château Noir
c. 1900–6
Oil on canvas
90.7 x 71.4 cm
Lent by the National Gallery 1997

Sometimes called 'the father of modern art', Paul Cézanne moved away from the naturalistic painting of the nineteenth century and towards the attention to form that characterised much art of the twentieth century. Despite this, his abiding concern was with the accurate transcription of his experience of nature, a preoccupation he inherited from the impressionists. While Cézanne retained the high-keyed palette of these painters, in his endeavours to realise his 'sensations', he broke from many of the principles of traditional painting, such as gradated modelling and perspective. He replaced conventional perspective with a freer method of draughtsmanship that allowed him to synthesise 'multiple views' of his subject matter and he substituted traditional modelling of forms with a method of applying patches of colour over the entire surface of the canvas, resulting in a blocky, tapestry-like effect that prefigures some forms of cubism.

Cézanne also broke from the impressionists in his concern with design, composition and form. He advised a young painter, Emile Bernard, to look for the 'sphere, the cylinder and the cone' in nature and, while these do not literally appear in Cézanne's paintings, the remark underlines his concern with describing satisfying groupings of forms.

In *The Grounds of the Château Noir* c.1900–6, painted near his home in Aix-en-Provence, Cézanne's concern with both naturalism and design is apparent. He carefully renders the complex forms of the rocky, wooded hillside with a matrix of subtly modulated patches of colour. Framed on either side by the curving trunks of the two foreground trees, this nondescript subject takes on the almost classical sense of balance and airy repose typical of his late works. **MB**

Paul Cézanne
1839–1906

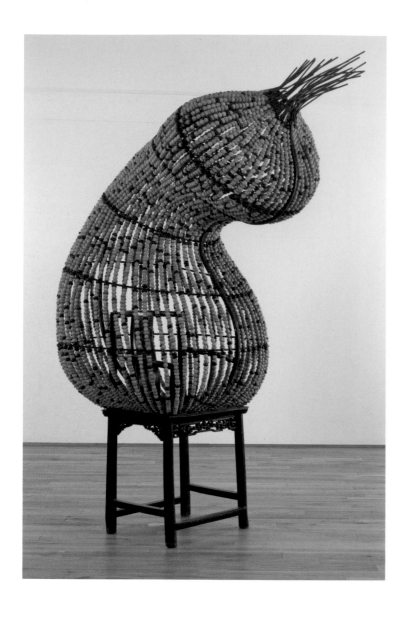

Chen Zhen lived and worked between Shanghai, New York and Paris and it was his intention in his work to integrate traditional Chinese culture with the culture of his adopted homes in the West. He described living between cultures, societies and languages as 'transexperience'. His approach to art-making was similarly inclusive; he referred to his work as an open architecture, assimilating influences from architecture, ecology, medicine, politics and philosophy. Throughout his life he retained a strong interest in healing and intended his work to have a therapeutic and meditative aspect. Chen suffered for more than twenty years from a serious blood disease that ultimately claimed his life; for him, healing was a very real part of his life as well as his art.

In his sculpture and installations Chen typically integrated everyday objects that had become redundant in a rapidly changing world, using, among other materials, old chairs, chamber pots and candles. In new and unexpected configurations the latent poetry of these materials becomes apparent. *Cocon de Vide* 2000 belongs to a series of related sculptures made between 1999 and 2000. This work features a biomorphic form resembling a large chrysalis resting on a chair. The form is made from Chinese abacus and Buddhist rosary beads threaded onto a metal frame. The hollow, drooping form invites anthropomorphic readings, evoking a figure bent in meditation or prayer. The work's title, which translates as 'empty cocoon', suggests a void and the potential for growth and transcendence from one state to another. **RT**

Cocon du Vide
2000
Wooden abacus beads, Buddhist rosary beads,
wooden chair, steel and paint
203 x 106 x 155 cm
Presented by Tate International Council 2009

Chen Zhen
1955–2000

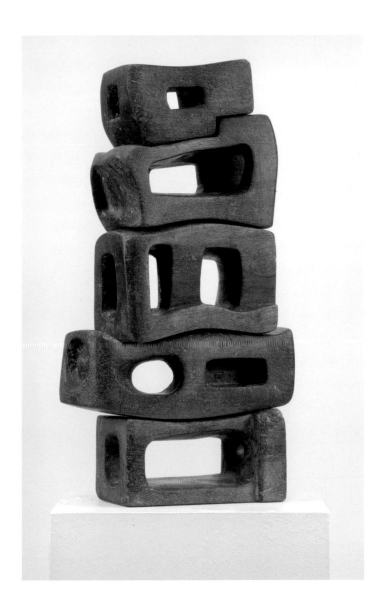

Saloua Raouda Choucair has long been one of the most significant figures in the history of modern Arab art. She began painting under the tutelage of leading Lebanese landscape artists Mustafa Farroukh and Omar Onsi, and studied at both the American University in Beirut and, from 1948 to 1951, at the Ecole des Beaux-Arts, Paris. There the influence of artists such as Fernand Léger marked the abstract nature of her work and she worked with Jean Dewasne and Edgard Pillet at the newly established Atelier de l'Art Abstrait. From the 1940s Choucair has been a lone female voice in the art scene of Beirut and distinguished from many other artists of her generation working there by her devotion to geometric abstraction. The depth of her facility is demonstrated through the wide range of materials that she has employed in her painting and sculptures.

Choucair's approach and understanding of western abstraction is enriched and complicated by her knowledge of Islamic aesthetics, as well as by the influence of mathematics and science. She used the two basic elements of Islamic design, the curve and the straight line, in such works as *Infinite Structure* 1963–5, a tower of blocks into which she cut rectangular and circular forms. These interlocking forms are characteristic of her sculptures of the 1960s onwards, which often created an interplay of solid and void. The work is also, in part, a homage to Constantin Brancusi's *Endless Column*. In *Poem Wall* 1963–5 and *Poem* 1963–5, of the same period, the interrelated forms refer to the structures of Islamic and Sufi poetry which are characterised by the use of stanzas which can stand alone beyond the context of the poem as a whole. In much the same way, Choucair considered each of her blocks to have its own unique qualities. **KM**

Poem
1963–5
Wood
33 x 17 x 7.5 cm
Presented anonymously 2011

Saloua Raouda Choucair
born 1916

Michael Craig-Martin
(born 1941)
An Oak Tree
1973
Glass, water, shelf
and printed text
Lent from a private collection
2000

Conceptual Art

The American art critic Lucy Lippard once commented that there are as many definitions of conceptual art as there are conceptual artists. Since the late 1960s, when the term was first coined, there has been a general consensus that conceptual art is concerned primarily with ideas and meanings, and considers the form or representation of those ideas to be of secondary importance. The purpose of this kind of artistic practice is to raise questions in the mind of the viewer, usually in order to draw attention to a particular political, social, cultural or philosophical issue or context. Conceptual art has been produced by numerous artists across the globe, in an extremely wide variety of media (painting, installation, video, photography, found objects, maps, text, etc.) over the past four decades.

While there is some debate about the true origins of conceptual art, the artist Marcel Duchamp is repeatedly held up by critics, academics and artists as a major influence because of his seminal use of the 'readymade' – an everyday object that is given the status of an artwork through its selection by an artist and placement in a museum, gallery or other art-related context. Although conceptual art is rooted in an attempt to question and deny accepted categories and conventions, there have been attempts to describe and name its various trends. Lucy Lippard's book *Six Years: The Dematerialization of the Art Object from 1966 to 1972* gathers together documents and texts exploring the artistic practice of a number of artists from this key period. The works created during Lippard's 'six years' are concurrent with the counter-cultural movements of the late 1960s and were often motivated by a desire to side-step the art market, which relied on the 'object' status of artworks for saleability. They fall roughly into the categories of performance (or action) art, process art, land art, text-based art (words), documentation, intervention and/or readymade.

The American artists Joseph Kosuth, Lawrence Weiner, Sol LeWitt, the transatlantic collective Art & Language and a number of British artists such as Michael Craig-Martin, John Latham and Keith Arnatt all played a major role in the creation and definition of conceptual art in the late 1960s and early 1970s. Although conceptual art has since become a broad tendency and a global phenomenon, their influence is clearly apparent in the work of a younger generation of artists from Britain who emerged in the late 1990s, such as Martin Creed and Ceal Floyer.

Joseph Kosuth's *Clock (One and Five), English /Latin Version* 1965, is an example of a conceptual artwork that employs readymade, text-based and documentary elements. A real wall-clock is displayed alongside a life-sized photograph of it and a set of enlarged dictionary definitions for the words 'time', 'machination' and 'object'. The artwork is not merely the sum of the physical objects on the wall. Kosuth is clearly asking us to think about the nature of representation and linguistic definition: 'how do we represent, for example, a clock?' (and therefore, 'what is the nature of all representation?'). Like many conceptual artworks, Kosuth's *Clock* was one of a series and was issued with a set of instructions. Often, the more information one has about the other works in the series and the artists' intentions or written instructions, the clearer the 'concept' becomes. **AC**

Joseph Kosuth (born 1945)
*Clock (One and Five),
English/Latin Version*
1965
Clock, photograph
and printed texts
61 x 290.2 cm
Purchased 1974

Coming to London as a Hungarian refugee from the war, Magda Cordell became closely involved with the Institute of Contemporary Arts in the mid 1950s. The ICA staged exhibitions and debates that generated new artistic ideas, especially those associated with the legacy of dada and surrealism as they converged with popular culture. Such writers as Reyner Banham and Lawrence Alloway, as well as the artists Richard Hamilton, Nigel Henderson, John McHale and Eduardo Paolozzi formed the Independent Group (p.130). Cordell and her first husband, the musical producer Frank Cordell, were part of these networks, each creating individually while collaborating with McHale (who became her second husband) on promotional films for commercial purposes as well as for friends such as their Independent Group colleagues the architects Alison and Peter Smithson.

As distinct from the glossy attractions of American advertising, Cordell's paintings shared with the work of Jean Dubuffet, Alberto Giacometti and others what Banham dubbed a 'new brutalism' in response to the figure. When Cordell held a solo show at the Hanover Gallery in January 1956 the energetic handling of her canvases also elicited comparisons to abstract expressionist works then being seen for the first time in London in the contemporaneous exhibition *Modern Art in the United States* at the Tate Gallery. *Figure (Woman)* 1956–7 dates from this crucial period and exemplifies Cordell's exploration of the body through a combination of material complexity and a physical penetration that is akin to flaying. With its reduction of extraneous limbs, the huge figure – more than two metres high – appears opened up for investigation. This monumentalising is assertive but, more covertly, may comment on the exploitation of the female body. **MG**

Figure (Woman)
1956–7
Oil on board
231.2 x 152.2 cm
Presented by the artist 1996

Magda Cordell
1921–2008

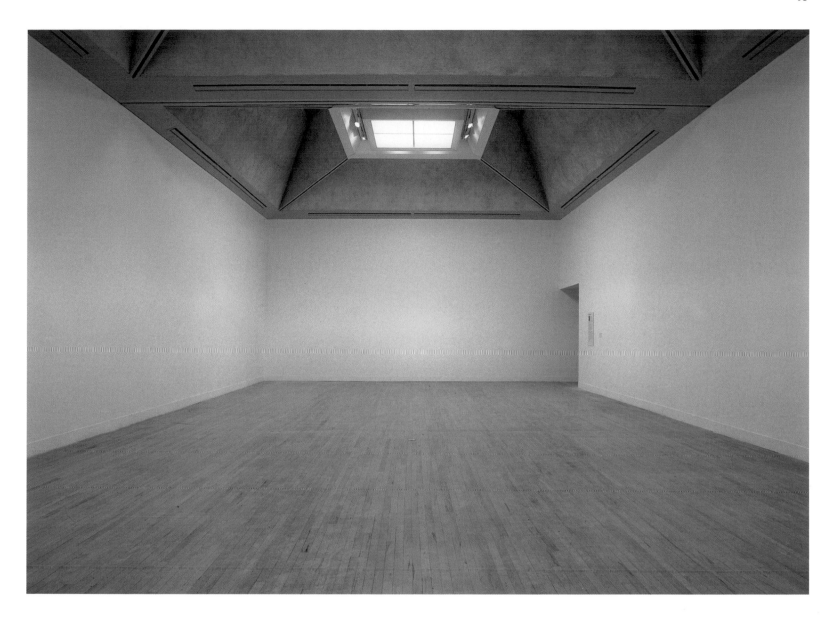

Since 1987, all of Martin Creed's works have been given simple, descriptive titles preceded by a sequential number. This system, which seems straightforward at first, is destabilised by the fact that Creed does not number his works logically. For example, there is no 'Work No. 1'. An important clue to Creed's artistic ideology can be found in Work No. 232, which consists of the statement: the whole world + the work = the whole world. In mathematical terms, this equation gives 'the work' a value of zero, so it can be interpreted as an assertion that all creative endeavour is futile. A more optimistic reading is that any work, no matter how small, can affect and somehow reform the world. For Creed 'nothing' is just as important as 'something', but the meaning of this work can shift with the perception of each viewer. The phrase was conceived by Creed in 1996 whilst he was considering his own artistic practice, and was originally installed in white neon on the facade of a former orphanage, and later on Tate's Millbank building.

Creed's work is informed by minimalism and conceptual art, and is often created from everyday elements such as masking tape, Elastoplast, Blu-tack, A4 paper, and even the simple act of switching on and off a light. His subtle interventions aim to maintain the equilibrium of their environments, yet ask fundamental questions about the nature of art, challenging the viewer to re-evaluate the works and the spaces they inhabit.

In 2001 Creed won the Turner Prize. **CM**

Work No. 227: the lights going on and off
2000
Materials and dimensions variable
Installation view, *Turner Prize*, Tate Britain, 2001

Martin Creed
born 1968

Cubism

It was Henri Matisse who is reputed to have described Georges Braque's 1909 paintings as made of 'little cubes'. Initially intended as an insult, the term stuck since it described the fragmented images as well as alluding to their structural element. This was, however, a simplification that did not encompass the perceptual and conceptual aspects of cubist practice. The structures of the paintings, initially inspired by the example of Paul Cézanne, aimed at conveying the complex nature of experience while acknowledging the flat canvas. New scientific theories and technological advances that penetrated the fixed surface of matter (such as X-rays and radio waves), suddenly made the Renaissance convention of perspective inadequate for capturing knowledge of modern life: the fact, for instance, that a bottle is both cylindrical and transparent with a rectangular printed label. This enquiry was also fuelled by the notion of flux, the multi-layered 'simultaneity of experience' proposed by the influential philosopher Henri Bergson.

In a famous collaboration over the five years 1909–14, Braque and Pablo Picasso developed a detailed visual analysis of reality. In their studios in Montmartre, dressed in workmen's overalls (an expression of political identification with manual workers), the two painters began by unravelling the familiar world about them: still lifes and figures dominate cubist painting. Cézanne's example influenced the limited colour and build-up of small brushstrokes, while African art (the focus of their earlier primitivist interest) encouraged the simplification of forms as planes or facets. The sophistication of their work reached its apex in 1911–12, when Braque introduced patterned or printed papers into his compositions and Picasso began to construct sculptures. Collage and assemblage – both hugely influential inventions – allowed the direct presence of everyday materials such as newspapers within the composition.

The influence of these works by Picasso and Braque, and later those of Juan Gris, became pervasive in Paris from 1911, although they only showed their work in the gallery of their dealer Daniel-Henri Kahnweiler. Jean Metzinger and Albert Gleizes headed the group of painters who exhibited their cubist works at the avant-garde Salons and published *Du Cubisme* to explain the movement's theoretical underpinning. This did little to counter the derision that cubism attracted from the press and public. Nevertheless, in 1912–14, its impact grew internationally, especially with artists whose work emphasised an urban dynamism, from the Italian futurists and British vorticists, to the Prague cubists and Russian constructivists. The First World War (1914–18) brought a new phase to cubism, often called 'synthetic', as Picasso and Gris began to assemble their images from fragments of reality. Other recruits included Jacques Lipchitz, who conceived near-abstract sculptures. Cubism's legacy can also be found in the work of painters such as Piet Mondrian.

The impact of cubism on subsequent art, even that not obviously associated with it, cannot be exaggerated. For some, cubism was the impetus to abstraction, for others it became one of several means for capturing the experience of the modern world. Later in the century, cubism was understood to have reinforced the formal, painterly qualities of abstract expressionism, and its quotation of urban images was echoed in pop art. Beyond these particular positions cubism epitomised the idea of avant-garde experimentation: challenging, controversial and revolutionary. **MG**

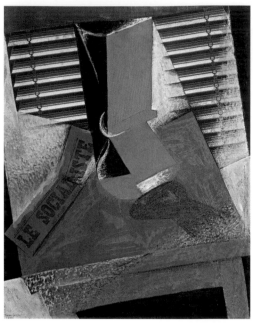

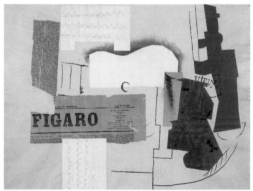

Above:
Juan Gris (1887–1927)
The Sunblind
1914
Gouache, collage, chalk
and charcoal on canvas
92.1 x 72.7 cm
Purchased 1946

Pablo Picasso (1881–1973)
*Bottle of Vieux Marc, Glass,
Guitar and Newspaper*
1913
Collage and pen and ink
on blue paper
46.7 x 62.5 cm
Purchased 1961

Below left:
Georges Braque (1882–1963)
*Clarinet and Bottle of Rum
on a Mantelpiece*
1911
Oil on canvas
81 x 60 cm
Purchased with assistance
from a special government
grant and with assistance
from the Art Fund 1978

Below right:
Pablo Picasso (1881–1973)
Seated Nude
1909–10
Oil on canvas
92.1 x 73 cm
Purchased 1949

Collage

In the early twentieth century, artists began pasting pieces of paper, fabric and even wallpaper to their works, challenging traditional methods of picture-making. Introducing ephemeral material in this way helped to develop the idea of an artwork as an independent object. The term 'collage' comes from the French word *coller* (to glue) and the method was first employed by the cubist artists Pablo Picasso and Georges Braque, who introduced real items such as newspaper clippings into their *papier collé* (pasted-paper) works. Collage was also employed by dada artists such as Kurt Schwitters, who coined the nonsense word *Merz* to describe his compositions made up of scavenged scrap items such as bus and theatre tickets. The possibilities of random arrangements of assorted images offered by collage particularly appealed to surrealist artists, who transformed this idea into painted works to create unlikely associations within a single image. **LA**

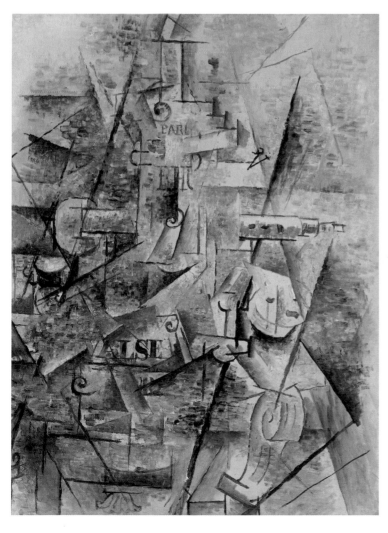

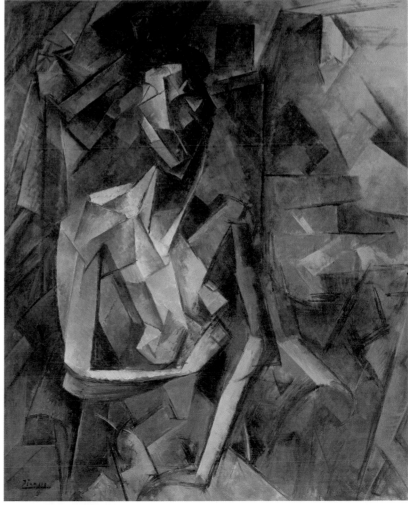

Dada

'I am writing a manifesto and there is nothing I want', claimed the poet Tristan Tzara in his *Dada Manifesto 1918*; 'and yet', he added, 'in principle I am against manifestos, as I am against principles'. Dada – Tzara reportedly chose the name by inserting a knife into a dictionary – was less an artistic style than an act of defiance. It was witty and disruptive, generated by a disgust with the certainties that had resulted in the First World War (1914–18). Dada emerged at the Cabaret Voltaire in Zurich in 1916. There, and in the neutral havens of Barcelona and New York, artists and intellectuals attacked the status quo through their performances, exhibitions and publications. Their strategies owed much to futurism but echoed the political radicalism of the 1917 Bolshevik Revolution. In place of technological progress and military might, dada was satirical, subversive and anarchic. In place of wartime nationalism, it was resolutely international. The range of participants in Zurich alone confirms this: Tzara and Marcel Janco from Romania, the poets Hugo Ball, Emmy Hennings, Richard Huelsenbeck and the painter Hans Richter from Germany, as well as the painters Jean Arp (from disputed Alsace) and Sophie Taeuber, who was Swiss.

Dada works were united in their subversion. Simultaneous poetry and collage, photomontage and object-making undermined high art. In Zurich, Arp adopted chance as a compositional method (gluing down torn paper where it fell), and Ball's sound poems abandoned words – which he considered corrupted by propaganda – for incantations of sounds. Though the circumstances were quite different, parallel activities flourished in New York, among a group of exiles from Paris and their American friends. There, Marcel Duchamp conceived his 'readymades', manufactured objects identified as art by the artist. He exhibited the most provocative of these, *Fountain* (an inscribed and upturned urinal) in 1917 (p.105). Man Ray made witty photographs and objects inspired by this example, and Francis Picabia – also the driving force in Barcelona – produced the subversive periodical *391* alongside his mechnomorphic paintings.

With peace, dada exploded in the turmoil of postwar Germany and France. Max Ernst and Kurt Schwitters (who formed his own movement, Merz) found beauty in the fragmentary world of collage and recuperated debris. A group formed around Huelsenbeck in Berlin and allied itself with the revolutionary politics by attacking, in the work of George Grosz and Raoul Hausmann especially, the complacency of the new Weimar Republic. On their arrival in Paris, Picabia and Tzara provided the focus for the convergence of these many strands, along with younger poets, including André Breton and Paul Eluard, who passed into surrealism.

Essentially indefinable, dada was a violent counterblast against conformity. Such incandescence could not be sustained and, in the mid 1920s, it lost its urgency. Nevertheless, its example reverberated through surrealism to the art of the 1960s and 1990s. Duchamp's dada provocations and ironic humour remain highly influential, while Picabia's bewilderingly contradictory styles of abstraction and kitsch anticipate postmodernism. 'Dada places doubt', he wrote, 'before action, and above all everything else.' **MG**

Kurt Schwitters (1887–1948)
Picture of Spatial Growths –
Picture with Two Small Dogs
1920–39
Mixed media collage on board
97 x 69 cm
Purchased 1984

Right:
Marcel Duchamp (1887–1968)
Why Not Sneeze Rose Sélavy?
1921, editioned replica 1964
Mixed media
11.4 x 22 x 16 cm
Purchased 1999

Below left:
Max Ernst (1891–1976)
Dadaville
c.1924
Painted plaster and cork
laid on canvas
68 x 56 x 6.3 cm
Purchased 1983

Below right:
Man Ray (1890–1976)
New York
1920, editioned replica 1973
Glass, steel, cork and linen tape
25.9 x 6.5 x 6.5 cm
Presented by Lucien Treillard
2002

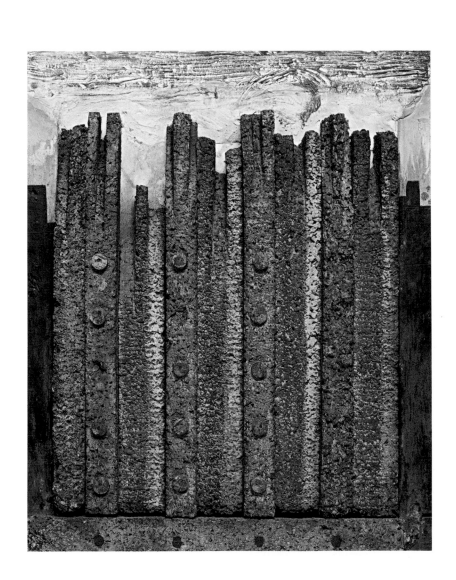

98

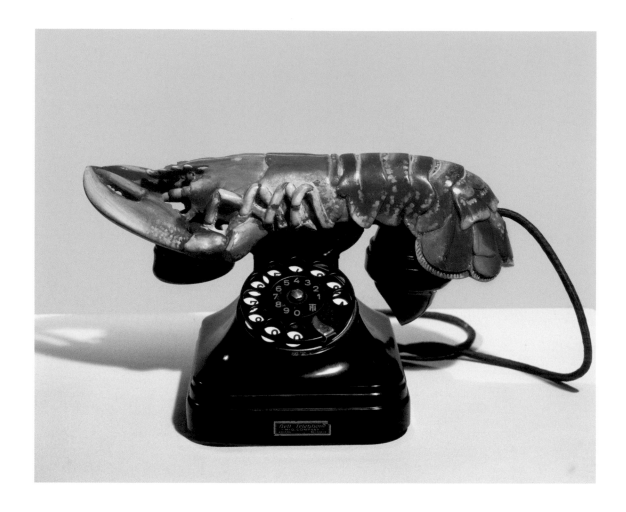

Surrealist Objects
The underlying force of surrealist objects derived from an idea of the expressive potential of the unrelated. The nineteenth-century poet Isidore Ducasse (writing as the Comte de Lautréamont) had laid down an example that became talismanic: 'the chance encounter of a sewing machine and an umbrella on an operating table'. The surrealists seized upon the spark of irrational originality in such juxtapositions, liberated from prosaic cause and effect. They found impetus in Marcel Duchamp's 'readymades', the objects of Man Ray (who made *The Enigma of Isidore Ducasse* 1920) and the realism of René Magritte's paintings. However, it was Dalí's enthusiasm for Alberto Giacometti's dream-like sculptures that generated the object-production of the 1930s. At first this resulted in complex agglomerations, but the more powerful works had the potential to infiltrate everyday life: the *Lobster Telephone* 1936 could, conceivably, ring. Like collage, object-making stimulated a rich legacy, from rough scrap materials brought together in the 1950s and 1960s by pop and nouveau réaliste artists to the provocative juxtapositions of artists such as Sarah Lucas and Damien Hirst. **MG**

The Catalan painter Salvador Dalí was one of the most controversial and popular artists of the twentieth century. From an early position of achievement – genius, as he would see it – he fashioned for himself a style of remarkable clarity through which his fantasies were depicted with convincing realism. He treated his own biography as the raw material for revelatory sexual and filial obsessions. These fed the works of the late 1920s that secured his entry into surrealism.

It was through *Un Chien andalou*, the film that he made with Luis Buñuel in 1929 (p.234), that Dalí burst upon surrealism in Paris. His combination of hallucinogenic imagery and Freudian confession reinvigorated the movement at a moment of crisis. The surrealists' leader, André Breton, allotted him a central role. Dalí renewed

the potential of illusionistic painting (together with René Magritte and Yves Tanguy) and introduced surrealist objects. He based his complex 'paranoiac-critical method' on the parallel realities experienced in paranoia, making layered images in which forms could be understood in multiple ways. His masterly skill is epitomised in the illusionism of *The Metamorphosis of Narcissus* 1937.

Dalí's self-promotion and commercialism irked the surrealists, especially at the time of their engagement with Communism in the 1930s. Although he produced extraordinary images of the Spanish Civil War in such works as *Autumnal Cannibalism* 1936, his fascination with Lenin and Hitler provoked his expulsion from the movement. He was too closely identified with surrealism to be jettisoned immediately. Collaborations on Hollywood movies in the 1940s and later explorations of optical illusions secured Dalí's independence. At the same time he cultivated his celebrity. In the end showmanship obscured his considerable achievements, even if he maintained an extraordinary level of popularity. **MG**

Lobster Telephone
1936
Plastic, painted plaster and mixed media
17.8 x 33 x 17.8 cm
Purchased 1981

Salvador Dalí
1904–1989

The Roaring Forties:
Seven Boards in Seven Days
1997
Chalk on blackboard
Each 243.8 x 243.8 cm
Presented by the Patrons
of New Art through the Tate
Gallery Foundation 2000

Tacita Dean has used film, photography and drawing to explore the boundaries between fact and fiction, perception and reality. Also fascinated by humankind's desire to conquer the elements, Dean turns a forensic eye onto the atrophied remains of failed visions, such as a utopian house lying derelict and abandoned to the weather, or Robert Smithson's *Spiral Jetty* 1970, a seminal work of Land art now immersed in the surrounding lake.

In *The Roaring Forties: Seven Boards in Seven Days* 1997, Dean constructs an epic narrative of sailors battling the elements in an area of the Atlantic known for strong gales. The unfolding of events is illustrated in the manner of a cinematic storyboard, using chalk on blackboards. The boards are inscribed with wind directions and camera angles, which prevent the viewer from becoming too immersed in the narrative. Areas of the chalk are smudged, hinting at the endless possibilities for reworking the story.

Dean's film *Disappearance at Sea* 1996 was inspired by the true story of Donald Crowhurst, who took part in the first single-handed yacht race around the world in 1969. Ill-prepared for the voyage, Crowhurst never even made it out of the Atlantic but, unable to admit to failure, he continued to send radio messages charting his now imaginary progress around the world. His boat was eventually found abandoned. Dean makes no direct attempt to depict the events, but instead evokes a sense of dislocation and of time running out by cutting between views of the lenses of a lighthouse and the sun setting across the sea. As the sky darkens, the beam of the lighthouse is seen swooping across the sea, a last glimmer of hope before the screen falls dark. Dean's use of 16mm film is significant. The whirring and the beam of light from the projector echo that of the lighthouse to further enhance the mood. In 2011 Dean's *Film* installation in the Turbine Hall was a polemic and lament for the medium. **HS**

Tacita Dean
born 1965

The Melancholy of Departure
1916
Oil on canvas
51.8 x 35.9 cm
Purchased 1978

Metaphysical Painting

Metaphysical painting was short-lived but highly influential. Following the ideas of Nietzsche, de Chirico used the term 'metaphysical' in order to suggest a deeper reality beyond the surface of things in his Parisian paintings of 1913–14. In wartime Ferrara he met Carlo Carrà, one of the founders of futurism, who was seeking a way back to a reconstructive art based in tradition. It was this view, in tune with a postwar 'return to order' (a return, that is, from avant-garde destructiveness), that prevailed in the Roman periodical *Valori Plastici* (1918–21), dominated by Carrà's art and writing. The publication was also notable for introducing the paintings of Giorgio Morandi. Theoretical differences ensured the swift disintegration of the group, but not before their style had been widely disseminated. Artists in Italy and Germany (such as Mario Sironi and George Grosz) were the first to demonstrate its impact, but it was most profound in the art of the surrealists Max Ernst, René Magritte and Salvador Dalí. **MG**

For much of his career, Giorgio de Chirico's style was slightly out of joint with contemporary taste. He established his reputation in Paris in 1911–15 with paintings showing unexpected objects in mysterious spaces infused with a melancholic atmosphere of loss. Under the influence of the philosopher Friedrich Nietzsche, he called this art 'metaphysical'. *The Uncertainty of the Poet* 1913 captures the eerie sense of potential in the depiction of a classical sculpture and a bunch of bananas set in a slightly disjointed Mediterranean square. During the First World War the painter and his musician-writer brother Alberto Savinio were posted for military service in Ferrara. There de Chirico was only able to paint at night, circumstances that may explain the intensity of *The Melancholy of Departure* 1916. He had long made parallels between the journeys in classical myths and his own displacement from the Greece of his childhood, but here travel takes on a further poignancy under the restrictions of war. Nevertheless, the brothers formed a circle that would bring the disconcerting metaphysical painting to wider notice within the context of a postwar return to realism.

De Chirico's early work was acclaimed by the surrealists, but they rejected his new work of the 1920s. His search for deeper ties to the classical tradition, culminating in his 1940s pastiches of Rubens, set him outside the modernist mainstream. His early work continued to be admired for its disquieting atmosphere but it was only with the diversity of postmodernism that his later career received serious consideration. **MG**

Giorgio de Chirico
1888–1978

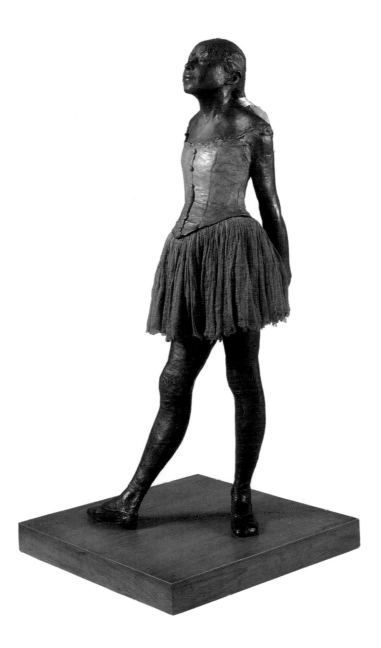

Edgar Degas is best known as an impressionist painter, concerned with truthfully capturing the fleeting moments of everyday modern life. However, he was less interested in the effects of light and colour in landscape that mark out the work of the other leading members of the group, such as Claude Monet, Camille Pissarro and Pierre-Auguste Renoir. Degas's great preoccupation was with form, an interest apparent not only in his paintings but also in a substantial body of drawings and sculptures. His favoured subject matter was the human figure, at rest and in motion,

and he found the ideal subject for this interest in the ballet dancers at the Paris Opéra.

His paintings of dancers, often shown rehearsing or resting, have an almost photographic spontaneity and informality. As with most of his work, the sense of spontaneity was contrived, the result of many preparatory studies. This seeming naturalness is also apparent in Degas's sculptures of dancers which perhaps convey, even better than the paintings, the forcefulness and control of the dancers' movements and the tension and fatigue evident on their bodies at rest. Despite their quality, Degas showed only one of his sculptures during his lifetime, *Little Dancer Aged Fourteen* 1880–1, a sympathetic portrayal of the self-control, discomfort and strain of the ballerina-in-training. The naturalism of the sculpture is increased by means of a real gauze tutu and a silk ribbon 'tying' the bronze hair. These features echo Degas's original wax model, which was fully clothed in fabric bodice, tutu and slippers, wore a horsehair wig, and had lifelike colour applied to the skin. **MB**

Edgar Degas
1834–1917

Orphism
Named after the mythical lyre player Orpheus, the term orphism was coined by Guillaume Apollinaire in 1912 to refer to a group of Parisian painters in whose work he saw a movement towards what he called 'pure painting'. These included Robert Delaunay, Fernand Léger and Francis Picabia. For Apollinaire, music's non-representational quality made it a model of a 'pure' art form; he wanted painting to abandon representation and express itself through form and colour alone. While the artists Apollinaire identified were making influential advances towards abstraction at the time, few shared his particular enthusiasm for pure painting, and some members of the group, such as Picabia and Marcel Duchamp, soon went on to pursue very different interests. **MB**

Robert Delaunay was one of the earliest artists to experiment with abstraction, using cubism as a departure point to move towards a highly abstract, colour-based mode of painting. He was particularly interested in experiments with pigment, and from around 1912 he sought to use colour as a pure means of expression, entirely freeing it from its traditional representational function. It was at this time that Delaunay was named by Apollinaire as a key member of the orphists, a diverse group of painters whose work was developing towards pure abstraction. From this time onwards, Delaunay typically constructed his compositions using pairs of complementary hues – yellow and violet, green and red, and orange and blue – which when juxtaposed intensify one another, a phenomenon known as 'simultaneous contrast'. Delaunay believed simultaneous contrast could be used to generate a range of effects in painting, including transparency, movement and harmony, and ultimately to convey a sense of personal and universal reality.

Windows Open Simultaneously (First Part, Third Motif) 1912 is a product of these concerns. Here, the Eiffel Tower, one of Delaunay's favourite motifs, is visible as a green wedge at the centre of the painting. Surrounded by buildings and framed by the suggestion of flowing curtains, the tower is melded into a near-abstract pattern of complementary coloured forms and planes, creating a shimmering, jewel-like effect. These ideas also gave rise to his most abstract works, based on a disc motif of concentric circles, which he began in 1913. **MB**

*Windows Open Simultaneously
(First Part, Third Motif)*
1912
Oil on canvas
45.7 x 37.5 cm
Purchased 1967

Robert Delaunay
1885–1941

Prose on the Trans-Siberian Railway and of Little Jehanne of France
1913
Watercolour and relief print on paper
195.6 x 35.6 cm
Purchased 1980

Russian-born Sonia Terk married the French artist Robert Delaunay in 1910. Around this time she abandoned her fauvist style of painting and turned instead to the design and making of textiles. Two years later, the Delaunays developed a manner of painting that they termed 'simultaneous', derived from the notion of simultaneous perception. Unlike the cubists, with whom Robert was associated, they focused on the colours that came from light, studying the illumination of Paris provided by new electric street lights. While cubist paintings depicted multiple viewpoints of objects and urban landscapes, with a mixture of figurative representation and abstraction, the Delaunays' 'simultaneous paintings' of 1912 devolved into colourful grids of pure abstraction.

A collaboration between Blaise Cendrars and Sonia Delaunay, *Prose on the Trans-Siberian Railway and of Little Jehanne of France* 1913 was hailed as the first 'simultaneous book', conceived to be viewed as imagery and read at the same time. On one side of the two metre-long page, the lines of Cendrars's unpunctuated poem are printed in varying colours and typefaces. Sonia Delaunay supplied a visual complement to the fluctuating rhythm of an interminable train journey recounted in the poem with blocks and streaks of vivid colour. At the base of the page, next to the finishing lines of the poem, she depicted a red Eiffel tower, illustrating the eventual termination of the journey in Paris.

Sonia Delaunay and Cendrars continued to collaborate for several years. Delaunay made further artistic innovations by applying her avant-garde painting ideas to designing posters for artists and commercial products, book covers and textiles as well as creating 'simultaneous outfits' and textiles for interior design. **EM**

Sonia Delaunay
1885–1979

The Tree of Fluids
1950
Oil on canvas
116.1 x 89 cm
Accepted by HM Government
in lieu of tax and allocated to
the Tate Gallery 1996

Jean Dubuffet spent a lifetime warring against the mainstream, and his importance as an artist, a writer and a collector has been felt both within and beyond the avant-garde. He coined the term 'art brut' for art produced by non-professionals working outside cultural norms, such as works by mental patients, prisoners and children, and amassed an important collection of such art. 'Normal means lack of imagination, lack of creativity', Dubuffet argued. 'I, personally, have a very high regard for the values of primitive peoples: instinct, passion, caprice, violence, madness.'

His own artistic output was extensive and varied. The earlier works are generally figurative, although as in *The Tree of Fluids* 1950, his concern is more with the use of texture and gesture to explore bodily fluids than with the employment of line and form to give conventional form to the figure. His work became increasingly abstract in the 1950s as he invested more and more interest in the elaboration of textures. He would often mix materials such as sand, tar and straw into his oil paint. *The Exemplary Life of the Soil (Texturology LXIII)* 1958 is one of a number of works in which he used unconventional methods to portray the textures of soil. For this work, he adapted a technique used by stonemasons to texture newly plastered walls that involved shaking a brush over the painting to scatter tiny droplets of paint across the surface. He was also an accomplished printmaker and, towards the end of the 1960s, he began to concentrate increasingly on sculptural and environmental projects. **SH**

Jean Dubuffet
1901–1985

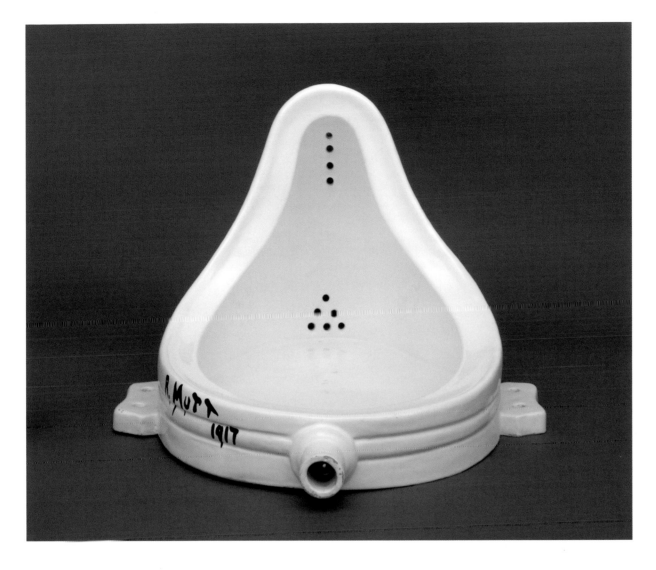

Fountain
1917, replica 1964
Porcelain
36 x 48 x 61 cm
Purchased with assistance
from the Friends of the
Tate Gallery 1999

Readymade

In 1917, when Duchamp submitted an ordinary urinal to an exhibition held by the New York Society of Independent Artists, titling it *Fountain* and signing it R. Mutt, he irrevocably changed the course of modern art. Three and a half decades later he remarked that 'readymades' such as this one allowed him to 'reduce the idea of aesthetic consideration to the choice of the mind, not the ability or cleverness of the hand'.

The first pure readymade – that is, an everyday object bearing no trace of modification other than the artist's signature or similar inscription – was a bottle rack that Duchamp had purchased in a Paris department store in 1914. He coined the term to describe this revolutionary strategy two years later. Other readymades include a comb, a snow shovel, a hat rack and a bicycle wheel mounted on top of a wooden stool. Duchamp claimed that he selected these objects on the basis of pure visual indifference. Putting the emphasis on idea and intellect rather than on craft and self-expression, Duchamp's readymades became an important influence on twentieth-century art, especially the art of the later 1960s and 1970s including pop art, minimalism and conceptual art. Duchamp's assertion that what is art is defined by the artist continues to reverberate through much artistic practice until the present day. **ABH**

Marcel Duchamp
1887–1968

Marcel Duchamp's lasting and influential contribution to twentieth-century and contemporary art was to have shifted the focus of artistic practice from the strictly visual to the realm of ideas, engaging the intellect and imagination of the viewer as much as the eyes. Employing a wide range of media including painting, photography and sculpture, his radical and iconoclastic work probes the boundaries of art, its theoretical definitions as much as the institutional framework in which it operates. Especially with his 'readymades', everyday objects he declared to be works of art, Duchamp challenged preconceived categories of taste, beauty and functionality.

Originally trained as an academic painter Duchamp largely abandoned easel painting after 1915 to concentrate on his seminal work *The Bride Stripped Bare by Her Bachelors, Even* 1915–23, a large-scale composition executed in oil and lead on glass, also known as *The Large Glass*. A version of this complex piece was recreated by British artist Richard Hamilton for Tate's major Duchamp retrospective in 1966 (p.28). The subject of much debate, the free-standing, transparent glass construction is divided into two equal parts: the upper 'female' section of the title's 'bride', and the lower 'male' section of her suitors. The characters are represented as stylised machines whose endlessly repetitive grinding alludes to the frustration of unfulfilled desire. The two sections are destined never to come together, further heightening the sense of disappointment.

From the early 1920s onwards, after an intense creative flurry, Duchamp appeared content to let others further elaborate the ideas implicit in his work and spent most of his time playing chess. Only after his death was it discovered that for the past twenty years he had been working on another major work, the installation *Etant donnés*. **ABH**

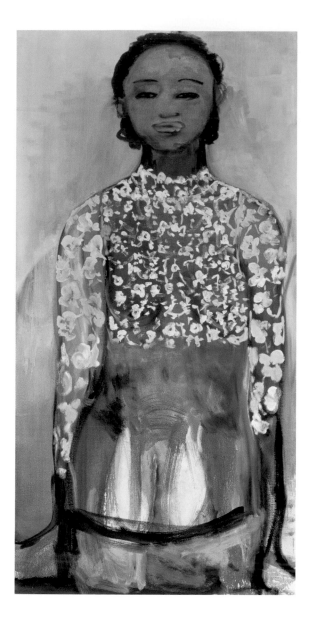

Marlene Dumas is one of the key figures responsible for the revival of painting in the 1990s. Her figurative works rely on imagery drawn from a wealth of sources: newspapers and magazines, as well as art-historical models. While it has been said that she follows in the expressionist tradition of Francis Bacon or Edvard Munch, her ironic and deconstructive approach to painting and image-making could also be termed neo-conceptual. Born in South Africa in 1953, she moved to Holland in the mid 1970s.

Dumas's work reveals a highly intelligent awareness of her own cultural, political and social surroundings: race, sexuality, and her role as a female painter within a male-dominated field are all playfully alluded to in the work. Her portraits of young girls and boys, and her images of naked women, often possess a mysterious symbolic power. Perhaps her greatest achievement is the sensual quality of her technique deployed in paintings and drawings that render the human condition with extraordinary tenderness and intimacy. In a sense she has created a sublimated erotics of painting, not merely by using pornography as source material, but by exploring the sensual nature of her chosen medium: thickly applied paint to suggest flesh, or the mordant delicacy of watercolours to evoke fragility and mortality.

Death has been a regular theme in Dumas's work, and recently she has made numerous paintings based on found images of corpses. *Stern* 2004 is a death portrait of Ulrike Meinhof, the German Red Army Faction terrorist who was found dead in her prison cell in 1976. *Lucy* 2004 is based on Caravaggio's painting of 1608 portraying the martyred saint who was tortured, blinded, burned at the stake and finally stabbed. The open mouths and thrown-back position of each head suggest sexual ecstacy. Dumas also makes the link between art and mortality: 'art is, and has always been, a preparation for death', she has written in a characteristically eloquent rumination on her art. **ED**

Marlene Dumas
born 1953

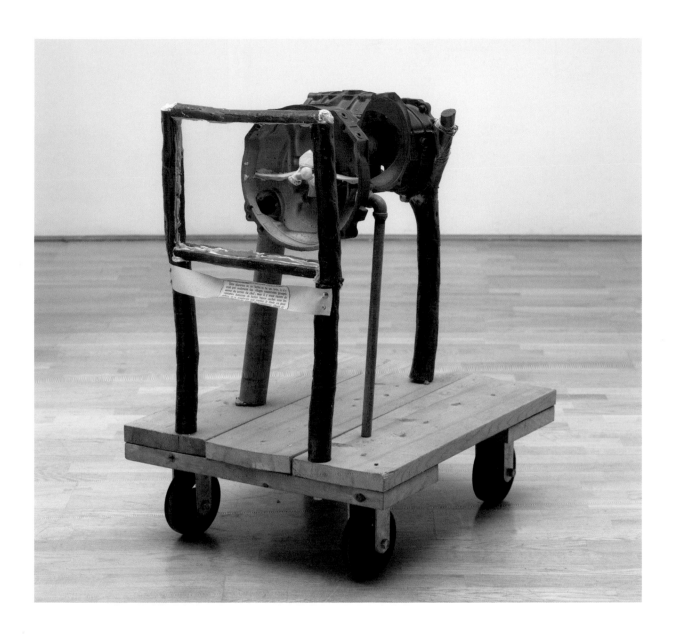

Jimmie Durham has consistently been concerned with matters of identity, whether through his political activities as a member of the American Indian Movement and representative at the United Nations, or through his practice as an artist, filmmaker and poet. He studied at the Ecole des Beaux-Arts in Geneva in the 1960s and, after an extended period of political activity in New York, has lived and worked in Mexico and Europe since the late 1980s.

As an American artist of Cherokee descent, Durham showed in the 1993 Whitney Biennial which proved to be highly significant for its inclusive focus on the work of artists outside the mainstream. Durham's contribution included *Dans plusieurs de ces forêts et de ces bois* … 1993. This assemblage of found, made and manufactured materials is characteristic of his confrontation between heterogeneous sources that parallel the complexity of the modern condition. The lengthy title, attached to the assemblage, translates as: 'In many of these forests and woods, not only were there underground villages grouped around the chief's burrow but, also, one could find true clusters of low-rise hamlets hidden under the trees, often so numerous that the forest could be full of them. Often smoke would betray their presence. Two of …' This links to an underlying political sensibility as it is taken from Victor Hugo's late novel about the French Revolution, *1793* (1874), and describes the occupation of the woodland by Royalists in revolt against the new state. Although Hugo's republican sympathies were evident in the book, Durham's use of the text is more ambivalent. Obliquely, this description of a return to nature may also suggest the resistance of a people against the sort of suppression into which the French Revolution sank. **MG**

Jimmie Durham
born 1940

Dans plusieurs de ces forêts et de ces bois, il n'y avait pas seulement des villages souterrains groupés autours du terrier du chef mais il y avait encore de véritables hameaux de huttes basses cachés sous les arbres, et si nombreaux que parfois la forêt en était remplie. Souvent les fumées les trahissaient. Deux de...
1993
Aluminium machinery part, wooden planks, tree branches, castor wheels, Coca-cola bottle, bone, galvanised steel, glass and other materials
97 x 77 x 66 cm
Purchased with funds provided by the 2010 Outset/Frieze Art Fair Fund to benefit the Tate Collection 2010

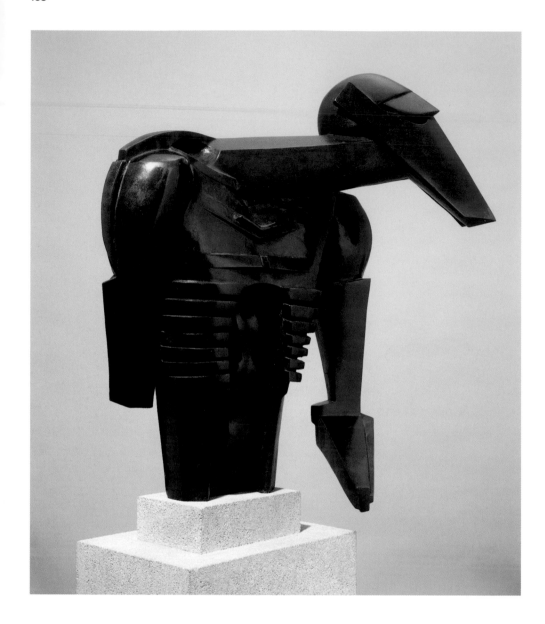

Jacob Epstein was born in New York City of Polish-Jewish parents. He trained at the Art Students League, then in 1902 moved to Paris and in 1905 to London, where he settled, becoming a British citizen in 1907. He was knighted in 1954. Epstein may be said to be the father of modern British sculpture, due both to his introduction of modernist ideas and to the huge fame and notoriety he achieved, the latter as a result of the public controversy aroused by his work from very early on. This controversy stemmed from the modernism of his style and from his bold treatment of themes relating to procreation, religion and the cycle of life. As Henry Moore later acknowledged, Epstein 'took the brickbats … took the insults … and took them first'. In the years from 1907–16 Epstein produced a substantial group of stone and marble carvings which constitute an important episode in the early history of modern sculpture, not just in Britain, but internationally. They include a sun god, two large totemic images of Venus, a series of three copulating doves (*Doves* 1914–15) and several images of pregnancy (*Figure in Flenite* 1913). However, in 1913–15 his association with vorticism saw the production of an exceptional work, *The Rock Drill*. Here his themes of procreation were embodied in the form of a powerful image of modern industrial man, a giant virility symbol consisting of a sculptured plaster humanoid riding a real mechanical drill. This was a pioneering piece of mixed media art as well as a major expression of a central theme of art at that time – the dynamism of modern life. Epstein later dismantled it and all that remains is the bronze-cast upper part of the figure, *Torso in Metal from 'The Rock Drill'* 1913–14. **SW**

Jacob Epstein
1880–1959

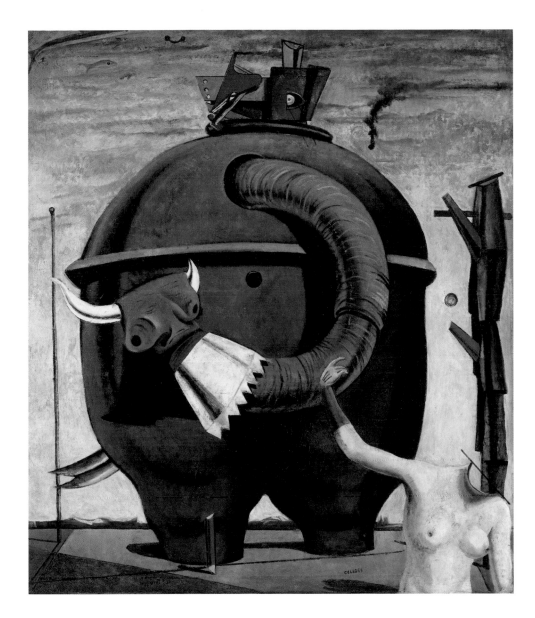

Celebes
1921
Oil on canvas
125.4 x 107.9 cm
Purchased 1975

The German artist Max Ernst became involved in dada following his traumatic experiences fighting in the First World War. He later wrote that 'Max Ernst died on 1 August 1914. He returned to life on 11 November 1918, a young man who wanted to become a magician and find the myths of his time.' By the early 1920s he had moved to Paris to join the artists and writers who formed the surrealist movement.

The surrealists had been captivated by his early collages, made from cut-up magazines. He went on to translate the idea of collage into paint, juxtaposing apparently unrelated imagery in works such as *Celebes* 1921 and *Pietà or Revolution by Night* 1923, which has been viewed as one of the first truly surrealist paintings.

As a key member of the surrealist group, Ernst became a proponent of their technique of 'automatism', creating images without the intervention of conscious thought. The importance of random encounters led Ernst to experiment with novel methods involving chance, such as *frottage*, in which pigment is rubbed over paper laid on a piece of wood or other textured surface and *grattage*, which involves scraping paint across similar surfaces. These enabled Ernst to discover new and surprising images without having to control the results. *Forest and Dove* 1927 and *The Entire City* 1934 both evolved from such techniques and represent two major themes in Ernst's oeuvre: that of the forest, seen as a metaphor for the imagination by surrealists, and that of the ruined citadel. **LA**

Max Ernst
1891–1976

Expressionism

Expressionism was never a single cohesive movement but, rather, a term applied to the work of a number of different artists' groups and individual practitioners in the early twentieth century. These artists, mostly based in northern Europe and particularly Germany, were seeking a new artistic language to express their sense of spiritual and intellectual dislocation. The philosophy of Friedrich Nietzsche, with its distrust of Western rationalism, was especially influential, encouraging artists to incorporate the instinctive and the irrational in their work.

Perhaps the defining characteristic of expressionism was the presentation of a deliberately distorted image of the world to convey the artist's own subjective vision. The surfaces of expressionist paintings were often highly textured with thick, expressive brushstrokes, and their use of boldly contrasting colours was decisively anti-naturalistic. Many artists found inspiration in non-Western and folk art, particularly masks and tribal sculptures from Africa and Oceania, which they believed possessed a rough vitality lacking in European culture.

One of the most significant expressionist groups was Brücke (Bridge), founded in Dresden in 1905, which included the artists Ernst Ludwig Kirchner, Emil Nolde and Karl Schmidt-Rottluff. The name of the group was an image of progress, of crossing from one shore to another, and reflected a belief that art had the power to transform society. This utopianism was manifested in their communal artistic practice, their challenge to sexual taboos, and their rediscovery of nature through retreats to locations such as the nearby Moritzburg Lakes.

In Germany, with the rise of Nazism, the artists associated with expressionism were condemned as 'degenerate'. Works in public collections were seized and destroyed, and many artists were removed from teaching positions or forced into exile. **SBo**

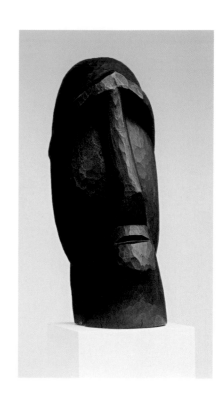

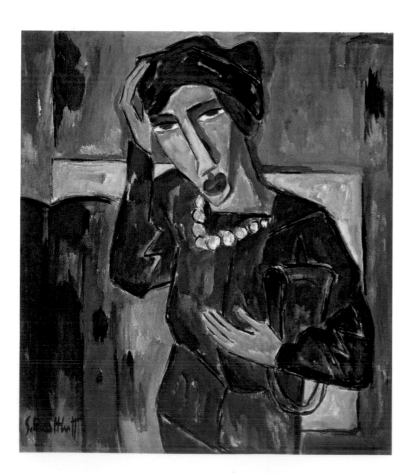

Above:
Karl Schmidt-Rottluff
(1884–1976)
Male Head
1917
Wood
34.3 x 13.3 x 16.5 cm
Presented by the executors
of Dr Rosa Shapire 1954

Left:
Karl Schmidt-Rottluff
Woman with a Bag
1915
Oil on canvas
95.2 x 87.3 cm
Presented by Dr Rosa Shapire
1950

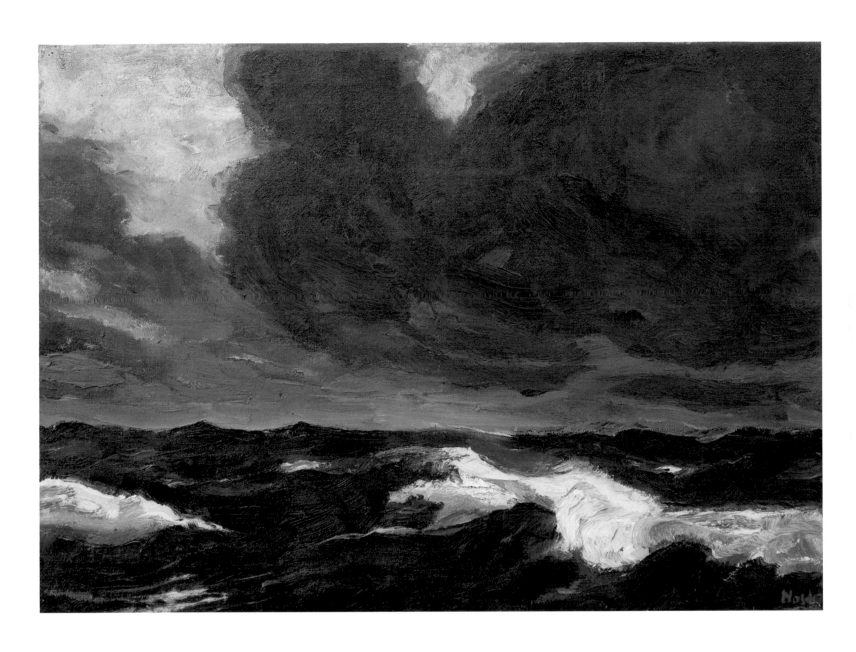

Emil Nolde (1867–1956)
The Sea B
1930
Oil on canvas
73.7 x 101 cm
Purchased 1966

Omer Fast was born in Israel and is now based in Berlin. He is best known for his video investigations of the conventions of representation, memory and trauma, media reportage, and the confessional interview. *CNN Concatenated* 2002 was made by breaking CNN presenters' words into phonemes lasting fragments of seconds. Fast then ran these fragments together to create a monologue that concerns the way television news spreads fear in its viewers' minds. The surprise of the work is how the newscasters appear to deconstruct their own activities.

Fast used similar techniques in looking at Hollywood's representation of complex histories. For *Spielberg's List* 2003 he filmed Holocaust sites in Poland, the sets and local extras of Steven Spielberg's film *Schindler's List*. Fast intertwined

footage of the sets and real places. He cut and mistranslated the interviews with the Polish extras in order to create confusion as to whether they were talking about the 1940s or their memories of the 1993 film.

In *The Casting* 2007 Fast addresses the trauma of war. The work is a double-screen installation with projections on both sides of both screens. One side shows an American soldier recalling two violent stories: one about a self-harming girlfriend he met in Germany and the other about accidentally killing a civilian while on duty in Iraq. The material is edited in complex ways: words spoken about Germany are transformed into sentences concerning Iraq and, from time to time, the soldier accuses Fast of twisting his words. On the other side, Fast restaged the casting of an actor to play the soldier. Reconstructions of his two stories were filmed as a series of tableaux with the actors holding their poses. More than the Iraq war, the work considers the ways that news stories are mediated and reconstructed, and the traumatic impact of violence on all protagonists. **MGo**

The Casting
2007
4-channel digital film with sound, 35mm film transferred to video
14 min
Lent by the American Fund for the Tate Gallery, courtesy of the North American Acquisitions Committee with additional assistance from Glenn Fuhrman, Bob Rennie, Elisa Nuyten, Laura Rapp 2010

Omer Fast
born 1972

Dan Flavin's name has become synonymous with his bold arrangements of fluorescent lights, which engage in an intimate dialogue with their surrounding architectural space. The first of these was *the diagonal of May 25, 1963 (to Constantin Brancusi)*, a simple gold-coloured tube mounted diagonally on the wall. The neutral geometric forms of Flavin's work, its use of serialisation and reliance on standardised, industrially produced materials, have often been associated with the cool, rational aesthetics of minimalism, as represented by the artist's contemporaries Carl Andre, Donald Judd and Sol LeWitt. However, Flavin never subscribed to such notions, referring on occasion to his work as 'maximalist' to redress the balance between its economy of means and its visual exuberance.

The immateriality of the light and the ephemeral nature of the tubes invite readings of Flavin's work as spiritual reflections on a transcendental world. While being influenced by his Catholic upbringing and his time in a priesthood seminary, Flavin always rejected such interpretations stating that his art 'is what it is, and it ain't nothin' else … it is very easy to understand'.

The idiosyncratic formula of Flavin's titles – consistently in lower case, and often with 'untitled' followed by a subtitle in parentheses that often describes the work's inspirational trigger – mirrors the sculptures' dynamic between pure abstraction and the specifics of place, time and source. Many of his works make reference to major figures of twentieth-century art including Henri Matisse, Donald Judd, Ad Reinhardt and Vladimir Tatlin, to whom he dedicated his single most sustained series of 'monuments'. **ABH**

'monument' for V. Tatlin
1966–9
Mixed media
305.4 x 58.4 x 8.9 cm
Purchased 1971

Dan Flavin
1933–1996

Fluxus

Fluxus has been variously described as 'the most radical and experimental art movement of the 1960s' and 'a wild goose chase into the zone of everything ephemeral'. Whichever view one takes, there is no doubt that Fluxus had a profound impact on minimalism, performance art, conceptualism and mail art, greatly influencing, along the way, the development of artists' co-ops, publishing, music, film and video.

The catalyst for Fluxus was the Lithuanian-born American George Maciunas, who studied fine art, graphics, architecture, art history and musicology in New York and Pittsburgh from 1949 to 1960. Fluxus, which was to be the title of a magazine in 1960, was never a movement, but rather a loose collective of over thirty artists, musicians and theorists who, as one key member, George Brecht, said 'had something un-nameable in common'.

Artists associated with Fluxus admired the work of Marcel Duchamp, John Cage, the dadaists and futurists, and created art that, to use Charles Baudelaire's phrase, 'contained at once the object and the subject, the world external to the artist and the artist himself'. Maciunas stressed concretism, humour and functionalism as the three main strands underpinning Fluxus. These ideas were brought to life (often in the street or in unusual locations, using whatever material was to hand, not least the audience) through performance, 'concerts' and film screenings as well as through the medium of small publications, where Maciunas would reinterpret an artist's idea to create a cheap multiple to sell to the masses.

One of the earliest manifestations of Fluxus in Britain, *The Festival of Misfits*, took place in London from 23 October to 8 November 1962. At Victor Musgrave's influential Gallery One, Ben Vautier lived in the front window, signing everyday objects as works of art, while his artistic collaborators, such as Robert Filliou, Addi Koepcke, Robin Page, Daniel Spoerri and Emmett Williams, created an interactive maze that visitors could explore. These artists, plus Gustav Metzger, also performed at the *Misfits Fair*, an evening concert held at the Institute of Contemporary Arts. The audience included Richard Hamilton and David Hockney. The next major centre for Fluxus activities was Gallery Ten in Blackheath, run by Brian Lane, who emulated Maciunas as an interpreter of artists' ideas producing beautifully made multiples for sale. Lane also enhanced the performative element of Fluxus through innovative concerts from 1968 to 1970, something that was developed more fully by David Mayor in his extensive exhibition *Fluxshoe*, which toured Britain during 1972–3. The work of ten Fluxus artists appeared in this seven-venue show with over forty other British and overseas artists taking part.

Fluxus artists were incredibly innovative. Counting among their number were a founder of video art (Nam June Paik); an early exponent of electronic music (Takehisa Kosugi); an initiator of 'concept art' (Henry Flynt); the creator of 'events' in which participants were instructed to make or perform what was written on cards (George Brecht); the originator of 'intermedia', where the use of two media leads to the creation of a third – for example drawing and poetry leading to visual poetry, or painting and theatre leading to performance art (Dick Higgins); and a developer of interactive installations (Yoko Ono). Fluxus can thus be seen as a way of life, a veritable art lab, that took Duchamp at his word to make the very act of living into a work of art. **AG**

Top:
Performance of Philip Corner's *Piano Activities* by (L–R): Emmett Williams, Wolf Vostell, Nam June Paik, Dick Higgins, Ben Patterson and George Maciunas at the 'Fluxus Internationale Festspiele Neuester Musik', Wiesbaden, September 1962
Photo: Hartmut Rekort, Staatsgalerie Stuttgart, Archiv Sohm

Above:
Carla Liss (born 1944)
Travel Fluxkit 1972
Tate Archive

Below:
George Maciunas (1931–1978)
FLuXuS (label) c.1966
Tate Archive

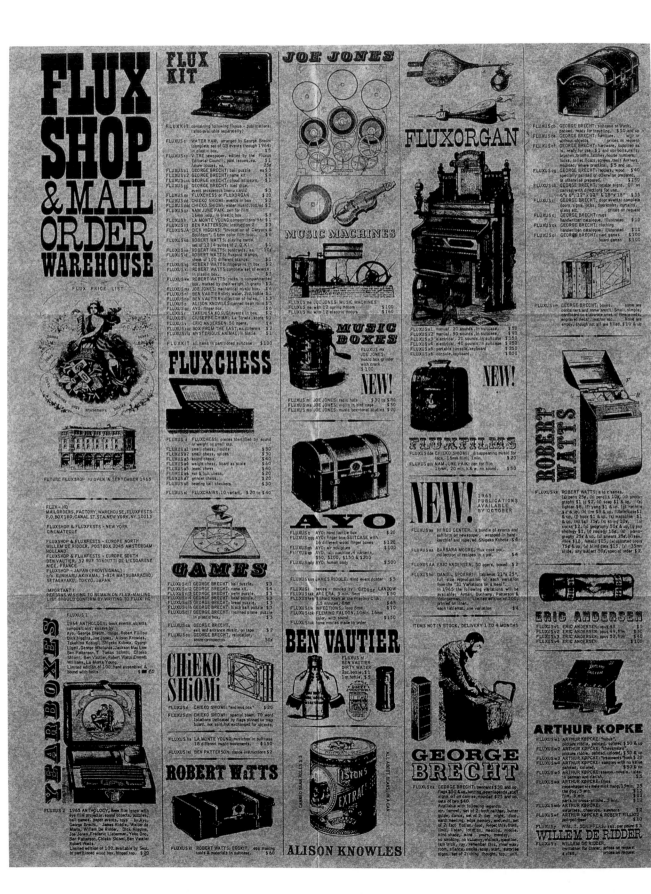

Fluxus Collective
VTRE, No. 5 (FLUXUS Vacuum TrapEzoid), March 1965

Spatialism
While teaching at the Academia de Bellas Artes in his native Argentina, the artist Lucio Fontana drafted with his students the *Manifesto Blanco* (White Manifesto), which was to become the foundation of spatialism (*spazialismo*) in 1947. It was followed by a series of other manifestos in collaboration with artists and writers issued until 1952.

Spatialism built on the experience of futurism, an earlier, utopian Italian movement of which Fontana was a great admirer. The idealistic new movement summed up Fontana's ideas about a fresh aesthetic, the central tenet of which was a 'spatial concept of art'. Movement, colour, time and space were to be the elements of the new art, which sought to transcend the established order and move towards a 'fourth dimension'. This would reveal the potential of art and society to pass through to a new era, where science and art would go hand in hand. **EB**

Spatial Concept
1949–50
Canvas
55 x 84.6 cm
Purchased with assistance from the Friends of the Tate Gallery 1985

Seeking to supersede the limitations that painting and sculpture imposed on art, Lucio Fontana worked passionately towards the definition of a 'spatial concept of art', hence the titling of many of his works as *Concetti Spaziali* (Spatial Concepts). Fontana sought to reinvest art with a dynamic character, with a fourth dimension going beyond time and space, revealing society's inherent potential for new cultural production and for progress. His vision was channelled through the movement of *spazialismo* (spatialism) and his experimentation with a variety of media, including sculpture, painting, ceramics and light installations. The most poignant visual translation of his quest, however, were works made in the 1950s and 1960s, in which he intervened in the canvas's surface, making holes (*buchi*, from 1949) and slashes (*tagli*, from 1959). Carefully premeditated and meticulously executed, Fontana's punctured canvases created both a break between the viewer and the painterly surface, and a level beyond it, leading into the infinite void. The hole was, for Fontana, his greatest discovery, a notion of the incomplete or unfinished, a prelude of what was yet to come, offering a passage through to the 'cosmos'. This created a positive expectancy, expressed in the title of a series of works by the word *Attesa* (Waiting).

Fontana's work had a profound, immediate influence on artists such as Piero Manzoni and Jannis Kounellis, and their repercussions can also be traced in contemporary artists' explorations, such as Anish Kapoor's void and Tatsuo Miyajima's temporal infinity. **EB**

Lucio Fontana
1899–1968

Since the mid 1980s Andrea Fraser has probed the social, institutional, political and economic structures of art through her video and performance works and writings. Fraser became widely recognised as one of a new generation of artists associated with institutional critique after her performance *Museum Highlights: A Gallery Talk* 1989 in which she took on the persona of a museum docent and conducted tours of the New Museum of Contemporary Art, New York and the Philadelphia Museum of Art. Speaking in the same superlative language used to describe the artworks, Fraser drew visitors' attention to the men's washrooms and other mundane aspects of the building, while her carefully researched and scripted talk also revealed certain ideological assumptions running beneath the surface of the museum's customary authoritative voice. Other performance/video works such as *Little Frank and his Carp* 2001 and *Official Welcome* 2001–3 show Fraser's further, often satirical, interest in presenting versions of the institutional voice.

In 2007 Andrea Fraser was invited to make an intervention in the Collection Displays at Tate Modern as her contribution to the temporary group exhibition *The World As a Stage*. Fraser created *Hello, Welcome to Tate Modern* 2007, a scrambled version of the museum's multimedia tour. Seeing her work as a form of 'institutional analysis … close to psychoanalysis', Fraser explained: 'You could say that all my work is about the repressed fantasies of our field and about the desires produced and pursued through these fantasies.' In *Projection* 2008 the viewer is caught between two projected images of the artist engaged in psychoanalytic dialogue, enacting the part of both analyst and analysed. Fraser's installation echoes her ability to question the relations at play in her own field, while operating as a key player. **AC**

Andrea Fraser
born 1965

Museum Highlights: A Gallery Talk
1989
Single-channel video, colour with audio track
29 min
Lent by the American Fund for the Tate Gallery, courtesy of the American Acquisitions Committee 2009

Right:
Giacomo Balla (1871–1958)
Abstract Speed –
The Car has Passed
1913
Oil on canvas
50.2 x 65.4 cm
Presented by the Friends
of the Tate Gallery 1970

Below:
Gino Severini (1883–1966)
Suburban Train Arriving in Paris
1915
Oil on canvas
88.6 x 115.6 cm
Purchased with assistance
from a member of the
Art Fund 1968

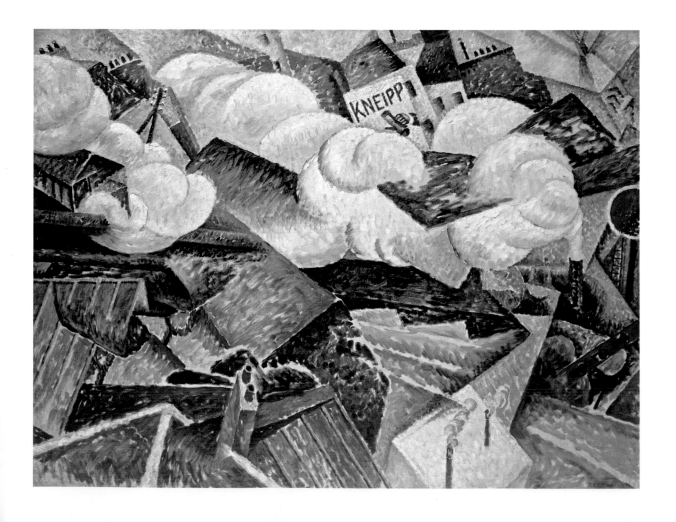

Futurism

The poet and founder of futurism, Filippo Tommaso Marinetti, was only partly being provocative when he declared: 'Let's kill the moonlight!' His attack was against all romantic notions: from symbolist poetry (through which he had made his name) to the misty-eyed tourism that he felt was strangling his native Italy. In his *The Foundation and Manifesto of Futurism* published in 1909, he attacked the uncritical admiration of the past and found potential instead in the rapid industrialisation that provided a sense of national inventiveness, coherence and modernity. The train, car and plane inspired his boundless admiration for speed and adrenalin-charged action, extending (notoriously) to the declaration of war as 'the world's only hygiene'.

With its genius for provocation, futurism struck a chord with a whole generation of intellectuals in Italy and beyond, stirring them to radicalism. Most notable among Marinetti's immediate recruits were the painters who signed the *Manifesto of Futurist Painters* in 1910; they included Umberto Boccioni, Carlo Carrà and Gino Severini. Marshalled by the poet, they produced an assault on artistic conventions that only found convincing pictorial form after they had absorbed developments in Paris. As a result, the fragmentary planes of cubist paintings infused the works in the influential futurist exhibition that toured Europe in 1912. Unlike cubist works, however, the shifting experience of modern life was seen in futurist paintings (much as in Marinetti's poetic *words in freedom*) as dynamic and psychologically charged. In this, the artists were influenced by the philosophy of flux developed by Henri Bergson, giving it form by introducing the 'lines of force' that slice through their compositions. These are evident in the abstracted helixes of Giacomo Balla's studies of a passing car, as well as in Boccioni's sculpture *Unique Forms of Continuity in Space* 1913, where planes extend the body into the surrounding space. The idea of mutual interaction was also raised to a wider social level; especially in their riotous performances, the futurists exploited provocation as a catalyst for change, while they adopted a political position that attacked what they saw as Italy's failed liberal parliamentary system.

It is hardly surprising that the futurists agitated for Italy's entry into the First World War in 1914. Based on a nationalist rhetoric aimed at the integration of the Italian-speaking lands of Austria-Hungary, they allied themselves with a range of radicals including Benito Mussolini. Success in May 1915 resulted in the futurists volunteering together, but tragedy was not far off: Boccioni was killed in 1916. Marinetti's genius for organisation ensured that futurism did not collapse with the war but began to expand into new media: radio, theatre, typography, design. However, the same spirit that had encouraged Balla and Fortunato Depero to propose the *Futurist Reconstruction of the Universe* in 1915 increasingly took on an oppressive tenor in Mussolini's Fascist state of the 1920s. Marinetti enthusiastically supported Fascism, and this association has cast a long shadow over the subsequent appreciation of the movement. **MG**

Below:
Umberto Boccioni (1882–1916)
Unique Forms of Continuity in Space 1913, cast 1972
Bronze
117.5 x 87.6 x 36.8 cm
Purchased 1972

Bottom:
Filippo Tommaso Marinetti
(1876–1944)
Cover of *Zang Tumb Tumb*, 1912
Tate Library

Model for 'Constructed Torso'
1917, reassembled 1981
Cardboard
39.5 x 29 x 16 cm
Accepted by HM Government
in lieu of tax and allocated
to the Tate Gallery 1995

Constructivism

Constructivism is a branch of abstract art founded by Vladimir Tatlin and Alexander Rodchenko in Russia around 1915 and developed by Naum Gabo and his brother Antoine Pevsner. The constructivists believed that art should reflect the modern world – in method, materials and form. Tatlin was influenced by Picasso's cubist constructions, which he saw in his Paris studio in 1913. These were three-dimensional still lifes made of scrap materials. Tatlin began to make his own, but they were completely abstract and made of industrial materials. Gabo and Pevsner had also been impressed with cubism as Gabo's *Model for 'Constructed Torso'* 1917 demonstrates. In 1920 the brothers issued 'The Realistic Manifesto', which outlined the formal aims and aesthetic principals of their constructive technique, as well as articulating the importance of space and time in their art. This manifesto is a refusal of the more utilitarian tendencies in Tatlin's work and theories. Constructivism was suppressed in Russia in the 1920s but was brought to Western Europe by Gabo, Pevsner and others. **RL**

Naum Gabo's interests in science and engineering – space, time, movement and construction – are explored in his sculptures. He employed intersecting solid or strung planes to represent form and volume – a technique developed in line with the constructivist theories developed with his contemporaries in Russia in the early decades of the twentieth century. Gabo was one of the earliest artists to experiment with kinetic or moving sculpture and his innovative use of man-made, opaque, translucent and transparent materials results in spatial interplay, refracting the light and allowing multiple viewpoints. Gabo used a reduced range of colours – reds, blacks, whites and yellows – which contrasted with the industrial materials he employed.

Many of the maquettes in Tate's collection were given to the gallery on Gabo's death and were reconstructed from component parts found in his attic. These small-scale models were often for monumental public schemes in which sculpture and architecture came together. However, they were rarely realised.

Throughout his life Gabo associated himself with and influenced various circles of artists and artistic movements, moving from Russia to Denmark and Norway at the outset of the First World War, then to Berlin and England, where he stayed for ten years before he left for the United States in 1946. Here he taught at Harvard and eventually died an American citizen. In later years and particularly while in Cornwall from 1939, he began to work with more traditional materials and methods such as stone carving and printmaking. **RL**

Naum Gabo
1890–1977

Ellen Gallagher is one of the most acclaimed contemporary painters to have emerged from North America. Her paintings, collages, drawings and animation, which shift between abstraction and figuration, create dynamic encounters between the historic and the present through commentary about race, racism and cultural identity. Gallagher creates a subjective cosmos by employing a language of simple forms – disembodied, bulging eyes, rubbery lips and transformative wigs – to signify race. Drawing these derogatory stereotypes from traditional minstrel shows, vaudeville and black photographs in magazines, Gallagher liberates them in order to explore the construction of African-American identity. She has stated: 'I am interested in both a painting's immediate

appearance and … in the way materials manifest meaning … In each canvas, the narrative comes from the legacy of marks.'

Bird in Hand 2006 is a complex relief built up in layers on canvas through the application of newspaper cuttings and advertisements, plasticine, rock crystals, silver paint and gold leaf. The title invokes the proverb 'a bird in the hand is worth two in the bush'. The protagonist, a one-legged black pirate or 'Pegleg' recurrs in Gallagher's work, inspired in part by the character Captain Ahab from Herman Melville's novel *Moby Dick*. Gallagher's long-standing interest in narratives surrounding the slave trade is evident in *Bird in Hand*. The work refers to the experience of slaves of the Cape Verde islands off the West Coast of Africa, the birthplace of the artist's father, which was for three centuries a hub of the transatlantic slave trade. *Bird in Hand* also evokes the mythical Drexciya or Black Atlantis, an underwater world populated by a marine species descended from drowned slaves, a theme to which other of her works, including the animated film installation *Murmur* 2003–4, refer. **JB**

Bird in Hand
2006
Oil, ink, paper, polymer, salt, gold leaf on canvas
238.3 x 307.2 cm
Presented anonymously 2007

Ellen Gallagher
born 1965

Untitled
c. 1977
Bronze
Each 55.5 x 63 x 67 cm
Purchased with assistance from
Tate International Council 2010

Gertrud Goldschmidt, known as Gego, was one of a generation of Venezuelan artists whose work explored geometric abstraction. Coming after the initial developments of the 1950s, Gego built upon ideas from optical and kinetic art but introduced elements of organicism that challenged the precision of the earlier forms of abstraction. From the mid 1960s onwards she made prints and drawings as well as sculptures from wire which embodied an expressive approach to geometric abstraction.

Many of Gego's sculptures take the form of webs or nets. While they were conceived as individual pieces, she frequently exhibited them in groups exploring the interaction of forms and their organisation in space. Their geometry recalls mathematical models but Gego subtly disrupted these ideal forms, especially when the works were accumulated in room-size environments, to establish a dialogue between the orderly and the chaotic. While her work can be seen in relation to abstract constructivist art, Gego moved beyond this frame of reference and developed a unique style based on her investigation of line, motion, space and the role of the spectator.

The four untitled works in Tate's collection are from a series of rigid, sphere-shaped sculptures which Gego made from welded bronze wire for her solo exhibition at the Museo de Arte Contemporáneo de Caracas, Venezuela, in 1977. Originally they were placed directly on the gallery floor and displayed as part of a group of around twenty, as a modular, environmental work. When seen as a group, the network of triangles and pentagons that make up the roughly spherical shape evoke a scrubland landscape of weeds and undergrowth. **TB**

Gego
1912–1994

Existentialism
The existential philosophy of Jean-Paul Sartre, which centred around notions of anguish, abandonment, despair and isolation, influenced a generation of postwar intellectuals and artists. Sartre was good friends with Giacometti whose sculpture *Four Figurines on a Base* 1950/1965, cast c.1965–6, exemplifies the key existentialist sentiments of alienation and loneliness. It relates to Giacometti's memory of four naked women in a brothel in Paris. The tiny size of the figures and the heavy base with sloping sides, which suggests a receding floor, recreates the sense of distance and confrontation experienced by the artist. 'The distance which separated us, the polished floor, seemed insurmountable in spite of my desire to cross it', Giacometti recollected. Other strands in existentialism reinforced its importance. Albert Camus wrote of isolation and absurdity in *The Outsider* (1942), while Maurice Merleau-Ponty's *The Phenomenology of Perception* (1945) was widely influential on artists seeking to understand a sense of 'being in the world'. Simone de Beauvoir's controversial *The Second Sex* (1949), which emerged from this same intellectual network, remains a crucial feminist text on gender inequality. **SH**

'I didn't want to create a figure that looked realistic on the outside, but wanted to experience life and to create only those forms that really affected me', Giacometti said. Born in Switzerland, he moved to Paris in 1920 and quickly became part of avant-garde circles. His early sculptural work was concerned with the uncanny and the erotic and he became an active member of the surrealist group from 1930 to 1935. It was not until the late 1940s that he started to make the tall, emaciated figures for which he has become best known. These were achieved through an obsessive process of building up the clay, only to cut it away again in an attempt to reach an inner essence. To many observers, these pieces, isolated and strangely remote, seem like metaphors for the disconnected human condition of the modern age. But Giacometti tended to deny the expressive quality in his work. He was always insistent that his art derived from his determination to convey how we perceive the world around us. He often repeated the same subjects over and over again, and asked only those closest to him to be his models, including his brother Diego, who is the subject of the bust shown here. Giacometti's sculptural figures are typically fragmentary, their slender, emaciated forms conveying a vivid but fragile human presence. The French writer Jean Genet commented: 'The resemblance of his figures to each other seems to me to represent that precious point at which human beings are confronted with the most irreducible fact: the loneliness of being exactly equivalent to all others.' **SH**

Alberto Giacometti
1901–1966

Left:
Bust of Diego
1955
Bronze
56.5 x 32 x 14.5 cm
Purchased with assistance from the Friends of the Tate Gallery 1965

Right:
Standing Woman
1948–9
Bronze
168 x 15.9 x 34 cm
Presented by the artist 1965

Left:
Drains
1990
Pewter
9.4 x 9.4 x 4.2 cm
Purchased 1992

Right:
Untitled 1989–92
Wood, wax, leather,
cotton and human hair
30 x 16 x 51.5 cm
Purchased 1992

Robert Gober's sculptures and installations take an uncanny look at the desires and fears we project onto everyday objects. His practice has involved meticulously handcrafting replicas of mass-produced objects including doors, cots and newspapers. These often have a particular metaphorical or biographical resonance for Gober, obliquely referring to his personal history and identity as a gay man in contemporary America.

Untitled 1989–92, a severed leg extending from the gallery wall, is both comic and horrible. The hyperrealism of the leg extends to the sock and shoe on the foot and the real human hairs embedded in the surface of the 'skin'.

Drains 1990 is a handmade copy of a sink-hole installed in the gallery wall. Taking an everyday object out of its ordinary context is a strategy that owes a debt to surrealism, and the series of works that Gober made in the late 1980s and early 1990s referencing plumbing paraphernalia recalls Marcel Duchamp's infamous *Fountain* 1917 (p.105). However Gober's repeated use of sink and drain imagery suggests a more sustained interest in the political and psychological implications of the pursuit of hygiene in the Western world. *Drains* was made at the height of the AIDS crisis in America and Western Europe. The drain suggests an underworld of bodily fluids and effluvia beneath even the most meticulously cleaned surfaces and may be read as an indictment of the attempts by some political factions to stigmatise the disease at the time. The plug hole also suggests the anus, a point that marks the distinction between the inside and outside of the human body, a site of discharge and of desire. **RT**

Robert Gober
born 1954

*Jimmy Paulette and Tabboo!
undressing, NYC*
1991
Photograph on paper
101.5 x 69.5 cm
Presented by the Patrons of
New Art (Special Purchase Fund)
through the Tate Gallery
Foundation 1997

Jimmy Paulette and Tabboo! have frequently been photographed by Nan Goldin. Here, they are pictured together in an intimate state of semi-undress, shorn of their wigs and evening finery and shown in a vulnerable and affectionate light: Jimmy Paulette standing just outside the bedroom, conscious of the camera and returning the gaze, Tabboo! preoccupied on the floor and sensuously reflected in profile in the full-length mirror, adjacent to his friend.

Since Nan Goldin left Boston as a child runaway in the 1960s, her photography has taken as its main subject the desires, dandyism and eccentricity of a group of people living on the margins of society. Her camera captures a secluded, youthful, nighttime world of bedrooms, night clubs, bars, hotel rooms, lofts and parties. Moving among drag queens and cross-dressers, many her close friends, Goldin has constantly investigated stereotypical gender distinctions, attempting to redefine them by showing alternatives. If her early images, including her black and white photos of the 1970s, may be seen as a celebration of difference, the identities she depicts in her work of the later 1980s and 1990s often seem more unstable. They frequently reflect selves which are threatened or elusive, conscious of their own otherness, and familiar with loss through AIDS. The vivid colouration (a departure from the real-life documentary associations of black and white) often heightens the sense of euphoria and camp in the later club scenes while underlining the poignancy of illness and death in the quieter images.

While Goldin's work has struck a chord with younger photographers seeking to blur the divisions between high art and fashion photography (she has notoriously been dubbed the mother of 'heroin chic'), it also remains a potent and enduring exploration of the variety of the human psyche within portraiture at the end of the millennium. **AM**

Nan Goldin
born 1953

Linen
1913
Oil on canvas
95.6 x 83.8 cm
Presented by Eugène Mollo
and the artist 1953

A leading artist of the early twentieth-century Russian avant-garde, Natalya Goncharova oscillates in her work between the neo-primitive and intensely modern. She was interested in traditional Russian art forms including iconography, folk art, needlework and popular Russian prints known as *lubki*. She was also influenced, however, by exposure to the paintings of her French contemporaries, including Cézanne, and became concerned with the analysis of form, adopting a style related to cubism. Together with her lifelong partner and collaborator, the artist Mikhail Larionov, she founded the rayonist movement, a synthesis of cubism, futurism and orphism. Like the impressionists, the rayonists were interested in newly developing scientific theories of vision.

Specifically, their works were concerned with the refraction of light off objects, and they strove to make the painted subject appear to be formed from rays of coloured light.

Dominated by dynamic angles and blocks of harmonious colour, Goncharova's painting *Linen* 1913 is characteristic of her experiments with the beginnings of abstraction and interest in colour and form during this period. The composition bears a resemblance to cubist collage, featuring shifting viewpoints and segments of Cyrillic text, the most complete of which, *Prache...*, is the beginning of the Russian word for laundry. The gendered underclothes depicted in the work can be read as a symbolic representation of her relationship with Larionov. Often dressing in men's clothing, Goncharova strove to blur the boundaries between masculine and feminine. She held little concern for social conventions, and controversially lived with Larionov out of wedlock, until marrying him late in her life.

While continuing to paint after moving to Paris in 1917, she also worked as an illustrator and became well known as a costume and set designer for classical ballets. **MB**

Natalya Goncharova
1881–1962

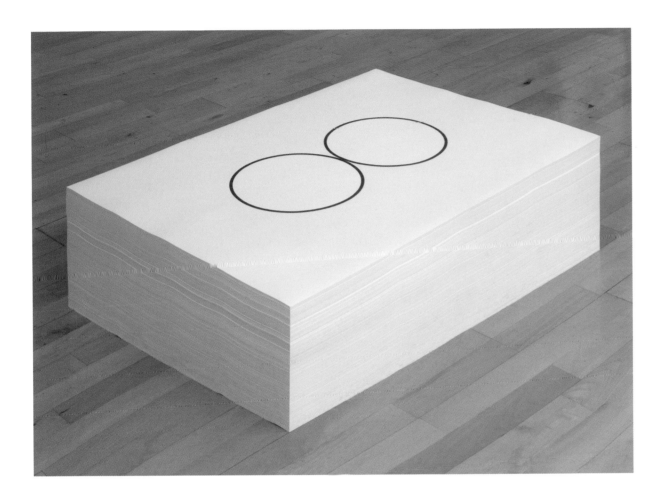

Felix Gonzalez-Torres worked in a variety of media to examine themes such as identity, the public and the private, desire, intimacy, loss and renewal. He was one of the most prominent Cuban émigré artists working in the USA and, alongside his solo career, was part of the collective Group Material (with Doug Ashford, Julie Ault and Tim Rollins) between 1979 and 1996. He was influenced by, but also sought to challenge, the minimalist and conceptualist art of the 1960s and 1970s. Working in series, he developed forms of sculpture and installation that involved the participation of the viewer, the curator, or both.

"Untitled" (Double Portrait) 1991 comprises a stack of printed sheets of paper. They are produced in 'endless copies' and placed directly on the gallery floor. Each visitor is invited to take a sheet, with the stack being periodically replenished. Although the artist specified an ideal height to be maintained, in practice, the form and volume is in constant flux. The work is, therefore, both the stack of printed sheets and its animation through the visitors' interaction. By introducing change and transience the work comments on minimalist sculpture and its emphasis on inert mass.

Gonzalez-Torres made numerous works in which simple pairings of identical objects – clocks, pillows or light bulbs – suggest 'perfect lovers'. "Untitled" (Double Portrait) also carries such associations, as the double gold ring design evokes the tradition of pendant portraiture associated with the commemoration of a couple. These rings could be seen as matching wedding bands and as symbols of eternity or enduring love. The work typifies Gonzalez-Torres's tendency to imbue otherwise simple forms and gestures with personal, emotional or political meaning. **TB**

Felix Gonzalez-Torres
1957–1996

"Untitled" (Double Portrait)
1991
Stack of printed paper
26 x 100.1 x 69.8 cm
Purchased jointly by Tate, with assistance from the American Patrons for Tate and the Latin American Acquisitions Committee; and Albright-Knox Art Gallery, Buffalo, with funds from Charles Clifton, James S. Ely, Charles W. Goodyear, Sarah Norton Goodyear, Dr. and Mrs. Clayton Piemer, George Bellows and Irene Pirson Macdonald Funds; by exchange: Gift of Seymour H. Knox, Jr. and the Stevenson Family, Fellows for Life Fund, Gift of Mrs. George A. Forman, Gift of Mrs. Georgia M.G. Forman, Elisabeth H. Gates Fund, Charles W. Goodyear and Mrs. Georgia M.G. Forman Fund, Edmund Hayes Fund, Sherman S. Jewett Fund, George B. and Jenny R. Mathews Fund, Bequest of Arthur B. Michael, Gift of Mrs. Seymour H. Knox, Sr., Gift of Baroness Alphonse de Rothschild, Philip J. Wickser Fund and Gift of the Winfield Foundation, 2010

128

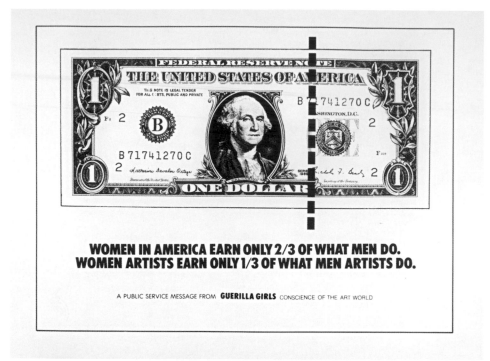

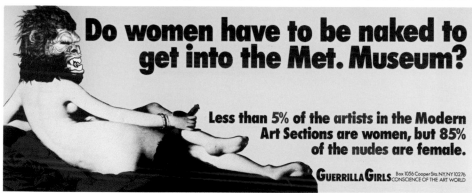

Feminism

Feminist art practice emerged in the 1960s, informed by the radical politics of the Women's Liberation Movement, as well as the Civil Rights, anti-war and students' rights movements. It operated alongside and interpenetrated the radical aesthetics of pop and conceptual art, performance and body art, photography and experimental film and video. From the 1970s to the present day, feminist art history has played a major role in reminding audiences of overlooked and forgotten women artists, and has criticised museums, galleries and other institutions for favouring male artists at the expense of female practitioners. In the 1970s, under the influence of psychoanalytical and poststructuralist theory, female artists such as Jenny Holzer, Cindy Sherman and Barbara Kruger started making works that interrogated the complex relationships between gender, power and representation.

Feminism can now be seen to have had a profound influence on the landscape of late twentieth- and twenty-first-century art. Yet the need for feminist art practice, like the work of the Guerrilla Girls, continues undiminished, since many issues of inequality with regard to race, age, class, sexuality and disability remain within the art world. **ED**

The Guerrilla Girls formed as an anonymous activist group in 1984 to be the 'conscience of the art world', and in particular to protest about sexual discrimination within that field. The initial impetus for their actions was an exhibition in 1984 at the Museum of Modern Art, New York, entitled *International Survey of Painting and Sculpture*, which purported to be an up-to-the-minute snapshot of the contemporary art scene, yet, from a total of 169 artists featured, only thirteen were women. The Guerrilla Girls hide their real identities behind gorilla masks for public appearances and interviews, and have adopted as pseudonyms the names of deceased female artists and writers such as Kathë Kollwitz, Frida Kahlo and Gertrude Stein, an act that also helps keep these figures in the public consciousness.

The Guerrilla Girls' first public actions in 1985 took the form of acerbic fly-posters, which they pasted up overnight in the fashionable New York art district of SoHo. Their ironic use of the language of advertising – like other artists in New York at that time such as Barbara Kruger and Jenny Holzer – exposed some shocking imbalances in the fortunes of male and female artists. Their first targets were their fellow artists and gallerists, but they soon moved on to critique museums, art magazines and other cultural institutions, widening their attacks to expose art-world racism and sexism, as well as other areas of social, racial and gender-based injustice and inequality. *Guerrilla Girls Talk Back* 1985–90 is a portfolio of thirty of these early poster works. One of the best-known, *Do women have to be naked to get into the Met. Museum?*, shows the famous image of Ingres's naked Odalisque sporting a gorilla mask, while the text exposes the lack of women artists versus the preponderance of naked female models on display in the museum. The work first appeared in the form of advertisements on New York City buses, paid for by the Guerrilla Girls themselves, until the bus company cancelled their leasing agreement on the grounds of indecency. **ED**

Guerrilla Girls

From *Guerrilla Girls Talk Back*
1985–90
Screenprints on paper
43 x 56 cm
28 x 71 cm
Purchased 2003

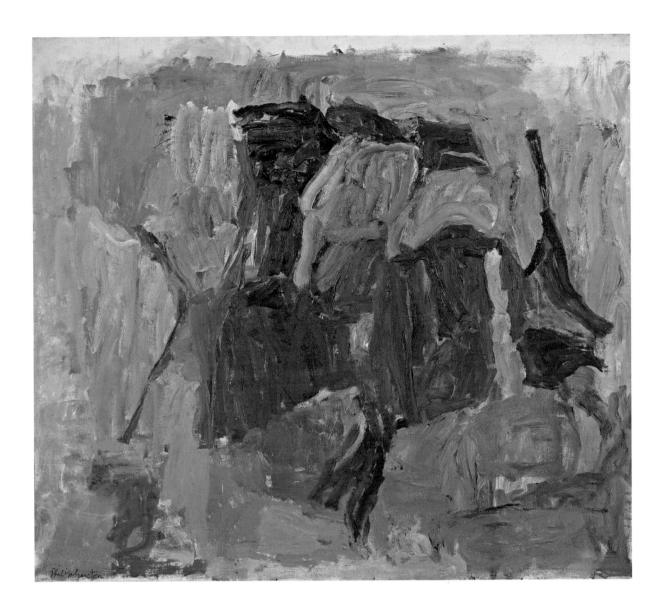

The Return
1956–8
Oil on canvas
178.1 x 199.1 cm
Presented by the Friends of
the Tate Gallery 1959

Philip Guston's career was an impassioned tug-of-war between abstract and figurative painting. Having established himself as one of the leading abstract expressionists, he seemed to turn his back on the movement in the late 1960s with his grotesque, bleakly humorous images of isolated objects, disembodied limbs and hooded Ku Klux Klansmen puffing on cigars. Yet this apparently radical shift in his work was, in many ways, a return to his artistic roots.

As a young man in the 1930s, Guston had painted social realist murals that reflected the political turmoil of America during the Depression. Living in New York in the 1940s, he came to reject figurative painting. His early abstract paintings were composed of shimmering combinations of short vertical and horizontal brushstrokes in pinks, reds and blues. Gradually, solid forms began to re-emerge, even in a painting as apparently abstract as *The Return* 1956–8. Guston said that the forms were like figures who had been away for some time and who were now returning – jostling each other a little in the process.

With America torn apart by the Civil Rights struggle and protests against the Vietnam War, Guston began to see abstraction as a kind of escapism, shrinking away from the turbulence of contemporary life. He developed a satirical, cartoon-like style by drawing the people and things around him: books, shoes, hands, ashtrays. In his paintings, however, his evident pleasure in depicting 'tangible things' is tempered by a mood of grim anxiety, and familiar objects can become enigmatic or sinister. **SBo**

Philip Guston
1913–1980

Richard Hamilton
1922–2011

From the late 1940s Richard Hamilton pioneered an art that explored aspects of the environment hitherto largely disregarded by art, and which did so in new ways. In particular, he looked at the burgeoning popular and consumer culture of the post Second World War period, stemming from the USA. In 1957 he produced a famous definition of 'pop art' (by which he meant at that time, 'popular culture'): 'Popular (designed for a mass audience).

Transient (short term solution). Expendable (easily forgotten). Low cost. Mass produced. Young (aimed at youth). Witty. Sexy. Gimmicky. Glamorous. Big business.' He proposed to make art with these qualities – all of them anathema to accepted notions of what art should be. The works that he produced are now seen as among the first important manifestations of what by the early 1960s had become known as pop art and which went on to become a major phenomenon in the USA and Britain, with a parallel movement in Europe under the name of *nouveau réalisme*. Hamilton's early pop works are complex, allusive and witty, both celebrating their subjects and analysing them. In *Hommage à Chrysler Corp.* 1957, metal foil and other materials are combined with oil paint to create an image based on Chrysler car advertisements. A glamour model caresses the car; she is represented by her bra cup, voluptuous lips and bodily curves, blending with those of the car. The mix of formal complexity and a high degree of abstraction, while never losing sight of the source material, became a key characteristic of the best pop art. **SW**

Towards a definitive statement on the coming trends in men's wear and accessories (a) Together let us explore the stars
1962
Oil, cellulose paint and collage on wood
61 x 81.3 cm
Purchased 1964

Austrian-born Raoul Hausmann was a founder member of the Berlin dadaists, whose other members included George Grosz, Hannah Höch and John Heartfield. He was engaged with a diverse range of practices including painting, fashion design, poetry, pamphleteering and publishing. However, he is most celebrated for his innovations in photomontage – combined fragments of photographs and typography often cut from magazines or newspapers. Hausmann defined the power of photomontage as lying in 'its contrast of structure and dimension, rough against smooth, aerial photograph against close-up, perspective against flat surface'. He used the potential for contradiction and paradox afforded by the new medium to lampoon what he saw as the conservativism of contemporary politics, the mass media and the world of fashion. In *The Art Critic* 1919–20 Hausmann vents his biting wit on an archetypal bourgeois critic. The roughly superimposed eyes and mouth suggest that the critic sees with someone else's eyes and speaks with someone else's mouth, while the fragment of a German banknote behind his neck unambiguously suggests financial motivations. Hausmann once said that the average German 'has no more capabilities than those which chance has glued on the outside of his skull; his brain remains empty', a judgement that clearly informed this work and many others by the satirist. **SH**

The Art Critic
1919–20
Lithograph and photographic collage on paper
31.8 x 25.4 cm
Purchased 1974

Raoul Hausmann
1886–1971

132

Family Jules: NNN (No Naked Niggahs) 1974 is one of four paintings that Barkley L. Hendricks made featuring a former student of his at Yale University, George Jules Taylor. In an apparently oriental interior, he is shown languidly seated on a luxurious white couch, his head tilted slightly back in complete confidence of his nakedness. By positioning a naked black male figure in the place of the traditional female 'odalisque' of academic painting, Hendricks

adopted an extremely radical stance. As his challenging title underlines, the painting confronts white fears and sexual stereotypes surrounding the black male. These factors are captured even in the detail of the shirt thrown over the couch which shows the face of a white woman turned towards the naked male body.

The radical message of his work is heightened by Hendricks's representational style that challenged contemporary trends in the field of black American art. In the late 1960s and early 1970s many artists turned to African art to make idealised images of black subjects, whereas he was known for his more realistic images of everyday black figures. Furthermore, in *Family Jules*, Hendricks not only confronted tendencies to Africanise or idealise the black body, but also tackled the reluctance of black artists to represent naked subjects long associated with exploitative images. Already a senior African-American painter at the time that he made *Family Jules*, Hendricks has been extremely important for younger generations of black American artists. **MGo**

Family Jules: NNN (No Naked Niggahs)
1974
Oil paint on linen
168.1 x 183.2 x 3.5 cm
Lent by the American Fund for the Tate Gallery, courtesy of the North American Acquisitions Committee 2011

Barkley L. Hendricks
born 1945

Barbara Hepworth was born in Yorkshire and trained at Leeds School of Art and then from 1921 at the Royal College of Art in London. Following Jacob Epstein, she and her contemporary Henry Moore, also from Yorkshire, became twin pioneers of modern sculpture in Britain. From the mid 1920s Hepworth began to make sculptures of the human, usually female figure, adopting the approach of direct carving (i.e. without a preliminary model) introduced by Constantin Brancusi and, in Britain, Epstein. With this went the doctrine of truth to materials, and these works and their successors were made from alabaster, marble, pink ancaster stone, ironstone, African blackwood, rosewood, mahogany, yew and many others. Delicately carved, these sculptures, up to 1934, nevertheless pulse with powerful instinctual feeling and deploy sexual and procreative imagery embodied in increasingly abstract but highly sensual, biomorphic forms, revealing the beauty of the material. In 1931 Hepworth had begun a passionate relationship with the painter Ben Nicholson. In 1934 she gave birth to triplets and she and Nicholson were married shortly afterwards. *Three Forms* 1935 is one of two similar sculptures that were the first she made after recovering from the births and has inevitably been related to her triplets. However, it marks the beginning of a more purely abstract phase of her art, in which she was preoccupied with form itself and the relationships of forms in space.

In 1939 she and Nicholson settled in St Ives in Cornwall and her abstract forms became imbued with the spirit of the landscape and seascape of West Cornwall. But her work continued to embrace a human dimension: 'I was the figure in the landscape and every sculpture … contained the ever-changing forms and contours embodying my own response to that landscape.' **SW**

Three Forms
1935
Serravezza marble
21 x 53.2 x 34.3 cm
Presented by Mr and Mrs J.R. Marcus Brumwell 1964

Barbara Hepworth
1903–1975

134

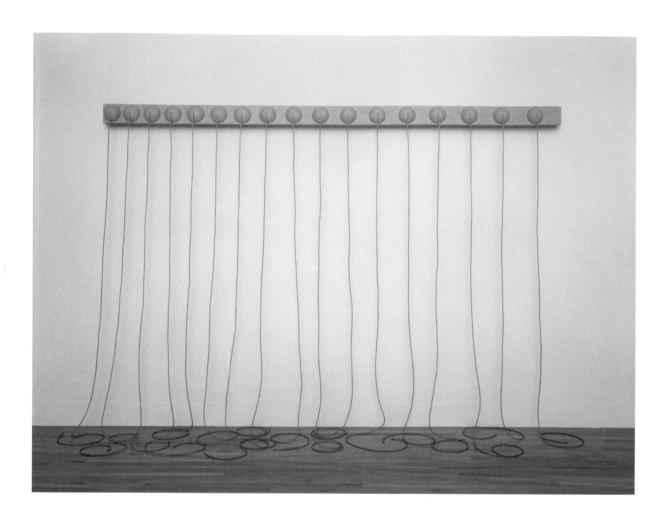

Addendum
1967
Painted papier mâché,
wood and cord
12.4 x 302.9 x 20.6 cm
Purchased 1979

Eva Hesse is associated with the American avant-garde art of the 1960s. Although trained as a painter she is best known for her drawings and three-dimensional work made between 1965 and 1970. She was associated with New York minimalism, in part because of the use in her work of repetition and unconventional, non-artistic materials. In other respects Hesse's is quite independent of the work being made at the time by her male counterparts. Many of her three-dimensional works are wall-based and carry strong references to the rectangular format of painting. But typically, and literally, these works go beyond painting. Hesse employed a wide variety of everyday materials which were often attached to a flat rectangular surface in such a way that they hung or dangled or fell to the floor. In particular it was in her use of non-rigid, flexible materials – such as rope, rubber tubing or latex – that Hesse moved away from minimalism. It also led her and other artists towards an art which, while remaining emphatically abstract, made strong references to the human body. *Addendum* 1967 is made from painted papier mâché, wood and rubber tubing. It is characteristic of her work of the period in that a rigid rectangular structure is used to support a number of free-hanging cords which intertwine as they come to rest on the floor. The space between each of the hemispheres is increased by half an inch as it progresses from left to right. For Hesse, *Addendum* contained a dynamic and unstable opposition, a 'contradiction of the rational series of semi-spheres and irrational flow of lines on the floor.' In an interview made after her death, Hesse's contemporary Carl Andre said of her legacy: 'Perhaps I am the bones and body of sculpture, and perhaps Richard Serra is the muscle, but Eva Hesse is the brain and the nervous system extending far into the future.' **DB**

Eva Hesse
1936–1970

Cabinets of Curiosities
Cabinets of curiosities (also known as *Wunderkammer* or wonder-rooms) were popular in Europe in the sixteenth and seventeenth centuries. These 'cabinets' were in fact usually room-sized collections of natural phenomena collected during overseas expeditions and believed at the time to be rare or marvellous examples of God's creation. Often, they contained a bizarre mix of fact and fiction. For example, the famous curiosity cabinet of Ole Worm, a seventeenth-century Danish physician and antiquary, contained a Scythian lamb, a wooly plant that was thought to be a fabulous sheep-like creature. With its attempt at an encyclopaedic collection of all things, the cabinet of curiosities is often seen as a precursor to the nineteenth-century museum of natural history or other modern-day museums. Collections such as Worm's were, of course, entirely dependent upon the funds and interests of those who were privileged enough to create them.

Artists such as the surrealist Joseph Cornell, or most recently Mark Dion or Damien Hirst, have created their own small-scale 'cabinets of wonder', revealing an ongoing fascination with the human desire to explore, collect, categorise, name, sort or preserve elements of the world around us – activities that Susan Hiller believes are as intrinsic to the act of making and viewing art as they are to the disciplines of psychoanalysis or archaeology. **AC**

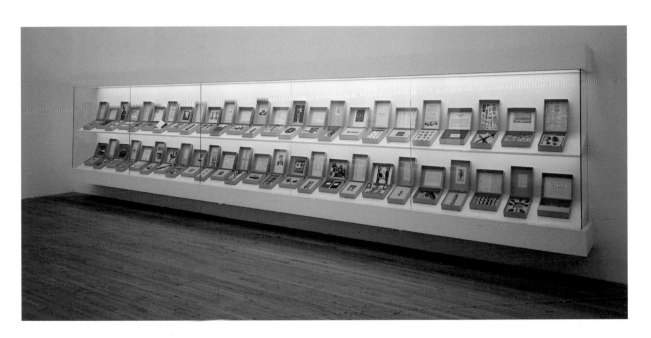

Susan Hiller was born in the United States, where she carried out fieldwork during her studies in archaeology and anthropology, before moving to London in 1967. Becoming disillusioned with the disciplines in which she trained, in particular their claims to objectivity, she turned to art as a means to express a more subjective vision. However, her academic background remains evident in many of the works she has produced throughout the last thirty years. Her art often incorporates existing cultural artefacts that have been sorted or classified in some way. *Dedicated to the Unknown Artists* 1972–6 consists of 305 postcards of rough sea views, collected by the artist and accompanied by charts and notes exploring the linguistic and visual descriptions of the seas. Using words and images from both high art and popular culture and a variety of media, Hiller explores ideas about gender, desire, language and memory. Much of her work also relates to her fascination with the unconscious and to 'unnatural phenomena'. Her major installation *Belshazzar's Feast, The Writing on Your Wall* 1983–4 makes reference to the Old Testament account of the appearance of mysterious signs or writings on the wall of Belshazzar, the King of Babylon. Exploring ideas of transmission and interpretation, the installation was also inspired by newspaper stories that the artist had read about ghost images appearing on television.

The carefully labelled archaeological collecting boxes in Hiller's *From the Freud Museum* 1991–6 bring together her collection of private relics and souvenirs. The work was developed after she was invited to create an exhibition at the former London home of the psychoanalyst Sigmund Freud, himself a collector of ethnographic art and artefacts. While Freud's collection reveals much about the accepted taste and cultural preconceptions of his time, Hiller has called her own a deliberate 'archive of misunderstandings, crises and ambivalences'. **AC**

Susan Hiller
born 1940

From the Freud Museum
1991–6
Mixed media
220 x 1000 x 60 cm
Purchased 1998

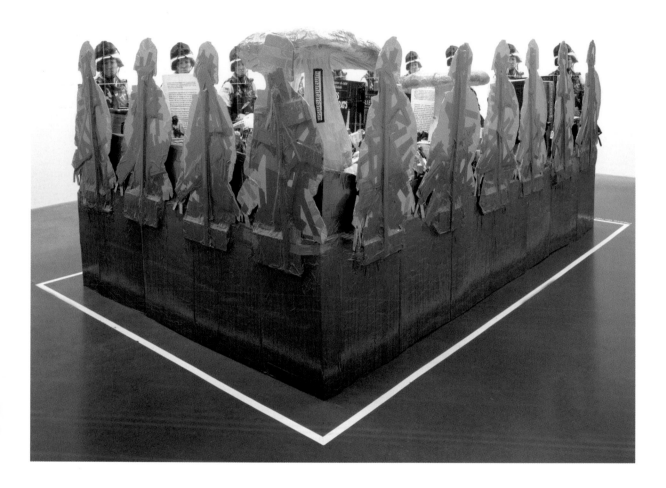

Thomas Hirschhorn is best known for sculptures and installations that comment on contemporary political and social issues. He uses banal, base materials including paper, foil and cardboard bound together with packing tape in apparently haphazard constructions. In his use of inherently unstable materials, Hirschhorn deliberately undermines the permanency of traditional political monuments.

Drift Topography 2003 comments on the Second Gulf War and the crisis in Iraq. Larger-than-life cardboard cut-outs depicting armed American soldiers surround a cityscape built of cardboard, boxes, plastic petrol containers and aluminium foil, punctuated by politically relevant books and photocopied extracts from newspapers and magazines in English and Arabic. Gigantic mushrooms rise from the centre of the construction suggesting the fecund decay of wartime and alluding to nuclear clouds.

Candelabra with Heads 2006 is a sculpture in which eight biomorphic forms made of packing material covered in brown packing tape appear to grow from a roughly constructed wooden armature. A partially covered bald mannequin head emerges from each form, giving the sculpture uncanny and disquieting anthropomorphic resonances. This sculpture belongs to a series the artist refers to as 'Concretions' in which he relates the geological and medical concept of concretion to a 'hardening' in contemporary culture. The solemnity or ceremonial connotations of the candelabra of the work's title are undercut by the deliberately crude and oversized construction of Hirschhorn's sculpture. **RT**

Thomas Hirschhorn
born 1957

YBA
YBA stands for Young British Artists, a group that emerged in the late 1980s and shook the foundations of British art. The group received public attention for the first time with the *Freeze* exhibition, curated by Damien Hirst, while he was still a student at Goldsmiths College in London. Attended by most of the YBAs and renowned for its influential teachers, such as Michael Craig-Martin, Goldsmiths had in previous years already been shaping new ideas and promoting new forms of cultural production. An overall characteristic of the YBAs was a consistently maintained openness towards the media of art and the form that it could take.

The YBAs came to prominence with a series of exhibitions held at the Saatchi gallery, then housed in a converted factory building in north London. Charles Saatchi subsequently became the most dedicated patron and collector of Britart, as the work of the YBAs was dubbed. The group gained intense media attention and some of them developed their art in tandem with their public personae. They also fostered a new interest in artist-curated shows in disused industrial spaces, something which became a trend in the 1990s and profoundly influenced the making of exhibitions in the following years. **EB**

Damien Hirst's work is imbued with his constant preoccupation with life, death, truth, love and art itself. He has, since his graduation from Goldsmiths College in 1989, pushed the boundaries of art, science and the media. A tiger shark suspended in a formaldehyde-filled glass case, the hatching and decay of butterflies, lifeless animals carefully arranged in vitrines and abstract paintings generated by machines, are only some of the means Hirst has employed to express the anxiety surrounding human existence.

Medicine and its by-products is a favourite theme for Hirst, who views it as the agent of resistance to death, our almost desperate attempt to control and temporarily postpone the end. *Pharmacy* 1992 combines much of his trademark elements with the breadth and impressiveness of a large-scale installation. The sterile environment, which emulates a real chemist's shop, envelops the viewer, who is confronted with unquestionably factual symbols – reminders of the unavoidable, such as the prominently suspended fly-zapper in the middle of the room.

The most notorious figure of the YBA generation, Hirst has cunningly interlinked his media-supported celebrity image with his art, thus offering a contemporary continuation of the tradition established by artists such as Salvador Dalí and Andy Warhol. Owing his debt to Francis Bacon, Donald Judd and Joseph Beuys, among others, Hirst has developed a signature art that has branded him as one of the most famous, or infamous, contemporary British artists. **EB**

Pharmacy
1992
Glass, faced particleboard, painted MDF, beech, ramin, wooden dowels, aluminium, pharmaceutical packaging, desks, office
Display dimensions variable
Purchased 1996

Damien Hirst
born 1965

Over the past thirty years Roni Horn has produced drawings, photographs, sculptures, essays and books, in which she seeks to challenge our perceptions and to offer experiences on a range of levels, and to actively engage the viewer with the work. For her sculptures she has often used plain, geometric forms, which is why her work has been linked to that of minimal artists such as Donald Judd and Sol LeWitt. However, in minimalism, sculpture is seen in terms of space, whereas for Horn it represents the 'physicality of a symbol'.

Nature and language are her principal interests, and symbolism, mythology and metaphor are central to her work. In *Thicket No.2* 1990 two solid, polished aluminium rectangles are embedded with yellow plastic letters which refer to William Blake's words 'Tyger tyger burning bright' from *Songs of Innocence and of Experience* (1789). The poem appears to refer to the Creation and to extol the Creator: 'What immortal hand or eye/Dare frame thy fearful symmetry?' Horn has been working with paired objects since 1980. For her, presenting identical objects in pairs is not about geometrical symmetry, but a way of exploring identity and difference. Horn has said that her interest in pairings, as well as the way in which she explores so many different idioms, relates to her own androgyny. **EB**

Thicket No.2
1990, reconstructed 1999
Aluminium and plastic
11.5 x 66 x 367.7 cm
Presented by Janet Wolfson de Botton 1996

Roni Horn
born 1955

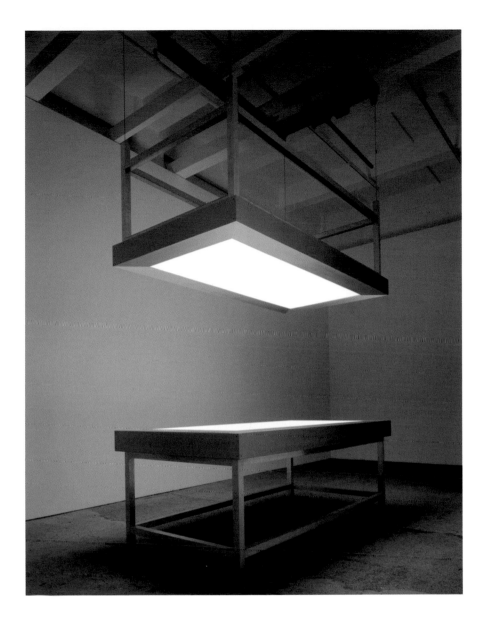

Lament of the Images
2002
Glass, perspex, metal,
electrical components
420 x 248 x 122 cm
Presented by the Latin American
Acquisitions Committee with
additional funds provided by
Steven and Solita Mishaan 2005

Alfredo Jaar makes photographic, light and text installations that examine the mass media, the medium of photography and the question of representation, in particular in relation to histories of power, violence and exploitation. His aim is 'to make art out of information most of us would rather ignore.' In an era in which we are bombarded with images but also, through their ubiquity, often made blind to them, Jaar believes that photography can deny the imagination both aesthetic and emotional engagement. He seeks to make visible again the social, political and human issues that are obscured in this process; his works refer to the fate of immigrants and refugees, the post-colonial condition and the effects of global capitalist production.

Jaar's main concern with the politics of images and their circulation is particularly clear in the works that he developed around questions of blindness and erasure. These include the sculptural installation *Lament of the Images* 2002 which relates closely to a three-room project with the same title. In contrast to the larger project, this sculpture is kinetic and is made from two light-tables; the upper, inverted table moves slowly down to meet the one situated on the floor. When this happens, the brilliant white light is extinguished and the gallery is plunged into darkness causing a dazzling or symbolic 'blinding' of the spectator. Jaar employs this process as a metaphor for our general awareness, diminished by the everyday flood of images and information. He also uses it to remind us of the power and domination exerted through the control of 'classified' images or those deemed to be sensitive by governments or corporate-owned archives. **TB**

Alfredo Jaar
born 1956

0 through 9
1961
Oil on canvas
137.2 x 104.8 cm
Presented by the Friends
of the Tate Gallery 1961

'I tend to like things that already exist', Jasper Johns has said of his subject matter. A leading figure of American pop art, he is known for using maps, flags, targets, numbers and other iconic and instantly recognisable subjects as the basis of his paintings, prints and sculptures. He was influenced early in his career by Marcel Duchamp's 'readymades' – found objects presented as works of art – and has consistently undermined conventional ideas of artistic originality by borrowing existing imagery from popular culture and other artists. His work combines simplicity and contradiction, and is best understood in relation to his love of poetry, psychology and philosophy, particularly the work of Ludwig Wittgenstein. 'Sometimes I see it and then paint it. Other times I paint it and then see it', he has remarked.

0 through 9 1961 is a highly characteristic work. Johns let the process of superimposing the sequence of numbers 0 to 9 dictate the structure of the painting. This allowed him to concentrate on the material qualities of the paint, building up a rich and complex surface as if making an abstract work. Johns's lifelong interest in processes of mark-making have also informed his extensive output in screen printing, lithography and etching. In printmaking he found a medium whose emphasis on repetition suited both his interest in popular imagery and his love of experimentation. He is now recognised as one of the most innovative printmakers of the late twentieth century. **SH**

Jasper Johns
born 1930

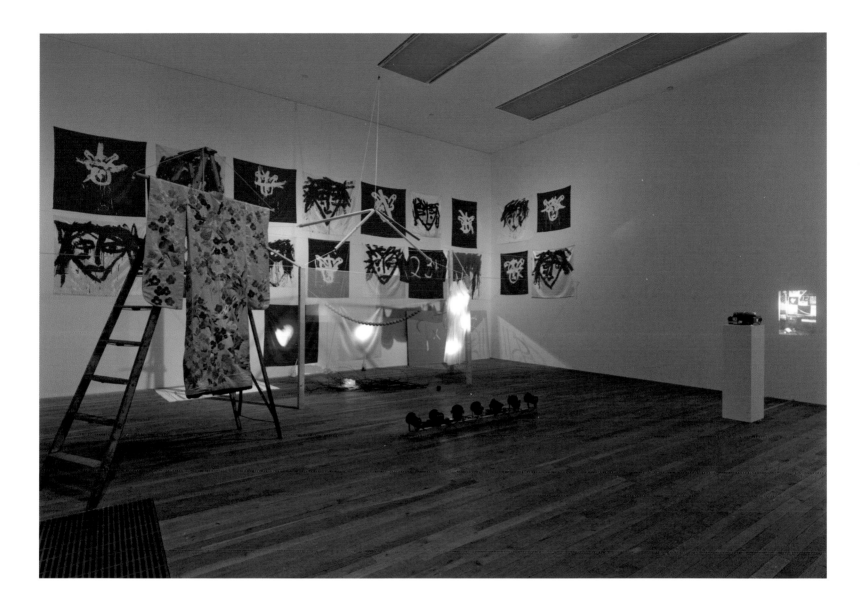

Although she began her career making sculpture, Joan Jonas has consistently experimented with new technologies and, she was one of the first artists in New York to incorporate film projection into her performances in the late 1960s. Jonas has always been drawn to the ancient narratives of world mythology and theatre. *Songdelay* 1973, for example, is a film of a choreographic action that drew upon her experience of Noh performers in Japan.

Jonas herself performed in her works between 1972 and 1976, sometimes as 'Organic Honey' (her masked alter ego), an 'electronic erotic seductress'. Drawings, costumes, masks and attempts to 'inhabit' the projected image, explored questions of identity, perception and memory. For Jonas, the

mirror and the mask became symbols of the feminine: of female self-portraiture, representation and reality versus the imaginary.

The Juniper Tree 1976 was the first work that Jonas specifically structured around a narrative, combining fairy tales, mythology, poetry and folk songs, into a complex, non-linear theatrical presentation. It retells an archetypal Grimm Brothers tale of a wicked stepmother who murders her stepson and the boy's revenge once reincarnated as a bird. The original performance was developed, through re-presentation, into the installation in which Jonas combined sound, projected slides, drawings, objects and lighting.

In later works, such as *Volcano Saga* 1985, Jonas experimented with new video technology as ways of transposing mythological content. In the installation and performance *Lines in the Sand* 2002, commissioned for Documenta XI and presented live at Tate Modern in 2003, she investigated themes of the self and the body via a narrative drawn from H.D.'s (Hilda Doolittle) epic poem 'Helen in Egypt' (1951–5), which reworks the myth of Helen of Troy. **CW**

The Juniper Tree
1976/1994
Mixed media
Display dimensions variable
Purchased with funds provided by the American Fund for the Tate Gallery 2008

Joan Jonas
born 1936

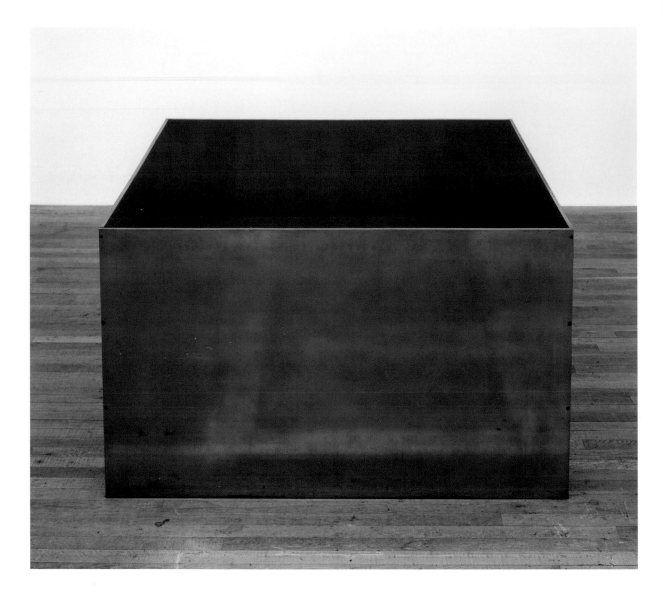

Seriality
From the 1960s many artists associated with minimalism experimented with seriality, using predetermined systems such as a simple mathematical progression or the repetition of a standard modular unit to structure their work. This approach to making art was anticipated in the serial production methods of abstract expressionist painters such as Mark Rothko, Jackson Pollock and Willem De Kooning, and can be traced back even further to Monet's series of paintings of individual motifs such as haystacks. However, by using industrial methods of production and operating according to a predetermined methodical system, artists of Judd's generation were able to avoid making intuitive or compositional decisions during the art-making process, thus making work that existed entirely in its own right and not as an expression of the maker's thoughts. By making works consisting of a number of identical components arranged at equal intervals from each other, Judd draws the viewer's attention to the intervening spaces. He also produced series of subtle variations on basic forms, emphasising the dramatic changes of effect that may arise when using different materials or making minor alterations to the form. Robert Morris's four mirrored cubes (*Untitled* 1965/71, p.190) are arranged so that the viewer can walk around them, setting up a complex series of reflections. **HS**

Donald Judd began making three-dimensional objects in order to pursue his interest in volume, space and colour. Rejecting the traditional European values of composition and representation, he wanted to eradicate all trace of the artist's hand, and was one of the first artists to have his work industrially manufactured. Concentrating on a limited number of forms, strikingly rendered in contrasting materials and colours, Judd created an astonishing range of visual effects.

In *Untitled* 1972 the austerity of form is in marked contrast to the sensuous effect of light hitting the red enamel base and reflecting on the copper interior walls of the open box structure. By encouraging concentration on the volume and presence of the structure, as well as the space around it, Judd's work draws attention to the relationship between the object, the viewer, and its environment.

In the 1980s Judd began to make works composed of metal units bolted together. In most of these pieces the individual components are enamelled in intense colours, which Judd carefully arranged so that no two components of the same colour would adjoin each other. Some formed large-scale floor pieces, whilst other smaller works such as *Untitled (DJ 85-51)* 1985 were designed to be hung at a specific height on the wall. *Untitled* 1989, Tate's floor piece, is one of a number of works of identical shape and size, but the only one entirely composed of galvanised iron.

Judd also engaged with philosophy, architecture, design and politics. His extensive writing and legacy of work has greatly influenced succeeding generations of artists and designers. **HS**

Untitled
1972
Copper, enamel and aluminium
91.6 x 155.5 x 178.2 cm
Presented by the American Fund
for the Tate Gallery 1992

Donald Judd
1928–1994

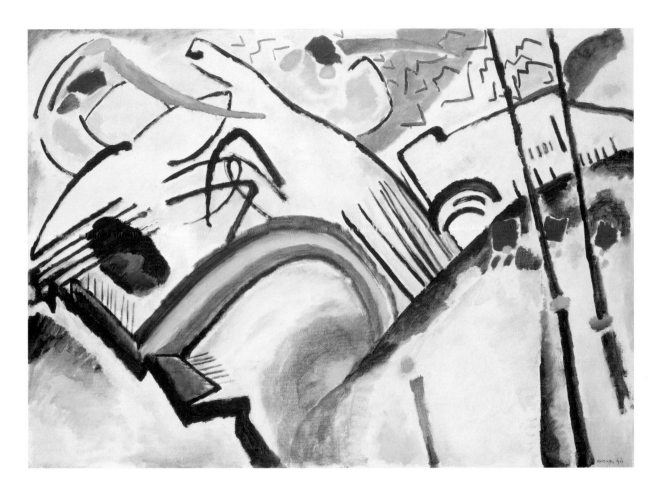

Synaesthesia
'Synaesthesia' is a term used to describe both a neurological condition and an artistic device. From the Greek *syn* meaning 'union' and *aesthesis* meaning 'sensation', it refers to the literal or artistic overlapping of the senses. A synaesthete may be able, for example, to see sounds, hear colours, or taste a tactile sensation.

In the early decades of the twentieth century, the composer Alexander Scriabin was creating experimental orchestral works that synthesised sound and coloured light. Around the same time, Wassily Kandinsky and the futurist Filippo Tommaso Marinetti were devising their own synaesthetic systems. Kandinsky is said to have experienced synaesthesia from a young age. Early in his career, he created abstract stage productions, also using coloured light, with titles such as *The Yellow Sound* and *Green Sound*. He was influenced by the music of Wagner and Schoenberg, as well as the theosophical writings of H.P. Blavatsky. His most widely known paintings – his 'Improvisations' or 'Compositions' – make clear reference to music and use colour and line in a free way to express 'inner necessity' or spirituality. **AC**

Cossacks
1910–11
Oil on canvas
94.6 x 130.2 cm
Presented by Mrs Hazel McKinley 1938

Wassily Kandinsky
1866–1944

Wassily Kandinsky was one of the pioneers of abstract art. In his distinctive path towards non-figuration, he used the symbolic power of colour and the directional thrust of line to create fully abstract paintings before the First World War. By reducing the descriptive details of recognisable motifs – frequently, castles on hills or horseback riders – he stripped away superfluous elements, leaving calligraphic lines as structuring devices within his compositions. Kandinsky conceived of his art as an alternative pathway to a spiritual realm, made more powerful by not being tied to the observed world. The essential qualities of sound, its unfolding through time, and the structures and tonalities of musical orchestration became critical analogies for his experiments in painting. To underline these links to the abstract characteristics of music, he titled many of his works 'compositions' and 'improvisations'.

Kandinsky's path toward abstraction was gradual and incremental. Early on, his imagery was inspired by folklore scenes and icons he encountered in Russia. Other influences were the heightened natural colours of the fauvist art he saw in Paris in 1905–6, and the landscape of southern Germany, where he lived and painted with the artist Gabriele Münter in the early years of the twentieth century. When the First World War broke out, he returned to Russia, soon becoming involved in the artistic activities of the fledgling Bolshevik State. After a short-lived return to figuration in a rococo style, his paintings gradually evolved towards a more centred, contained and linear expression in response to the work of other artists such as Malevich and El Lissitzky. Becoming disenchanted with an increasing political control over artistic expression, he left Russia for Berlin in 1921, and was invited to join the Bauhaus, where he remained until the National Socialists closed the school in 1933. He settled in Paris in 1933, where he continued to work until his death in 1944. **SR**

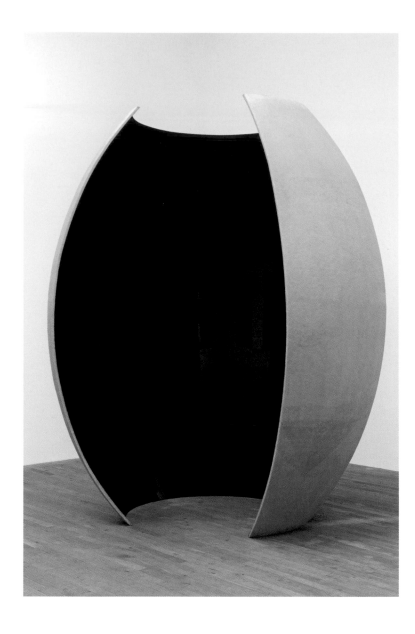

In the past three decades Anish Kapoor has challenged the boundaries of sculpture. Polarities such as place and placelessness, darkness and light, substance and emptiness have been central to his work and are expressed through a wide spectrum of materials. His early, powder-pigment coated sculptural groups were followed by works that explored the void, either as freestanding objects or as architectural interventions in the museum space. A continuous passage from convex to concave and from matt to polished surfaces is characteristic of his work, as are visual references to ancient art combined, however, with a bold exploration of abstract forms and unorthodox materials.

Kapoor's enigmatic forms induce in the viewer a heightened awareness of his or her own presence and perceptions. In *Ishi's Light* 2003 the egg-shaped sculpture's outer shell is rough, gradually shading into the sharply contrasting, highly polished interior, thus creating a smooth transition from the tangible to the intangible. The dark, deep colour of the sculpture's reflective interior concavity magnetically invites the viewer inside the work, where one's presence suddenly seems to hover in silence, experiencing emptiness not as nothingness, but as a transition towards a different perception of space and time. **EB**

Ishi's Light
2003
Fibreglass, resin and lacquer
315 x 250 x 224 cm
Presented by Tate International
Council 2005

Anish Kapoor
born 1954

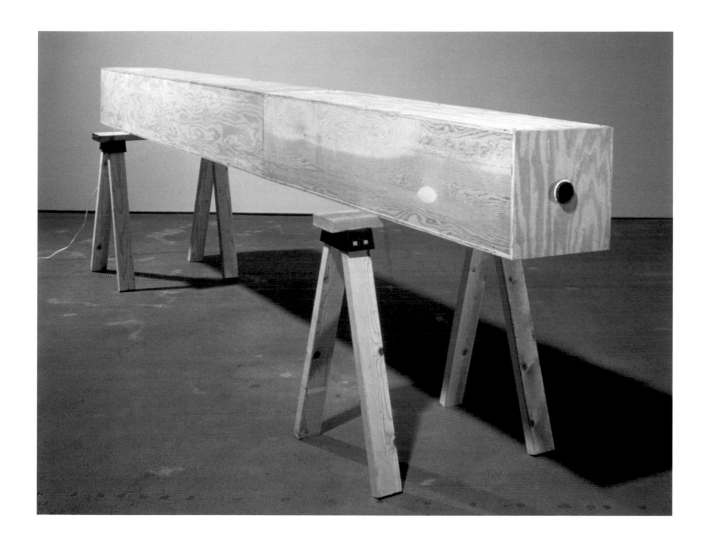

Through his installations and performances Mike Kelley has explored themes of failure, abjection and psychoanalysis, often via imagery taken from popular culture. His work might be characterised as a form of conceptual 'surrealism'. As a student at CalArts in the 1970s, Kelley was influenced by the approach of John Baldessari and the performances of Matt Mullican and Stewart Sherman. His subsequent performances – evolving towards the complex cross-disciplinary format of *Plato's Cave, Rothko's Chapel, Lincoln's Profile* 1985 – were also affected by his parallel project, the rock band *Destroy All Monsters*, and by musician Sun Ra.

The themes of dysfunctionality, subversion and repression shifted focus in the mid 1980s when he began working with found objects, specifically soft toys. *More Love Hours Than Can Ever Be Repaid* 1987 had craft items such as cuddly toys and Afghan textiles sewn onto canvas, reflecting on the way tokens of affection can be invested with desire. This related to Kelley's interest in the borderline between the animate and inanimate in *The Uncanny*, the archive that constituted his 2003 Tate Liverpool show. In *Channel One, Channel Two and Channel Three* 1994, the placement of elements and the grating noise played in the boom box are deliberately informal yet unsettling.

Biography (albeit openly fabricated at times) became increasingly important for Kelley in the 1990s. In 1995 an incomplete architectural model of the institutions in which he had studied formed the core of his project, *Educational Complex*. In 2005 his major exhibition *Day is Done* took found photographs from American High School yearbooks as a starting point for theatrical 'episodes' in which he played out imagined versions of the original events. The photographs, sets and videos were presented in a grand, fairground-like maze that represented a form of the popular subconscious.
CW

Channel One, Channel Two, and Channel Three (detail of Channel Two)
1994
Wood, plastic and audio track
Display dimensions variable
Lent by the American Fund for the Tate Gallery 2007

Mike Kelley
1954–2012

White Curve
1974
Painted aluminium
161.9 x 513.1 cm
Purchased 1980

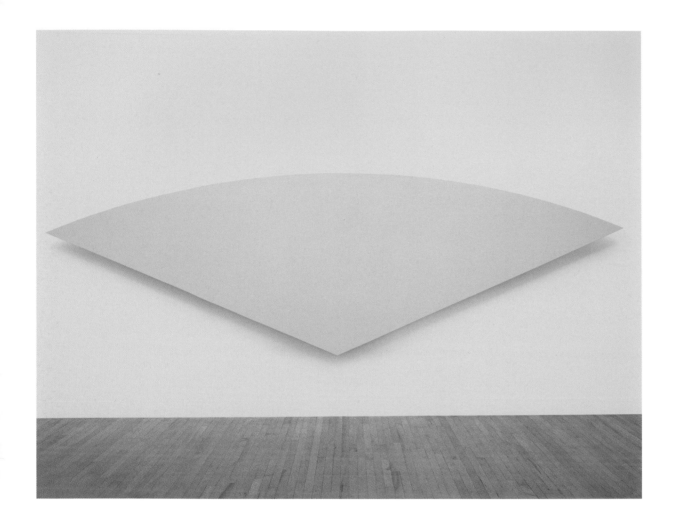

Ellsworth Kelly's work engages with the act of looking in a direct way. His paintings and sculptures are intended to heighten the viewer's awareness of 'pure experience' in physical and visual dimensions. Since the 1950s Kelly has based his art on simple things observed in the real world – small fragments of everyday life such as the spaces between buildings or the shadows cast by trees. He develops and refines what he sees through a series of drawings and collages before arriving at the final abstract motif.

In the late 1940s Kelly went to Paris, where he was influenced by Romanesque and Byzantine architecture as well as surrealism and neo-plasticism. On moving to New York in 1954 he was associated with the abstract expressionist movement, although his work emphasises the flat surface of the picture plane through the use of simplified form and dominant monotone colour, which are more usually associated with minimalism. *Broadway* 1958 is one of a series of paintings made in New York when Kelly was experimenting with the relationship between figure and background. The red form dominates through its flat physical presence while the white segments surrounding it suggest a perspectival view.

Kelly continued to reduce the painted background until, by the late 1960s, he had entirely jettisoned the rectangular backdrop support in favour of the literal background space of the wall. A frequent form is the fan shape featuring in *White Curve* 1974, a monochromatic painting made on sheet aluminium, which hangs at a distance from the wall, occupying a place between painting and sculpture in its relation to the architectural space. **EM**

Ellsworth Kelly
born 1923

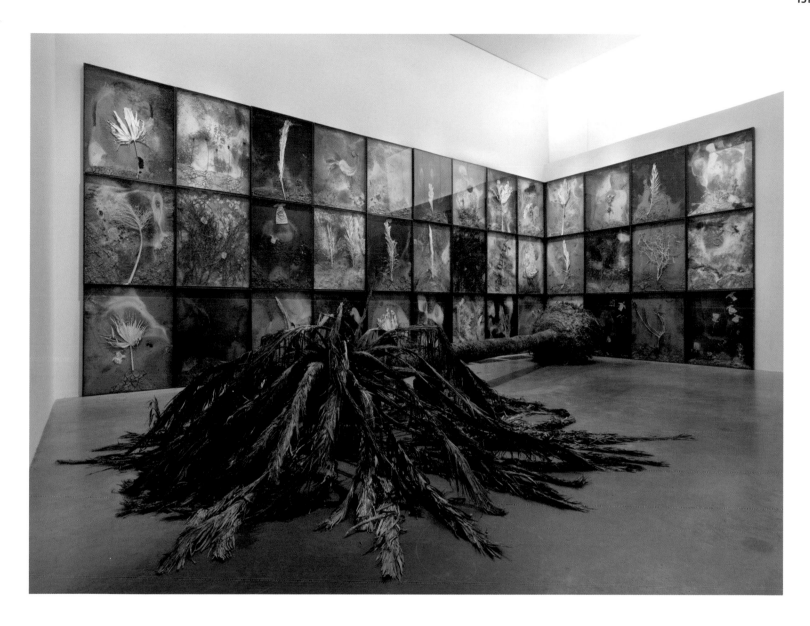

Among the generation of German artists who examined the troubled history of their parents' generation, Anselm Kiefer has consistently captured the ambiguities of its layering of silence, myth and tradition. A profoundly learned artist, he has explored a wide range of historical and cultural references, including the classic texts of the German enlightenment, Biblical and Cabalistic sources, as well as the legacy of the more recent Wagnerian and Nazi past.

A one-time student of Joseph Beuys, Kiefer came to prominence in 1969 with a series of actions he called *Occupations* in which he photographed himself making the Nazi salute – a one-time commonplace transformed into a taboo – in European sites laden with historic resonances. These works (a number of which are now in the ARTIST

ROOMS collection) addressed the continuing presence of the past, just as the grand-scale *Parsifal* paintings of 1973 are both Wagnerian and inscribed with the names of the then contemporary left-wing terrorists of the Baader-Meinhof group. A confrontation with the ambiguities of ideologies is also found in the huge image of Mao Zedong, *Let a Thousand Flowers Bloom* 2000; the optimism of the dictator's statement and valedictory pose is counteracted by the dry briers that protrude from the painting's surface.

Kiefer's command of grand themes is epitomised by *Palm Sunday* 2006, the gallery-size installation in the ARTIST ROOMS collection of a fallen palm tree and layers of steel-framed vitrines containing paintings encrusted with clay, hair, clothes, dried plants and other evocative material. Many bear inscriptions in different languages referring to the story of Christ's entry into Jerusalem that would culminate in the Crucifixion. In common with other of Kiefer's works, *Palm Sunday* offers the potential for immersion in complex issues of history, philosophy and religion whose possibilities are far from being predetermined. **MG**

Palm Sunday
2006
Mixed media
Display dimensions variable
ARTIST ROOMS Acquired jointly with the National Galleries of Scotland through The d'Offay Donation with assistance from the National Heritage Memorial Fund and the Art Fund 2008

Anselm Kiefer
born 1945

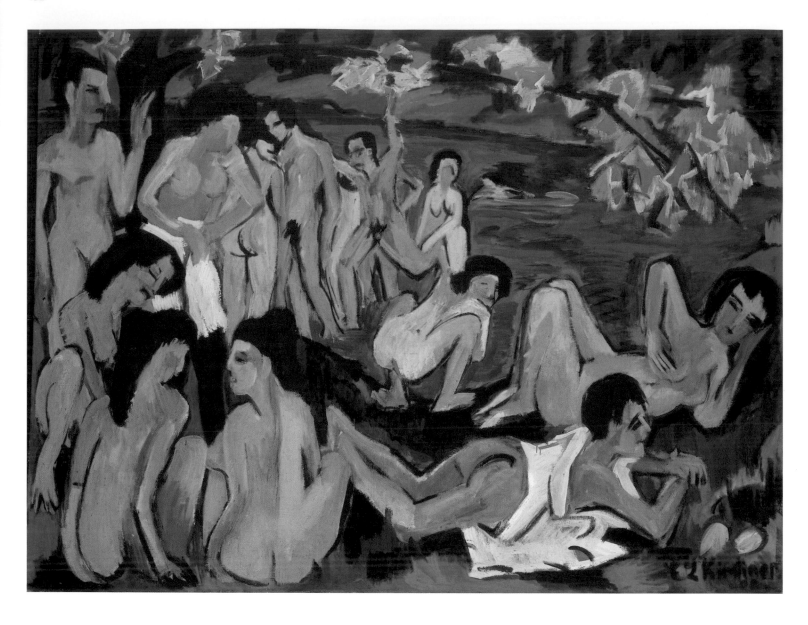

Ernst Ludwig Kirchner aimed to create paintings that expressed freedom from social and artistic conventions in both style and subject matter. His jagged brushwork and often garish palette were common features of Brücke (Bridge), the artistic group he co-founded in Dresden in 1905. Influenced by the Parisian art world and inspired by non-European art, Kirchner's loose handling of paint exemplified a shift towards an expressionist mode of representation.

The nude was a crucial motif for Brücke artists and Kirchner frequently depicted models relaxing in his Dresden studio or frolicking in the countryside, at one with the natural world. Against the backdrop of a growing cult of nature and nudist movements, associated in Germany with a specifically national ideal, Kirchner was in some senses invoking a conventional subject. However, in works such as *Bathers at Moritzburg* 1909/26 the openly sexualised depiction of interaction between men and women took what was a mainstream notion into more shocking territory. In particular, the reclining female figure at the right and squatting woman in the centre appear to turn provocatively towards the viewer. Living on the margins of bourgeois society, Kirchner's explicit breaking of moral codes can be equated with his ambitions for artistic liberation.

Brücke was short-lived and by 1913 Kirchner had shifted his focus to the decadence of the modern era. In a series of celebrated urban street scenes made in Berlin, his increasingly taut and angular style seems to anticipate the tensions of the First World War. **LA**

Bathers at Moritzburg
1909/26
Oil on canvas
151.1 x 199.7 cm
Purchased 1980

Ernst Ludwig Kirchner
1880–1938

IKB 79
1959
Paint on canvas on wood
139.7 x 119.7 x 3.2 cm
Purchased 1972

During his brief but influential career, Yves Klein sought ways to evoke the immaterial or invisible in his art, what he called the 'void'. As a teenager he had once day-dreamed of signing 'the far side of the vault of heaven' and thus claiming it as his 'greatest and most beautiful artwork'. He devoted his career to attempting to render the void tangible.

Uninterested in the traditional values of representation, Klein believed that colour could be a subject in itself, and in the late 1940s he painted his first 'monochrome', a flat field of a single, vibrant colour. Fascinated by the effects of the colour blue, which he saw as giving 'rise to a sense of immersion in a space greater than infinity … the blue is the invisible becoming visible', he developed a technique of combining pure pigment with synthetic resin to make a distinctive and intense colour, which he patented as 'International Klein Blue'. He produced nearly 200 monochrome canvases of varying textures, including *IKB 79* 1959, and went on to apply the pigment to three-dimensional objects, including sponges, a globe and replicas of iconic statues.

Klein also introduced a performative aspect into his work. In 1960 he conducted performances in which nude models were painted blue then instructed by the artist to press themselves against the canvas, creating an imprint of their torsos and thighs, the areas of the body in which Klein felt the creative energy of the universe could be found. In another series known as the *Fire Paintings*, a flame thrower was used to create images on specially treated cardboard. **HS**

Yves Klein
1928–1962

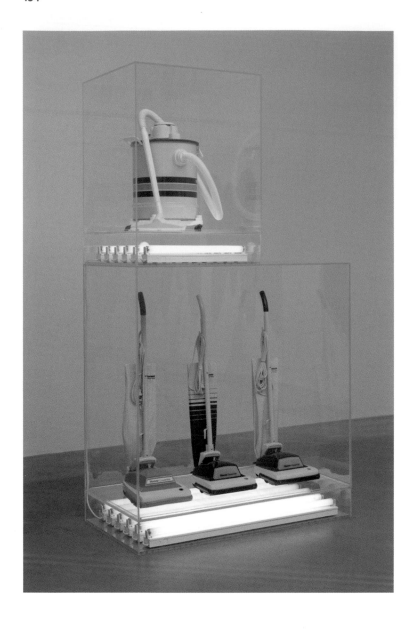

*New Hoover Convertibles,
Green, Red, Brown, New Shelton
Wet/Dry 10 Gallon Displaced
Doubledecker*
1981–7
Vacuum cleaners, plexiglass
and fluorescent lights
251 x 137 x 71.5 cm
ARTIST ROOMS Acquired jointly
with the National Galleries of
Scotland through The d'Offay
Donation with assistance from
the National Heritage Memorial
Fund and the Art Fund 2008

'The New' was the simple title that Jeff Koons chose in 1980 for his first sculpture series. It immediately demonstrated his intimate relationship with the complexity of popular visual culture. Isolated in specially constructed cabinets, he presented commercial domestic appliances as art objects. *New Hoover Convertibles* 1981–7 is one of these arrangements, with the vacuum cleaners uplit as modern icons. The works made with basketballs (p.213) extend this approach into another realm of commerce and popular activity: sport. Self-consciously working within the tradition of Marcel Duchamp's readymades and Andy Warhol's *Brillo Boxes*, Koons completely immersed himself in the strategies of appropriation whilst also gauging the cultural temperature of the moment.

In the later 1980s, sex, as the ultimate measure of the *zeitgeist*, became a dominant theme. Koons and his wife starred in images that were simultaneously sexually explicit and idealised, as epitomised by their billboard coupling *Made in Heaven* 1989. Using richly contrasting practices – from advertising to traditional carving – Koons used and addressed the popular imagery of Hollywood, television and magazines.

His embrace of kitsch is similarly astute. The *Easyfun Animal Mirrors* 1999 (p.31) tap into the merchandising of cartoon characters. Koons raised the diagrammatic outlines and perfect surfaces to a grand scale. Each was editioned in different colours, though Koons specially selected the unique group of nine in the ARTIST ROOMS collection to complement the individual animals. Once installed, the multiple reflections achieve a complex optical effect of infinite blends of colours. **MG**

Jeff Koons
born 1955

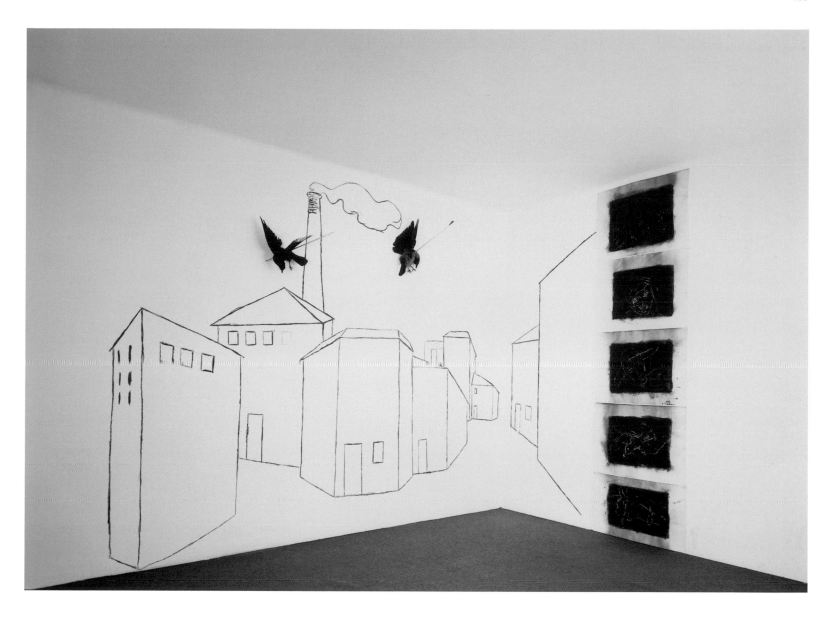

Jannis Kounellis's quasi-theatrical installations, which incorporate materials as diverse as iron, cotton, coal, coffee, wood, fire, stones, plaster, earth, sacks, plants and live animals, challenge with their boldness of realisation and depth of meaning. His name has been inextricably linked with the arte povera movement.

Originally from Greece, Kounellis moved to Italy to study art in the late 1950s and has been living there ever since. He often invests his work with references to history, architecture and myth. *Untitled* 1979 brings together these interests with potent symbols such as smoke, a reference to erasure and regeneration, and birds, which signify hope and freedom of imagination. It looks back to his very early works, made in the 1950s, featuring large stencilled letters and symbols on paper, but also foreshadows his large-scale installations of the 1980s and the 1990s where he employed industrial materials such as coal and iron combined with symbols alluding to human presence, such as fire. **EB**

Untitled
1979
Charcoal, paper, arrows and stuffed birds
360 x 500 cm
Purchased 1983

Jannis Kounellis
born 1936

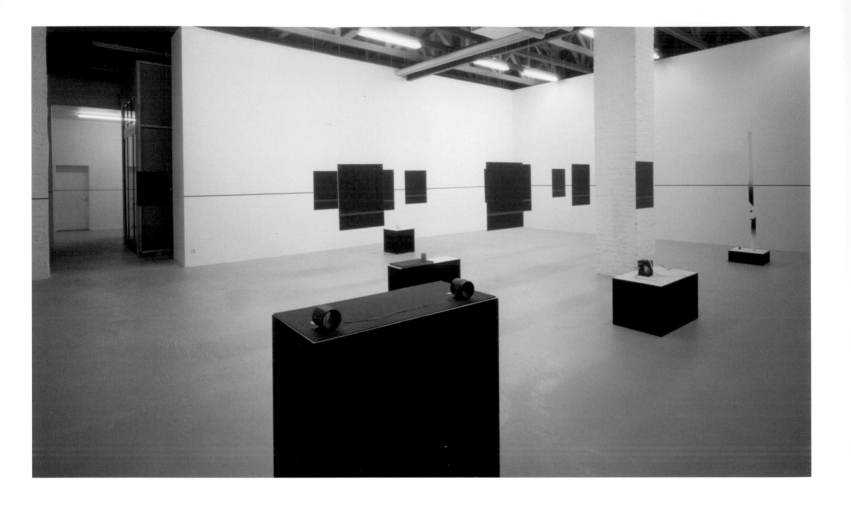

Edward Krasiński is considered one of Poland's most significant avant-garde artists. His earliest works, made in Krakow, were surrealist paintings, while later, having moved to Warsaw in 1954, he became acquainted with the constructivist artist Henryk Stażewski and the performances of Tadeusz Kantor. Both impacted Krasiński's subsequent work that combined formal and material concerns with conceptual questions relating to perception, communication and the physical nature of the object in space. During the mid 1960s the artist became preoccupied with the reduction of sculpture to mere line and created objects from found

materials such as telephone cabling, rubber and wire. Many of these small objects explored the transmission of energy. The artist paid particular attention to the installation of these works, often showing them on pedestals arranged in labyrinthine configurations, reflecting on both their presence in space and the mechanisms involved in presenting artworks in an institutional setting.

Around 1970 Krasiński shifted his concerns from the material to a more rigorous exploration of the conceptual framework around an art object following his chance discovery of blue Scotch tape in 1969. The intervention of single lines of tape, marking out and unifying objects and space, became his signature, always installed at a height of 130 centimetres. In 1973, the artist made his first 'axonometric' paintings, entitled 'Interventions', which he displayed in groups connected by a strip of blue tape. *Untitled* 2001, a room installation consisting of twelve suspended mirrors of equal size, is intended to be seen alongside objects by the artist placed on pedestals and the axonometric paintings all linked together by the blue tape line. **JM**

Untitled
2001
Mirrors and tape
Twelve parts,
each 50 x 60 x 0.4 cm
Display dimensions variable
Presented by Tate Members
2007

Edward Krasiński
1925–2004

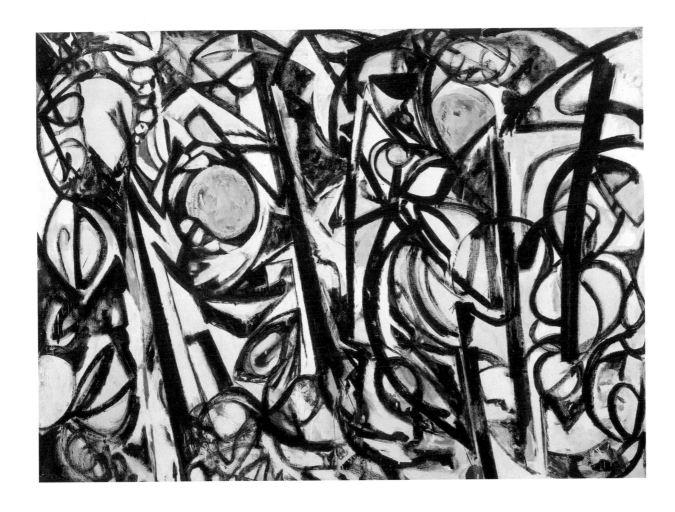

Lee Krasner was the only female painter associated with the first generation of abstract expressionists. Like many American artists forging a career during the Depression era, she initially depended mainly on government work, and was involved in a number of public art projects. Although her early paintings were figurative, after studying at the Hans Hofmann School of Fine Arts in the late 1930s, she started to explore vigorous and expressive forms of abstraction. In 1945 she married the artist Jackson Pollock and together they moved out of New York City to a rural village in Long Island. Although the period that followed was a productive one for Krasner, her reputation was largely eclipsed by Pollock's extraordinary rise to fame.

In interviews, Krasner insisted that her life and work were inseparable, and it was immediately after Pollock's death in a car accident in 1956 that she created her most memorable paintings. *Gothic Landscape* 1961 is characteristic of her work during this period, its violent brushstrokes suggesting an outpouring of grief. At the time of making the work, Krasner was suffering from insomnia and was mainly painting at night. This may explain the limited palette of blacks, whites, ochres and browns. Although it is essentially an abstract painting, the thick vertical lines in the centre can be seen as trees, and in the later 1960s and 1970s Krasner worked with more and more nature-derived imagery. In the fifty years during which she was active, Krasner experimented with an extraordinary range of styles, and was influenced by artists as diverse as Henri Matisse and Piet Mondrian. **SH**

Gothic Landscape
1961
Oil on canvas
176.8 x 237.8 cm
Purchased 1981

Lee Krasner
1908–1984

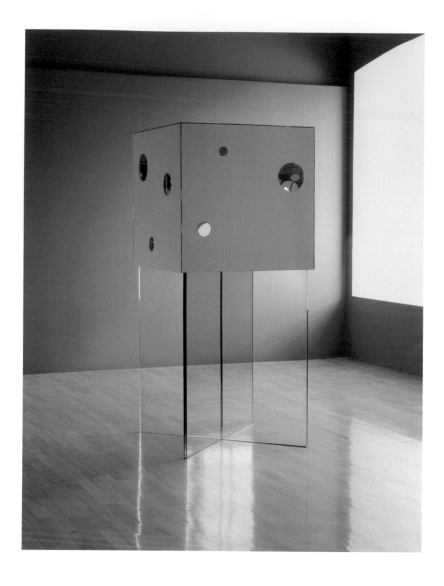

Infused with autobiographical and psychological content, Yayoi Kusama's paintings, collages, sculptures, films, performance art and environmental installations share an obsession with pattern, repetition and accumulation. From childhood Kusama suffered from hallucinations that often took the form of nets or spots multiplying to dominate her field of vision. These hallucinations became the basis of her visual vocabulary. Early in her career she began covering surfaces (canvases, walls, floors and, later, household objects and naked assistants) with polka dots; these would become recognisable motifs in her work. Other bodies of work extended her fixations: since the late 1950s she has made *Infinity Net* paintings where the surfaces of the canvas are covered with repeated net forms. She has also covered household objects with accumulations of phallic protrusions and macaroni in her *Sex Obsession* and *Food Obsession* sculptures and installations.

The Passing Winter 2005 is one of an ongoing series of works Kusama has made using the potential of mirrored interiors to connote infinite space. A mirrored cube is placed at eye level, resting on thick panes of glass arranged vertically to form a simple x-shaped plinth. Apertures in the surface of the cube, in the shape of Kusama's signature polka dots, allow the viewer to look inside. The interior is also mirrored, setting up endless reflections not only of the structure of the sculpture but of viewers regarding the work. The potential for social engagement is a key component of the work. Kusama has also extended her use of mirrors in environmental installations which viewers are invited to enter. **RT**

The Passing Winter
2005
Mirror and glass
180 x 80.5 x 80.5 cm
Purchased with funds provided by the Asia Pacific Acquisitions Committee 2008

Yayoi Kusama
born 1929

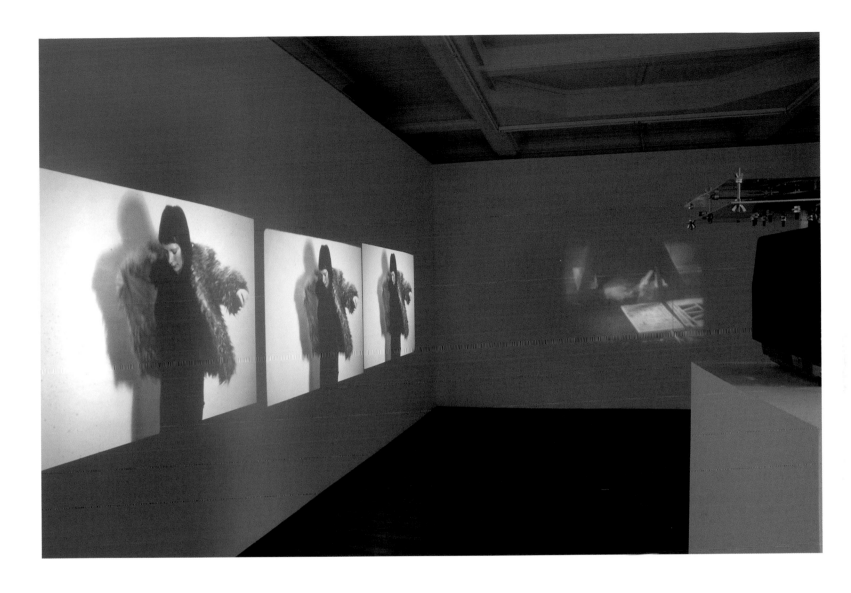

David Lamelas was born in Buenos Aires, where he emerged as a key pioneer of conceptual art practices of the 1960s and 1970s. He is best known for structuralist films and media installations that he produced when living in Belgium, London and Los Angeles. These projects challenge conventional understandings of how meaning is produced and information imparted. His work demonstrates a fascination with interdisciplinary projects, with fiction and role play, and with space, time and location.

Lamelas's personal experience of relocation between Europe and the Americas, imbued his conceptualist concerns with the results of his efforts to assimilate new cultures. *Time*, first performed in France in 1970, consisted of members of the public standing shoulder to shoulder along a line. It begins with the first designated person telling the time to the person next to them. They 'hold on' to it for sixty seconds before announcing it to the next participant. The performance continues until the last person announces 'to the world' the final time. In this way, time is perceived as information, as activity but also as a man-made construct.

Film Script (Manipulation of Meaning) 1972, made two years later during Lamelas's period in London, consists of a looped 16mm film projection and three sequences of slides playing simultaneously. The film follows the everyday activities of a young woman (the critic and curator Lynda Morris), walking through the city and going to work (actually Nigel Greenwood's gallery). The slide projectors present slightly different versions of the same story, variously re-editing the sequence of images so as to indicate how meaning can be manipulated. It is one of the first film installations produced by a conceptual artist and deconstructs the relationships between image, narrative, time, and the construction of reality. **SC**

Film Script (Manipulation of Meaning)
1972
16mm colour film and triple slide projection
Displayed dimensions variable
Presented by Tate Patrons 2010

David Lamelas
born 1946

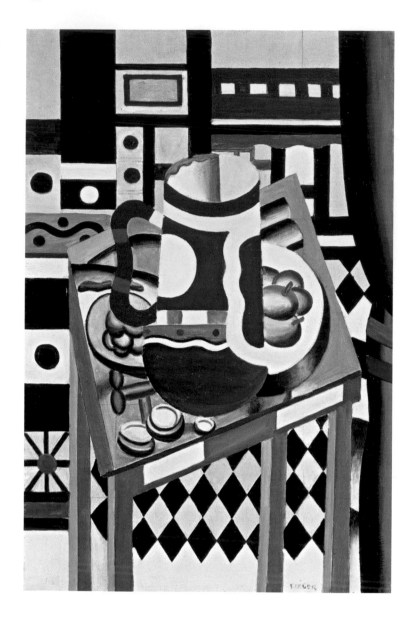

Fernand Léger was apprenticed to an architect in his native Normandy before moving to Paris in 1900, where he worked as a draughtsman while studying at the Ecole des Arts Decoratifs and the Académie Julian. He soon befriended Robert Delaunay and Albert Gleizes, and started exhibiting at the Salon d'Automne from 1907, the year of Cézanne's posthumous retrospective, which left a lasting influence on his work. From 1909, he played a part in the development of cubism, but his rounded, tubular style led a critic to call him a 'tubist'. He had his first one-man show at Galerie Kahnweiler, Paris, in 1912. While serving in the French army in 1914–18, he developed a passion for machines and industrial design. Around 1920, he met Le Corbusier and Amédée Ozenfant, and both architect and painter encouraged his interest in mechanical forms. In the early 1920s, Léger's work became more precise and mathematical, as is evident in works such as *Still Life with a Beer Mug* 1921–2. The geometric patterns and flat, schematic depiction of the subject-matter shows the influence of the 'call to order' that swept through the Parisian avant-garde at the time. In the late 1920s, he began to introduce natural forms into his paintings, such as the curving lines and organic shapes in *Leaves and Shell* 1927. During the Second World War, he took refuge in the United States, teaching and painting sporadically in San Francisco, New York and Quebec. Upon his return to France, evidence of his love for modernity, everyday street life and workers began to emerge in more loosely composed canvases such as *The Acrobat and his Partner* 1948. By the time of his death in 1955, he had created one of the more recognisable and popular styles in twentieth-century art. **CB**

Fernand Léger
1881–1955

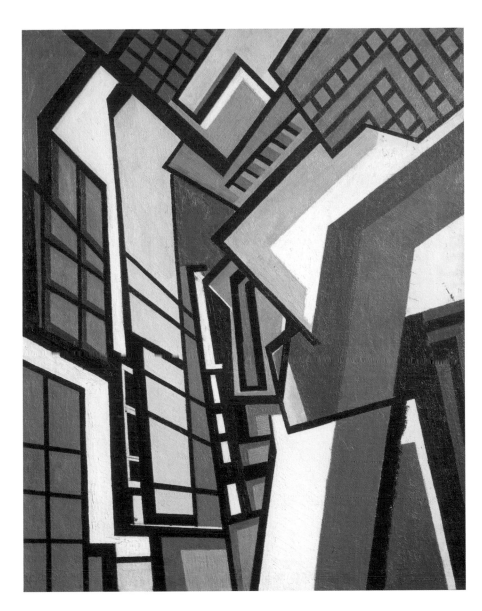

Workshop
c.1914–15
Oil on canvas
76.5 x 61 cm
Purchased 1974

Wyndham Lewis had a turbulent private life and his career as an artist and writer was rarely free from controversy. His role as founder of vorticism in the years immediately preceding the First World War, however, cast him as a great innovator, and a key figure in the history of modern British art. He was an extremely fine draughtsman, and his painted works in oil and watercolour show a fascination and ability with colour and a keen eye for design.

After a period studying in continental Europe in the early years of the twentieth century, Lewis began experimenting with his own brand of modernism. Although no oil paintings survive from this period, existing drawings of abstracted figures show his understanding of cubism and a particular stylistic debt to futurist artists such as Umberto Boccioni, whose work was exhibited in England around 1912.

In 1913, Lewis was temporarily associated with the London-based Bloomsbury group, contributing designs in their craft-based Omega studio. However, following a disagreement with the group, Lewis embarked on his own venture of vorticism, creating works characterised by a bold, near-abstract style that reflected his complex attitude to the modern world. The urban metropolis is evoked through dramatic, angular compositions peopled with automatons and dominated by skyscrapers. The composition of *Workshop* c.1914–15 suggests both the physical interior of the artist's studio and his inner, creative space. The painting has also been linked to the popular Victorian view of Britain as the 'Workshop of the World', a view supported by Lewis. The deliberately brash palette and uncomfortable, claustrophobic geometry reflects Lewis's confrontational approach and relentless attack on tradition. **LA**

Wyndham Lewis
1882–1957

Five Open Geometric Structures
1979
Painted wood
92 x 672 x 91.4 cm
Presented by Janet
Wolfson de Botton 1996

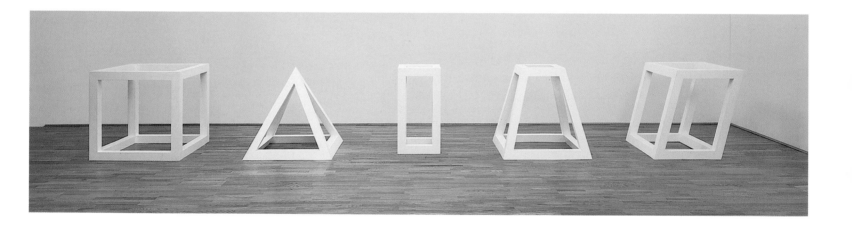

Sol LeWitt
1928–2007

Sol LeWitt is seen as a leading figure in both minimal and conceptual art. Since the 1960s he has created a distinctive idiom and produced a wide range of work including site-specific wall drawings and paintings, sculpture, design objects, drawings and prints. Reacting against what he and many of his contemporaries considered the emotional extremes of abstract expressionism, LeWitt looked for inspiration to the legacy of German and Russian constructivism. His interest in structures and rejection of the subjective led him to define a personal vocabulary based on simple geometrical forms, particularly the cube and the grid, which he employed to construct his highly individual, complex works. Sculptures such as *Five Open Geometric Structures* 1979 are impersonal works made by assistants according to his instructions. Challenging to the eye and mind, these are based on systems that may seem logical, since they are meticulously organised following a carefully premeditated idea. They are, however, as the artist himself has commented, intuitive, purposeless, and not illustrative of theories.

LeWitt started making wall drawings in the late 1960s. Drawn by competent draughtsmen on a prepared wall from a set of instructions, they explore combinations and permutations of lines and colours. They are devised in such a way that they can be carried out in almost any space, within reason, and will fit that space. They are thus to a degree site-specific. Although they are fundamentally explorations of two-dimensional surfaces, the site-specificity of the drawings obliges the viewer to perceive them as part of the three-dimensional space in which they are installed. **EB**

Whaam!
1963
Acrylic and oil on canvas
172.7 x 406.4 cm
Purchased 1966

Roy Lichtenstein is best known for his distinctive cartoon style in which bold black outlines and areas of regular dots imitate scaled-up areas of mechanical printing. He developed this signature style in the early 1960s, producing his first paintings based on characters from comic strips in 1961. Rejecting the personal, expressive style of abstract expressionism, Lichtenstein turned to the clichéd content of commercially produced comic strips, challenging what had previously been acceptable as art. Comic strips were ideal material for the new pop movement, which, like cubism earlier in the century, focused on common objects and experiences. Lichtenstein appropriated comics for their ability to express highly charged emotional subject matter in a manner that is stylised and obvious, distancing them from their content. He saw them as an ideal means to reflect what he believed to be the dominant visual culture in America at that time.

Formal concerns are central to Lichtenstein's comic-strip paintings, which are not simple copies but are carefully adjusted for maximum aesthetic impact, combining flat, graphic simplification with the monumentality of classical archetypes. For Lichtenstein, cartoons were a contemporary version of the ideal forms represented in classical art. He compared his reduction and distillation of his source material to the processes employed by Picasso, in which stylised features become emotive symbols. The double-canvas work *Whaam!* 1963 typifies this approach. In 1962–3 Lichtenstein made many paintings based on war comics, in which violent acts feature as aestheticised and stylised motifs. Other comic-strip paintings depict intimate moments in the home, the speech bubbles expressing thoughts and feelings at once banal and reassuringly human. **EM**

Roy Lichtenstein
1923–1997

Glenn Ligon first gained notoriety in the United States in the late 1980s, creating conceptual, text-based paintings that investigated the social, linguistic and political construction of race, gender and sexuality. Ligon's practice encompasses painting, printmaking, sculpture, installation and video. His work, which incorporates diverse sources such as literary texts, photographic scrapbooks, sayings from Muhammad Ali and Richard Pryor's jokes, addresses issues of quotation or appropriation, and the representation of individual identity in relationship to culture and history.

Malcolm X (version 2) #1 2000 is one of a series of paintings, based on Black Pride themed colouring books published in the late 1960s and early 1970s, and made by Ligon in collaboration with school children. Ligon selected from the children's colouring exercises, copying their expressive gestures onto canvases over silk-screened black outlines from the books. The image of Malcolm X, one of several in the series, shows the civil rights leader rendered in saturated colour. Ligon has described how the children's gestures exhibited a freedom unmediated by overt concerns with identity politics or questions of race.

Untitled 2006, a black neon sculpture spelling out the word 'America' in capital letters, typifies the process of reversal in Ligon's practice. The glass tubes have been painted with black paint, and light is emitted only where the black paint has chipped off. The artist has described the piece as 'a comment on the idea of America as an idealised place, simultaneously represented as a shining light and an eclipsed star.' **TB**

Untitled
2006
Neon and paint
61 x 426.7 cm
Purchased with funds provided by the American Fund for the Tate Gallery 2008

Glenn Ligon
born 1960

Sculpture
1915–16
Limestone
98 x 28 x 18 cm
Purchased with assistance
from the Friends of the Tate
Gallery, Mrs Jack Steinberg
and the Rayne Foundation 1982

One of the most significant cubist sculptors, Jacques Lipchitz developed cubist ideas on the analysis of form throughout his career. While his earliest sculptures were naturalistic representations of the human figure, after being introduced to the work of cubist painters, including Pablo Picasso, Lipchitz began experimenting with the application of the principles of cubism to the sculpted object. Attempting to engage the imagination of the viewer, he explored novel ways in which form could be represented. Some works from this period depict the 'negative space' around the object by rendering it as solid and incorporating the resultant form into the sculpture.

Sculpture 1915–16 is one of Lipchitz's earliest cubist works, developed from his assemblages made the previous year. While the work appears entirely abstract, it in fact represents a figure seated at a table, rendered from a characteristically cubist grouping of intersecting geometric forms. The totemic structure also bears a close relationship to architectural forms, exaggerated by its rendering in carved stone (from a clay model).

Concerned that the forms were not recognisable in his sculptures, Lipchitz soon began to make his work less rigorously abstract. His investigations into space developed with a series of dynamic pictorial constructions called 'transparents'. In his later period, his work is dominated by semi-abstracted, muscular human figures, often illustrating religious and mythological subjects. Despite their stylistic differences from sculptures made during his high cubist period, these works too have an ambiguity and simplification of form that Lipchitz maintained was informed by cubist principles. **MB**

Jacques Lipchitz
1891–1973

'My work is about my sense, my instinct, my own scale and my own physical commitment.' In this summary, Richard Long indicated the role within his art of a response to, and his personal place within, the world. He added: 'It is about real stones, real time, real actions'. Long's key early work to realise these interests was *A Line Made by Walking* 1967, in which the line was made by his repeated passage across a meadow. This delicate interaction in nature has associations with primeval path-making but it is also laden with an appreciation and response to the environment and the passage of time. The work is lost with natural regeneration; only the trace, in the form of Long's photographic record, remains.

Many of these interests linked Long's activities to colleagues in America and in Europe (he participated in *Arte povera + azioni povere* in Amalfi in 1968). However, much of Long's work has developed around solitary, often epic, walks that propose a rethinking of the tradition of landscape art often considered to be quintessentially British. As well as interventions recorded along his documented walks, Long has often identified materials on these journeys and used them in pieces assembled as more permanent artworks. The qualities of mud mixed for wall drawings and the placement of sticks or stones in floor pieces bears witness to the physical experience of the artist's body while conforming to certain essential geometrical forms, especially the line and the circle. In this way *Small White Pebble Circles* 1987, for instance, reflects the reach of his outstretched arms while also alerting the viewer to the extraordinary uniformity and diversity to be found in nature. **MG**

Small White Pebble Circles
1987
Marble pebbles
4 x 200 x 200 cm
Presented by Janet Wolfson de Botton 1996

Richard Long
born 1945

Drumroll
1998
Video installation, 22 min 8 sec
Lent by Pamela and Richard
Kramlich and the American
Fund for the Tate Gallery,
fractional and promised gift, 2000

Steve McQueen belongs to a young generation of British artists working in film and video. He has developed, since the early 1990s, an original practice, which challenges the conventions of cinema and furthers the possibility of his medium. Extreme uses of techniques such as editing, close-ups and framing endow his works with a dramatic character, while repetition, the position of the camera and a focus on details and the action of the protagonists lend his films ambiguity and tension.

McQueen's early works were predominantly black and white, without sound. *Drumroll* 1998 marks a shift to colour and is his first film to use sound. It is a triptych of projected images documenting the rolling of a metal oil barrel down the streets of Manhattan. Cameras affixed to the edges and centre of the barrel reproduce rotating images of shop fronts, the traffic in the streets and flashes of the sky, while the soundtrack is composed of the traffic din and the clatter of the barrel. The viewer is thus placed in the centre of the artwork. *Drumroll* exemplifies the importance of the human body in McQueen's practice. It also brings together other recurring themes in his art such as journeying, movement, dislocation and exile.

McQueen won the Turner Prize in 1999. His challenging feature films *Hunger* (2008) and *Shame* (2011) have been greeted with acclaim. **EB**

Steve McQueen
born 1969

René Magritte played on perceptions of reality, producing apparently recognisable images in disconcerting and unfathomable narratives. Initially involved with a group of Brussels-based intellectuals, Magritte was drawn into the Parisian surrealist group in the mid 1920s. As with many surrealist artists, he found inspiration in the metaphysical painting of Giorgio de Chirico. He developed a deadpan, hyperreal painting style through which he aimed to examine 'the naked mystery of things'. In contrast to the biomorphic abstraction found in Yves Tanguy's work, Magritte composed his paintings from a vocabulary of objects taken from the everyday world.

Many of these objects have symbolic meaning, often derived from the writings of the psychoanalyst Sigmund Freud. The bowler hat and candle found embedded in the lead plaque in *The Reckless Sleeper* 1928, for example, represent the female and male sexual organs. While living in Paris between 1927 and 1930, Magritte became immersed in the surrealist preoccupation with dreams and the subconscious, which can be seen manifested in this work, in which a sleeping figure is depicted in a coffin-like structure, evoking uneasy associations.

The Annunciation 1930 is one of Magritte's largest canvases. The magisterial and strangely quiet landscape includes an odd assortment of objects, including two bilboquets, a term Magritte used to describe the sculptural objects reminiscent of chess pieces or wooden balustrades which appear regularly as anthropomorphic figures in his paintings. The title invokes a religious subject, but has also been seen as a provocative strike at André Breton for his anti-Catholic attack on Magritte's wife for wearing a crucifix. **LA**

René Magritte
1898–1967

Left:
The Annunciation
1930
Oil on canvas
113.7 x 145.9 cm
Purchased with assistance
from the Friends of the
Tate Gallery 1986

Above:
The Future of Statues
1937
Painted plaster
33 x 16.5 x 20.3 cm
Purchased 1981

Kasimir Malevich was the founder of suprematism, a pioneering abstract art movement that he described as an attempt 'to free art from the dead weight of the real world'. Writing in 1927, he went on to proclaim that 'Art no longer wants to serve the State and Church, it no longer wishes to illuminate the history of manners, it wants to have nothing further to do with the object as such, and believes that it can exist in and for itself without "things".'

Born in Ukraine, Malevich was in his mid twenties when he moved to Moscow to study art. He quickly absorbed the lessons of impressionism, cubism and futurism, producing paintings that combined the formal innovations of the French avant-garde with the strong colours and stylised figures of peasant folk art and icon painting. In 1915 he launched suprematism with an exhibition in St Petersburg. The signature painting was a black square against a white background, which he placed high in the corner of the gallery, the position traditionally occupied by the icon in Orthodox homes. This gesture reflected his belief in the spiritual, even mystical qualities of abstract art.

From the simple static forms of the early suprematist paintings, Malevich began to create works such as *Dynamic Suprematism* 1915 or 1916, in which an array of geometrical shapes appear to be in flux, clustering together or drifting apart. The asymmetrical tilt of the white triangle provides a restless background to the composition, which keeps a fine balance between order and disintegration.

After the October Revolution, Malevich was increasingly absorbed in teaching, writing and developing architectural projects. He went back to painting in the late 1920s, partly returning to figuration. Many of these late works depict the peasant culture that was now threatened by Stalin's policies of collectivisation. **SBo**

Dynamic Suprematism
1915 or 1916
Oil on canvas
80.3 x 80 cm
Purchased with assistance
from the Friends of the
Tate Gallery 1978

Kasimir Malevich
1878–1935

Cadeau
1921, editioned replica 1972
Iron and nails
17.8 x 9.4 x 12.6 cm
Presented by the Tate
Collectors Forum 2002

Man Ray (born Emmanuel Radnitsky) was a painter, photographer, draughtsman, filmmaker, and maker of dada and surrealist objects. Along with Marcel Duchamp and Francis Picabia, he was involved in the anarchic dada movement in New York, which emphasised the illogical and the absurd, and encouraged the use of chance in artistic production.

When Man Ray moved to Paris in 1921, he was quickly accepted by André Breton and joined his circle of followers, who later became the surrealists. Inspired by Freud, they tried to tap into the creative powers of the subconscious mind, using bizarre juxtapositions to trigger hidden ideas. They endeavoured to produce work that, in the words of writer Isidore Ducasse, was 'as beautiful as the chance encounter of a sewing machine and an umbrella on an operating table'. Man Ray explored surrealist ideas of chance, desire and dream states through new photographic techniques. By placing objects on sensitised paper and exposing them to light he created 'Rayographs', cameraless photos that made familiar objects seem mysterious and strange. Together with Lee Miller, he also produced 'solarised' photographs, in which the tones of shadows are inverted, making figures appear to float in thin air. However, it was his objects that became iconic symbols of dada and surrealism. *Cadeau* 1921 rendered a domestic iron useless, while endowing it with a new bizarre, humorous and poetic aspect. *Indestructible Object* (p.234) is one of many replicas of *Object of Destruction*, first created in 1922–3 and smashed to pieces by Man Ray himself. By creating a plethora of replicas throughout his career, Man Ray challenged the notion of the artistic 'original' in a true dada spirit of subversion. **CM**

Man Ray
1890–1976

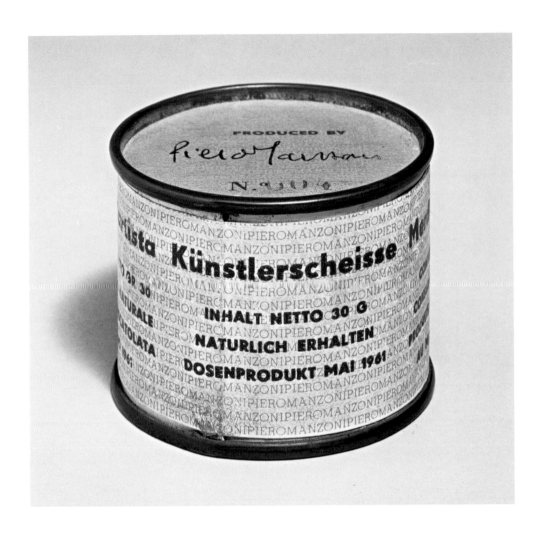

The Abject
The abject has been a central concept in contemporary art, particularly since the beginning of the 1990s. The theory of the abject was developed by Julia Kristeva in her 1980 book *Powers of Horror*. Partly influenced by the writings of Georges Bataille, Kristeva elaborated the abject as elements of the body or bodily functions that are impure and potentially threatening to our cleanliness, propriety and, eventually, order. Excrement, menstrual blood, even the skin on a cup of hot milk are signs of the abject, but Kristeva's primary example is the corpse, which traumatically reminds us of our own mortality. She wrote: 'A wound with blood and pus, or the sickly, acrid smell of sweat, of decay … refuse and corpses *show me* what I permanently thrust aside in order to live.' For artists, the purpose of drawing attention to the abject may be said to be to combat more idealising and complacent views of human nature and existence.

A complex notion, the abject has been adopted by many artists and in numerous ways, including in a feminist context (the abjection of female bodily functions within a patriarchal order) and as the basis of a culture of shock and disgust. Piero Manzoni, Cindy Sherman, Louise Bourgeois, Paul McCarthy, Gilbert & George, Kiki Smith, Robert Gober and Jake and Dinos Chapman are some of the artists whose work manifests the abject. **EB**

Piero Manzoni was one of the most innovative and influential artists of the twentieth century, and is seen as a founder of what came to be known as conceptual art. In his tragically short life he sought to establish an 'imageless' art and to challenge the traditional artistic order. His *Achromes*, a series of reliefs comprising a base covered in white material such as chalk, cotton, fur, bread or polystyrene, were an early expression of his approach, followed by provocative performances staging his ideas, such as marking eggs with his thumbprint and then eating them.

His most notorious works, however, fetishised his own body and bodily functions, for example *Artist's Breath* 1960, one of a series of works in which he blew up a balloon and sealed it to a wooden base.

Artist's Shit 1961 belongs to the same period. Manzoni created ninety industrially sealed and labelled cans containing (as far as we know) his own excrement. The cans were intended to be sold for the weight of their contents in gold (30 grams). The artist said that the contents of the tin was 'the most intimate' thing by an artist that one can own, thus commenting on the desire of collectors for the most authentic possible work of an artist and, beyond that, on the value of the artwork, on the art market and economic systems in general. *Artist's Shit* also foreshadows the near-obsessive exploration of the self that characterises a great deal of contemporary art. **EB**

Artist's Shit
1961
Tin can with paper wrapping with unidentified contents
4.8 x 6.5 x 6.5 cm
Purchased 2000

Piero Manzoni
1933–1963

Sampling
Sampling describes the method of creating a new sound composition by assembling fragments of pre-existing recordings, similar to the visual strategy of collage. This is typically done with a sampler, most often a program on a digital computer, but is also possible with tape loops or vinyl records on a phonograph. Samples often consist of a short section of a song, such as a particular drum beat or guitar riff, that is then used much like a musical instrument to play its part in a complex new arrangement. Though there are examples dating back as far as the 1940s, sampling only became popular in the 1980s as part of the emerging hip hop and rap scene in the United States. In its reliance on 'found' material and its subversion of conventional models of originality, sampling is akin to the readymade, placing a similar emphasis on the artist's selection process and on rendering the familiar unfamiliar. **ABH**

Christian Marclay subverts and transcends traditional boundaries between art and music. He began his career as a musical performer in the late 1970s, when he pioneered the use of records and turntables as media for performance and improvisation, often including scratched, broken or otherwise altered records in his concerts. He works in a wide variety of media including vinyl records, album covers, musical instruments, magnetic tape, photography and video, and his use of 'found' materials, as well as wit and humour, can be traced back to the legacy of Marcel Duchamp's 'readymades'.

Similar to musical recordings made by sampling, Marclay's installation *Video Quartet* 2002 is entirely made up from the visual and musical work of others, mostly Hollywood movies, edited together with Final Cut Pro software on a standard home computer. Marclay has created a kaleidoscopic tapestry of nearly 700 carefully selected clips from films such as *Psycho* (1960), *The Sound of Music* (1965), *Barbarella* (1968), *Poltergeist* (1982), *Back to the Future* (1985) and *Captain Corelli's Mandolin* (2001). *Video Quartet* astutely plays with the common hierarchy between seeing and hearing: whereas it is possible to absorb the soundtrack as one coherent sensory impression, due to the scale of the projection one is not able to take in all four screens at any one time. Thus the customary importance given to image over sound as the driving force of cinematic film is reversed. **ABH**

Video Quartet
2002
Four-screen projection, found Hollywood film clips transferred to colour video, audio track, 14 min
Purchased from funds provided by the Film and Video Special Acquisitions Fund 2003

Christian Marclay
born 1955

Morning
1965
Acrylic and pencil on canvas
182.6 x 181.9 cm
Purchased 1974

In 1957 Agnes Martin moved from New Mexico to New York for a ten-year period, becoming part of the abstract expressionist group. Although she shared with its members, particularly Mark Rothko and Barnett Newman, an urge towards quasi-religious transcendentalism, her paintings are also inspired by her reading of the ancient Chinese philosophy of Taoism. The bare desert landscape of New Mexico, to which she returned in 1967, remaining there until her death in 2004, is also an important source. Since the early 1960s she has made paintings of identical format, the seventy-two-square-inch canvas providing the ground for her meditative expression. In common with minimalist works, Martin's paintings are characterised by geometric abstraction, repetition and reductive simplicity. However, unlike minimalist works, which celebrate impersonal industrial processes, they are made with a delicate hand-drawn line, suggesting emotional states.

For Martin, perfection, the Platonic ideal, has no place in the real world but may only be imagined. The purpose of art, she believed, is to create a visual language that approaches the expression of this perfection, not by being it, but by evoking it. This perfection may also be understood as 'abstract emotion', the kind of sublime, wordless emotion conjured by music and by art rather than the common feelings triggered by events in people's lives. *Morning* 1965 is one of a group of paintings whose titles name things in nature that may arouse a sense of perfect beauty. Its grid of fragile rectangles on white canvas evokes a day in its earliest moments of becoming. **EM**

Agnes Martin
1912–2004

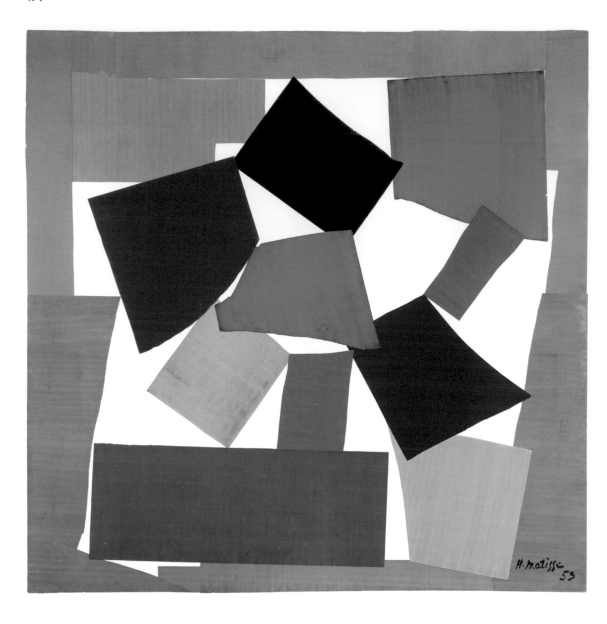

Throughout his long career, Henri Matisse explored the expressive and decorative qualities of colour and form, always drawing inspiration from nature, whether in near-abstract works, or in the arcs and arabesques of landscapes, still lifes and interiors. As a leading member of the Fauve group between 1905 and 1907, his early work was characterised by an animated handling of pure, non-naturalistic colour, inspired by the Mediterranean light.

By 1914 Matisse had simplified his method, limiting his palette and paring down forms in works which approach abstraction. *Trivaux Pond* was made around the time Matisse returned to more literal representation and is one of several landscapes he made in 1916 and 1917 in the Bois de Meudon, a park close to his Paris home. With its linear arrangement of verticals, lyrical blending of motifs and controlled use of greens and blue, the work presents an image of harmony in nature, while retaining something of the more muted quality of his preceding works.

Made some thirty years later, *The Snail* shows Matisse exploring colour and form through very different means. A dynamic example of his late work, Matisse used cut-out painted paper to create bold, decorative images. Based on the curving form of a snail's shell, the roughly torn paper is arranged according to contrasting colours. Despite the obvious differences between this and his earlier painting, Matisse maintained that 'there is no separation between my old pictures and my cut-outs, except that with greater completeness and abstraction, I have attained a form filtered to its essentials … I have preserved the sign which … is necessary to make the object exist in its own form.' **LA**

The Snail
1953
Gouache on paper,
cut and pasted on paper
mounted on canvas
286.4 x 287 cm
Purchased with assistance
from the Friends of the
Tate Gallery 1962

Henri Matisse
1869–1954

Gordon Matta-Clark was the most adventurous artist to emerge from the vibrant lower Manhattan community of the 1970s. During architectural studies at Cornell he encountered land art projects and, on moving to New York, he created sculptures with melted glass, fried photographs, and organic materials. Together with friends he also set up the restaurant FOOD, where the menu could often be described as a series of sculptural concoctions. An important meeting-place, FOOD was subsequently heralded as a precedent for the 'relational aesthetics' artists of the 1990s.

From the early 1970s until his death from cancer in 1978, Matta-Clark made a series of works in and from abandoned buildings. In 1972 he made an installation called *Wallspaper* at the artists' space at 112 Greene Street that he helped to run. In the Bronx he took photographs of painted and wallpapered interior walls that had been exposed when building façades were demolished. He then distorted the colours of the photographs and printed them on newspaper; sheets of the paper were mounted in Greene Street covering its wall with images of walls elsewhere in the city. In other works, Matta-Clark cut into buildings, slicing and removing sections of floors and walls, to create highly unusual spaces. Made at a time of economic collapse in New York, the cuts were a literal deconstruction of urban architecture and an assault on gallery-friendly sculpture. In 1974 the artist's dealer acquired a wooden house in suburban New Jersey which the artist cut down its middle and lowered one side to create *Splitting*. In Paris the next year Matta-Clark cut through two soon-to-be demolished buildings creating *Conical Intersect*, a telescopic view onto the new Centre Pompidou just beyond. Matta-Clark made elaborate films in relation to these projects that convey the disorientating experience of his activities. **MGo**

Wallspaper
1972
72 offset colour prints on paper
Each 87 x 57.6 cm
Lent by the American Fund
for the Tate Gallery 2012

Gordon Matta-Clark
1943–1978

Cildo Meireles is often considered a pioneer of installation art. Born in 1948 in Rio de Janeiro, he was influenced early in his career by a slightly older generation of Brazilian artists, such as Lygia Clark or Hélio Oiticica, who had developed a neo-concretist style – a type of art that involves the viewer in more than the act of distanced observation. Meireles has made works that vary greatly in scale, material or subject matter, though he is perhaps best known for the creation of a number of large-scale environments incorporating sound, smell, or touch and inviting the perceptual engagement of the viewer. His work is often motivated by a strong socio-political consciousness.

Meireles's major installation *Eureka/Blindhotland* 1970–5 makes explicit the non-visual properties of objects – in particular, volume, weight and density, which are normally considered only as implicit aspects of sculpture. The work consists of a number of elements, including 200 black rubber balls of the same size but varying weights, which are placed in a theatrical, spotlit area surrounded by nets. Visitors are encouraged to feel the weights of the different balls, while a soundtrack plays a series of recordings of the balls being dropped from various heights. *Eureka* (meaning 'I have found it') is the word famously exclaimed by the Greek mathematician Archimedes when he entered his bathtub and, observing the displacement of water, discovered the means of determining the proportion of base metal in King Hiero's golden crown. The title of the work thus makes reference to the mathematical principles and physical properties with which the artist is fascinated, and to the reciprocal impact of a body entering a given space. **AC**

Eureka/Blindhotland
1970–5
Rubber, lead, cork, textile, metal, paper and audio
Display dimensions variable
Presented by the American Fund for the Tate Gallery 2007

Cildo Meireles
born 1948

Ana Mendieta left Cuba for the USA as a child and her work is influenced by both her Cuban heritage and experience of exile. In her work she combined her fascination for Afro-Cuban ritual and Santeria religion with contemporary art practices prevalent in the 1970s including performance, body, feminist and land art. While performance was a central part of her practice, Mendieta rarely staged actions for an audience. Instead she filmed and photographed events in which she was a solitary participant, whether in the studio or at specific landscape or archaeological site. She also created drawings and sculptural works that are closely related thematically to the performative works. Critical of the exclusion of artists of diverse races and cultures from the art world, during the 1970s she became associated with a New York circle of feminist artists.

Mendieta's principal recurring motif was the naked female form through which she examined issues of personal identity and femininity. She moved from the use of her own body, in contemporary settings, to the more universal silhouette of her body sited within the landscape. The film *Untitled (Blood and Feathers #2)* 1974 shows an action Mendieta performed at Old Man's Creek in Iowa in which she poured blood over her body and then rolled in feathers, ending with her arms outstretched, seemingly part-human, part-bird. The bird is both a symbol of the spirit and of sacrifice, while water represents rebirth. Her use of blood also has multiple meanings, addressing both sexual violence and Afro-Caribbean religious ritual. Mendieta's performances combined diverse influences including the work of Frida Kahlo (of whom she was an early admirer) and the Vienna Aktionists. **TB**

Untitled (Blood and Feathers #2)
1974
Single channel projection, 8mm colour film transferred to video, silent, 3 min 30 sec
Presented by the Estate of Ana Mendieta Collection and an anonymous donor 2009

Ana Mendieta
1948–1985

Untitled (Living Sculpture)
1966
Aluminium
Displayed dimensions variable
Purchased with funds provided
by an anonymous donor 2009

A participant in the landmark exhibition *Arte povera + azioni povere* in Amalfi in October 1968, Marisa Merz has been associated with the arte povera group from the outset. She has, nevertheless, retained a slight remove from the group; her delicate and ephemeral work, in combination with her personal reticence, has tended to confirm her position as the lone woman among her male colleagues. Even the recollection, frequently expressed by friends, that the home shared with Mario Merz was considered 'her house' lends credence to the equation between domesticity and the female realm that her art simultaneously celebrates and challenges.

Some of these issues are evident in *Untitled (Living Sculpture)* 1966, a crucial work for Merz's practice and made on the eve of the emergence of arte povera. Constructed of sheet aluminium stapled into tubes to resemble anarchic ducting, it formed an environment that dominated the Merz household. Light-weight and suspended from the kitchen ceiling it literally reversed accepted notions of sculpture, occupying and defining space.

Merz's assertion that 'there has never been a division between my life and work' reflects both on her adoption of feminine practices and her role as a woman and mother. These coalesced in the knitted objects, such as *Untitled (Small Shoe)* 1968, that she made to fit her own body. The delicacy of the related geometrical structures strung between needles is shot through with rigour, as she knitted with nylon and with copper wire. Such works, often enlarged and multiplied, have formed the basis of later installations with modelled elements, found and made objects, all of which retain a relationship to the artist's physical experience of the world. **MG**

Marisa Merz
born 1931

Red (detail, as installed) 1968–75
(printed c.1999–2000)
Colour digital print on paper
84 photographs,
each 45.5 x 30.5 cm
Purchased with assistance from
the Art Fund (with a contribution
from the Wolfson Foundation)
and Konstantin Grigorishin 2011

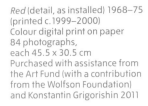

Boris Mikhailov was born in Kharkov, Ukraine, in the former Soviet Union, and came to prominence as a photographer in the 1990s. His work encompasses documentary, modernist and conceptual practices, engaging both with the style of street photography and a more conceptual approach to presentation. Many of Mikhailov's pieces are conceived as large series that are displayed as room-sized installations which examine the politics of everyday life during the Soviet era and its aftermath. His work often focuses on the social conditions of the marginal and most vulnerable figures in society.

In *Red* Mikhailov depicts life in and around Kharkov between 1968 and 1975, using the colour red as a symbolic reminder of the inescapable presence of the Soviet regime.

Each image contains something red in it and the constructivist-inspired arrangement of the photographs reinforces his suggestion that the colour permeated every aspect of daily life, making the ideology of communism omnipresent. Mikhailov has explained that, 'Having united the pictures by red, I got a series about "the soviet". Yes "red" in Russia is beautiful, and blood, and the red flag. Everyone associates red with the official soviet. Maybe that's enough. But few know that red went through all our lives, on all its levels.'

The individual images depict a diverse array of situations and subjects, both private and public. Initially inspired by the demonstrations at which red flags and banners were carried through the streets, Mikhailov then moved on to find flashes of red in every situation he came across. His work has a close-up, bleak and uncompromisingly graphic style that draws attention to subjects that would otherwise be overlooked. The photographs are not simply a document of a time or place but a sophisticated, subjective, even poetic reframing of the effects of social and political conditioning. **SM**

Boris Mikhailov
born 1938

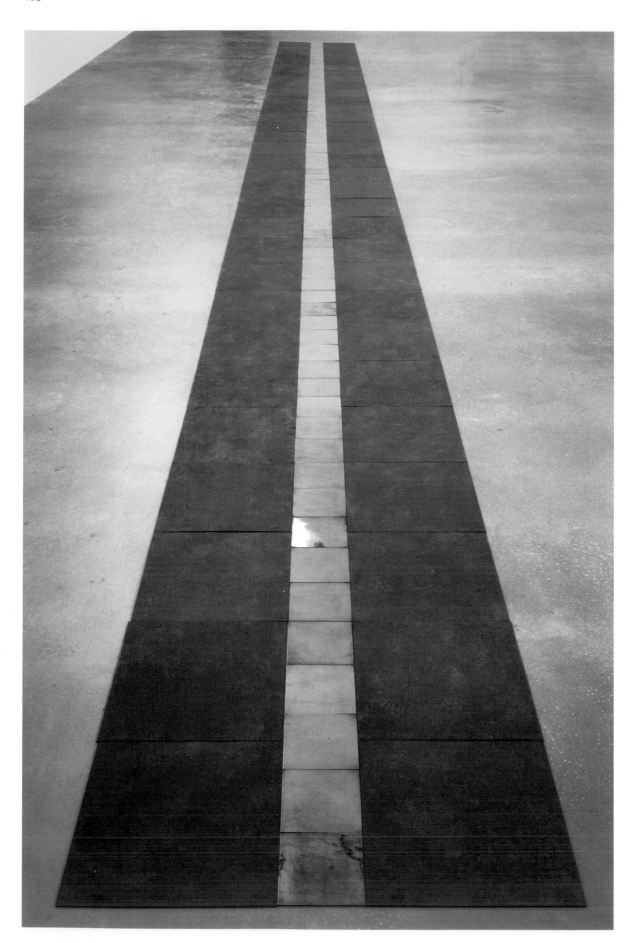

Carl Andre (born 1935)
Venus Forge
1980
Steel and copper plates
0.5 x 120 x 155.5 cm
Presented by Janet Wolfson
de Botton 1996

Minimalism

Minimalism is an extreme from of abstract art and one of the strongest cultural manifestations of the idea that art should have its own reality and form rather than try to represent the world. Also referred to as 'minimal art', it emerged in New York during the early 1960s. The artists who are usually grouped together under the term – Frank Stella, Donald Judd, Dan Flavin, Carl Andre, Sol LeWitt and Robert Morris among them – had no common programme, but all of their work is characterised by cubes, right-angled forms, industrial and manufactured materials, and symmetrical or grid-like arrangements. Many of their ideas were derived from the Russian constructivists and suprematists such as Kasimir Malevich, whose paintings were arrangements of abstract, geometric forms. The term 'minimalism' started to become widespread after the philosopher and art writer Richard Wollheim wrote, in 1965, that there was a wave of contemporary work with 'minimal art content'. Although he was discussing Marcel Duchamp's readymades, Robert Rauschenberg's combine paintings and Ad Reinhardt's black paintings, the term was soon applied to Judd, Flavin, Andre and others, as well as to a whole range of wider cultural tendencies, from music to interior design.

Frank Stella's *Six Mile Bottom* 1960 predates the use of the term 'minimalism' by a few years, but his artistic aims reflect those of Judd and others. To paint the work, Stella used an ordinary house-painter's brush, working with commercial paints taken straight from the can. He wanted to eliminate any representational reading of his work, commenting in 1964 that 'my painting is based on the fact that only what can be seen there is there'.

Carl Andre's *Equivalent VIII* 1966 (p.61), a precise arrangement of 120 firebricks, is an iconic work of minimalist art. A sculpture of extreme simplicity and purity, it invites the viewer to focus on the materials and the context of its presentation. Dan Flavin admired Vladimir Tatlin's proposal for the *Monument to the Third International* 1919, a revolving spiral structure that would have been taller than the Eiffel Tower, and his *'monument' for V. Tatlin* 1966–9 (p.113) demonstrates the minimalist debt to the Russian constructivists. As with all Flavin's sculptures, his homage was made using manufactured fluorescent tubes. As a writer, Donald Judd was minimalism's best apologist and he also became its best-known practitioner. However, he preferred the term 'specific objects' to describe his work, a description that reflects his desire to eliminate any factor that might interfere with the physical qualities of a self-sufficient sculpture. He wrote that 'a shape, a volume, a colour, a surface is something in itself'. The clean lines and industrial materials of *Untitled* 1990 make the sculpture an exemplary piece of late minimalism. Contemporary artists such as Martin Creed, David Batchelor and Anish Kapoor continue to explore minimalism's legacy. **CB**

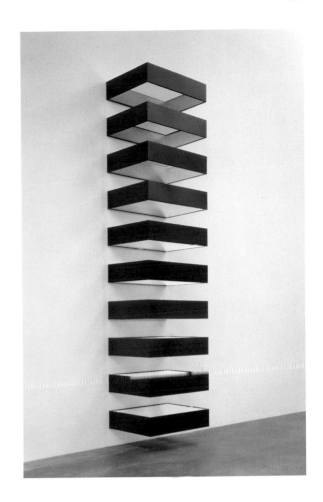

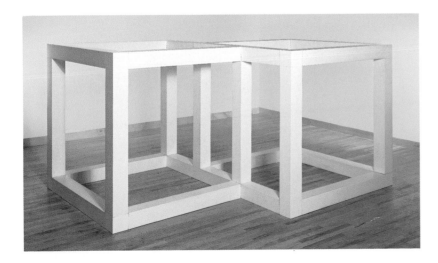

Above:
Donald Judd (1928–1994)
Untitled
1990
Anodised aluminium,
steel and acrylic
Display dimensions variable
Presented by the American
Fund for the Tate Gallery 2002

Left:
Sol LeWitt (born 1928)
*Two Open Modular Cubes/
Half-Off*
1972
Enamelled aluminium
160 x 305.4 x 233 cm
Purchased 1974

Biomorphism
The concept of biomorphism is most commonly linked to evocative but abstract organic forms created by artists during the twentieth century. It is particularly associated with surrealism, and the term was first used in this frame of reference by the American critic and art historian Alfred H. Barr in 1936. The transformative power and strangeness of biomorphic forms appealed to surrealist artists who recognised that, though dislocated from reality, this abstracted imagery evoked the cyclical rhythms of the natural world. Joan Miró's compositions involved configurations of floating amoebic shapes set against flat expanses of colour, while Yves Tanguy populated his canvases with non-human creatures, which appear to have derived from early evolutionary organisms. **LA**

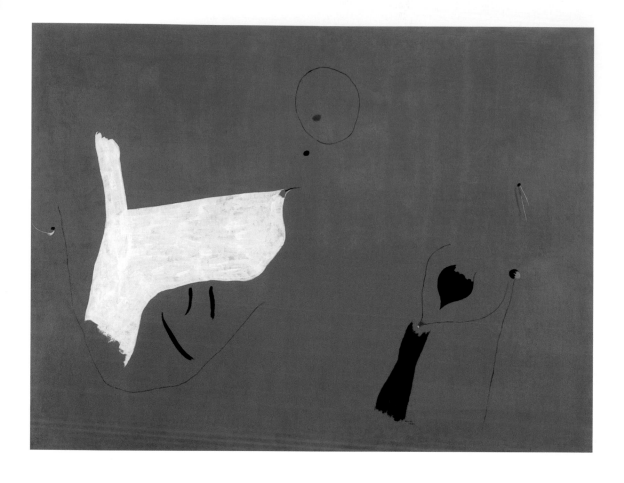

Joan Miró held his first exhibition in Paris in 1925, marking his 'tumultuous entrance' into surrealism. He was viewed by the movement's leader, André Breton, as the exemplary surrealist painter and his working practices, particularly his advocacy of automatic drawing and the important role that poetry held in his work, were in keeping with surrealist concerns.

In spontaneous, abstract compositions, Miró dislocated forms into separate signs that acted as visual metaphors. These ambiguous symbols often represent body parts, sometimes referring to human reproductive processes, such as the black breast-like form that appears to feed a strange, amoebic organism in *Painting* 1927. This work may have been based on Guillaume Apollinaire's 1917 poem 'The Breasts of Tirésias'. Miró frequently used poems as starting points for his work, incorporating his own writing into *tableaux-poemes* (picture-poems), the first of which date from the mid 1920s. He returned to this form in the 1930s in works such as the lyrically titled *A Star Caresses the Breast of a Negress (Painting Poem)* 1938, in which dancing words and images form linguistic and visual rhymes. In his late works, Miró again used colour fields as the backdrop for compositions of complex, abstracted signs. *Message from a Friend* 1964 (p.29) evolved from an image of an upward-facing arrow inscribed on a letter sent to Miró by the artist Alexander Calder. Over several years, Miró made numerous drawings on the theme. By the time he came to paint Tate's version, the arrow had turned downwards, transformed into a great black mass, which penetrates the lower section of the painting. **LA**

Painting
1927
Tempera and oil on canvas
97.2 x 130.2 cm
Purchased with assistance from the Friends of the Tate Gallery 1971

Joan Miró
1893–1983

Tatsuo Miyajima creates works that focus on the concept of time. Having started by making performances in the early 1980s, he has sought, since 1987, to render his art more tangible and enduring, though still performative. To this end he employed LED (Light Emitting Diode) technology for his now famous installations, where sequences of the numbers 1 to 99 and back are presented by digital counters, each working at a different pace. His earlier, relatively static installations of the late 1980s gave way to more animated works during the course of the 1990s. In these, counters are arranged in basic geometrical shapes or in grids, causing the numbers to run in parallel lines and create a variety of rhythms. In *Lattice B* 1990, for example, time appears to be moving in all directions.

For Miyajima time is 'organised freedom', continuous, infinite and inconceivable. He is influenced by Buddhism, and the circularity of Eastern time. As a result, spirals, which represent time in Oriental culture, figure prominently in his works. For him, the LED counters, keeping score in groups of ten and excluding zero, a state of nothingness and unused potential energy, represent the human being, as in Buddhist philosophy. But spirals also relate to chains such as DNA. European philosophy as well as the linearity of Western time are equally important elements in his work. He established his core concept early in his career: 'keep changing, connect with everything, continue forever', continuously striving towards 'one art of all'. **EB**

Lattice B
1990
Light emitting diode
counters
Presented by Janet Wolfson
de Botton 1998

Tatsuo Miyajima
born 1957

Are these images evidence of mental colonisation or did they serve to challenge prevailing images of 'The African' in the western world?

Santu Mofokeng began his career as a street photographer in Soweto, South Africa. From 1985 to 1992 he was a member of Afrapix, a collective of photographers who documented the resistance movement and sought to reveal the inequality and oppression that characterised apartheid. In 1988 he also joined the African Studies Institute at the University of the Witwatersrand where he worked as a researcher and documentary photographer for almost a decade. During this time he pursued several personal projects, going beyond 'struggle' paradigms to document the efforts made by black South Africans to maintain everyday life in what amounted to siege conditions.

In 1992 Mofokeng firmly turned his back on photojournalism and put together an exhibition about Soweto that focused on the personal rather than the political. The show, which included borrowed family albums, led to a major research project that involved photographing and researching images of black working and middle class people taken in South Africa between 1890 and 1950. By reproducing these photographs as slides with intertitles, Mofokeng sought to reinvigorate the original narratives about identity, lineage and personality. They are distinct from the more well known images of the time that supported racist attitudes and ignored the impact of colonialism and the influence of missionaries. Some of the family photographs clearly include props, costumes and staged backdrops. Nevertheless, there is no evidence of coercion and each image presents the subjects' sensibilities, desires and sense of self. Brought to light in the post-apartheid era and first exhibited as a slide installation at the 1997 Johannesburg Biennial, Mofokeng's *The Black Photo Album/ Look at Me* 1997 is an archive of inestimable value that sheds light on a critical time in South Africa's history. **KG**

*The Black Photo Album/
Look at Me*
1997
80-slide projection, black and white, 6 min 40 sec
Purchased 2010

Santu Mofokeng
born 1956

K VII
1922
Oil on canvas
115.3 x 135.9 cm
Purchased 1961

Bauhaus

Mention art education and the conversation will inevitably turn to the Bauhaus, the most influential art and design school of the twentieth century. Founded in 1919 by the architect Walter Gropius, the school counted amongst its teachers some of the best-known artists and architects of its time, including Wassily Kandinsky, Paul Klee, Oskar Schlemmer, Josef Albers, László Moholy-Nagy and Mies van der Rohe. Like many avant-garde practitioners, the Bauhaus masters firmly believed in art as a force of positive social reform: good design for a better world.

Having originally advocated a new unity of art and craft, much in the spirit of the craftsmen working anonymously on Medieval cathedrals, from 1923 onwards the school began to concentrate on designs for industrial production. Bauhaus classics include Marcel Breuer's bent-steel chair, 'Wassily', and Marianne Brandt's semi-spherical silver teapot.

Having left its purpose-designed dwellings in Dessau in 1932, the following year the school was closed by the Nazis. By this time, however, the majority of its most famous teachers had already left, disseminating the utopian Bauhaus ethos across Europe and the United States. **ABH**

Rejecting traditional boundaries between high and low culture László Moholy-Nagy's work encompasses a cornucopia of media including painting, photography, sculpture, film, stage sets and graphic design. Born in Hungary, in the early 1920s Moholy emigrated via Vienna to Berlin, then the Mecca of the Eastern European avant-garde. From 1923 until 1928, he headed the metal workshop and the preliminary course at the Bauhaus. His appointment coincided with the reorientation of the school from handicrafts towards the machine aesthetics of industrial production with an emphasis on clean lines and functional forms.

Originally trained as a lawyer, Moholy had little formal artistic education, initially being drawn to poetry. Deeply shocked by the horrors of the First World War, he embraced the leftist-orientated avant-garde notion of art as a force for social change. This utopian ambition found its visual expression in a rigorously abstract language that broke with art-historical traditions to be democratically accessible to all. Inspired by Russian constructivism and its insistence that art had to be pure and void of any representational references, paintings such as *K VII* 1922 are characterised by Moholy's idiosyncratic emphasis on transparency and light. Built from opaque areas of colour, the geometric shapes seemingly float above each other to create pictorial depth without spatial illusion.

Following the rise of the Nazis, in the mid 1930s Moholy moved to Amsterdam and London before finally settling in Chicago to set up the New Bauhaus (subsequently the School of Design in Chicago and from 1944 onwards the Institute of Design). His teachings and books such as the posthumously published *Vision in Motion* (1947) played a seminal role in the transition of modernist ideas from Europe to postwar America. **ABH**

László Moholy-Nagy
1895–1946

De Stijl
De Stijl (The Style) was a Dutch collective of artists, architects and writers led by Piet Mondrian and Theo van Doesburg that promoted the social and moral function of art, architecture and design. Its theories were put forward in the journal *De Stijl*, first published in 1917. During the 1920s De Stijl became increasingly international, exerting influence on abstract movements and design schools across Europe. Visually, De Stijl is characterised by strictly geometric forms composed of horizontal and vertical lines, which confine themselves to the three 'pure' primary colours – yellow, blue and red – against neutral tones of white, grey and black. This abstract style was intended to express a utopian ideal in which life and art would be integrated harmoniously to renew society, and reflected the important spiritual aspect of De Stijl. Mondrian left the group in 1924 following a dispute with van Doesburg. The *De Stijl* journal continued to be published until 1932.
LA

Piet Mondrian's discovery of cubism, first in Amsterdam and later in Paris in 1912, had a profound effect on his subsequent career. In contrast to the colourful post-impressionist paintings he had previously made, he began to incorporate the visual principles of cubism into his work by reducing his palette to pale monochromes and paring down forms to sequences of intersecting lines and planes. His interest lay in the abstract quality of line, and he explored this in paintings such as Tate's *The Tree A* c. 1913, one of a series of works in which he investigated leafless branches. Driven by a desire to unify the picture surface and to seek out the 'essence' of painting, Mondrian gradually suppressed the subject in favour of a concentration on the formal elements of picture-making. By 1916 he had eliminated all motifs from his work, and by 1920 he had returned to Paris and published his theory of abstraction, termed 'neo-plasticism', reflecting his concern with the 'plastic' or material attributes of painting and form.

In his neo-plastic works, Mondrian aimed to create harmony between line and colour in order to represent essential universal relationships such as male/female, mind/body, and so on. *Composition B (No.II) with Red* 1935 characterises this geometric abstraction. The tension created by the horizontal and vertical lines, which form asymmetrically arranged rectangles, is countered by a single pure, red square. After the mid 1930s, Mondrian incorporated parallel lines painted closely together to create more energetic arrangements such as *Composition with Yellow, Blue and Red* 1937–42, intended to reflect the grid of the modern city. **LA**

Composition B (No.II) with Red
1935
Oil on canvas
80.3 x 63.3 cm
Accepted by HM Government in lieu of tax with additional payment (General Funds) made with assistance from the National Lottery through the Heritage Lottery Fund, the Art Fund, the Friends of the Tate Gallery and the Dr V.J. Daniel Bequest 1999
© 2012 Mondrian/Holtzman Trust c/o HCR International Washington DC

Piet Mondrian
1872–1944

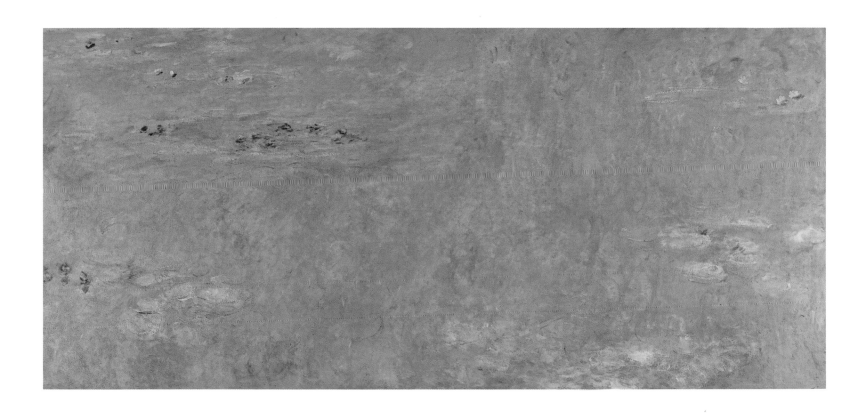

Claude Monet is one of the best-known painters of the late nineteenth and early twentieth century, and as the principal pioneer of impressionism he had a vital impact on the subsequent history of modern art. Rather than focusing on the grand traditions of history or religious painting, he depicted landscapes and images of the contemporary world, working directly from nature. The term impressionism was first coined after his landscape *Impression: Sunrise* (now housed in the Marmottan Museum, Paris) was exhibited in 1874. In such works, Monet aimed to capture sensations produced in fleeting moments, concentrating on the means through which paint could be used to evoke light and shadow. He used pure colours in small, rapid brushstrokes to recreate the atmosphere of a particular time of day, or the fog of the modern industrialised city.

Claude Monet
1840–1926

In the 1890s Monet embarked on a project in which he painted subjects repeatedly in order to capture changing light and weather effects through dawn to sunset, often painting several canvases during a given day. This method was to influence subsequent artists in the early twentieth century, such as Piet Mondrian and Wassily Kandinsky, who recognised that by working in series, subject matter could become less important than the formal qualities of the painting itself – that is, the paint, the canvas, colour, line and form. This idea eventually led to elimination of the motif altogether, and in this sense Monet's work may be viewed as a forerunner of abstraction. An abstract quality is evident in his late series of water-lily paintings, which he produced in his studio at Giverny from 1914 until his death in 1926. Many of these expansive canvases create a sense that colour is dissolving across the canvas. However, despite the vast scale and fluid handling of paint, Monet's subject never entirely recedes, and we remain aware of the bright yellow lily-pads floating on the rippling pond, and the suggestion of clouds and sky reflected in the water. **LA**

Water-Lilies
after 1916
Oil on canvas
200.7 x 426.7 cm
Lent by the National Gallery 1997

Henry Moore was born in Yorkshire. Following army service in the First World War he trained at Leeds School of Art and then from 1921–4 at the Royal College of Art in London. Following Epstein, he and his contemporary Barbara Hepworth, also from Yorkshire, became twin pioneers of modern sculpture in Britain. From the mid 1920s Moore began to make sculptures of the female figure, adopting the approach of direct carving (without a preliminary model) introduced by Brancusi and, in Britain, by Epstein. With this went the doctrine of 'truth to materials', the idea that the material should be worked in such a way as to respect and reveal its innate properties. This partly accounts for the simplified forms and uncluttered surfaces of his work. But Moore was also affected by non-European sculpture, particularly pre-Columbian and African works. From 1924 he made a series of mother and child groups, which express with great force this fundamental theme. In 1929 he made the first of his recumbent female figures, intense statements of the mystery of the feminine that increasingly related the female body to the forms of landscape, creating earth-mother images. By 1938 he had begun to pierce these, introducing new elements of spatial and thematic complexity into his work (*Recumbent Figure* 1938). He stressed that 'a hole can have as much shape meaning as a solid mass' and he spoke of the 'mystery of the hole – the mysterious fascination of caves in hillsides and cliffs'. At the same time, some of his work became highly abstract, but with powerful biomorphic forms (*Composition* 1932). This dual path continued after the Second World War. He pursued the mother and child theme and began to work in plaster for casting in bronze, which enabled him to make much larger and more spatially complex works. *Upright Internal/External Form* 1952–3 was, said Moore, 'based on this idea of one form being protected by another … I suppose in my mind was also the Mother and Child idea and of birth and the child in embryo.' **SW**

Henry Moore
1898–1986

Upright Internal/External Form
1952–3
Plaster
195.6 x 67.9 x 69.2 cm
Presented by the artist 1978

Daido Moriyama is recognised as one of the leading members of the influential Provoke movement in Japan of the late 1960s and early 1970s. He is known principally for a style that combines radical formal innovation with a keen sense of social awareness and critique. The combination of urban documentation with an intensely subjective approach has become known as the Provoke aesthetic (after the magazine in which this kind of work was first published) and is seen as the most significant and innovative photography of the postwar era coming from Japan. The work *Farewell Photography* was first published as a photo book in 1972 and later printed as a series from the original negatives which Moriyama believed were lost until rediscovering them in 2010.

Farewell Photography represents his most complete statement, up to that point, about both the potential and the limitations of the photographic medium. It was, he has said, an attempt to 'get to the end' of photography, to stake out and explore its extreme extent. It consists of thirty prints and, like the pages of the book, the images are drawn from a variety of sources both photographed and found by Moriyama. Cumulatively they add up to a disorienting and disturbing account of urban Japan. The images themselves are blurred, close-up, unbalanced, cropped, distorted and double exposed, with fragmentary figures, off-kilter buildings and marvellous abstractions generated by accidents and deliberate interventions in the picture-making process. Having said 'good-bye' to photography in 1972, Moriyama's return to this emotional scene in 2010 sheds yet more light on that moment and what it has come to stand for, as much through the difference between the book and the later installation as the instantly recognisable form and content of the revolutionary photographic language that the installation sets out and revisits. **SB**

Farewell Photography
1972, printed 2010
Gelatin silver print on paper
30 photographs,
each 40.9 x 59.1 cm
Purchased with funds provided by the Photography Acquisitions Committee 2011

Daido Moriyama
born 1938

Both as an artist and as a critic, Robert Morris played a central role in defining three artistic movements of the 1960s and 1970s: minimalist sculpture, process art, and earthworks. In his 'Notes on Sculpture' published in the journal *Artforum* in 1966 he attempted to define an absolute essence of sculpture, describing it as 'scale, proportion, shape, mass'. To reveal these essential properties, he advocated using simple forms such as cubes, pyramids and regular polyhedrons. Like other minimalist sculptors including Donald Judd and Carl Andre, Morris believed that paring the artwork down to simple shapes allowed for a more direct relationship between the viewer and the work. He strove to create sculptural 'situations' in which 'one is aware of one's own body at the same time that one is aware of the piece'.

Morris's interest in the interaction between the spectator of an artwork and the environment in which it is situated owed much to his early engagement with dance. In fact he created his earliest minimalist objects as props for dances performed by the Judson Dance Theater (whose members included his wife Simone Forti). The untitled sculpture of 1965/71 exemplifies Morris's interest in the relationship between moving bodies and still objects. The work consists of four large cubes of mirror glass placed at the corners of a square. As the viewer walks between the cubes, their mirrored surfaces produce a series of complex and shifting interactions. **SH**

Untitled
1965/71
Mirror plate glass and wood
Each 91.4 x 91.4 x 91.4 cm
Purchased 1972

Robert Morris
born 1931

Commonly regarded as one of the fathers of expressionism, Edvard Munch used his own life as the source material for his work, a radical development in the evolution of modern art. Early tragedies – the death of his mother and elder sister from tuberculosis during his childhood and adolescence – haunted his adult life. *The Sick Child* 1907 is the fourth version of a painting that Munch made after visiting the house of an ailing child with his doctor father. It combines memories of the red-haired child Munch encountered there with the protracted trauma of his sister's sickbed. He

regarded the first version of this picture as heralding a new departure in his art. Both in the style of painting – flattening perspective – and in its subject matter – physical vulnerability and grief – *The Sick Child* challenged contemporary fashions and was harshly criticised in Oslo art circles. However, Munch's approach was better appreciated abroad, particularly in Germany, where he began to exhibit regularly.

In common with the work of the German expressionist artists, Munch's portrayal of the darker sides of human existence was perceived as highly threatening by the Nazi Party who believed that art should serve the purpose of exalting the idealised Aryan way of life. In 1937 Nazi officials purged German museums of works that were considered by the Party to be 'degenerate', including eighty-two paintings by Munch. A selection of these works was exhibited under the title *Entartete Kunst* or Degenerate Art, demonstrating the perceived moral turpitude of those who did not subscribe to their political beliefs. Many of those included in this exhibition are now considered to be the greatest modern artists. **EM**

The Sick Child
1907
Oil on canvas
118.7 x 121 cm
Presented by Thomas Olsen
1939

Edvard Munch
1863–1944

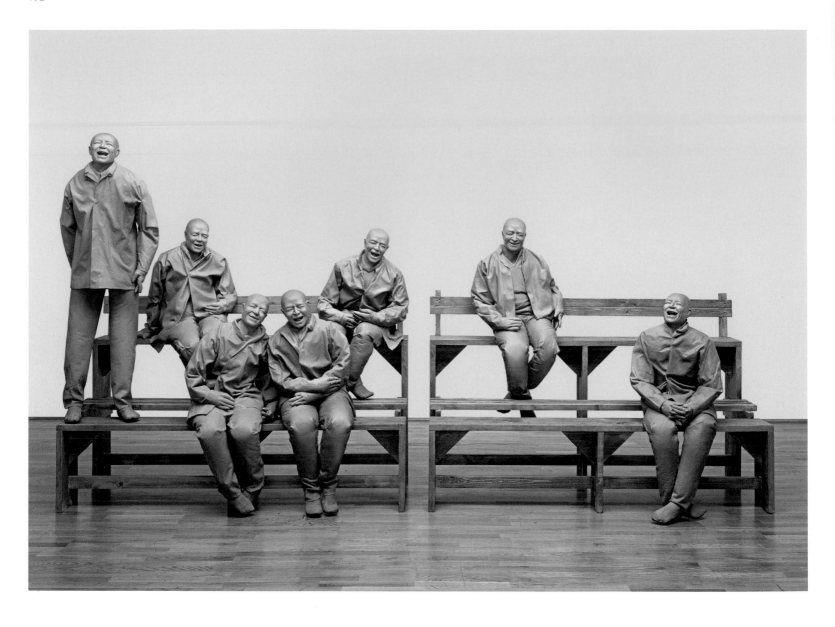

Juan Muñoz was a figurative sculptor who first gained attention in his native Spain during the late 1980s. Much of his work addresses the dynamics of architectural and public space, highlighting the potential of sites to provide the backdrop for interpersonal dramas. His smaller-scale sculptures often feature recurring architectural motifs such as balconies, banisters and railings, placed in unlikely situations in the gallery.

Muñoz's larger installations are overtly theatrical, often consisting of large-scale, site-specific scenarios in which the viewer is confronted with monochrome, cast-resin figures including dwarves, ventriloquist's dummies and ballerinas. These installations typically elicit an unsettling, ambivalent response in the viewer. In *Towards the Corner* 1998, seven hysterically laughing figures with Oriental features sit or stand on a set of benches facing towards a corner of the gallery. This placement encourages the viewer to move around the sculpture to see the figures from the front. Their extreme jollity in the absence of any apparent cause provokes a series of reactions in the viewer, from initial amusement or bemusement to a more uncomfortable and anxious response. In front of the benches, the viewer moves from feeling complicit in the figures' mirth to sensing that he or she is the object of their derision.

Muñoz was also known as a draughtsman and made a series of delicate drawings of interiors known as 'Raincoat drawings' because he composed them with chalk on sections of black fabric used for the commercial manufacture of macintoshes. **RT**

Towards the Corner
1998
Wood, resin, paint and metal
210 x 378.5 x 113 cm
Purchased with assistance
from Tate Members 2003

Juan Muñoz
1953–2001

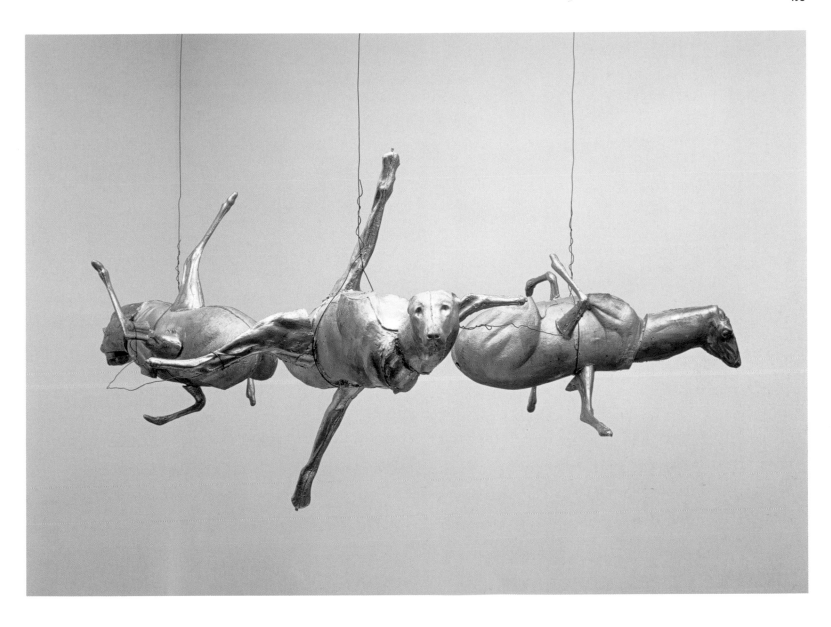

Bruce Nauman has worked in a vast range of media since the late 1960s, including sculpture, neon, performance, text, installation, film, video and photography. He originally studied mathematics at college, and his practice has the character of scientific enquiry: an open-ended investigation into the stuff of the world, its materials, the body, language and emotions. 'To every rule, I also try to find the opposite, to reverse it', he has said.

The studio and the body of the artist have always been at the core of Nauman's practice, and early in his career he developed the notion that everything the artist did in the studio was art, thereby redefining art as an activity rather than a product. The realisation that he spent most of his time in the studio pacing up and down led to his seminal film, video and photographic works of the late 1960s, in which he repeats various physical activities for the camera: walking,

dancing, playing the violin, putting on make-up, making faces. He has continued to use video throughout his career, developing numerous disturbing works with actors, who are often dressed as clowns, seemingly trapped in repetitive linguistic or physical situations, as in *Double No* 1988.

In the 1970s Nauman developed a series of empty spaces, cages and corridors that placed the spectator in tense or claustrophobic physical surroundings. These works were often augmented by texts, video or closed-circuit TV. During the 1980s, in direct response to the widespread use of imprisonment and torture by many South American regimes, he made a series of works from chairs and steel girders suspended by taut cables from walls and ceiling. These were further developed when he started using taxidermist's moulds to create hanging sculptures of disfigured animal carcasses, as in *Untitled (Three Large Animals)* 1989. In 2001 Nauman made the major, seven-screen, film installation *MAPPING THE STUDIO II with color shift, flip, flop, & flip/flop (Fat Chance John Cage)*, which uses footage of his New Mexico studio submitted to colour and image manipulation. **ED**

Untitled (Three Large Animals)
1989
Aluminium and wire
120 x 300 x 300 cm
Presented by the Froehlich
Foundation, Stuttgart 2000

Bruce Nauman
born 1941

Adam
1951–2
Oil on canvas
242.9 x 202.9 cm
Purchased 1968

Newman, who was the son of Polish-Jewish immigrants to America, first established himself as a critic rather than a painter. Although a committed anarchist, in 1933 he offered himself as a candidate for Mayor of New York City. It was not until after the Second World War, when he became a key member of the group of artists known as the abstract expressionists, that he developed his signature artistic style.

Adam 1951–2 and *Eve* 1950 are typical of Newman's mature work. They are characterised by large expanses of one colour interrupted by vertical bands of another that literally split the composition into sections. For Newman these 'zips' created a tension between simplicity and complexity, solidity and fragility. He wanted viewers to stand close enough to his paintings to experience all their nuances of colour and structure, and to undergo feelings of heightened self-awareness. As the titles of these two works indicate, he was preoccupied with the Jewish myths of Creation. He was also greatly troubled by the aftermath of the Second World War, especially in relation to the Holocaust. 'I felt the issue in those years was – what can a painter do?', he wrote. In spite of the pared-down appearance of his works, he saw them as addressing 'life', 'man', 'nature', 'death' and 'tragedy'.

Newman always insisted on the rich emotional and spiritual content of his work, but for most of his life it met with incomprehension. It was not until he was nearly sixty that he began to be recognised as one of America's foremost artists. His influence on the development of minimalist painting and sculpture since the 1960s is now undisputed. **SH**

Barnett Newman
1905–1970

Circle

Circle: International Survey of Constructive Art was published in Britain in 1937 to promote abstract art. The book was compiled and edited by the architect J.L. Martin and the artists Naum Gabo and Ben Nicholson. One of a number of publications associated with the internationally orientated avant-garde activity that developed in Britain in the 1930s, its background involves the group Unit One, founded by Paul Nash in 1933 with Nicholson, Barbara Hepworth and Henry Moore. In 1934 Unit One held its first exhibition and published a book titled *Unit One: The Modern Movement in English Architecture, Painting and Sculpture*. Many of the artists were also in touch with the Paris-based group Abstraction-Création, which in turn had emerged out of the earlier Cercle et Carré (Circle and Square) group. The Russian constructivist Naum Gabo was an influential figure in the British avant-garde during his years in Britain from 1935–46, but other distinguished European abstract artists passed through in the late 1930s, not least Piet Mondrian, who lived in London from 1938–40. As Hepworth put it, 'suddenly England seemed alive and rich – the centre of an international movement in architecture and art'. This was brought to an end by the outbreak of war in 1939. **SW**

With the sculptors Barbara Hepworth and Henry Moore, the painter Ben Nicholson completed a trio of pioneering modernist British artists in the 1920s and 1930s. Like them, after the Second World War he became an established figure, opening the way for a younger generation of abstract artists. On a visit to Paris in 1921 Nicholson saw a cubist painting by Picasso and was deeply struck by it. Over the next ten years he developed a highly sophisticated appreciation of the new pictorial freedoms and possibilities offered by cubism. With this went a technique and painterly sensibility of outstanding delicacy and refinement. He also became increasingly interested in exploring surface texture, preparing his paintings with a freely brushed ground, sometimes thickened with marble dust. Over this he would paint extremely thinly, frequently scraping away the surface or incising into it. In 1932–3 he made several month-long trips to stay with his first wife Winifred Nicholson in Paris, visiting the studios of Picasso, Brancusi, Mondrian and other leading modern artists. Following this, his paintings became increasingly abstract and his interest in surface led him to work in relief. From 1933 he produced a series of abstract reliefs, which he painted white. As a group they make a major contribution, on an international level, to the whole idea of an art of pure, universal beauty that was central to art at that time. His concerns in these works were with creating subtle relationships between two elementary forms of opposite character – the rectangle and the circle – and then adding complexity by extending this relationship into three dimensions in a series of shallow relief levels or planes. Nicholson stressed that this geometric art was not cold or mathematical: 'A square and a circle are nothing in themselves and are alive only in the instinctive and inspirational use an artist can make of them in expressing a poetic idea.' **SW**

1934 (relief)
1934
Oil on wood
71.8 x 96.5 x 3.2 cm
Purchased 1978

Ben Nicholson
1894–1982

Nouveau Réalisme

In May 1960 the critic Pierre Restany published a manifesto that proclaimed the arrival of nouveau réalisme (new realism) in France. A joint declaration was signed by the artists Arman, François Dufrêne, Raymond Hains, Yves Klein, Martial Raysse, Daniel Spoerri, Jean Tinguely and Jacques Villeglé, stating their vision of 'new perceptual approaches to reality'. This group and a number of others in their circle shared an interest in exploring their immediate, urban environment in a direct manner. They incorporated objects such as automobile parts, posters, fabrics, dishes and cans into their work. Often seen as a counterpart to American and British pop art, nouveau réalisme also adopted the dadaist idea of the *objet trouvé* (found object) and extended the medium of collage. By including and transforming everyday objects into art, these artists ask the viewer to reconsider the value and shape of all things ordinary, overlooked, mass-produced, or trashed.

The artist known as Arman (Armand Fernandez) started to present rubbish as art in 1959 in a number of works to which he referred as the 'poubelles'. These were similar to his 'accumulations', in which identical objects were presented in a given format. Two works by Arman in the Tate Collection, *Condition of Woman I* 1960, and *Bluebeard's Wife* 1969, include items one would normally find in a household bathroom cabinet. In both works the objects are encased within resin or glass and presented on a plinth or pedestal, elevating them to the status of art. Similarly, 'objects found in chance positions, in order or disorder' were fixed to their base (a table, tray, box or drawer) and mounted vertically on the wall by the artist Daniel Spoerri. César (César Baldaccini) made sculptures and reliefs from compressed car parts. His compressions, which could be regarded as collage or assemblage, turned functional objects into what look like blocks of scrap metal, rendering them useless while simultaneously giving them a new role as a work of art. While Arman, Spoerri and César took their materials from the factory floor or domestic space, Jacques Villeglé found his 'readymade' canvases in the streets of Paris, where he removed large sections of torn, multilayered fly-posters in order to re-present them in the gallery.

Perhaps the most famous artist of the group, Yves Klein, was less interested in everyday, mass-produced or readymade objects than his peers, choosing rather to focus on what Villeglé had called 'distance from the act of painting' through his experiments with process and his interest in the universal or transcendental properties of a material or colour. Klein died prematurely, in 1962, at the age of thirty-four, but although his career was cut short he had been remarkably influential on the development of several strands of artistic practice that were to become more fully formed later in the century, including performance and conceptual art. The Bulgarian artist Christo (Christo Javacheff) was also associated with nouveau réalisme in the early 1960s, when he began to wrap objects in plastic and rope, thus transforming them and drawing attention to their shape and contours. Christo's wrapped objects, the soft sculptures of Gerard Deschamps and the early works of Niki de Saint Phalle also show the influence of nouveau réalisme, as well as surrealism. Equally, it is possible to see the legacy of nouveau réalisme in work produced during the 1990s by the 'Young British Artists' such as Tracey Emin, Sarah Lucas and Michael Landy, who are concerned with the stuff of everyday life and the cultural assumptions and by-products of today's throw-away society. **AC**

Arman (1928–2005)
Condition of Woman I
1960
Mixed media, metal,
wood and glass
192 x 46.2 x 32 cm
Purchased 1982

Below:
Jacques Mahé de la Villeglé
(born 1926)
Jazzmen
1961
Torn posters mounted on canvas
217 x 177 cm
Presented by the Friends
of the Tate Gallery 2000

Right:
Daniel Spoerri (born 1930)
Prose Poems
1959–60
Mixed media on wood
69 x 54.2 x 36.1 cm
Purchased 1982

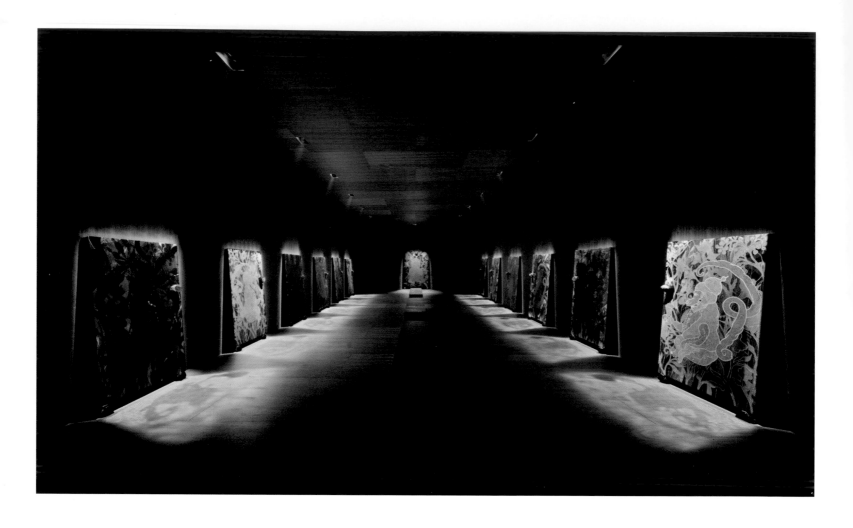

Through a vigorous reinvention of oil painting, Chris Ofili has explored concerns about imagery, identity and violence associated with the black experience in Britain. Ofili uses innovative techniques through which to express complex cultural concerns. He has used oils enhanced with phosphorescent glazes, resins, glitter, embedded collage elements and, famously, nodules of dried elephant dung.

The integration of collage in particular keys Ofili's paintings to contemporary issues. *No Woman, No Cry* 1998 presents a powerful weeping woman in a work addressing memory and loss evoked by the title of Bob Marley's song. By collaging images of the student Stephen Lawrence into the woman's falling tears, Ofili referred specifically to his racially motivated murder in London in April 1993 which remains a *cause célèbre* of institutionalised racism and

injustice. In other works he has drawn upon images from comics, popular music and styling magazines, inventing the vulnerable black superhero Captain Shit. It was the inclusion of elephant dung and collaged images of the female sex in *The Holy Virgin Mary* 1996 that caused outrage when the *Sensation* exhibition of YBAs reached the Brooklyn Museum in 1999. That Ofili's engagement and foregrounding of black cultures has been a cause for controversy remains indicative of deeply embedded vested interest.

The Upper Room 1999–2002 is an extraordinarily ambitious project. It addresses the event of the Last Supper through thirteen, differently coloured, canvases of the same figures set in a room designed by the architect David Adjaye. Typical of Ofili's accumulated sets of associations, the religious significance is interleaved with his interest in rhesus macaques monkeys that he studied in Puerto Rico. The figures are, therefore, evidently simian introducing a sense of untamed nature into the reverential atmosphere.
MG

The Upper Room
1999–2002
Oil, acrylic, glitter, graphite, fibre tip pen, elephant dung, polyester resin and map pins on canvas
13 paintings: 12 paintings 183.2 x 122.8; 1 painting 244.2 x 183 cm
Purchased with assistance from Tate Members, the Art Fund and private benefactors 2005

Chris Ofili
born 1968

Hélio Oiticica was a leading member of the influential generation of Brazilian artists of the 1950s –70s. He joined the Grupo Frente (1954–6) in his teens, becoming one of the founders of the Rio-based neo-concrete group (1957–62). The latter proposed a radical response to and reimagining of concrete art and constructivism, emphasising experimentation, investigations of space, and art's active relation to the viewer. From the 1960s, Oiticica developed a philosophical practice that aimed to reconnect art and life – a project he expressed through the concept of 'vivencias' or lived experience – and to translate geometric abstraction into a language of the body.

Oiticica worked in series. Among his earliest works were the *Metaesquemas* 1957–8, meticulous, geometric abstractions of monochrome planes of colour which were inspired by Mondrian and Malevich. These were followed by successive series of three-dimensional works suspended from the ceiling, including the *Bilaterals* 1959 and *Spatial Reliefs* 1959–60, which explore the complex experience of colour, time and structure. In the mid 1960s, Oiticica began to make sculptural objects he called *Bólides (Fireballs)*, in which he aimed to give a new structure to colour: they often incorporated earth or pigment in powdered form. In later works he developed his ideas of colour, 'sensorial' experience and social protest into participatory environments that he termed 'Penetrables'. These included *Tropicália Penetrables PN 2 and PN 3* 1967, and the project *Eden* at the Whitechapel Art Gallery, London, in 1969. *Tropicália*, that included plants, sand and live parrots, embodied Oiticica's aim to 'institute … a state of Brazilian avant-garde art' resulting from his engagement with aspects of Brazilian culture such as favela architecture, 'the spontaneous, anonymous constructions in the great urban centres – the art of the streets, of unfinished things, of vacant lots.' His work of the 1970s included multimedia productions, performances, installations and films. **TB**

Hélio Oiticica
1937–1980

Tropicália, Penetrables PN 2 'Purity is a myth' and PN 3 'Imagetical'
1966–7
Mixed media
Display dimensions variable
Purchased with assistance from the American Fund for the Tate Gallery, the Latin American Acquisitions Committee, Tate Members and the Art Fund 2007

Happenings
Coined in 1959 by Allan Kaprow, the term 'happening' was used to describe non-narrative theatre works presented to small audiences in studios, galleries and off-beat locations in New York in the late 1950s and early 1960s. Directly influenced by dada, their subject was the absurdity of everyday life, which the performers expressed through music, non-verbal sound and physical action in specially constructed environments designed to break down the boundaries between art and life. Claes Oldenburg, Jim Dine, Robert Rauschenburg, Red Grooms and Robert Whitman were the principal creators of these events which frequently invited audience participation. The New York happenings were contemporaneous with the actions organised in Europe by the Viennese actionists, whose goals were more overtly politically subversive than the American artists. In the 1970s happenings gave way to performance art which focused more on the individual artist than a group experience. **EM**

A central figure in the development of American pop art, Claes Oldenburg is best known for his soft sculptures and massive public installations based on comically enlarged domestic and everyday objects. Inspired by signs, billboards and objects in the windows he passed on the way to the studio, in 1961 Oldenburg opened *The Store*, a shop furnished with an array of his scaled-up, expressively sculpted and painted consumer goods, including clothes and food. Such works as *Counter and Plates with Potato and Ham* 1961 (p.208) were offered for sale, fusing art objects with commercialism. This conflation of artistic creativity with commerce represented a seminal moment in the development of pop art. Similar sculpted objects were also used as props in Oldenburg's 'happenings', a series of multimedia performance events staged between 1960 and 1966. In contrast to his soft sculpture, which transformed hard objects into soft, body-like entities, Oldenburg's happenings depersonalised the participators and objectified their bodies.

Oldenburg has produced several works on the theme of drainpipes, suggested to him by the letter T and an advertisement in a Swedish magazine for a drainpipe that had curves and bends. Putting the two together, Oldenburg created *Soft Drainpipe – Blue (Cool) Version* 1967 and its alter ego, *Soft Drainpipe – Red (Hot) Version*. The dimensions of the blue version may be altered by adjusting the pulley from which it hangs against the wall, varying the human and animal body parts it evokes (a penis, an elephant's ears and trunk, a crucified figure). The red version is made of red vinyl cut from the same pattern and filled with Styrofoam pellets, resulting in a more solid, unvarying stuffed form. **EM**

*Soft Drainpipe –
Blue (Cool) Version*
1967
Acrylic on canvas and steel
259.1 x 187.6 x 35.6 cm
Purchased 1970

Claes Oldenburg
born 1929

Cornelia Parker, who was nominated for the Turner Prize in 1997, is best known for appropriating objects and subjecting them to acts of violence. But in her careful manipulation and subsequent display of the remnants, she exposes layers of meaning within them.

To make *Thirty Pieces of Silver* 1988–9, Parker scoured junk shops and boot sales to collect hundreds of silver objects no longer wanted by their owners. She then laid them out on a road and arranged for them to be run over by a steamroller. The contorted remains are shown suspended in thirty disc-like formations, hovering a few inches above the gallery floor, which gives them an ephemeral, fluid appearance. As in many of her works, Parker was interested in the metamorphoses of form and meaning that objects may undergo. Most silver objects have sentimental or commemorative value over and above their material worth – the sports-day trophy, for example, or the wedding present of best cutlery – and yet they eventually turn up in junk shops. The biblical reference implicit in the title suggests a betrayal, but whether this might allude to Parker's act of 'cartoon violence', or to the former owners' relinquishment of the objects, is open to conjecture.

The history of an object can trigger associations that may transform its value. In 1998 Parker visited the Tate conservation studios and was shown a number of canvas liners that had been removed from paintings by J.M.W. Turner. Intrigued by the fragile beauty of the liners, Parker subsequently displayed them with an adjacent label to indicate from which painting they had been removed. They have since been accessioned into the collection, thus transformed by Parker from discarded remnants to artworks in their own right. **HS**

Thirty Pieces of Silver
1988–9
Silver and metal
Purchased with assistance from
Maggi and David Gordon 1998

Cornelia Parker
born 1956

Trap
1968
Braided steel wool
400 x 250 x 200 cm
Purchased 2009

In little over four years, from 1964 to 1968, Pino Pascali produced an array of works that secured him a distinctive role in the evolution of arte povera. Witty and poignant, Pascali's cannons, animals, rivers and silkworms challenged sculptural conventions. Described by the artist as 'feigned sculptures', his works eschewed easy classification, and definitions such as image, object or sculpture appeared obsolete in relation to these spectacular works. The provocative quality of the titles, the anomalous scale and the broad vocabulary of objects and materials out of which the works were made all contributed to the ironic and paradoxical vein that most forcefully characterised Pascali's production.

Driven by a remarkable technical dexterity, Pascali forged a fantastical cosmogony out of steel wool, fake fur, straw, earth and found objects. The result is a striking conflation of natural and industrial elements that prompted a fine play between an idealised archaic universe and twentieth century technological developments. *Trap* 1968 is exemplary of this interplay, as steel wool pads, a contemporary household staple, were meticulously braided to create a primordial trap. The feeling it conveys is both of the domestic as well as evoking some primitive narrative. Such a sense of narrative was enhanced by a performance and a series of staged photographs in which Pascali took on a Tarzan-like guise, animating and interacting with *Trap* and other works from the 'Reconstruction of Nature' cycle to which it belongs. Included in a two-part exhibition at the Galleria L'Attico in Rome in March 1968, *Trap* is among Pascali's final works; he died in a motorcycle accident at the age of thirty-two in September 1968. **FF**

Pino Pascali
1935–1968

LA
FEUILLE
DE
VIGNE

DESSIN FRANÇAIS

FRANCIS PICABIA

Francis Picabia adopted an iconoclastic approach to making art, in which he regularly destroyed or painted over his canvases, eliminating previous styles in order to avoid repetition. Known for his extravagant lifestyle, love of parties, fast cars and boats, he was a larger-than-life figure who continually defied stylistic conformity. Despite his participation in the dada movement in Paris and association with surrealism, his highly individual approach ultimately separated him from affiliation to any specific avant-garde movement.

Three of Tate's five works by Picabia were radically altered by the artist, and each of these is known in its previous state through photographs. He painted *The Fig-Leaf* 1922 over his mechanomorphic painting *Hot Eyes*, a work based on a technical drawing of an air-turbine brake that had caused great scandal when exhibited in 1921. By resubmitting the canvas in its new guise, with the connotations of censorship implied by its new title, Picabia made a pointed statement about the conservatism, as he saw it, of the established art world.

In around 1929 Picabia began a series of works known as the 'transparencies', which evolved out of figurative paintings he had made in the 1920s. Often associated with surrealist preoccupations with the interior life of the subconscious, they feature linear figures, animals and foliage, superimposed in layers suggesting fragmentary and ambiguous space. The ethereal, subaquatic quality of *Otaïti* 1930 is typical of these works, and its motifs such as the ram's head and double mask appear in other 'transparencies'. The central female figure appears to prefigure Picabia's kitsch nudes of the following decade. **LA**

The Fig-Leaf
1922
Oil on canvas
200 x 160 cm
Purchased 1984

Francis Picabia
1879–1953

The Three Dancers
1925
Oil on canvas
215.3 x 142.2 cm
Purchased with a special Grant-in-Aid and the Florence Fox Bequest with assistance from the Friends of the Tate Gallery and the Contemporary Art Society 1965

Pablo Picasso is perhaps the most famous and important artist of the twentieth century, known both for his celebrity persona and complex personal relationships as well as for his virtuosity. In a career spanning over seventy years, his artistic inventiveness led him to work in an unparalleled variety of styles: from the melancholic 'blue period' (*Girl in a Chemise* c.1905), through the great innovations of cubism, to monumental, neoclassical paintings and works featuring deformations of faces and bodies to express heightened emotion (*Weeping Woman* 1937).

Picasso's innovation also lay in his manipulation of unlikely materials. The wooden relief *Still Life* 1914 could be described as a cubist collage in three dimensions. The knife, glass, piece of cheese and slice of sausage that rest on a table are all made in wood, as is the decorative dado rail behind. The still life becomes an object in itself, and the piece of upholstery fringe used to represent the tablecloth plays on our perceptions of what is real and what is artifice.

Still Life was shown in the *Exhibition of Surrealist Objects* in Paris in 1936. Picasso had exhibited with the surrealists from the mid 1920s following his shift from neoclassicism towards a violently expressive style in which he distorted and metamorphosed the human figure. *The Three Dancers* 1925 was made at this moment of transition, and is considered one of his most important works. The exuberance and joy of dance is undermined by the aggressive manner in which the figures are depicted, particularly the sharp-toothed female at the left, whose exposed breasts and twisted body represents woman as femme fatale. **LA**

Pablo Picasso
1881–1973

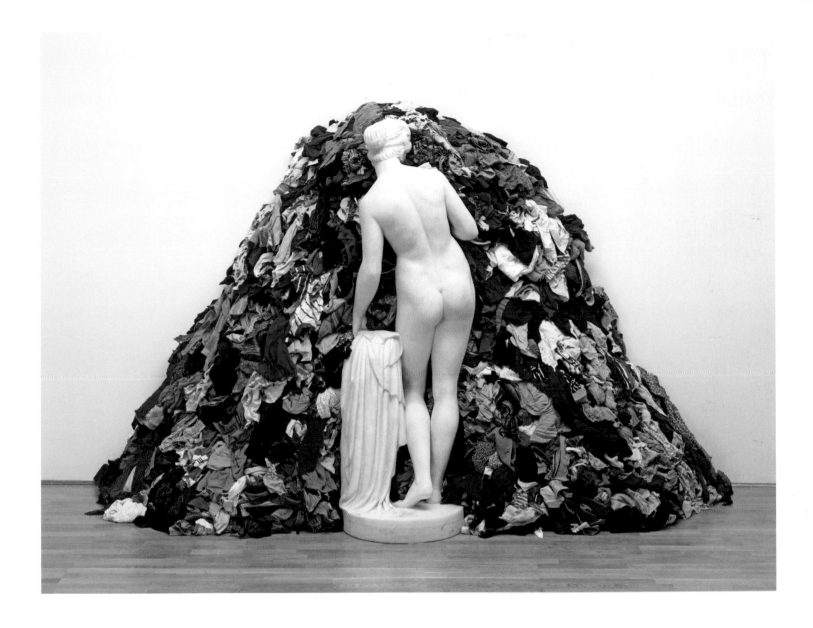

Venus of the Rags
1967, 1974
Marble and textiles
212 x 340 x 110 cm
Purchased with assistance from
Tate International Council 2006

Michelangelo Pistoletto has been acknowledged as one of the most significant figures in Italian art since the 1960s. He first came to prominence in 1963 with his series of *Mirror Paintings:* painted versions of photographs of people laid on polished steel sheets that raise questions of identity, perception and engagement with contemporary culture. These were followed in 1965–6 by structures that he called *Oggetti di meno (Minus Objects)* that retained some recognisable link to functionality and that Pistoletto saw as existing in a border zone between an ideal world and the material world, between art and life.

In 1967–8 such objects gave a powerful impetus to Pistoletto's involvement with arte povera. He had begun to make work with everyday materials, including the clothes donned and discarded in the performances of Zoo, the theatrical community established with his wife in 1967. This current surfaces in *Venus of the Rags*, first conceived in that year, which confronts a Venus (acquired from a garden centre) with a pile of rags. The work addresses a dualism between Italy's classical heritage and the possibility of making contemporary art, as the amorphous accumulation of the material literally absorbs the traditional. This is a confrontation that suggests how shifts in radical artistic practice ran parallel to the revolutionary atmosphere in Italy and Europe at that moment.

Among his many projects of the 1970s, Pistoletto projected a number of *Segno Arte*, literally 'sign for art', pieces though most were only realised in the late 1990s. Echoing the *Minus Objects*, they take the form of two touching triangles which he envisaged applying to a whole array of ordinary objects made in any material. More expansively, he has held a series of workshops on the role of art and of the artist at his foundation at Cittadellarte. **MG**

Michelangelo Pistoletto
born 1933

Untitled (Triptych)
2002
Polyester resin and acrylic
paint on fabric
Left panel: 400 x 300 cm
Centre panel: 400.3 x 300 cm
Right panel: 397.9 x 299.7 cm
Purchased with assistance
from Tate Members, Noam
and Geraldine Gottesman,
Harvey Shipley-Miller and
private donors courtesy of the
American Patrons of Tate 2004

Sigmar Polke's work may be understood as an analysis of the mark-making central to two-dimensional representation. From his earliest practice, he emphasised a dynamic tension between expressive gesture – often humorously subverting its traditional subjectivity – and mechanical reproduction. His paintings combine found printed images with more organically made marks. He used half-tone photography from newspapers and magazines, enlarging and reproducing it on canvas, often corrupting the original beyond recognition. From 1964 he began overlaying imagery on printed fabrics, creating a double layer of patterning and undermining the traditional relationship between subject and background. Latterly he painted on transparent fabric, through which the structural support of the wooden stretchers was clearly visible. *Triptych* was made in this manner. Volumes of white, green and red paint were poured onto a base of translucent resin on the three transparent canvases and caused to flow in different directions resulting in pools and expressive dribbles. The final layer of imagery is based on a greatly enlarged black and white half-tone grid, taken from a found illustration. The painting was conceived when Polke was working on a series of 'Printing Errors' (1996–8), which examined the minute ink slippages and spillages that read as errors on the printed page.

Because of his use of mass media imagery Polke is commonly associated with the pop movement. In particular, his use of benday (printing) dots connects him with American pop artist Roy Lichtenstein. Polke's work may be understood as an investigation into the codes by which knowledge is structured and communicated in our age of mechanical reproduction. The tension between various types of mark-making and between figurative imagery and abstraction are central concerns of his art. **EM**

Sigmar Polke
1941–2010

Number 14
1951
Enamel on canvas
146.5 x 269.5 cm
Purchased with assistance from
the American Fellows of the Tate
Gallery Foundation 1988

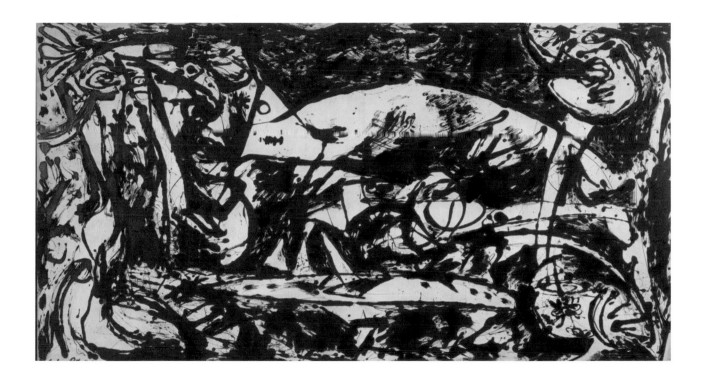

Jackson Pollock was a key member of the group of American artists known as abstract expressionists, and arguably one of the most revolutionary painters of the twentieth century. His methods flew in the face of traditional artistic practices and he became renowned for making paintings by dripping paint onto a canvas on the floor. 'On the floor I am more at ease', he explained. 'I can walk around … and literally be in the painting.'

Pollock's practice was particularly influenced by Native American art, Mexican mural painting and Carl Jung's theories of the unconscious, of which he became aware during treatment for a mental breakdown in his mid twenties. In 1944, he was championed by Peggy Guggenheim and by the influential art critic Clement Greenberg, who thought he made 'some of the strongest paintings I have yet seen by an American'.

Consistently wild and rebellious, Pollock's life was always troubled by alcohol and depression. In spite of widespread recognition, it is possible to interpret anger and frustration in his work. In 1956, he was killed in a car crash. He quickly became immortalised as a symbol of creative freedom and risk-taking, and in this exerted a strong influence on the rising cult of individualism in American and European art. As a result of his 'action painting', the emphasis he placed on the physical act of art-making, and its relation to the artists' inner impulses, his legacy has been seen as particularly important for the development of performance art in the 1960s. **SH**

Jackson Pollock
1912–1956

208

Right:
Claes Oldenburg (born 1929)
*Counter and Plates
with Potato and Ham*
1961
Painted plaster
11.7 x 107.3 x 57.8 cm
Presented by E.J. Power
through the Friends of
the Tate Gallery 1970

Below:
Andy Warhol (1928–1987)
Marilyn Diptych
1962
Acrylic on canvas
Each 205.4 x 144.8 cm
Purchased 1980

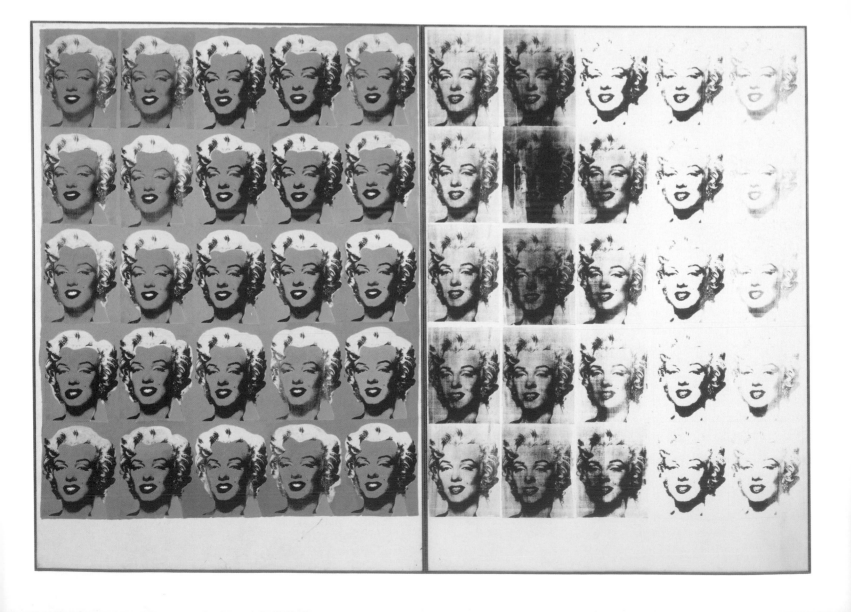

Pop Art

The term pop art came into wide use in the early 1960s to describe a distinctively new approach to painting and sculpture that had developed more or less simultaneously in Britain and the USA from the mid 1950s. The name derived from the new art's exploration of source material drawn from popular and commercial culture ranging from junk food and its packaging to advertising, pop music, Hollywood movies, fairgrounds, tabloid newspapers, comics, sci-fi, crime and girlie magazines, and street signs. A parallel development took place in Western Europe under the name of nouveau réalisme (new realism). Consciously referring to nineteenth-century theories of realism, the name signalled a wider scope of subject matter than that implied by the name pop art: that is, any aspect of reality hitherto deemed inappropriate as the basis of ambitious art, including art itself. It also emphasised a key characteristic of pop art: that this new subject matter was being treated in new ways.

Pop art and nouveau réalisme emerged from a combination of aesthetic and social revolt. The aesthetic revolt was against the idea of abstract art and in favour of a new engagement with the everyday world. With this went a rejection of a political and social conservatism that had reached an apogee in the immediate post-Second World War period before being exploded in the 1960s.

In Britain what became pop art was pioneered by the Independent Group, whose leading figures included Richard Hamilton and Eduardo Paolozzi. From 1956 Hamilton produced a series of founding works of pop art, among them *Hommage à Chrysler Corp.* 1957 and *$he* 1958–61. These were based on American advertising for, respectively, automobiles and refrigerators and point up a fascination with American consumer culture characteristic of British Pop. Both address the use of women in advertising and, in the case of *$he*, the social construction of woman as housewife. In Hamilton's work the source images are typically highly processed, resulting in formal and technical complexity and a degree of allusiveness. Nevertheless, the flavour and vividness of the source is preserved. This complex interplay between source and formal structure, worked out in different ways, is fundamental to pop art. At about the same time Peter Blake, ten years Hamilton's junior, began to make paintings and collages from specifically British pop sources. He became a prominent figure among a group of slightly younger pop artists who emerged at the 1961 *Young Contemporaries* exhibition in London, among them David Hockney.

In the USA pop art was pioneered from the mid 1950s by Jasper Johns and Robert Rauschenberg in collage and assemblage works using found materials, often combined with painting. Johns's *Flag* paintings, made from 1955, established a key aspect of US pop art: the use of a two-dimensional source image in such a way that the distinction between the source and the art object was blurred, questioning the dividing line between art and life and therefore the nature of art itself. From this premise Roy Lichtenstein and Andy Warhol went on to create great and radical bodies of work, mainly in painting, although both also produced three-dimensional pieces. Claes Oldenburg worked in three dimensions from the start and may be considered the principal pop sculptor. Perhaps his most important contributions were his soft sculptures of everyday objects made in fabric, often stuffed with kapok, and displayed so that they took on extraordinary metamorphic shapes. His *Soft Drainpipe* (p.200) is a perfect example of this. Capable of being manually reconfigured, it offers multiple readings in addition to its source, a drainpipe and length of guttering: male genitals, elephants ears and trunk, Mickey Mouse head, hammer, letter T and so on. Richard Artschwager also played interesting games with his source material. *Table and Chair* 1963–4 is clearly a work of art – a mediated representation of real objects. Disconcertingly however, it could, just, be used as furniture. Furthermore its forms, two rectangular boxes and a rectangular slab, are those of the minimal art that flourished in parallel with pop.

In its heyday in the 1960s pop art was often condemned as brash and superficial. But it had roots in earlier phases of twentieth-century art, notably dada and surrealism, and its influence has been lasting and pervasive. **SW**

Above:
Richard Hamilton (born 1922)
$he
1958–61
Oil, cellulose paint
and collage on wood
121.9 x 81.3 cm
Purchased 1970

Below:
Andy Warhol (1928–1987)
Black Bean
1968
Screenprint on paper
88.9 x 59.1 cm
Purchased 1978

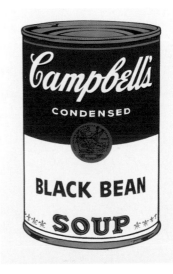

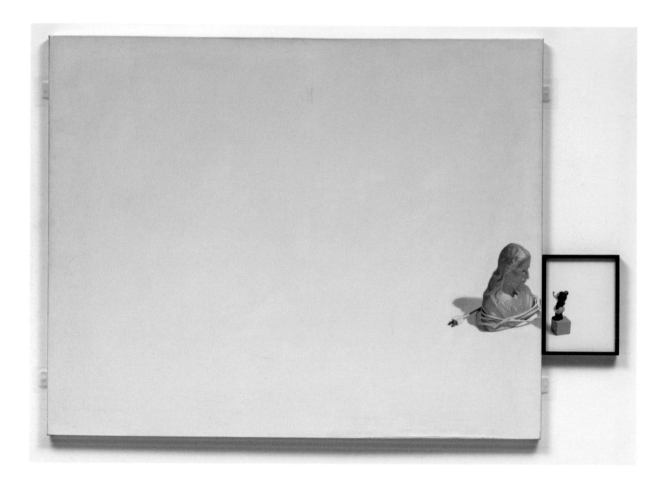

Recognised as one of Argentina's leading conceptual artists, Liliana Porter has lived in New York since 1964 where she cofounded the New York Graphic Workshop with Luis Camnitzer and José Guillermo Castillo. She has consistently explored the distinction between the real and the represented object and, through printmaking, painting, photography, film and installation, has focused on how to reconstruct reality through fictitious processes. Her works present the spectator with what seem like existential propositions, though modified with humour.

Porter made a series of defining works at the New York Graphic Workshop, including *Wrinkle* 1968, a group of ten photo engravings which show a sheet of paper progressively crumpling, until it appears as a wrinkled paper ball. The work epitomises her conceptual approach to art-making as well as her interest in emphasising the viewer's capacity to grant meaning to what is seen.

In later work Porter has brought together objects whose nature would usually position them on different levels of significance. The bust of Jesus Christ that she painted illusionistically on the plain white ground of *The Light (Dialogue)* 1996 derives from a kitsch lamp (complete with cable and plug) and is located as if looking out of the canvas. Adjacent and just beyond this edge, Porter placed a framed black and white photograph of Mickey Mouse who faces the yellow Christ and whose shadow mysteriously links the two. Through her eloquent juxtaposition of these objects, Porter has charged them with meaning so that, as in many of her deceptively simple works, they appear suddenly animated, as if having found a way of establishing communication among themselves. **TB**

The Light (Dialogue)
1996
Acrylic on canvas and framed black and white photograph
127.4 x 182.2 cm
Lent by the American Fund for the Tate Gallery, courtesy of the Latin American Acquisitions Committee 2007

Liliana Porter
born 1941

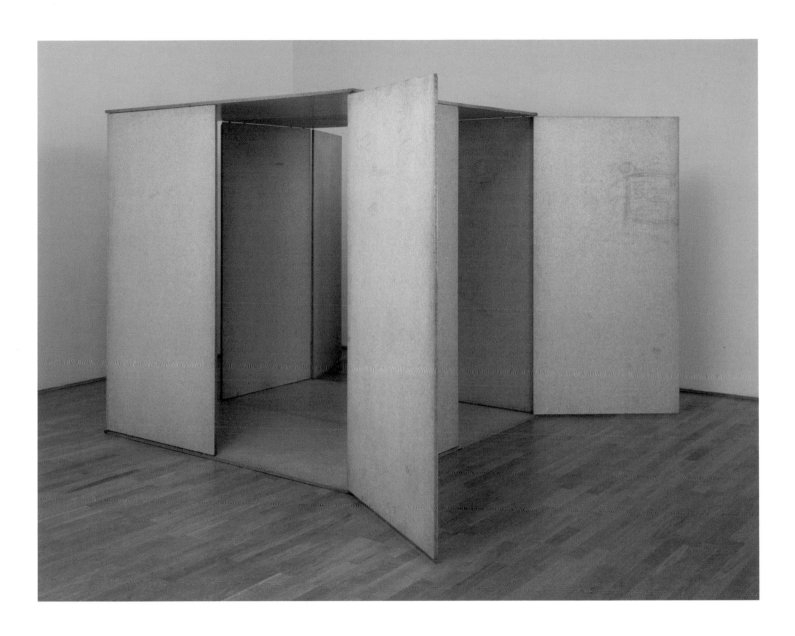

Charlotte Posenenske trained with Willi Baumeister and her early work, which consists predominantly of paintings and works on paper from 1959–60, reflects the constructivist training she had absorbed. These geometric abstractions take on an increasingly industrial appearance both in their serial production and use of commercial paints. From the mid 1960s Posenenske began to make both wall relief objects and freestanding sculptures that fully realised her increasing interest in systems and structures derived from mass production and standardisation. At this time she was also exposed to the work of American minimalists through a period spent in New York and as a result of her association with Paul Maenz, her gallerist in Düsseldorf. Innovatively she also began to incorporate an element of interactivity (both choreographed and open to audience participation) into both the construction and placement of her work.

Posenenske's concept of art was democratic, reflected in her use of unlimited, reproducible editions. The active role given to the 'consumer' again emphasises the participatory aspect of her practice. *Prototype for Revolving Vane* 1967–8 is the original model that the artist went on to use for a series of box-like constructions in the form of a room, articulated and open to various arrangements and configurations. Door-like elements can be revolved on a vertical axis and, originally, were designed to be manipulated by the viewer. The *Revolving Vanes* can be reproduced ad infinitum. The prototype benefits from being made from found particleboard on which the remnants of graffiti can be seen, highlighting the artist's use of cheap, easily available materials. In 1968 Posenenske withdrew from the practice of making art in order to study sociology and made no subsequent works. **JM**

Prototype for Revolving Vane
1967–8
Particle board
Display dimensions variable
Presented by Tate Patrons 2009

Charlotte Posenenske
1930–1985

Postmodernism

Fiona Rae (born 1963)
Night Vision
1998
Oil and acrylic on canvas
244 x 213.5 cm
Purchased 1998

'Postmodernism' describes a broad range of cultural tendencies that emerged as a reaction to modernism during the second half of the twentieth century. The term 'modernism' itself is applied to a vast and diverse group of art and artists, many with competing or contradictory characteristics, and this is equally true of postmodernism. Yet there are important differences, and perhaps architectural history provides the clearest illustration of the transition between the two eras. In 1966, the American architect Robert Venturi poked fun at the modernist motto 'Less is more' – shorthand for the clean lines and unadorned architecture of the Modern Style – with the phrase 'Less is a bore'. His comment was meant more as a witty epigram than a call to arms, but it helps to point out many of the cultural changes that were brewing at the time. While modernism could be partly characterised by utopian ambitions, high seriousness and a deep concern with form, postmodernism revels in a broadly pluralist approach, celebrating outmoded genres, art-historical parody, surface decoration and upfront social commentary.

Postmodernism's playful approach to tradition and art history is fuelled in part by scepticism about cultural progress, a tendency that has led some critics to accuse postmodern artists of relinquishing culture to the capitalists. Many postmodern artists, moreover, set out to collapse the distinction between high and low culture. Pop art, with its love of consumerism and tawdry, everyday things, could perhaps be seen as the first form of postmodernism, and emerged in New York at about the same time as minimalism, which might be called the last gasp of modernism. Roy Lichtenstein's *Whaam!* 1963 (p.163) revels in the vivid graphics of American comics and is one example of how postmodernist art assailed the highbrow aims of modernism. Other artists who practised what might now be considered a precursor to postmodernism are the Americans Jasper Johns, Robert Rauschenberg and Cy Twombly, who reacted to the high seriousness of abstract expressionism with work that was witty, socially engaged and called upon a broad range of references, from recent history to ancient poetry.

During the 1970s and 1980s, many American artists – including Barbara Kruger, Richard Prince, The Guerrilla Girls and Jenny Holzer – created art that was socially and politically demanding. Yet an element of celebration was also important to postmodernism, and many artists, such as Jeff Koons, pursued kitsch and consumerism in their work. In *Three Ball Total Equilibrium Tank (Two Dr J Silver Series, Spalding NBA Tip-Off)* 1985, Koons suspended a trio of commercial basketballs in an aquarium as if they were precious relics. In the 1980s, painters David Salle and Julian Schnabel combined layered imagery with bombastic themes, and their work has become synonymous with 1980s postmodernism in New York. Since the late 1970s, Cindy Sherman and Jeff Wall have explored the area between documentary and fiction in photography, and their work has become enormously influential. Bruce Nauman's *Double No* 1988, a looped video installation of two clowns bouncing on pogo sticks – with one television placed upside down on top of the other so that the clowns seem to be banging heads – is just one example of video art, a medium that became increasingly popular with postmodernist artists at the end of the twentieth century.

Contemporary art continues to be touched by a postmodernist ethos. Fiona Rae's *Night Vision* 1998, for instance, blends elements of hard-edge geometric abstraction reminiscent of modernism with expressive smears of pigment that disrupt the flat surface of the painting as if the artist were 'sampling', like a DJ, the history of abstract art. Similarly, Christian Marclay's *Video Quartet* 2002 (p.172) samples footage from Hollywood films to create a structure that is fractured, with a collage of seemingly discordant sounds and images, and yet creates a coherent whole from this diverse range of found material. **CB**

Left:
Jeff Koons (born 1955)
Three Ball Total Equilibrium Tank (Two Dr J Silver Series, Spalding NBA Tip-Off)
1985
Mixed media
153.6 x 123.8 x 33.6 cm
Purchased 1995

Below:
Jeff Wall (born 1946)
A Sudden Gust of Wind (after Hokusai)
1993
Photographic transparency
and illuminated display case
250 x 397 x 34 cm
Purchased with assistance from
the Patrons of New Art through
the Tate Gallery Foundation and
from the Art Fund 1995

Robert Rauschenberg's career has been long and varied, and although he is seen as an important historical figure in performance art, set design and experiments with art and technology, he is best known as a leader in bridging the period between abstract expressionism and pop art. One of his best-known works is the *Erased de Kooning Drawing* of 1953, a small work on paper made from the marks remaining after rubbing out a drawing by the abstract expressionist Willem De Kooning. Often seen as a rebuff to the preciousness associated with the artist's gesture, Rauschenberg's conceptual experiment with what he called 'the simultaneous unmaking of one work and the making of another' also relates to the monochrome paintings he had been making while studying with Joseph Albers at Black Mountain College in North Carolina.

By the late 1950s, Rauschenberg had begun to incorporate found imagery from newspapers and magazines into his drawings, prints and paintings. *Almanac* 1962, made by silk-screening found images in a loose, poetic manner, and then overlaying them with painterly brushstrokes, is characteristic of his work at this time. Among his most celebrated achievements are the so-called 'combines' he made from 1954 to 1962, which integrated aspects of painting and sculpture and often included bizarre objects such as stuffed animals, street signs or bedding. There is rarely a specific meaning or narrative in Rauschenberg's works; rather, viewers are invited to make their own interpretations from the visual flux of media, subjects and gestural marks. **SH**

Almanac
1962
Oil, acrylic and
silkscreen on canvas
245 x 153.5 cm
Presented by the Friends
of the Tate Gallery 1969

Robert Rauschenberg
1925–2008

Monochrome
Often mistakenly described as a 'blank canvas', monochrome painting is the term applied to works of art that are made up of a single colour or tone. The practice of monochrome painting was a surprisingly resilient one throughout twentieth-century American and European avant-garde art. At times the attraction for artists was nihilistic, at others more spiritual.

Paradoxically, monochrome works were executed in different historical contexts both to criticise and to reaffirm the value of painting. The origins of the practice lie with the work of Kasimir Malevich and Aleksandr Rodchenko in Russia in the 1910s. Monochrome painting then flourished in the United States in the 1950s and 1960s, when it was closely related to minimal sculpture, dance and filmmaking. Important practitioners from this period included Robert Rauschenberg, Ad Reinhardt, Brice Marden and Robert Ryman, as well as Piero Manzoni and Yves Klein in Europe. Contemporary artists including Gerhard Richter and Anish Kapoor have continued to experiment with the monochrome, finding in it endless possibilities for exploring and contesting artistic values. **SH**

Ad Reinhardt was a purist. His lifelong search was for 'art as art and as nothing else'. He expressed this idea both in his paintings and his writings as a series of negations. 'No lines or imaginings, no shapes or composings or representings, no visions or sensations or impulses, no symbols or signs or impastos, no decoratings or colourings or picturings, no pleasures or pains, no accidents or ready-mades, no things, no ideas, no relations, no attributes, no qualities – nothing that is not of the essence', he wrote in 1962. Though he never swerved from a rigorous abstraction, it was not until the last years of his life, when he limited himself to making square black paintings, that he seemed to have achieved his goal. Although the black paintings, of which Tate's *Abstract Painting No. 5* 1962 is exemplary, appear at first to be completely monochrome, close examination reveals an underlying grid of very subtly coloured squares. Each of the colours was mixed with black oil paint to give a matt surface quality. Because of these paintings, and his deep interest in Eastern philosophy, Reinhardt was sometimes referred to as the 'black monk' of the New York art scene. He is widely recognised as an important early figure in minimalism and his influence as a teacher and writer is evident in the work of many American artists of the 1960s and 1970s. **SH**

Abstract Painting No. 5
1962
Oil on canvas
152.4 x 152.4 cm
Presented by Mrs Rita Reinhardt through the American Federation of Arts 1972

Ad Reinhardt
1913–1967

Lis Rhodes is a major figure in the history of artists' filmmaking and Expanded Cinema in Britain. She has experimented with both film and sound, and, by pushing the spatial boundaries of cinema, she creates a more participatory role for the viewer. She began to incorporate performance, photography, text and spoken word into films in the 1970s, a period in which she also worked as the cinema curator at the London Filmmakers' Co-op. Her works voice feminist ideas in relation to dominant cultural practices and she has been instrumental in drawing attention to the lack of women's representation in the arts and filmmaking.

Rhodes made *Light Music*, a 16mm film double-projection, in 1975 and it has come to be regarded as a seminal exploration of optical sound and Expanded Cinema. The two projections in *Light Music* face one another, and the abstract pattern of black and white horizontal and vertical lines that appear on the screens are also read by the projector as audio. As the title indicates, this creates a direct, indexical relationship between what is seen and what is heard, as the dramatic sound corresponds to the spaces between the lines. By hazing the room for *Light Music* Rhodes also gives the crossing projection beams a sculptural quality, as the stripes on-screen become three-dimensional bands of light and dark in the space. This format is designed to encourage the viewer to move between the screens and to engage directly with the beams, so that projected light and the space between the projections become part of the central formal relationship of the work alongside the images and sound. In this way the classic proscenium format of the cinema is transformed into a collective event in which audience intervention creates a unique and complex spatial situation. **SC**

Light Music
1975
2-screen 16mm film installation with sound, 25 min
Purchased 2011
Installation view in the former oil tanks, Tate Modern 2009

Lis Rhodes
born 1942

The Second World War
The final months of the Second World War bought horrific revelations of Nazi death camps and the unleashing of atomic weapons on Japan. European artists such as Alberto Giacometti, Jean Fautrier, Germaine Richier and Francis Bacon made work that was visibly informed by the prevailing mood of dislocation and existential unease. They depicted the human body as wounded, decayed and isolated. Other artists, including Boris Taslitzky and André Fougeron, saw realist styles as the best means to create politically committed works that would engage a mass audience with the grim political realities of the time. In the late 1940s, the onset of the Cold War threatened yet another conflict. In New York, younger painters including Jackson Pollock, Mark Rothko and Barnett Newman responded to the ideological disputes of the time by forging new forms of expressive abstraction that commentators quickly linked to ideas around personal and political freedom. **SH**

Germaine Richier's early work was classically figurative. After the Second World War, she began to use bronze in a more expressive way, and frequently incorporated objects from the natural world, such as driftwood, into her sculptures, creating an array of disturbing creatures. *Storm Man* 1947–8 and *Hurricane Woman* 1948–9 are typical: their pitted and scarred surfaces, as well as their mutilated facial features, suggest intense human suffering. In her sometimes brutal treatment of her working material Richier can be likened to Alberto Giacometti. For both artists the atmosphere of violence and destruction in postwar Europe determined the direction of their work. Richier believed that in order to be effective, art should not 'withdraw from expression', since 'we decidedly cannot conceal human expression in the drama of our time'.

Richier's works frequently suggest the metamorphosis of humans into animals. In *Shepherd of the Landes* 1951, a shepherd has merged with the stilts he uses to help see over long distances of grazing territory, to create a hybrid creature. *Chess Board (Large Version)* 1959, Richier's final work, consists of five oversized playing pieces that are as horrific as they are playful. The King brandishes a set of sculptor's calipers. The Queen, who has a horse-like head, raises her arms, as does the Knight, while the Castle stands on three legs. The bishop is a hunched figure wearing a three-cornered hat. Richier's half-human, half-animal forms exerted a significant influence on the postwar generation of British sculptors, including Reg Butler, Kenneth Armitage and Lynn Chadwick. **SH**

Shepherd of the Landes
1951, cast 1996
Bronze
149 x 89 x 60 cm
Lent from a private collection
1998

Germaine Richier
1902–1959

In the early 1960s, the German artist Gerhard Richter began to make paintings based on photographs. While some of these were taken from newspapers and magazines, they also included amateur and family snaps. Richter was drawn to the awkwardness and lack of sophistication of such images: 'There was no style, no composition, no judgement', he has said. 'It liberated me from personal experience. There was nothing but a pure picture.' He often exaggerated the blurred quality of his source material, as if to emphasise that he was painting an object – a photographic print – rather than the person or landscape it depicted. This approach enabled him to maintain an ironic, questioning distance from his subject matter: the prosaic reality of life in postwar Europe, encompassing city scenes, portraits, advertisements, the cultural heritage of the past and the political turbulence of the present.

Abstraction became a significant part of Richter's output during the 1970s and 1980s. The acid colours and dense surface of these works were built up in successive layers, each one scraped back then painted over again with a range of different brushes and thick spatulas. These techniques, eradicating the artist's original intentions to create something unforeseen, can be understood as another strategy for removing his personality from the work. *St John* 1988 belongs to a series called the 'London Paintings', each named after one of the chapels at Westminster Abbey. However, the titles are not intended to be descriptive, nor should this be taken as a religious work. In contrast to earlier artists such as Wassily Kandinsky or Mark Rothko, Richter insists that abstract paintings do not embody spiritual values or the transcendent sublime – they're just paintings. **SBo**

St John
1988
Oil on canvas
200.5 x 260.5 cm
Presented by the Patrons of New Art through the Friends of the Tate Gallery 1988

Gerhard Richter
born 1932

Deny II
1967
PVA emulsion on canvas
217.2 x 217.2 cm
Purchased 1976

Bridget Riley shot to international prominence in 1965 when her work was included in *The Responsive Eye* exhibition at the Museum of Modern Art in New York. Her black and white paintings of the preceding five years use repeated forms and lines to produce illusions which draw the viewer's attention to the mechanisms of perception. In *Hesitate* 1964, the illusion of a deep fold is irresistible, even as it is evidently created by the diminution of circles into ovals and by the subtle shifts in tone. The considerably larger *Deny II* 1967 uses related devices, though the move to a darker ground brings greater sobriety. The painting belongs to a series (all with mysteriously emotive titles) in which Riley used different grades of grey to change 'tempo'. She described how she pitched 'this type of grey movement against the structure of the formal movement' of the ovals.

Immediately regarded as part of the international op art trend (together with Victor Vasarely), Riley introduced colour into her work around 1970–1. While always informed by an understanding of earlier artists such as Seurat and Cézanne, she controlled the potentially vast complexity of juxtaposed hues through formal simplicity, usually reliant upon stripes with relieving and enlivening interstices of white. Serpentine lines introduced illusions of waves. In the 1980s, working in France as well as London, Riley restructured this formal vocabulary by cutting the dominant verticals with diagonals. The resulting rhomboids and lozenges of intense colour overlap the vertical divides to introduce suggestions of space. In these dense fields of colour Riley's long-standing concern with the conjunction of visual and emotional energies remains paramount. **MG**

Bridget Riley
born 1931

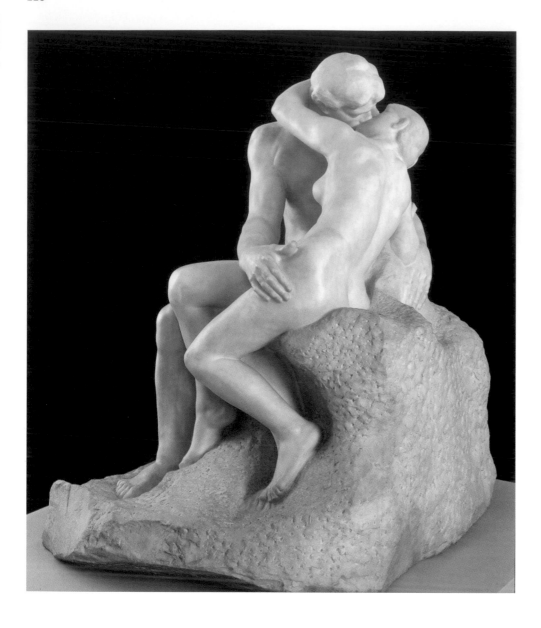

Auguste Rodin, perhaps the greatest of nineteenth-century sculptors, is renowned for his vigorous and expressive rendering of the human form. He was originally trained as an ornamental mason, and his ability to capture the subtleties of the human figure was so extraordinary that when he exhibited an early work, *The Age of Bronze*, in 1877, he was accused of casting his work from life. Rodin was, however, concerned with the articulation of ideas over form, and many of his works appear incomplete or intentionally fragmentary as a result. With its free treatment of form, usually to dramatic or emotive ends, Rodin's work is especially valued as a precursor of pure expression, as well as expressionism more specifically.

While *The Kiss* 1901–4 features two of Rodin's more idealised figures, the lack of inhibition conveyed by their pose captures the essence of human sexual intimacy. As with many of Rodin's groups of figures, *The Kiss* was originally conceived as part of *The Gates of Hell*, a larger, unfinished commission begun in 1880, which illustrated scenes from Dante's *Inferno*. The depicted couple are Francesca da Rimini and her husband's brother, Paolo Malatesta, the thirteenth-century adulterous lovers doomed to the second circle of hell in Dante's work. Rodin shows the lovers at the moment of their first impassioned kiss, before they are discovered – and subsequently murdered – by Francesca's husband.

The work in Tate's collection is one of three full-scale marble versions carved during Rodin's lifetime, although he also created several smaller versions of the work in clay, plaster and bronze. Rodin encouraged the reproduction of his works, and further editions of many of his sculptures have been produced posthumously. **MB**

The Kiss
1901–4
Pentelican marble
182.2 x 121.9 x 153 cm
Purchased with assistance from the Art Fund and public contributions 1953

Auguste Rodin
1840–1917

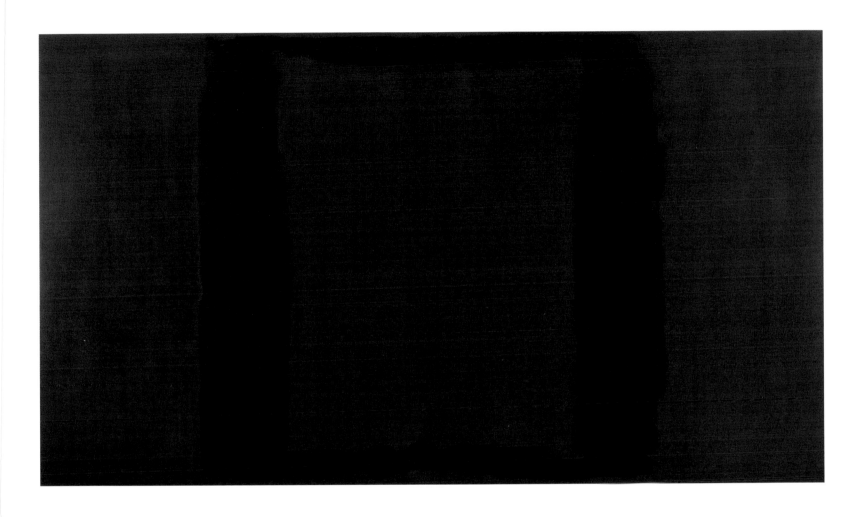

Mark Rothko's style of painting refers both to the simplified compositions and flat areas of colour used by artists such as Matisse and to the abstract expressionist work of his American contemporaries.

His *Seagram Murals* were originally commissioned to enhance the decor of the Four Seasons restaurant in the Seagram Building in New York. But after a meal there in 1959, Rothko suddenly withdrew from the commission and returned the money. Instead, he gave the *Seagram Murals* to the Tate in the late 1960s. His main concern was that they should be displayed in a compact space under reduced light. The murals arrived at the gallery in 1970 – the year the artist committed suicide.

Through his use of pillar and window forms and flat colour planes, Rothko alludes to classical and renaissance architecture – in this case to the blind windows and the deliberately oppressive atmosphere of Michelangelo's Laurentian Library in Florence – as well as to Roman villas and Grecian temples. When interviewed about the commission, Rothko later claimed that by referring to these previous empires, he intended to challenge the power of the burgeoning American empire and its elites by confronting diners with his paintings.

Whereas Rothko's earlier works draw on a brighter palette of intense colour, here it is the sombre blacks, reds and maroons, as well as their manner of display, that promote quiet, meditative contemplation for some viewers and claustrophobia in others. **RL**

Black on Maroon
1959
Mixed media on canvas
266.7 x 457.2 cm
Presented by the artist through the American Federation of Arts 1969

Mark Rothko
1903–1970

One of the most influential postwar Brazilian artists, Mira Schendel explored philosophical concerns in her work such as the nature of being, the idea of nothingness, faith and certainty. While her work was part of a rethinking of the European tradition of abstract-geometric 'concrete' art in Brazil in the 1950s and 1960s, her practice was extremely idiosyncratic and through it she pursued ideas and forms that extend far beyond this frame of reference. Her production encompassed painting, drawings, monotypes and notebooks, as well as sculptural works that draw upon the concept of time and the philosophy of language. The abstract painting *Untitled* 1963 exhibits Schendel's experimental approach,

her reduced palette and use of organic rather than precise geometry. She is best known, however, for her monotypes on Japanese paper and 'graphic objects' that utilise text as a formal element. Such works as *Untitled (Disks)* 1972 were displayed between sheets of Perspex – so there is no perceived front or back – and hung away from gallery walls.

Born in Zurich in 1919, Schendel studied philosophy at the Catholic University in Milan. However, owing to her Jewish heritage, her studies were cut short by the restrictions introduced by the Italian Fascist regime under the notorious Racial Laws. After the war, she emigrated to Brazil where her career as an artist began. In São Paulo, she established an intellectual circle that included the psychoanalyst and poet Theon Spanudis, the theoretical physicist and art critic Mario Schenberg, philosopher Vilem Flusser and concrete poet Haroldo de Campos. This network occupied a key place in émigré circles in Brazil. Significantly, Schendel did not locate herself in any single cultural or aesthetic tradition; instead, her experience of displacement underpinned the linguistic, theological and philosophical plurality within her art. **TB**

Untitled (Disks)
1972
Letraset, graphite on paper
and transparent acrylic
27 x 27 x 0.7 cm
Lent by the American Fund for
the Tate Gallery 2007

Mira Schendel
1919–1988

Karl Schmidt-Rottluff was one of the leading painters of German expressionism. Through his friend Erich Heckel, he met Ernst Ludwig Kirchner and Fritz Bleyl while studying in Dresden. Together they formed the Brücke (Bridge) group. The name was a quotation from a passage by Nietzsche about youthful initiates making a bridge towards a new future. The group's relaxed, communal lifestyle and contemporary morals are reflected in the many studio scenes with young girlfriends and models that Schmidt-Rottluff, Heckel and Kirchner painted in the years after they met. They also travelled together to local lakes and more distant parts of the German coasts to paint landscapes and seascapes.

Schmidt-Rottluff's work of this period is characterised by bold colours placed directly adjacent to one another using vigorous brushwork. Around 1910–11, after his confrontation with ethnic sculptures in the museums of Dresden and Berlin, his compositions became more block-like. He also made sculptures (p.110) and joined his fellow expressionists in reviving older German traditions of the woodcut. Schmidt-Rottluff was particularly prolific, producing around 600 woodcuts by the mid 1920s. His art was defamed during the Third Reich and removed from museum collections. However, he continued to work and after the war was appointed a professor at the Academy of Fine Arts in Berlin. Throughout his career he remained a figurative artist, specialising in the depiction of landscape. **SR**

Karl Schmidt-Rottluff
1884–1976

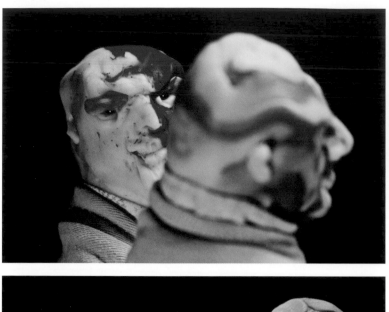
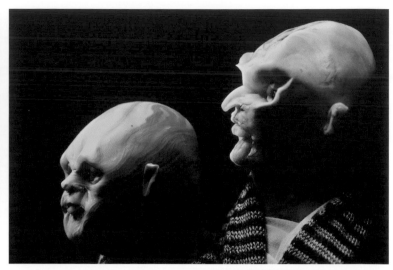

Thomas Schütte is a German artist who creates installations, models, sculptures and photographs, as well as watercolours and drawings of great immediacy and delicacy. These works oscillate in theme between the suggestion of public and utopian ideals, an interest in the graphic language of power, the inscription of meaning within particular spaces, and the description of personal and subjective experience.

Early in his career, Schütte developed the notion of a 'repertoire'– a stock of different types of work or 'fields' of activity to which he regularly returns. These interrelate in what he calls 'a balance of contradictions', allowing interpretations of his work to remain as flexible as possible,

and creating the sense of a simultaneity of interests, materials and forms rather than a linear progression from one type of work to another.

Schütte's works, including public sculptures and installations, have revealed his political interests, referencing the Holocaust, the plight of asylum seekers and refugees, and the rise of neo-Fascism in post-unification Germany. In *United Enemies* 1994, subtitled *A Play in Ten Scenes*, he was influenced by a study trip to Rome that he had undertaken a year earlier, at a significant moment of change and upheaval for Italian politics. The resulting installation centres on tiny modelled male figures, perhaps inflected by classical statuary, bound together and shown under glass domes like those used to display stuffed birds and animals. Prints lining the room provide close-up views of the figures' often distorted and comically caricatured faces. The work suggests how humanity is bound together whether we like it or not, sharing the same fate. The diminutive scale of the figures makes their struggles appear petty, creating a gentle satire on the nature of human politics and communication. **ED**

From *United Enemies*
1994
Lithographs on paper
Each 64 x 95 cm
Purchased 1995

Thomas Schütte
born 1954

Merz
Taking the name from a fragment of text in one of his collages, Kurt Schwitters coined the term *Merz* in 1919 to refer to his assemblages, and subsequently used it to for all his works, including his poetry. An artistic 'movement' that included Schwitters alone, its underlying principle was the allocation of equal worth to all materials. For Schwitters, *Merz* was an aesthetic style that signified freedom from social, cultural and political conventions. **MB**

Kurt Schwitters is best known for his collages of discarded materials, which he called *Merz*. While associated with both the dadaists and constructivists, he was never part of either movement. His collages, performances and writings bear similarities to the work of the dadaists, but differ in intent. Whereas dada was a self-proclaimed anti-art, espousing defiantly negative principles of disruption and rejection, Schwitters's *Merz* were essentially constructive, reassigning value to discarded fragments by positioning them within a constructed composition. There is a systematic rigour to his assemblages, built on structures derived from cubism. He extended the principles of *Merz* to the interior of his house in Hanover, where he created his first *Merzbau*, a precursor to contemporary installation art.

After being branded a 'degenerate artist' and forced to leave Nazi Germany, Schwitters escaped first to Norway and then, when that country was invaded, to England. *Picture of Spatial Growths – Picture with Two Small Dogs* 1920–39 (p.96) was one of a few works he managed to have brought out of Germany. He reworked the surface of the picture in Norway, adding further layers of papers and objects, including the two small china dogs that give the work its title. Also assembled in Norway, *Opened by Customs* 1937–8 is typical of Schwitters's compositions, a highly ordered arrangement featuring pieces of rubbish and fragments of German and Norwegian newsprint. The title was added to the work by Schwitters's son, taken from two customs labels included in the composition. **MB**

Opened by Customs
1937–8
Paper collage, oil and pencil on paper
33.1 x 25.3 cm
Purchased 1958

Kurt Schwitters
1887–1948

Coming from a background in choreography and political economy, both of which play a fundamental role in his work, Tino Sehgal does not produce tangible objects. The human voice, language, movement and interaction are the artistic materials with which Sehgal stakes out a radical position within the tradition of sculpture and installation. He is not interested in leaving any form of material trace nor does he allow photographs of his ephemeral interventions. He views visual art as being completely interrelated with society and functioning along identical economic conditions, namely the production and exchange of commodities. He is interested in challenging these conditions by creating works that appear as the production of meaning through a transitory situation.

He does so by fulfilling the conventions of a visual artwork without physically producing anything, assembling meaning by directing people rather than creating objects.

Sehgal effectively designs situations that take the form of fleeting gestures. They are based on movement and the spoken word, with one or several people acting out a set of instructions. He has worked with a variety of 'interpreters' including museum guards, singers, children and the owners of his galleries, to create provisional pieces of art that challenge the traditional museological context.

This is Propaganda 2002 is a seminal work. It consists of a female invigilator who sings the work's title whenever a new visitor enters the gallery space. Acting as an interruption in the normative experience of movement through the gallery spaces and the unreactive presence of museum officials, this work calls the visitor to attention, questioning the easily-consumed museum experience. Sehgal disrupts the visitor experience with a self-consciousness that encourages a questioning of the institution, its methods of display, and the role of the artwork in contemporary society. **JM**

Tino Sehgal
born 1976

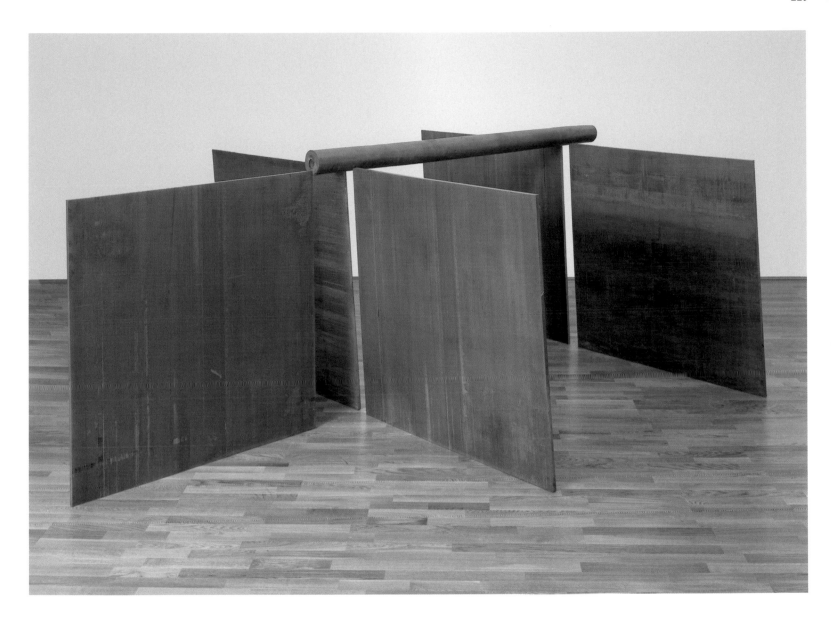

Richard Serra's abstract sculptures explore the innate properties of heavy materials, and the way in which our physical awareness is determined by space, place, time and movement. His early work from the late 1960s emphasised physical processes over final form, and included a series of works created by throwing molten lead against the walls of his studio. Serra also made a number of short films at this time.

By 1969, Serra had begun producing his 'prop pieces', sculptures whose parts are balanced solely by forces of weight and gravity. His sculpture *2-2-1: To Dickie and Tina*

1969 is an example of such a self-supporting configuration. It consists of two pairs of lead sheets and one single sheet, which stay upright only by the force and weight of another rolled lead tube that rests on one corner of each of the sheets. The result is both dramatic and slightly threatening. A later work, *Trip Hammer* 1988, seems even more precarious. One sheet of steel stands upright, 2.6 metres high and 1.3 metres deep, and balances on an edge 5 centimetres wide. Another sheet rests horizontally on this thin edge, its only other means of support provided by its minimal contact with the wall.

Serra has continued working with large-scale assemblies of sheet metal, but since 1970 his work has been increasingly site-specific. The more recent works are often vast in scale and while seen by some as poetic configurations of space, have been criticised by others as too confrontational. In the 1980s, *Tilted Arc*, a 120-feet-long, 12-feet-high curving wall of metal installed in the centre of the Federal Plaza in New York City, caused intense controversy, and was finally removed for scrap. **SH**

2-2-1: To Dickie and Tina
1969, 1994
Lead antimony alloy
132 x 349 x 132 cm
Purchased with assistance from the American Fund for the Tate Gallery 1997

Richard Serra
born 1939

Untitled A
Untitled B
Untitled C
Untitled D
1975
Photographs on paper
Each 41.4 x 28.3 cm
Presented by Janet Wolfson
de Botton 1996

In the mid 1970s many artists were using photography to record performances, but Cindy Sherman was one of the first to pioneer photography as a fine art medium in itself. Although she has made herself the prime subject of her pictures, her work can scarcely be described as self-portraiture. Rather than using the medium to explore her true identity, she employs costumes and make-up to project alternative personae derived from her imagination.

Sherman studied to be a painter but was drawn to the idea of using make-up as a form of painting, her own body becoming the canvas. *Untitled A, B, C* and *D* 1975 belong to an extensive series of photographs in which she transforms herself from one character to another. The make-up used is deliberately crude, but despite the theatricality of the images, she nevertheless successfully implies a range of characters, including a young girl, an older woman and a man. Masquerade had earlier been employed by the surrealists as a means of exploring the nature of desire and sexual identity. Sherman uses it to test the boundaries between race, class, age and gender.

Sherman's interest in artifice is further explored in her *Film Stills*, in which she casts herself as the subject in imaginary film scenes. She described how the female types in these images were derived from the plethora of images absorbed from cultural sources such as film, TV, advertisements and magazines, as well as real acquaintances who served as role models in her youth. Detached from any real scenario, Sherman's evocative *Film Stills* invite the viewer to construct their own narratives around the images. **HS**

Cindy Sherman
born 1954

The American artist Taryn Simon undertakes photographic projects that are often political in scope, and usually accompanied by a publication. *An American Index of the Hidden and Unfamiliar* 2007 comprises sixty-two images made over the course of four years through which she documented sites and activities which are usually inaccessible to the public and to public scrutiny. Her work is formal in composition and her accompanying text (in full below) gives background details about the documented site and outlines why it is ordinarily out of bounds. **SM**

Submerged in a pool of water at Hanford Site are 1,936 stainless-steel nuclear-waste capsules containing cesium and strontium. Combined, they contain over 120 million curies of radioactivity. It is estimated to be the most curies under one roof in the United States. The blue glow is created by the Cherenkov Effect or Cherenkov radiation. The Cherenkov Effect describes the electromagnetic radiation emitted when a charged particle, giving off energy, moves faster than light through a transparent medium. The temperatures of the capsules are as high as 330 degrees Fahrenheit. The pool of water serves as a shield against radiation; a human standing one foot from an unshielded capsule would receive a lethal dose of radiation in less than ten seconds.

Hanford is a 586 square mile former plutonium production complex. It was built for the Manhattan Project, the U.S.-led World War II defense effort that developed the first nuclear weapons. Hanford plutonium was used in the atomic bomb dropped on Nagasaki in 1945. For decades afterwards Hanford manufactured nuclear materials for use in bombs. At Hanford there are more than 53 million gallons of radioactive and chemically hazardous liquid waste, 2,300 tons of spent nuclear fuel, nearly 18 metric tons of plutonium-bearing materials and about 80 square miles of contaminated groundwater. It is among the most contaminated sites in the United States.

Nuclear Waste Encapsulation and Storage Facility, Cherenkov Radiation Hanford Site, US Department of Energy Southeastern Washington State
2007
Photograph on paper
65 x 83.9 cm
Purchased 2008

Taryn Simon
born 1975

David Smith's sculptures combine both monumentality and spontaneity in remarkable synthesis. He grew up in Indiana, where he formed an admiration for trains and railroads. Aged nineteen he worked as a welder and riveter in a car factory, developing a deep respect for the materials iron and steel. He stated of steel: 'What it can do in arriving at form economically, no other material can do. The metal itself possesses little art history. What associations it possesses are those of this century: power, structure, movement, progress, suspension, destruction, and brutality.'

Smith trained as a painter, however, coming to sculpture through collage and relief works. In *Home of the Welder* 1945 he draws flat planes together to form a volumetric whole with references to Egyptian building models and reliquary houses. The influence of surrealist sculpture, particularly Giacometti's early work, is evident in the depiction of a dream world. Smith creates a symbolic tableau using objects such as the millstone and chain to express the frustration and sense of confinement that he felt in relation to his work at this time and his childless first marriage.

Wagon II 1964 was made just a year before Smith's life was tragically cut short by a car accident. The sculpture demonstrates his ability to bend and draw in steel with apparent effortlessness, combining a sense of repose with an underlying suggestion of powerful latent energy. The wheels are both practical and symbolic, liberating the sculpture from a static position on a plinth and suggesting nature's eternal cycle. **MP**

David Smith
1906–1965

Wagon II
1964
Steel
214 x 117.5 x 287.5 cm
Purchased with assistance from the American Fund for the Tate Gallery, the Art Fund and the Friends of the Tate Gallery 1999

Frank Stella first came to prominence with a series of abstract geometric paintings in the early 1960s. Reacting against the demonstrative style of such abstract expressionists as Jackson Pollock and Franz Kline, he followed instead the more conceptual approach of Jasper Johns, whose paintings of the American flag stressed the object-nature of works on canvas. In his earliest work, Stella used compositions of stripes that emphasise the paintings' rectangular structures. In the famous *Black Paintings* 1958–60 narrow bands of black enamel are separated by fine lines of unpainted canvas that echo the horizontal, vertical or diagonal axes of the rectangle. *Six Mile Bottom* belongs to the subsequent series of *Aluminium Paintings* 1960–1 characterised by a similar use of aluminium paint, reinforcing the two-dimensionality and symmetry of the picture surface. In this series Stella cut away the small rectangles of canvas that were excluded by the logic of the striping pattern. He further developed this process in the following series of *Copper Paintings*, cutting away much larger areas of canvas and eliminating the original rectangular form.

Stella's insistence that 'what you see is what you see' was a significant influence on the development of minimalist sculpture, particularly that of Donald Judd, in its simplicity and quasi-industrial repetition. During the mid 1960s Stella began using colour for such works as *Hyena Stomp* 1962. By the 1970s he was combining organic forms and gestural brushstrokes with the earlier geometric structures in complex wall reliefs that have evolved into wholly three-dimensional structures. **EM**

Hyena Stomp
1962
Oil on canvas
195.6 x 195.6 cm
Purchased 1965

Frank Stella
born 1936

Surrealism

In his *Surrealist Manifesto* of 1924, the movement's leader André Breton declared: 'Surrealism rests on the belief … in the omnipotence of the dream, and in the disinterested play of thought.' The surrealists acknowledged the power of the unconscious, the suppressed and the irrational. As the means towards this intellectual, sexual and political liberation they drew upon and modified the (often contradictory) theories of Freudian psychoanalysis and Marxist politics. This synthesis is evident in the title of their first periodical: *La Révolution surréaliste*.

In these early years the surrealists actively explored the potential of the irrational. Breton and the other poets, including Paul Eluard and Robert Desnos, found release from conscious control through word games and automatic writing (unedited word association). In the belief that everyone could be an artist, they collaborated on techniques such as the game of visual 'Consequences' known as *Cadavre exquis* (Exquisite Corpse). The painters, including Joan Miró and André Masson, found individual ways of adapting automatic techniques to pictorial form. Their fluid lines and open fields of colour evoke the liberated world of the unconscious. Automatism would gain strength periodically within surrealism, notably in the 1940s work of Matta and Arshile Gorky in America.

Simultaneously, surrealist art evoked the illusory space of dreams, following the example of Giorgio de Chirico. Ernst adapted this mode in the 1920s, and Yves Tanguy, René Magritte (around whom a Brussels group formed) and Salvador Dalí painted inexplicably disrupted situations. Their explorations also shifted into a wide variety of media. Photography and film were introduced through Man Ray's experiments and the explosive impact of *Un Chien andalou* (1929), on which Dalí collaborated with Luis Buñuel, while Alberto Giacometti's sculptures encouraged Dalí to promote provocative surrealist objects that could infiltrate everyday life.

The movement was regularly subject to bitter internal disputes, which included defections to a rival group around Georges Bataille's periodical *Documents*. However, fragmentation was matched by internationalism in the 1930s as surrealism broadened its reach through a string of exhibitions linked to sister groups in Brussels, Prague and Tenerife. The *International Surrealist Exhibition*, held in London in 1936, was the first to challenge the way in which art was displayed. With Breton, the artists Roland Penrose and E.L.T. Mesens set up striking juxtapositions of small works against large, realistic against abstract. Such extraordinary exhibitions attracted wide publicity (25,000 visited the London show in a month) and a stream of new recruits. There was a notable number of women artists among them, including – in Britain alone – Eileen Agar, Lee Miller and Leonora Carrington.

Among art movements, surrealism was unusually long-lived (continuing into the 1960s), and this may be attributed to the potency of reconciling 'the real and the imagined … the communicable and the incommunicable'. When Breton, Matta, and others were exiled to New York during the Second World War, surrealism made its impact on the abstract expressionist artists they encountered there, including Gorky and Jackson Pollock. Surrealism's legacy is still discernible; its assertion of the often transgressive liberation of the mind has profoundly marked subsequent cultural activity. **MG**

René Magritte (1898–1967)
Man with a Newspaper
1928
Oil on canvas
115.6 x 81.3 cm
Presented by the Friends
of the Tate Gallery 1964

Opposite:
Salvador Dalí (1904–1989)
Autumnal Cannibalism
1936
Oil on canvas
65.1 x 65.1 cm
Purchased 1975

Opposite, left:
Man Ray (1890–1976)
Indestructible Object
1923, remade 1933,
editioned replica 1965
Wooden metronome
and photograph
21.5 x 11 x 11.5 cm
Presented by the Friends
of the Tate Gallery 2000

Opposite, far left:
Luis Buñuel (1900–1983) and
Salvador Dalí (1904–1989)
Un Chien andalou
1929
Film still
Courtesy BFI

Yves Tanguy is known for the subterranean worlds he created, in which strange, biomorphic forms exist in empty landscapes. Having joined the Surrealist movement in 1925, he became fascinated with automatic drawing, creating images spontaneously from his imagination. He regularly participated in the Surrealist game of the 'exquisite corpse', where players would draw one part of a 'body' secretively, fold the sheet over and pass to the next player until a bizarre whole being was completed.

Despite receiving no formal artistic training, Tanguy had a great facility with paint, creating seamlessly smooth surfaces and minutely painted organic forms. He developed his distinctive language during the late 1920s and early 1930s, and while his biomorphic images are said to be derived from the rock formations he had seen in Brittany, they appear to have little in common with the real world. Tanguy progressively honed his compositions, and following a visit to Africa, his landscapes became expansive voids, which appear to extend into infinity. In *Azure Day* 1937, only two vague, cloud-like accumulations help to differentiate between sky and land. In the foreground, strange skeletal beings are grouped in confrontational formations. Their delicately pastel-coloured shapes and the apparently benign title of the work appear incongruous when viewed against the threatening atmosphere that pervades the composition. **LA**

Azure Day
1937
Oil on canvas
63 x 81.2 cm
Accepted by HM Government in lieu of tax on the estate of Cynthia Fraser, Chairman of the Friends of the Tate Gallery 1965–71, and allocated to the Tate Gallery 1996

Yves Tanguy
1900–1955

Eine Kleine Nachtmusik
1943
Oil on canvas
40.7 x 61 cm
Purchased with assistance
from the Art Fund and the
American Fund for the
Tate Gallery 1997

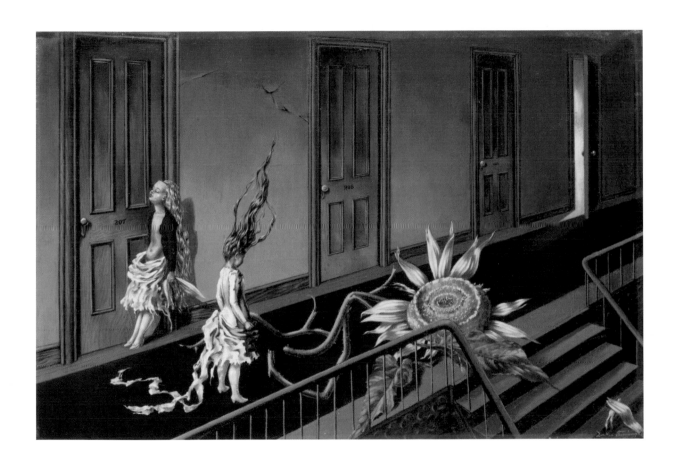

Dorothea Tanning latterly worked as a painter, sculptor and printmaker, and as a writer and poet. She became involved with surrealism in the 1940s, after meeting the group of artists in exile in New York from Paris during the Second World War, including Max Ernst, whom she later married. Her paintings from that period draw on personal and literary narratives of childhood fantasies and nightmares.

Tanning loved Gothic novels as a child and many characteristics of the genre are present in *Eine Kleine Nachtmusik* 1943. The title 'A Little Night Music' is borrowed from one of Mozart's most popular and light-hearted chamber works, and Tanning's painting certainly has more than a little of the 'night' about it. A dreary hotel corridor is the setting for a sinister and unnerving scene of unexplained events and unseen forces; a giant sunflower appears to menace or bewitch two young girls, one of whom leans lifelessly in a doorway while the other's hair stands on end, either through fright, static or a wind that affects nothing else in the scene.

Tanning's work evolved in the 1950s, as she experimented with different painting and, later, sculptural approaches. However, her use of motifs such as mirrors and flowers – symbolic material, almost always evoking the female human form – and dreamlike elements remained constant. **RL**

Dorothea Tanning
1910–2012

Rirkrit Tiravanija is best known for installation performances that directly engage the audience in a social environment. He is of Thai origin and in his early works he often used the skills he learned from his grandmother, a cook. His installations frequently take the form of stages or rooms for sharing meals, cooking, reading, playing music and engaging in other forms of social interaction. His work subtly questions the structure and purpose of the institutions in which it is shown.

Untitled, 2005 (sleep on earth, eat on sand) was made for the exhibition *The Politics of Fun* in the Haus der Kulturen der Welt, Berlin, in 2005. The work consists of a disused contractor's shed in which the artist set up a cooking station from which he made and served pad thai to gallery-goers. He had first made Thai curry in this way at a show entitled *Pad Thai* at the Paula Cooper Gallery, New York, in 1990 and this work is historically significant as it marked the last such performance.

In its incarnation in Berlin the work was installed just outside but was visible through the gallery windows. Cooking took place in and around the shed, and one of its walls was taken off and used as a tabletop on which the food was served. With one side removed, it resembled a stage set or vitrine. In keeping with Tiravanija's practice, the remnants of the Berlin performances, including cooking utensils and food remains, now constitute part of the work and are sealed in the shed. The effect of this 'time capsule' recalls the vitrines of Joseph Beuys and also the use of organic matter in the work of Dieter Roth. **JM**

*Untitled, 2005
(sleep on earth, eat on sand)*
2005
Contractor's shed, 4 gascookers,
Thai-style mats, metal, wood,
plastic, polystyrene, rubber,
paper and food
Shed 300 x 200 x 300 cm
Display dimensions variable
Purchased with assistance from
Tate International Council 2009

Rirkrit Tiravanija
born 1961

Luc Tuymans is one of a handful of artists responsible for the reinvigoration of painting during the 1990s. The arrival of conceptual art in the 1960s and later lens-based media such as photography and video had suggested that painting was an outdated and irrelevant medium, out of joint with a new age of radical technological and social developments. Part of Tuymans's success is based on his confrontation with the anachronism, inadequacy or 'belatedness' of painting, as he describes it.

Born in Antwerp in 1958, Tuymans briefly interrupted his career as a painter in the 1980s to become a filmmaker. Subsequently he has infused his paintings with filmic techniques such as close-ups, cropping, framing and sequencing. In addition he draws much of his subject matter and imagery from newspapers, films and television. His subject matter ranges widely from major historical events such as the Holocaust or Belgian colonial politics, to paintings that depict psychological states and emotions, to the banalities of wallpaper patterns or Christmas decorations. The undoubted centrality of subject matter in these works is undercut by their characteristic evasiveness, by what is left out or avoided rather than what is explicitly represented.

Illegitimate I 1997 is part of a group of works completed and first exhibited together, which express a sense of sickliness and contamination. The hazily rendered image is perhaps reminiscent of a traditional wallpaper motif, or the outline of female reproductive organs. Tuymans embraces ambiguity, enjoying the possibility of multiple interpretations for his work. He paints on unstretched canvases pinned to the wall, making numerous preparatory drawings and photographs, but insists that the time spent actually painting is always confined to a single day. **ED**

Illegitimate I
1997
Oil on canvas
210.1 x 131.1 x 2.3 cm
Purchased 1998

Luc Tuymans
born 1958

From *Quattro Stagioni*
(A Painting in Four Parts)
1993–5

Left to right:
Primavera
Acrylic, oil, crayon,
and pencil on canvas
313.2 x 189.5 cm

Estate
Acrylic and pencil on canvas
314.1 x 215.2 cm

Autunno
Acrylic, oil, crayon
and pencil on canvas
313.6 x 215 cm

Inverno
Acrylic, oil, and pencil on canvas
313.5 x 221 cm

Cy Twombly's paintings are distinctive for their inventive use of gesture. The abstracted forms on his canvases were produced through various different methods of applying paint, ranging from gentle brushwork to harsh scrapings, impasto daubs and graphic inscriptions. He developed his style in the wake of abstract expressionism and the 'action painting' of artists such as Jackson Pollock.

Twombly moved from his native America to Rome in 1957 and immersed himself in classical culture. The subjects of his paintings were often derived from literary and mythological sources and frequently feature fragments of text from classical poetry.

His works also evoke transience and decay. He often rubbed out or overworked sections of his paintings, suggesting the passage of time and alluding to the broader sweep of history. The delicacy of these erased passages acts as a metaphor for the fragility of memory. These erasures are particularly evident in the blackboard paintings that he began making during the late 1960s.

Quattro Stagioni 1993–5 is a series of four large paintings representing the seasons and the cycle of life, death and rebirth. The strong colours and expressive mark-making on the canvases suggest the emotive nature and violent changing of the seasons. The bright reds of spring and the searing yellows of summer contrast with the earthy browns and greens of autumn and the more solemn, muted blues and blacks of winter. The abstracted form of a boat recurs in the paintings, suggesting the passage to the underworld in the Egyptian Book of the Dead. **RT**

Cy Twombly
1928–2011

Bill Viola has been instrumental in the development of video installation in contemporary art since the 1970s. His work focuses on universal human experiences and reflects his interest in religious philosophy (including Zen Buddhism and Christian mysticism) as well as the traditions of Eastern and Western art. *Nantes Triptych* 1992 presents the viewer with three simultaneous, monumental projections showing a woman giving birth, a male figure plunged in water and an old woman dying. Echoing the structure of a Christian altar-piece, the two outside images document the harsh physical realities of entering or leaving the world, while the central image appears to convey a more subjective, dreamlike or spiritual state. Viola has spoken of his own near-death experience when he came close to drowning in a lake at the age of ten. His fascination with depicting the state of submersion in water reflects his desire to explore the encounter between 'the spirit world and the world of consciousness', water being a widely recognised symbol of spiritual renewal and/ or the unconscious.

These themes recur on a grand scale in *Five Angels for the Millennium* 2001. In this work five large-scale projections surround the viewer with slowed footage of figures plunging below or surfacing through water. An accompanying soundtrack reaches a crescendo as the figures ascend out of the water. The individual titling of the screens – 'Departing', 'Birth', 'Fire', 'Ascending' and 'Creation' – make clear reference to Viola's longstanding engagement with religious and mystical concepts. **AC**

Nantes Triptych
1992
Video and mixed media,
29 min 46 sec
Purchased with assistance from the Patrons of New Art through the Tate Gallery Foundation and from the Art Fund 1994

Bill Viola
born 1951

242

Vorticism

Launched in London in 1914 by the artist, writer and polemicist, Wyndham Lewis, vorticism was a British rival to futurism. The name was given currency by the title of the journal *Blast: Review of the Great English Vortex*, whose publication marked the launch of the movement. Vorticism shared the futurist enthusiasm for the energy and dynamism of the modern industrial and mechanical world. However, the vorticists rejected the futurist attempt to convey the romance of speed, referring contemptuously to 'automobilism' and the 'accelerated impressionism' of futurist painting. Instead they sought a more profound, architectural and abstract expression of this vision, exemplified in, for example, Lewis's *Workshop* of 1914–15 (p.161).

The first of *Blast*'s only two issues contained among other material two aggressive manifestos by Lewis 'blasting', in highly eccentric language and typography, what he considered to be the effete and backward-looking nature of British art and culture: 'BLAST First (from politeness) ENGLAND … CURSE ITS CLIMATE … DISMAL SYMBOL … of effeminate lout within.' But he then 'blessed' England for its maritime and industrial power, as well as its tradition of satire, and proclaimed the vorticist aesthetic: 'The New Vortex plunges to the heart of the Present … we produce a New Living Abstraction.' The only group exhibition of the vorticists was held in London in 1915, and as the First World War gathered pace, vorticism, like so much else, came to an end, although in 1920 Lewis made a brief attempt to revive it with Group X.

The other vorticist artists were Lawrence Atkinson, Jessica Dismorr, Cuthbert Hamilton, William Roberts, Helen Saunders, Edward Wadsworth and the sculptors Jacob Epstein and Henri Gaudier-Brzeska. David Bomberg was not formally a member of the group but produced major work in a similar style.

Very few vorticist paintings have survived, but there is a substantial body of works on paper. Outstanding paintings are Lewis's large *The Crowd* 1914–15, which evokes a revolutionary event in a stark urban and industrial setting, and David Bomberg's two large canvases *The Mud Bath* and *In the Hold*, both of 1913–14. Of his work Bomberg wrote: 'I appeal to a *sense of form* … in some work I completely abandon *Naturalism* and Tradition … My object is the *construction of Pure Form*.' He also wrote, 'I live in a *steel city*'. Among major surviving vorticist sculptures are works by Gaudier-Brzeska and Epstein, which present a mechanistic, modernist image of man and nature. Gaudier's giant carving, *Hieratic Head of Ezra Pound* 1914, is a vorticist portrait of the American poet who played an influential role in avant-garde circles in London from 1909–20 and strongly supported vorticism. Epstein's *Rock Drill* 1913–15 (p.108) combined a real machine with the highly abstracted life-size figure of its operator to create a towering and powerful image of modern industrial man. All that now survives of this work is the figure's torso, cast in bronze. **SW**

Henri Gaudier-Brzeska (1891–1915)
Bird Swallowing a Fish
c.1913–14, cast 1964
Bronze
31.8 x 60.3 x 27.9 cm
Purchased 1964

Right:
Front cover and page
from *Blast*, no.1, July 1914
Tate Archive

Below:
Edward Wadsworth (1889–1949)
Abstract Composition
1915
Gouache, pen and
pencil on paper
41.9 x 34.3 cm
Purchased 1956

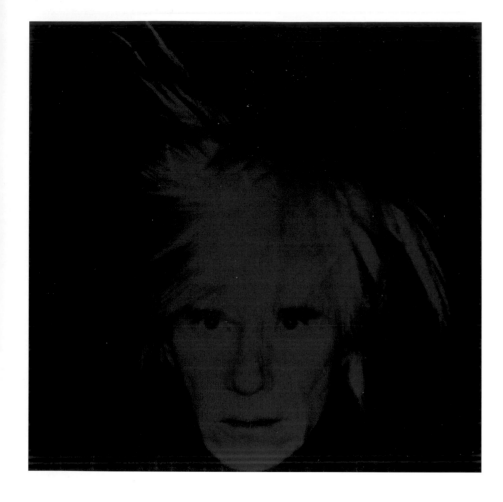

Celebrity
Warhol's comment that 'in the future, everyone will be famous for fifteen minutes' seems to have been borne out in the late twentieth and early twenty-first centuries, with the popularity of reality TV and greater public access to professional broadcast media. Celebrity remains a modern fascination, and thus a common subject of art. Painters as diverse as Elizabeth Peyton and Wilhelm Sasnal have made portraits of well-known actors, models and musicians, while Sam Taylor-Wood has used her famous friends, including Elton John, David Beckham, Marianne Faithfull and Robert Downey Jr in her artworks.

Warhol not only made portraits of celebrities, but became a celebrity in his own right. With his white-blond wig and deadpan speaking style, he was arguably the first artist of the media age to cultivate his persona as a recognisable 'brand', although a precedent can be found in Salvador Dalí. In the UK, art has periodically made the front pages of newspapers. In the 1970s controversy raged over the artistic merit of Carl Andre's *Equivalent VIII* (p.61), which became known as the 'Tate bricks'. More recently artists including Damien Hirst and Tracey Emin have actively cultivated their own media image as part of their artistic practice. **RT**

One of the most celebrated figures of the twentieth century and arguably the most important proponent of American pop art, Andy Warhol began his career as a commercial artist. As an illustrator for magazines and the advertising industry, he developed a distinctively clean and simple graphic style. His earliest works as a fine artist are drawings and paintings depicting consumer goods and images from the popular press.

In the early 1960s he began making images using silkscreening. This technique allowed for repetition of images on a large scale. The replication serves to depersonalise the images that Warhol chose and ultimately to render them equally banal or profound, regardless of whether they depict consumer objects, famous faces or electric chairs.

Many of his most recognisable pictures were sourced from the media and convey his fascination with celebrity and mortality. His works featuring Marilyn Monroe (p.208), Elizabeth Taylor and Elvis Presley depict the stars at the height of their fame. The blurring and fading that result from the intrinsic deterioration of the image in the silkscreening process suggest the inevitability of decay and death. In his images of Jacqueline Kennedy during the hours after the assassination of President John F. Kennedy, Warhol fetishises the First Lady's anguish, highlighting the media's morbid and compulsive fascination with private grief broadcast on a public scale.

In addition to his portraits of celebrated figures of the day, Warhol made several series depicting 'disasters' including car crashes and people jumping from high rise buildings in suicide attempts. These suggest his enduring interest in creating modern memento mori, images that act as reminders of mortality. **RT**

Andy Warhol
1928–1987

Self-Portrait
1986
Acrylic and screenprint on canvas
203.2 x 203.2 cm
Presented by Janet Wolfson de Botton 1996

Video Art
In 1965 Sony introduced the Portapak portable video system and changed art practice at a stroke. Like many new technologies it was originally developed by the military, but artists working outside the mainstream, as well as avant-garde dancers and filmmakers, embraced the new medium enthusiastically, avidly exploiting what it offered in terms of instant replay, portability, and solitary, economical filming, which could allow a new intimate relationship between the body and the camera. Video was not easily commodified, it could connect audiences and events immediately and directly in a way that traditional painting and sculpture could not, it was an important tool for documenting performance and happenings, and it could be used as a vehicle for critiquing mass media TV and Hollywood. Early uses by artists such as Bruce Nauman, Nam June Paik and Yoko Ono included live video feeds, and unedited real time footage.

The 1980s saw the development of video sculptures and installations, where the works became integrated into structural and architectural features giving a sense of permanence to a medium that in its infancy had traded on its immateriality, transience and fragility. By the 1990s video had become a key and at times dominant medium in international art exhibitions and as fears over longevity and conservation diminished, was increasingly acquired by major museums and private collectors. Cinema style and multiple projections immerse the viewer in a total visual and aural environment. The medium continues to offer a connection with the real world of TV, Internet, surveillance cameras and video games. **ED**

Gillian Wearing first came to prominence in the early 1990s for works featuring real people in real settings. While her photographs and films use the tropes of documentary reportage and reality television, her interest lies in the psychological subtext beneath the appearance of everyday life. She explores how the most intimate facets of our psyches are communicated to others.

For her photographic series *Signs that Say What You Want Them To Say and Not Signs that Say What Someone Else Wants You To Say* 1992–3 she photographed passers-by on the London streets holding placards on which they had inscribed messages. The signs range from the didactic to the emotive, revealing the complex inner world of each individual and the extent to which they are prepared to reveal themselves to a complete stranger.

The strategy of encouraging personal disclosure is also evident in Wearing's *Confess All On Video. Don't Worry You Will Be in Disguise. Intrigued? Call Gillian* 1994. The work's title was the wording of an advertisement she placed in the London listings magazine *Time Out*. Several participants responded, confessing personal stories on camera while wearing masks to protect their identities. Wearing's video functions as a contemporary equivalent of the confessional or the analyst's couch. The audience is invited to share the cathartic experience of the participants' 'talking cure' while drawing their own assumptions about the relative truth or fiction of the various narratives.

In *10-16* 1997, adults are shown lip-synching recorded interviews with young people between the ages of ten and sixteen. Putting the adolescents' words into the mouths of adults emphasises the enduring fragility of youthful hopes and fears with humour and poignancy. **RT**

10-16
1997
Video
Presented by the Patrons of New Art through the Tate Gallery Foundation 1998

Gillian Wearing
born 1963

Inspired in part by surrealism, the Thai filmmaker Apichatpong Weerasethakul's works present a world that is distinctly mutable and elusive. Conventional narrative unravels as storylines change course and genres morph between fiction, fantasy and documentary. Drawing heavily on anecdotal traditions from rural Thai villagers, as well as personal politics, social issues and his own early fascination with science fiction, Weerasethakul sees history caught in an endless cycle of dreams.

Primitive 2009 brings Weerasethakul's unique sensibility to bear on the long history of racial migration and slaughter in the Thai border town, Nabua. Less political documentary than haunting jungle dreamscape, the 8-screen video projection comprising the installation re-imagines the local history as an elusive science fiction story rooted in folklore. From the 1960s until the early 1980s Nabua, where the Mekong River divides Thailand from Laos, was a 'red zone', where the Mao-influenced Communists hid in the jungle. The Thai army curbed the communist insurgent farmers through physical and psychological assault.

For Weerasethakul, the jungle is a place of darkness and mystery, but also a place in which distinctions between the fictional and the real dissolve. It is a parallel world, populated by enchanted spectres, and it forms a perfect stage for the artist's fascination with reincarnation, transformation and light. In *Primitive* he combines the recent history of violence with the ancient legend about the ghost of a widow who abducted any man who entered her empire, earning Nabua the nickname 'the widow town'. He transforms the town into one of teenage men, descended from the farmers and freed by the widow ghost. They fabricate their own memories and build a new world, manufacturing a spaceship in the rice fields. **SC**

Primitive
2009
8-screen video projection, colour, with audio track, silent and sound, variable duration from 1 min to 29 min 34 sec
Purchased with funds provided by the Asia Pacific Acquisition Committee 2011

Apichatpong Weerasethakul
born 1970

Rachel Whiteread studied painting at Brighton Polytechnic (1982–5) and sculpture at the Slade School of Fine Art (1985–7). Her sculptures are made by casting the interior spaces of familiar objects such as a bath or a table, using plaster, resin or rubber, processes usually associated with the preparation of sculpture rather than the finished work. The intimate, domestic nature of her earliest works such as *Shallow Breath* 1988 – a cast of the space beneath the bed in which the artist was born – or *Ghost* 1990 – a cast of the interior of a living room in a terraced house similar to her childhood home – laid the foundations for the melancholic representation of memory evident in her body of work to date.

Whiteread, who won the Turner Prize in 1993 and represented Britain at the Venice Biennale in 1997, is one of the few artists of her generation to have worked on public sculpture of monumental scale. These major works include *House*, a life-sized concrete cast of the interior of a condemned terraced house in London's East End (1993, destroyed 1994), the cast of an entire library for *Holocaust Memorial* in Vienna (completed 2000) and *Monument*, a resin cast of the empty plinth in Trafalgar Square (2001), for which it was made. For the Unilever Series Turbine Hall commission at Tate Modern in 2005, Whiteread created *EMBANKMENT* (p.22). Comprising approximately 14,000 casts made from ten differently sized cardboard boxes stacked and built up in the space, it formed a labyrinthine installation speaking of personal history – but never revealing what the box might have contained – and of both the museum's industrial past and its present, as keeper of collective memory. **CW**

Untitled (Air Bed II)
1992
Polyurethane rubber
122 x 197 x 23 cm
Purchased with assistance from the Patrons of New Art through the Tate Gallery Foundation 1993

Rachel Whiteread
born 1963

Untitled
1975–80
Photograph on paper
14 x 14 cm
ARTIST ROOMS Acquired jointly
with the National Galleries of
Scotland through The d'Offay
Donation with assistance from
the National Heritage Memorial
Fund and the Art Fund 2008

Poetic and allusive, Francesca Woodman's photographs possess a remarkable psychological intensity. Her ethereal works appear to explore and dissolve the boundaries of the human body. Many of her images present young women in otherwise deserted interior spaces where the body almost merges with its surroundings, covered by sections of peeling wallpaper, half hidden behind the flat plane of a door or crouching over a mirror. Often using slow exposures that blur the moving figure into a ghostly presence, Woodman's work combines performance with self-exposure, suggesting the exploration of extreme psychological states.

Born into a family of artists, Woodman began taking photographs at the age of thirteen, and her work reflects her absorption of a range of visual material from surrealist and fashion photography to Baroque painting. She sometimes included fetishistic found objects and phallic props that are seen in relation to her own body or to the bodies of her models. Many of the photographs suggest a spirit of playful experimentation at odds with their sense of claustrophobia. As her work evidently addresses gender and representation it has been read in the context of feminism and identity politics.

Most of the photographs in the ARTIST ROOMS collection were given by Woodman to her boyfriend, who appears with the artist in the double portrait *Italy, May 1977–August 1978* 1977–8. Three untitled works dated from 1975 to 1980 include personal inscriptions from the artist. **AC**

Francesca Woodman
1958–1981

Untitled
2007
Enamel on linen
320 x 243.8 cm
Purchased with funds provided by the American Fund for the Tate Gallery, courtesy of the North American Acquisitions Committee and Oscar Engelbert, Beatrice Bonnet-Dian and Alain Jathiere, Cynthia and Abe Steinberger, Mr Christen Sveaas and an anonymous donor 2012

Christopher Wool began painting in New York City in the 1970s when many ambitious young artists of his generation were drawn to photography, appropriation and video. His works internalised then current critiques of painting: he would often cover a canvas with a floral pattern applied with a paint roller, associating painting with cheap decoration.

In the late 1980s and 1990s, Wool made a number of paintings featuring stenciled black lettering on a white ground, with one word run into the next. These works summoned up graffiti, but they were also concerned with painterly questions, such as how to paint language so that the appearance of the letters could be as compelling as the meaning of the text. *Untitled (You Make Me)* 1997 is from this series: it is a characteristically curtailed phrase which seems to await completion.

Wool has become more and more interested in photography and has published artist's books with black and white images of the streets around his Lower East Side studio. It is easy to see how the urban stains and spills relate to the marks in his paintings. He will often photograph small drawings, play with them in photoshop, silkscreen the distorted images onto paper or canvas before adding further ink or paint onto the silkscreened surfaces. The large untitled abstract canvas from 2007 is typical of this time. Wool sprayed black enamel paint across the canvas and then wiped it with rags soaked in solvent. The commanding work recalls abstract expressionist gestures and, at the same time, the grime of Wool's urban environment. **MGo**

Christopher Wool
born 1955

Having studied painting at the prestigious China Academy of Art in Hangzhou, Yang Fudong took up film and photography in the later 1990s. In often slow and elegiac sequences he brings together references to China's cultural traditions with close observation of what makes them relevant to contemporary society, as for example in his *Seven Intellectuals in a Bamboo Forest* 2003–7. Starting from the heavily mythologised real-life story of a group of young men who rejected careers as government officials in favour of a life

of reflection, drinking, music, poetry and philosophising in the countryside, Yang Fudong brings out the alienation of youth but also makes bigger claims about contemporary society and the changes affecting rural and urban populations.

This is nowhere more apparent than in his six-screen installation *East of Que Village* 2007. Its desolate, barren landscape is occupied by feral dogs roaming the open spaces and semi-abandoned buildings of a village in China's remote north. The atmospheric black and white photography ranges from wide shots of barren landscape to close-ups of dogs gnawing on an animal carcass, accompanied by a near-silent soundtrack only punctuated by dogs barking, whimpering, fighting, or the idling two-stroke engine of a small truck. Work in the fields and quiet interactions in the village define the sparse relationships between the few human inhabitants, and between humans and dogs.

More widely, Yang's work engages in an open-ended allusive reflection on human existence and artifice, whether in this haunting depiction of bare life or in elaborate tableaux of the privileged youth of contemporary Shanghai. **MD**

East of Que Village
2007
Video, six channels,
black and white with sound,
20 min 5 sec
Presented by Tate Members
2009

Yang Fudong
born 1971

By combining the skills of a historian, a curator and an artist, Akram Zaatari salvages and interrogates the past. Through his art practice, and as a co-founder of the Arab Image Foundation in Beirut, Zaatari examines photographic and filmic images to challenge the perceived norms of history. His project *Objects of Study/The archive of studio Shehrazade/Hashem el Madani/Studio Practices* 2007 gathered the production of one of a Lebanese city's commercial photographic studios. Through its straightforward presentation of portraits, the variety of ordinary lives evokes and complicates recent experience in a country torn apart by war.

In many works Zaatari explores the mediation through television and the Internet of social relationships, conflict, war and resistance in the Middle East. The outcome of a three-year long research project on the circulation of images, *This Day* 2003, shot in Lebanon, Syria and Jordan, is both a voyage in geography and in memory. From images of Bedouins and camels in the desert to those of the Arab-Israeli conflict, the feature-length video looks at states of mind in relation to the divided geography of the region. In the later *Nature Morte* 2008, Zaatari presents two men preparing, in silence, for a military action. The presence of Mohammad Abu Hammane, a former member of the Lebanese Resistance, evokes the awakening of an older resistant through the experience of his younger colleague. Zaatari made the video in a village where the fedayeen (Palestinian resistant fighters) had based themselves in the late 1960s and only a few kilometres from territory still disputed between Lebanon and Israel. In this way Zaatari activates the instability of testimonies and documents, turning them into open systems that question and reconstruct the collective memory. **SC**

This Day
2003
Video, colour with audio track, 86 min
Presented by the artist 2009

Akram Zaatari
born 1966

Photo Credits

Index

Page numbers in *italic* type refer to illustrations; **bold** numbers refer to main entries.

default254